VISUALIZING LABOR IN AMERICAN SCULPTURE

Visualizing Labor in American Sculpture focuses on representations of work, from the decade in which the American Federation of Labor was formed, to the inauguration of the federal works projects that subsidized American artists during the Great Depression. In both monumental form and small-scale edition, these sculptures provide a public record of attitudes toward labor during a transitional period in the history of relations between labor and management. Melissa Dabakis argues that sculptural imagery of industrial labor was both shaped by and helped shape belief systems about the nature of work and the role of the worker in modern society. By situating a group of important sculptures within a context of labor history, gender studies, and American art history, her book addresses key monuments and small-scale statuary in which labor was often constituted as "manly" and where the work ethic mediated both artistic production and reception.

Melissa Dabakis is Associate Professor of Art History and Co-Director of American Studies at Kenyon College. A recipient of fellowships from the National Endowment for the Humanities and the J. Paul Getty Grant Program, she has contributed to *American Quarterly* and *Prospects: An Annual of American Cultural Studies.*

CAMBRIDGE STUDIES IN AMERICAN VISUAL CULTURE

Series Editor:

Patricia Hills, *Boston University*

Advisory Board:

Albert Boime, *University of California, Los Angeles*
Garnett McCoy, *Archives of American Art, Smithsonian Institution*
Lowery Stokes Sims, *Metropolitan Museum of Art*
Terry Smith, *University of Sydney*
Roger Stein, *University of Virginia*
Alan Wallach, *College of William and Mary*

Cambridge Studies in American Visual Culture provides a forum for works on aspects of American art that implement methods drawn from related disciplines in the humanities, including literature, post-modern cultural studies, gender studies, and "new history." The series includes studies that focus on a specific set of creative circumstances and critical responses to works of art, and that situate the art and artists within a historical context of changing systems of taste, strategies for self-promotion, and ideological, social, and political tensions.

VISUALIZING LABOR IN AMERICAN SCULPTURE

MONUMENTS, MANLINESS, AND THE WORK ETHIC, 1880–1935

MELISSA DABAKIS

Kenyon College

CAMBRIDGE
UNIVERSITY PRESS

PUBLISHED BY THE PRESS SYNDICATE OF THE UNIVERSITY OF CAMBRIDGE
The Pitt Building, Trumpington Street, Cambridge, United Kingdom

CAMBRIDGE UNIVERSITY PRESS
The Edinburgh Building, Cambridge CB2 2RU, UK http://www.cup.cam.ac.uk
40 West 20th Street, New York, NY 10011-4211, USA http://www.cup.org
10 Stamford Road, Oakleigh, Melbourne 3166, Australia

First published 1999

Printed in the United States of America

Typefaces New Baskerville 10/13 pt. and Futura *System* DeskTopPro/ux® [RF]

*A catalog record for this book is available from
the British Library.*

Library of Congress Cataloging-in-Publication Data

Dabakis, Melissa.
Visualizing labor in American sculpture : monuments, manliness,
and the work ethic. 1880-1935 / Melissa Dabakis.
p. cm. – (Cambridge studies in American visual culture)
Includes bibliographical references and index.
ISBN 0-521-46147-2 (hb)
1. Labor in art. 2. Sculpture, American. 3. Sculpture.
Modern – 19th century – United States. 4. Sculpture, Modern – 20th
century – United States. I. Title. II. Series.
NB1952.L33D24 1999
730'.973—dc21 98-45452
 CIP

ISBN 0 521 46147 2 hardback

For C.D. and R.E.Y.

CONTENTS

ILLUSTRATIONS

ACKNOWLEDGMENTS

It is a pleasure to acknowledge the debt that I owe to others for their help and encouragement in the researching and writing of this book. Nonetheless, it is a difficult task, I admit, to provide sufficient gratitude to all those who offered support over the many years of this project's existence. My best efforts follow. This book would not have been possible except for the generous support from Kenyon College Faculty Development Grants, an ACLS Grant in Aid, an NEH Travel to Collections Grant, an NEH Fellowship for College Teachers and Independent Scholars, and a J. Paul Getty Fellowship in Art History and the Humanities. Visiting scholar appointments in the Art History Department of Boston University and at the Center for Literary and Cultural Studies at Harvard University greatly facilitated the final stages of research for this book.

In excavating primary and secondary sources, I traveled to archives, libraries, and museums all over the country. I wish to acknowledge the staffs of the following institutions who provided indispensable research assistance: the Albright Knox Art Gallery, the American Swedish Historical Museum; the Archives of American Art; the Art Institute of Chicago; the Bancroft Library at the University of California, Berkeley; the Boston Museum of Fine Arts; the Boston Public Library Special Collections; the Brooklyn Museum; the Chicago Historical Society; Columbia University Special Collections and Archive; the George Meany Memorial Archives; the Harvard University Libraries; the Labodie Collection at the University of Michigan; the Metropolitan Museum of Art; the National Academy of Design; the National Museum of American Art at the Smithsonian Institution; the National Sculpture Society; the New York Public Library; the Newark Museum; the Newberry Library; the Pennsylvania Capitol Preservation Committee; the Philadelphia Museum of Art Archives; the Ryerson Library at the Art Institute of Chicago; the Taniment Library at New York University; and the Worcester Art Museum.

Many friends and colleagues read or heard drafts of the manuscript in its multiple manifestations or spoke to me at length about different aspects of the book. I have very much appreciated their thoughts, comments, and criticisms, and I hope that their concerns have received the appropriate attention. My thanks go to William J. Adelman, Mildred Albronda, Michele Bogart, Harry Brod, Julie Brown Clifton Crais, Wanda Corn, Linda Docherty, Eugene

Dwyer, Betsy Fahlman, Ellen Furlough, James Gilbert, Archie Green, Brian Greenberg, Barbara Groseclose, Ruthann Hubbert-Kemper, Patricia Johnston, Sura Levine, Joanne Lukitsch, Lucy Maddox and the editorial committees of *American Quarterly,* Janet Marstine, Garnett McCoy, the Newberry Seminar in American Social History, Robert Reynolds, Jr., Peter Rutkoff, Pamela Scully, Roger Stein, Cecelia Tichi, Alan Wallach, Cécile Whiting, and Rebecca Zurier. My special thanks goes to Ellen Todd who read the entire manuscript with attention and care and helped me corral its diverse conceptual strands into a more coherent structure. Patricia Hills, the editor of the American Visual Culture series at Cambridge University Press, offered her invaluable scholarly expertise while supporting this project from its very genesis. To them both I am especially indebted. Donna Maloney provided enormous technical support in the last stages of the manuscript preparation. Beatrice Rehl, fine arts editor at Cambridge, helped shepherd this book through all stages of the publication process. And, finally, my special thanks and gratitude are reserved for my husband, Daniel Younger, photographer, editor, and one-man support network.

Portions of this book have previously appeared in abridged and revised form in various journals:

"The Individual vs. the Collective: Images of the American Worker in the 1920s." *IA: The Journal of the Society for Industrial Archeology* 12 (2) (1986): 51–63.

"Formulating the Ideal American Worker: Public Responses to Constantin Meunier's 1913–1914 Exhibition of Labor Imagery." *The Public Historian* 11 (Fall 1989): 113–32.

"Martyrs and Monuments of Chicago: The Haymarket Affair." *Prospects: An Annual of American Cultural Studies,* Jack Salzman, ed., Vol. 19 (1994): 99–135.

"Douglas Tilden's *Mechanics Fountain:* Labor and the 'Crisis of Masculinity' in the 1890s." *American Quarterly* 47 (June 1995): 204–36.

"Representing the AFL: *The Samuel Gompers Memorial.*" *Labor's Heritage* (December 1997): 4–21.

INTRODUCTION

Work, as central to the American experience, has enjoyed a critical position in social, political, and economic thought, but its role within cultural practice has received little attention.[1] This book takes as its focus a study of the representations of work and industry in American sculpture from the decade in which the American Federation of Labor was formed to the inauguration of the federal works projects that subsidized American artists during the Great Depression. Among the many concerns this book will address is the contentiousness surrounding images of labor, a remarkable fact given the centrality of the work ethic to American cultural experience.

"In the United States, at least," writes Nicholas Bromell in his study of antebellum literature, "work takes place everywhere yet appears to find cultural representation almost nowhere."[2] Within the realm of visual culture, locomotives and steam engines – symbols of technological progress – rather than the workers who constructed them, piqued the American imagination of the nineteenth century. Currier and Ives, for example, a lithography firm established by Nathaniel Currier in 1835, produced dozens of prints of industrial behemoths, like the steamboat and locomotive, but not one print of the newly emergent factory and its attendant industrial labor force.[3] Lamenting that the life of the worker held little interest to contemporary readers of Gilded Age literature, William Dean Howells asserted later in the century:

The American public does not like to read about the life of toil. What we like to read about is the life of noblemen or millionaires; . . . if our writers were to begin telling us on any extended scale how mill hands, or miners, or farmers, or iron-puddlers really live, we should soon let them know that we do not care to meet with such vulgar and commonplace people.[4]

In terms of sculptural expression, which had traditionally conveyed themes associated with the transcendent realm of the spirit or the perfected world of the material, middle-class and elite patronage demanded, as we shall see, a sanitized and, at times, allegorical account of work. When represented with any degree of realism, images of labor inferred the conflicted aspirations of the culture of capitalism. In general, private and civic patronage sought representations of work and the worker that either valorized (depicted in the

language of the ideal) or romanticized (invoked a nostalgic agrarian idyll) contemporary notions of labor.

In denouncing the effects of industrial capitalism and its ravaging of the work experience, John Quincy Adams, a progressive social critic, exploded the contradictions associated with the sculptural monument to labor and its commemorative function. In 1903, he postulated an ironic homage to the contemporary worker by foregrounding the de-skilling of labor in industrial processes.

Could we get St. Gaudens or Meunier to represent in bronze or marble the operatives in any great factory where division of labor is carried to the extreme, and then represent just those parts of the operatives which are actually engaged in their work, we could fill a museum with mutilated statues as ludicrous as any to be found in foreign lands.

Indeed, the representation of the industrial worker, the subject of this book, occupied a complicated position within the fine arts due, in part, as Adams sardonically asserted, to the ideological contradictions and political tensions inherent in mechanized and routinized labor. Nonetheless, despite his previous lampooning of the commemorative process, he concluded his 1903 article with a plea for more monuments to labor.

Up to the present time, the subject matter of nearly all art has been such as to appeal only to the rich. . . . Statues of generals and of statesman [*sic*] are all very well, but we want placed in prominent points in our cities and about our factories statues of noble working people, so that a workingman as he passes one of these shall feel his backbone stiffen and throwing his head up will exclaim, "Thank God, I am a workman."

The purpose of art, it would seem, should be to idealize work. In our factories, all about them, we should place works of art, which should make men proud of being workers, for the chief evil in our industrial conditions today is that men look upon work merely as a commutation of life's obligation.[5]

Although at first asserting the absurdity of commemorating alienated labor, Adams later argued in the same article that public monuments have a responsibility to reinvigorate the work ethic by depicting workers in a proud and dignified manner – so that their backbones may stiffen. Indeed, this essay made explicit the range of meanings that may be assigned to contemporary images of the worker. The public monument to labor and small-scale sculpture of laboring themes, I shall argue, participated in a conflicted discourse that helped shape and define assumptions about the nature of work and the role of the worker in society.

The monument to labor represented, for the most part, a public recognition of the changed conditions of labor in the late nineteenth and early twentieth centuries. Plans for the erection of labor monuments appeared for the first time in the 1880s, a period characterized by the expansion of industrial capitalism and a growing class consciousness that led to the birth of the

modern American labor movement. Whether serving the ends of progressive labor causes – as did the *Haymarket Monument,* installed in Waldheim (now Forest Home) Cemetery in 1893 (Fig. 9) in commemoration of eight anarchist activists, or paying tribute to the forces of social order underlying the work ethic ideology – as did the 1911 sculptural commission for the Pennsylvania State Capitol (Figs. 7 and 8), these sculptures provided a public record of contemporary attitudes toward labor. Indeed, the meanings associated with these public monuments were continuously mediated by dominant political debates.

The role of sculpture to commemorate – to call to remembrance or to serve as a memorial to – proved central to its aesthetic, social, and political functions in the nineteenth and early twentieth centuries. In writing about Civil War memorials, Kirk Savage has explained:

The increasing tendency in the nineteenth century to construct memory in physical monuments – to inscribe it on the landscape itself – seems symptomatic of an increasing anxiety about memory left to its own unseen devices. Monuments served to anchor collective remembering, a process dispersed, ever-changing, and ultimately intangible, in highly condensed, fixed and tangible sites. Monuments embodied and legitimated the very notion of a common memory, and by extension the notion of the people who possessed and rallied around such a memory.[6]

Monuments to labor attempted to construct a common meaning with regard to a practice that held a long and contested social and political history in this country. As the monument sought to solidify meaning through the permanence of site and material, its content – in this case, the commemoration of work and the worker – refused such stability. "Work is a concept, and a word," Nicholas Bromell asserts, "that functions in American culture primarily as a blank, as an open space into which various meanings can be inserted. . . ." He continues:

Work is deliberately left open . . . its meaning unfixed, because it is a crucial site of conflict and change. . . . At the same time, this very fluidity means that work's meaning will always be contested as one class, or group, or profession, tries to establish a privileged claim to work's fountain of values.[7]

To be sure, the social significance of labor inhabits a highly disputed field. In its most general application, labor refers to all productive work – and as such evokes the powerful legacy of the work ethic. Understood within modern historical conditions, work comes to signify, in Raymond Williams's words, "that element of production which in combination with capital and materials produced commodities." By extension, labor represents the services performed by workers for wages as distinguished from those rendered by entrepreneurs for profit. Moreover, the term implies a broad conceptual framework within which, Williams continues, the "economic abstraction of the activity and the social abstraction of the activity and the social abstraction of

that class of people who perform it'' serve various interests.[8] Thus, an under-
lying assumption of this book maintains that political tensions and ideological
conflicts inform the meaning, representation, and commemoration of labor
in this country.

In acknowledging the competing interests and various ideological claims
associated with the sculptural commemoration of labor, this study addresses
both the concerns of patronage – those served by the financial commission of
the monument – and the audience – those who view and give personal
significance to the sculpture. Indeed, a number of questions complicate the
project of commemorating labor: What particular events or persons are cho-
sen for commemoration, in effect, what constitutes the social definition of
labor? Whose labor is being remembered? Who is responsible for this choice,
that is, for the commissioning and the financial support of the monument?
Who contributes to this process of recollection?

All monuments participate in the production and management of public
memory – a highly mediated system of meaning with special language, beliefs,
symbols, and stories that privilege some historical interpretations over others.
When installed in municipal settings under civic patronage, labor monuments
speak primarily about the structures of power in society and tend to commem-
orate activities that underscore the desire to maintain order and avoid dra-
matic change. In effect, they form a part of a struggle to consolidate middle-
class identity and interests. Although memorials are open to resistant (or
oppositional) readings, dominant political forces construct powerful and per-
vasive historical representations.[9] George Grey Barnard's *Apotheosis to Labor,*
the sculptural commission installed on the facade of the Pennsylvania State
Capitol in 1911, represented an allegorical interpretation of labor that in-
voked the spiritual authority of the Bible and commemorated the moral
legacy of the work ethic (Figs. 7 and 8). Didactic in nature, this sculptural
program rehearsed the beliefs of the chiefly Protestant middle class of Harris-
burg while providing a model of decorum for the population of immigrant
workers newly arrived from eastern Europe. In celebrating an ideal central to
American identity, this monument encoded the work ethic ideology within a
nationalist spirit.

In contrast, monuments commissioned by the interests of labor – radical
political organizations or labor unions – often, but not always, commemorated
resistance as a form of public memory. In so doing, these monuments have
served as markers of histories often erased by official repression and have
provided spaces (both ideological and physical) in which labor communities
have produced their own collective memories and commemorated their own
historical struggles.[10] In the example of the *Haymarket Monument* in Waldheim
(now Forest Home) Cemetery, the setting of the memorial – despite its
funereal function – has served as an historical site claimed by disparate and
at times opposing elements of the political left (Fig. 9). A wide array of
groups, from traditional labor organizations to fringe anarchist factions, lay

claim to the Haymarket legacy by utilizing the site of the monument for public assembly and invoking the image of the monument as a symbol of labor's heritage.[11]

Ultimately, it is the viewer, standing before the monument, who completes the memorial process – a process constituted by shifting and fluid historical meanings. The significance of the monument remains forever embedded within its context – from the physical setting of the memorial to the historical circumstances of its apprehension by a particular viewer. As James Young reminds us, "We cannot separate the monument from its public life, that the social function of such art *is* its aesthetic performance."[12] In fact, it is the dialogic quality of each memorial site – the interaction between viewer and monument – that produces historical understanding. Rather than embodied (and reified) within the public monument, social meaning accrues through the accumulation of discrete experiences brought to bear upon the memorial by its many viewers.[13] Young explains,

Memorials provide the sites where groups of people gather to create a common past for themselves, places where they tell the constitutive narratives, their "shared" stories of the past. . . . At some point, it may even be the activity of remembering together that becomes the sacred memory; once ritualized, remembering together becomes an event in itself that is to be shared and remembered.[14]

In the example of *The Mechanics Fountain* of San Francisco, the intended meaning of the monument by its patrons – an homage to industrialism and progress – has undergone a dramatic shift in recent years (Fig. 27). Although rarely recognized by most middle-class inhabitants of the city, the monument now stands as a symbol of labor pride. With its focus upon the heroic male industrial worker, the sculpture has been adopted by San Francisco's laboring community as a marker of its productive capacity. Rather than embedded in the physical forms of the monument, its commemorative power remains a product of both social interaction and historical circumstance.[15]

Each one of the monuments under study in this book functions as a commemorative site in a distinctive way. This selection of monuments – from diverse geographical locations in the United States and varied historical moments – exposes the wide array of meanings attached to work and the worker. Indeed, monuments to labor represent broad constituencies – each with unique political positions and social goals. The aim of this book is to articulate the complicated elements that constitute the social formation, "labor," and to explore how sculptural expression participates in the process of producing public memory and eliciting private remembrance.

In complementing this study of the public monument to labor, this book further seeks to outline the shifting role of sculpture from purveyor of public values to object of private consumption within a market economy. By the end of the nineteenth century, artistic modernism had eroded the successful expression of civic meaning and national morality in public monuments.

Thus, a personal and, at times, idiosyncratic content infused modern sculpture of laboring themes produced for a private art market. With the reinvigoration of public art through the New Deal cultural programs of 1935, we bring this narrative to a close. These social programs, which for the first time in American history lent federal monies to support fine art production, have received significant scholarly and popular attention in the past two decades. Although a close analysis of New Deal sculptural expression – much informed by the tradition of labor imagery outlined in this book – should be undertaken, that project remains for a future generation of scholars.

■ ■ ■

This book details several public monuments to labor commissioned in the late nineteenth and early twentieth centuries, analyzes the institutional support afforded to labor sculpture in this country, and studies the increasing popularity of small-scale sculpture of laboring themes throughout the first three decades of the twentieth century. Providing a series of case studies and thematic essays rather than a survey format, it integrates the theoretical perspectives of new historicism with the interdisciplinary concerns of labor studies, gender studies, and visual representation. The sculptures of laboring themes under study here engage a variety of political and social discourses, encompassing issues important not just to the history of labor, but the changing ideals of work and masculinity in the late nineteenth and early twentieth centuries.

Central to the arguments in this book will be the examination of the dominance of the American work ethic and the gendering of labor as a masculine practice. In Chapter 1, "From Craftsman to Operative: The Work Ethic Ideology and American Art," I propose that representations of labor articulated American middle-class notions of the work ethic at a time when industrialism had radically altered the traditional nature of labor. Moreover, I show that few images of women in industry have existed in American visual culture and that definitions of labor and masculinity have functioned as mutually reinforcing concepts. This chapter outlines the historical sources of significant themes relevant for the study of the varied monuments and small-scale sculpture introduced in the following pages of the book. In so doing, it presents a selective overview of American labor imagery in the nineteenth and early twentieth centuries, seeking to demonstrate the effect of the shifting significance of the work ethic ideology and changing historical conditions of labor upon representational strategies deployed in imagery of the industrial worker.

In Chapters 2 to 4, I study the nature of the public monument to labor. Through the close scrutiny of four sculptural projects, I explore the social, political, and aesthetic dimensions comprising the monument's public life; I analyze the uneasy relationship between representations of labor and the patronage system (both private and civic); and I investigate the role of the

viewer in producing historical meaning through the public memorial. Chapter 2, "Martyrs and Monuments: The Haymarket Affair," and Chapter 3, "The Spectacle of Labor: The World's Columbian Exposition of 1893," attend to the labor monument in Chicago, an important historical locus for American labor history. In its commemoration of the 1886 bloody confrontation between workers and police near Haymarket Square, Albert Weinert's *Haymarket Monument* served as a sign of class warfare to more radical elements of the labor community. Representing a strong and powerful woman defending the body of a dead worker, the *Haymarket Monument* figured the feminine as a disruptive force that resisted and opposed the symbolic authority of the state. The *Police Monument* of 1889 by Johannes Gelert recalled a radically different interpretation of the same event. This sculpture commemorated the police involvement in the labor dispute, and in so doing gave visual form to an official public memory of the tragic incident. In the same year that the *Haymarket Monument* was unveiled, Gelert exhibited his *Struggle for Work* at the 1893 World's Columbian Exposition. Timely in its message, his sculpture expressed the misfortunes of those affected by the Great Panic of 1892–3 by representing three men contending for a work ticket thrown from a factory window. This imagery served the interests of the bourgeois fair visitors by depicting workers in competition for the scarce resource of jobs and thus rendering them as passive victims of contemporary economic conditions. Defining labor and its political claims in a variety of ways, these monuments demonstrated the multivalent meanings attached to labor relations in Chicago in the 1890s.

Representations of work varied significantly throughout the the United States as labor assumed different dimensions within various cultural and geographical contexts. In Chapter 4, "The Erotics of the Laboring Body, Douglas Tilden's *Mechanics Fountain*," I analyze this monument to labor, a privately commissioned and realistically styled sculpture installed in 1901 on Market Street in San Francisco. Functioning as much as a paean to industry as it did to the worker, the monument promoted the civilizing effects of industry on the wild frontier. Moreover, in its focus upon workers' bodies, Tilden's monument constructed a hierarchical ordering of the masculine along the intersecting axes of race and class.

The role of cultural institutions and private patronage in supporting sculptural production is discussed in the following two chapters. In analyzing the patronage of labor imagery, I explore a major exhibition by the Belgian artist Constantin Meunier in Chapter 5, "A Museological Tribute to the Work Ethic: The Constantin Meunier Exhibition." This chapter argues that Meunier's visual imagery confirmed American middle-class notions of the work ethic at a time when industrialism had radically altered the traditional nature of labor. Meunier produced images of modern industrial workers, stoically resigned to the hardships of their fate. While appealing to reformist sympathies in recording the arduous toil of the worker, his sculptures helped

assuage the fear of industrial unrest by providing a popular model for the perfect industrial worker: productive, efficient, and, above all, submissive. In analyzing the appeal of Meunier's labor imagery to American audiences, I examine the ways in which the perceived meaning of his sculpture articulated complex and often conflicting attitudes toward labor and the laboring classes to a middle-class audience. Informed by the specific historical conditions of labor, the critical reception of Meunier's oeuvre in this country differed significantly from that in Europe. When exhibited in the United States between 1913 and 1914, Meunier's sculpture provided images of diligent industrial workers – images that contrasted with the representations of radicalized and militant strikers dominating current political debates.

The relationship between small-scale statuary of laboring themes and the private market is investigated in Chapter 6, "The Stoker, the Ragpicker, and the Striker: American Genre Sculpture in the Progressive Era." I argue that at the turn of the century the production of small-scale sculpture proliferated, and with it, the sculptural themes associated with working-class life. A young generation of sculptors, most notably, Mahonri Young, Chester Beach, Abastenia St. Leger Eberle, Charles Oscar Haag, and Adolf Wolff, gained professional support from such institutions as the newly formed National Sculpture Society, the National Academy of Design, and the Macbeth Gallery, institutions that openly promoted the exhibition and sale of small-scale sculpture. Among these sculptors, no unified movement existed – although Young, Beach, and Eberle showed together on several occasions. In fact, a plurality of working-class subjects appeared in these sculptural works, conveying a wide range of social concerns, political commitments, and ideological underpinnings. The chapter is divided into three sections. The first section concerns the issues of patronage and institutional support for small-scale sculpture, concentrating on the work of Mahonri Young and Chester Beach. While dignifying and honoring daily toil in their images of men engaged in manual labor, these sculptures also invoked the popular belief in an American work ethic as defined in terms of contemporary masculinity. Abastenia St. Leger Eberle forms the focus of the second section. While participating in a variety of reform movements from suffrage to settlement houses, she paid special attention to the world of working-class women – poor immigrants at work at their humble tasks and young Lower East Side girls at work and play in the city streets. Finally, I discuss the development of a radical labor politics in the small-scale sculptural production of Charles Oscar Haag, who represented striking workers and union members, and Adloph Wolff, who produced images philosophically aligned with the political theories of anarchism.

In Chapter 7, I argue that the meaning of labor stood at the center of ideological debates of the 1920s and 1930s in the United States and that the image of the skilled industrial worker – a class of workers ever diminishing due to technological progress – served the interests of both labor and capital. A discursive network of images – the sculpture of Max Kalish, the paintings of

Gerrit Beneker, the photographs of Lewis Hine and Margaret Bourke-White, as well as mass-media imagery – represented these skilled workers as partners in the industrial process. Reproduced widely in popular journals as well as labor and management publications, these images enjoyed a broad audience consisting of skilled and unskilled workers, organized labor, and industrial management. Although images of the skilled heroic worker appeared frequently in visual culture of the 1920s, few representations challenged this near hegemonic construction, except in the small-scale statuary of Saul Baizerman, Adolf Wolff, and Aaron Goodelman. Though less known and far less popular, these sculptures suggested an alternative understanding of the role of the worker in capitalist society, an alternative that formed the basis of a proletarian visual expression espoused by the John Reed Clubs, centers of radical cultural production between the years 1929 and 1935 with which these artists were variously engaged.

"Organized Labor and the Politics of Representation: *The Samuel Gompers Memorial*" forms the conclusion to this book. Commissioned by the American Federation of Labor and dedicated in 1933, the *Gompers Memorial*, executed by Robert I. Aitken, serves as a visual record of organized labor's historical legacy. The monument is a testament to the tenets of craft unionism – the organizing of skilled workers by specific crafts or trades. Marking the end of an era, it stands apart from the heady atmosphere of change and reform inaugurated by the nascent industrial unionism movement, which intended to protect all workers – skilled and unskilled – within large labor organizations. Dedicated on national ground in Washington, D.C., the monument commemorated the historical achievements of labor – an organizational feat, initiated by Samuel Gompers, that should not be underestimated in the history of this nation.

In studying the history of labor through public monuments and small-scale statuary, we understand that the history of middle-class and elite attitudes toward labor has been constituted by many ideological rifts. Similarly, we learn that the American labor movement itself – with solidarity and differing forms of collectivity at its core – has been anything but a monolithic force. The varied sculptural expressions discussed in this book help articulate these historical complexities and in so doing contribute an added dimension to a visual culture of labor.

CHAPTER ONE

FROM CRAFTSMAN TO OPERATIVE

The Work Ethic Ideology and American Art

In the late eighteenth and early nineteenth centuries, the image of the artisan or skilled mechanic embodied the traditional values of dignity, morality, and diligence – those traits commonly associated with the work ethic ideology. Typically, these skilled craftsmen were pictured with the symbols of their trade, marking their status and industry while affirming the republican values that comprised their working lives.[1] John Neagle's *Pat Lyon at the Forge* of 1826–7 serves as an important example of such imagery. (Fig. 1). Painted in Philadelphia, this portrait presents Patrick Lyon, a blacksmith earlier in his life, who at the time of this commission had retired from his trade with an ample fortune.[2] In this large painting (it measures 93 × 68 inches), Lyon is pictured at the forge in his blacksmith shop. He is dressed in a slightly frayed leather apron, a traditional symbol of the mechanic, and worker's blouse with sleeves rolled up to reveal his muscled arms. He stands before the smoking fire of the forge, one hand resting upon his hip, the other, blackened by work, holding an anvil. Strewn on the floor around him are the accouterments of his craft – long- and short-armed mallets and large and small pliers; on the workbench lay awls of differing dimensions as well as two large open books. As the master craftsman, Lyon dominates the space of his shop and engages the viewer with authority. In the shadows behind Lyon stands a young boy who tends the fire with bellows. He is the young apprentice to whom Lyon will impart the "art and mystery" of his trade.

While Lyon was working at his successful blacksmith and locksmith business, authorities wrongfully accused him of stealing money from a bank in which he had installed two vault doors. He was arrested and imprisoned for six months in the Walnut Street Jail – the cupola of which appears in the background of the painting. Eventually, the real culprits were found to be the bank watchmen. Lyon, after his release from prison, lived in poverty and disgrace for seven years. To avenge this wrong, he brought a malicious prosecution suit against the bankers and constable, winning a favorable judgment and compensatory damages. With his newfound wealth, Lyon proceeded to build his entrepreneurial fortune.[3]

This slight digression into the autobiographical facts of Lyon's life provides a context for one possible interpretation of the painting. In commissioning this full-length, life-sized portrait of himself, Lyon explained to Neagle, "I

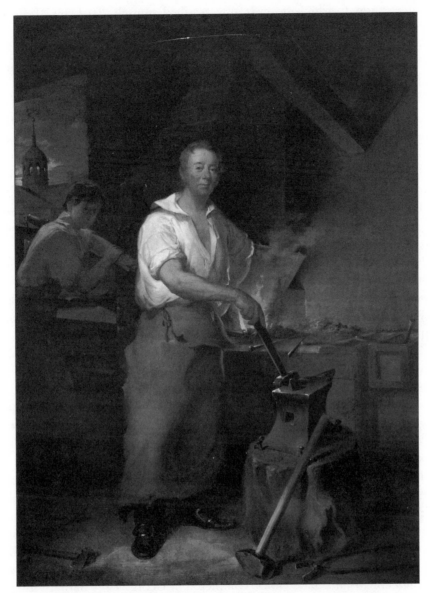

Figure 1. John Neagle, *Pat Lyon at the Forge,* 1826–7, oil on canvas, 93" × 68". Museum of Fine Arts, Boston. Henry H. and Zoe Oliver Sherman Fund. (Courtesy of the Museum of Fine Arts, Boston.)

wish you, sir, to paint me at full length, the size of life, representing me at the smithery, with my bellows-blower, hammers, and all the et-ceteras of the shop around me." He continued, "I wish you to understand clearly, Mr. Neagle, that I do not desire to be represented in the picture as a gentleman – to which character I have no pretension. I want you to paint me at work at my anvil, with my sleeves rolled up and a leather apron on."[4] Lyon had instructed Neagle to paint him as a master craftsman rather than as a "gentleman," the

social position to which he currently ascribed himself. To Lyon, the word
"gentleman" connoted both dishonesty and immorality as it was the gentle-
men of Philadelphia who had unjustly accused him of criminal activity. For
the most part, it was from this elite social class that he chose to distinguish
himself despite the shining buckles and fancy leather shoes apparent in the
portrait – sartorial accouterments that belied his artisanal status and con-
firmed his present success in the "gentlemanly" world. Nonetheless, within
the cultural codes dictated by the work ethic ideology, the mechanic – the
skilled craftsman of a preindustrial economy – stood as a paragon of virtue
and it was in this manner that Lyon chose to commemorate his life and
accomplishments.

The history of the work ethic in this country, or more specifically, the
history of shifting attitudes toward work, reveals the gradual transition from a
"free labor" or republican economy committed to the well-being of the
independent farmer and skilled artisan – like Pat Lyon – to the development
of industrial capitalism, a system in which wage labor prevailed and the
product of one's toil no longer served as one's own. Unlike Neagle's portrait
of Pat Lyon, which celebrated the dignity and autonomy of skilled craftsman-
ship, images of the industrial worker – produced in the years following the
Civil War and the subject of this book – exposed, and at times, attempted to
reconcile the friction between pride in work and estrangement from the
satisfaction of productive toil. Such representations, even while celebrating,
masking, or decrying the conditions of contemporary labor, highlighted (wit-
tingly or unwittingly) the economic conflict between labor and capital, that
is, between those who sold their labor and those who owned the means of
production, including the labor of others.

These profound changes in the nature and meaning of work affected both
the production and reception of images of laboring themes. This chapter
begins with a study of the antebellum figure of the republican mechanic,
whose image within visual culture takes on a nostalgic resonance when later
associated with representations of the industrial worker. It ends with a critical
appraisal of the work ethic ideology as represented in a sculptural program
for the Pennsylvania State House completed by George Grey Barnard in 1911
(Figs. 7 and 8). By the turn of the century, as we shall see, the work ethic
ideology had devolved from a seemingly meaningful social philosophy around
which people had organized their lives to an abstract principle deployed, for
the most part, by an elite social class to contain and manage the lives of
working people.

Furthermore, it is important to note that the work ethic ideology has
historically operated in tandem with the social discourses on masculinity, and
together they form the scaffolding that sustains the basic arguments of this
book. To be sure, the changing historical conditions of labor produced new
and often conflicting identities for the American worker in the years of
growing industrial production following the Civil War. From noble titan to

downtrodden clod, this identity has stood as a conspicuously gendered one. Few images of women in industry have existed in American visual culture.[5] Moreover, modern industrial labor has been consistently coded as a masculine practice. To that end, definitions of labor and masculinity have functioned as mutually reinforcing social categories. As we shall see in this and the following chapters, the male working-class body, in both painting and sculpture, has served as a stabilizing sign for conflicted masculine identities despite the inherent class frictions encoded in these often contentious representations.

This chapter also highlights the particular tensions accompanying the transition from a republican economy to industrial capitalism. In so doing, it presents a range of subjects that are thematized within the visual lexicon of labor imagery: a nostalgia for images of agrarian labor; the appearance of a newly established category of worker – the "unemployed" – a category that attempted to rationalize the economic fluctuations in the boom-and-bust cycles; and, finally, organized labor's renegotiation of the meaning of work under the conditions of industrial capitalism.

■ ■ ■

Devotion to work and commitment to the ideals of a work ethic have served as national traits unique to the American experience.[6] Throughout antebellum culture, the notion of work as personal fulfillment dominated American life. As Daniel Rodgers explained, "The work ethic had rested on a set of premises about the common, everyday work of men that made sense, by and large, in the North" in antebellum America. "Work was an outlet for self-expression, a way to impress something of oneself on the material world. Work was a means to independence and self-advancement."[7] This understanding of the nature of work had its roots in the Protestant ethic's notion of "the calling," a life task that embodied the fulfillment of worldly duties as the highest form of moral activity. Through the teachings of Calvin and the Protestant Reformation, labor as a prudent and thrifty activity served as an end in itself. When adopted in this country, American Calvinism associated work with a state of grace and human labor with salvation. Thus the Emersonian dictum – toil and ye shall be rewarded – recalled the spiritual roots of the work ethic while asserting the significance of individual achievement, a cornerstone of American ideology.[8]

In antebellum America, a belief in the work ethic held as its basis the notion that the worker owned his own toil, reaping the successes of his effort. The Jeffersonian model of self-reliant yeoman farmers and independent artisans populating an ideal republican nation buttressed such fundamental beliefs. This philosophy – that political and economic independence undergirded liberty and democracy – exerted considerable force throughout the century despite the expansion of industrial capitalism, an economic order in which the worker labored at the will and for the profit of another. To many, the development of wage labor came uncomfortably close to a system of slave

labor – a system, argued some labor reformers, that cheated, demoralized, and "enslaved" the workingman.[9]

As the circumstances of labor shifted in the industrializing United States during the nineteenth century, Karl Marx, writing in England, produced influential manuscripts that outlined the effects of industrial capitalism upon the worker. In his early writings, he emphasized labor as the determining factor in the evolution of culture and attached an unprecedented importance to the role of the worker. In according the laborer such dignity in his writings, he stressed that man's essential identity was that of *worker* and that his essential activity was that of *work*. In his labor theory of value, the foundation of his economic doctrine, Marx argued that the value of the commodity must depend ultimately upon the amount of socially necessary labor time that was expended in producing it. In an industrial economy, however, the capitalist strove to increase the surplus value of labor, that part of the labor process in excess of the worker's wages – the portion that belonged to the capitalist as profit. In "Alienated Labour," Marx wrote in 1844:

> the worker is related to the *product of his labor* as to an *alien* object. . . . The worker puts his life into the object; and now it no longer belongs to him, it belongs to the object. . . . The *externalization* of the worker into his product does not only mean that his work becomes an object, an *external* existence, but that it exists *outside him* independently, as something alien to him, as confronting him as an autonomous power. . . . The alienation of the worker in his object is expressed within the laws of political economy thus: the more the worker produces, the less he has to consume; the more values he creates, the less value, the less dignity, he has. . . .[10]

In theorizing the condition of labor as alienated from the worker and the product of labor as accumulated capital, Marx argued that wage labor would lead to a proletarian revolution.[11] Despite his revolutionary predictions that held more credence for Europe's rigidly stratified societies of disenfranchised workers, the Marxist model provided a complex and convincing explanation of a newly emergent political economy in the United States. In fact, Marxist theories of labor stripped of their revolutionary potential and the Calvinist model of work as spiritual redemption informed attitudes toward and representations of American labor in the second half of the nineteenth century.

On a practical level, the most notable embodiment of both Marxist and Calvinist principles among the middle class appeared in the Arts and Crafts Movement in the United States. With its origins in England, John Ruskin and William Morris condemned industrial capitalism for degrading work, despoiling nature, and inhibiting creativity. Influenced directly by Marx's writings, the Arts and Crafts philosophy understood modern culture as alienating people from themselves, their labor, and the natural world. In fact, Ruskin defined art as "man's expression of his joy in labour."[12] Eileen Boris has explained:

The craftsman ideal offered an alternative, perhaps even an oppositional, culture: that is, a set of symbol systems, social understandings, and behavior patterns in contrast to the dominant norm. A new productive order [would ensue], a new sort of community with the craftsman as the characteristic citizen and craftsmanship as the core value. . . .[13]

In essence, the Arts and Crafts Movement associated handicraft and productive labor with moral satisfaction – a functional expression of the work ethic.[14]

The craftsman style – which stressed natural materials and simplified geometric design – became a sign of reform among members of the middle class. In an 1884 series of essays, "A Factory as It Might Be," Morris envisioned factories where people worked "in harmonious co-operation towards a useful end." In this utopian scheme, the conditions of workers would be improved through newly redesigned quarters – attractive buildings in garden settings and finely decorated rooms for dining, study, and recreation. Gustav Stickley, in his influential magazine *The Craftsman*, argued not for a return to craft in the sense of manual labor, but for the worker to master the machine as a useful tool for creative productivity. Small-scale industry, therefore, served as the key to reforming the ills of industrialism. In this way, the Craftsman ideal attempted to recuperate a work ethic ideology as manifested by antebellum artisans, like Patrick Lyon. In fact, many Arts and Crafts leaders in the United States, Stickley among them, espoused the ideology of individualism and thus opposed the union movement, asserting that as a collective endeavor, organized labor hampered the ability of the individual to reap success through superior craftsmanship. From their middle-class perspective, they advocated cooperation between labor and capital – an experiment in what would become paternalistic profit sharing.[15]

It is in antebellum America where we find the roots of a preindustrial model of labor, closely associated with the work ethic, that later became a nostalgic ideal within industrial capitalism. The traditional hierarchy of the skilled trades – master craftsman, journeyman, and apprentice – served as the organizing principle of both social and economic life in a preindustrial economy. The image with which we began this chapter, Neagle's *Pat Lyon at the Forge*, while representing the personal wishes of a specific patron, also demonstrated the social prestige of the tradesman at that time (Fig. 1). The master – Pat Lyon in this case – was the proprietor who ran the shop and worked with the journeymen – the skilled workers whom he paid by the day or the piece depending on the trade. Preindustrial artisans like Lyon were highly respected citizens – literate men skilled with the hand and mind, as the open tomes in the painting suggest. Apprentices – such as the young lad pictured by Neagle in the background of the painting – began their training as teenagers and usually spent three to seven years learning the trade. Between the ages of 18 and 21, they were promoted to journeyman and given a suit of clothes and a set of tools as a sign of entering their profession.[16]

Thus, skilled artisans, pictured with their tools, were generally identified with Republicanism – a somewhat utopian vision of a nation comprised of responsible and egalitarian citizens drawn from the producing classes of mechanics, farmers, and manufacturers. Asserting that the capitalist market stimulated greed and compromised morality, this republican ideal posed a tension between self-interest and the good of the whole. The yeoman and mechanic claimed their independence by keeping the market at arm's length and abjured the idle rich and dependent poor as parasites living off the state or the labor of others.[17] Despite Lyon's later foray into entrepreneurial capitalism – from which he made his fortunes, he took much pride in his origins as a craftsman, as his portrait attests (Fig. 1). Indeed, the mythic aura surrounding notions of Republicanism – even as capitalism flourished – was given visual form in the golden halo of light that enveloped the sturdy persona of Lyon, the blacksmith at his forge.

Neagle's depiction of Pat Lyon formed part of a nascent artistic tradition that, in alluding to classical mythology, depicted the noble craftsman as Vulcan at his forge. Throughout the nineteenth century, this image of Vulcan celebrated the skilled trades. Ironworkers, for example, chose to call their union, "The Sons of Vulcan."[18] Similarly, in a mural commission for the Pennsylvania State Capitol, Edward Austin Abbey depicted an heroically scaled Vulcan floating above toiling Pennsylvania ironworkers in *The Spirit of Vulcan, The Genius of the Workers in Iron and Steel* (Fig. 2). Moreover, Walt Whitman, in arguably his most famous poem, "Song of Myself," drew attention to the lives and livelihoods of many common people, among them the blacksmith. In describing the smithy, he wrote, "Blacksmiths with grimed and hairy chests environ the anvil, / Each has his main-sledge, they are all out, there is a great heat in the fire."[19] Indeed, in all three images, the skilled worker, whether at the forge or in the foundry, assumed heroic proportions. In asserting an association (either explicitly or implicitly) with the Olympian God Vulcan – often depicted with powerful physique and enormous strength (despite his lameness), the image of the blacksmith reinforced a notion of masculinity as constituted by strenuous manual labor.

Championing an artisanal republic in an age of growing industrialism served as one of the callings of the American poet, Walt Whitman. Raised in a semiliterate family of the laboring class, Whitman enjoyed little education, leaving school at the age of 11 to toil at a variety of apprentice-level jobs in New York. As a young man, he worked as a carpenter, gained the skills of a journeyman printer in Brooklyn, and later served as a newspaper writer and editor. He was a radical Democrat, supporter of workingmen's politics, and journalist-advocate of the Free Soil movement, which opposed the admission to the Union of new states permitting slavery. In his first edition of *Leaves of Grass,* published in 1855, Whitman included an engraved frontispiece, based on a daguerreotype of himself as a day laborer, dressed in workingman's trousers, shirt unbuttoned to reveal his undershirt, and hat cocked on his

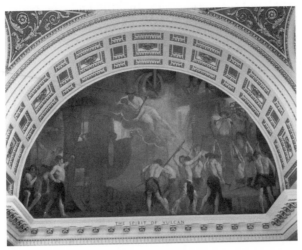

Figure 2. Edwin Austin Abbey, *The Spirit of Vulcan, The Genius of the Workers in Iron and Steel*, 1907, mural. Rotunda of the Pennsylvania State Capitol, Harrisburg. (Courtesy of the Pennsylvania Capitol Preservation Committee and Hunt Commercial Photography.)

head. This image suggested the poet's revolt against an elite literary profession. In establishing the role of author as a democratic presence, he identified himself within this engraving as a common man who spoke for the people.[20]

In his poetry, Whitman is one of the few nineteenth-century writers to address himself to the workingman and woman. He lavished praise upon the common person – the worker who made this country bountiful. In "I Hear America Singing," he exalted the mechanic, the carpenter, the mason, the boatman, the shoemaker, the wood-cutter, and, significantly, the mother, the young wife at work, and the girl sewing or washing, "Each singing what belongs to him or her to none else."[21] With such words, he furthered the republican values of free labor and self-sufficiency and commemorated the moral values of the work ethic. Even when skilled labor and traditional handicrafts were succumbing to the pressures of technology, Whitman stressed the creative hand of the worker. In his poem, "Song of the Exposition," begun in 1871 and rewritten in 1881 after his visit to the 1876 Centennial Exposition in Philadelphia, Whitman praised the role of the worker in both traditional crafts and new industrial processes: "Not only all the world of works, trade, products,/ But all the workmen of the world here to be represented."[22] Moreover, in highlighting the discrepancy in class positions between those who attended the fair and those who labored to produce the commodities on display, he wrote, "The male and female many laboring not,/ Shall ever here confront the laboring many."[23]

To a small but select contemporary audience, Whitman's *Leaves of Grass* provided a vital model for communicating a celebration of artisanal toil. His role, as he described it, was not "to pick out evils from their formidable masses (even to expose them,)/ But add, fuse, complete, extend – and cele-

brate the immortal and the good.''[24] Despite the changed conditions of labor – the disempowering and de-skilling of the worker that took place during his lifetime – Whitman produced an iconography of the worker that continued to convey a trenchant optimism for the future while armed with republican legends of the past.[25]

■ ■ ■

This Jeffersonian model of republicanism inspired much of the imagery of rural labor that dominated nineteenth-century visual culture. By the second half of the century, this republican ideal, however, showed signs of strain as social tensions inherent in the shift from an agrarian to an industrializing economy colored the bucolic nature of this pastoral myth. In their American reception, the paintings of Winslow Homer (1836–1910) and Jean François Millet (1814–75), for example, conveyed the anxieties of a culture in economic and social flux. Unusual in its depiction of women industrial workers, Homer's *The Morning Bell* of ca. 1872 centers upon a young woman on her way to work at a rural mill[26] (Fig. 3). As Bryan J. Wolf points out, she is dressed in a fashionable jacket and sun bonnet, both signifiers of the middle class – the same bonnet that appears in Homer's tourism paintings, such as *The Bridge Path, White Mountains,* of 1868.[27] Behind the central figure whose erect and proper posture signal her breeding, stand three other women – presented in frontal, profile, and back views, like three (working-class) graces – who huddle together in a group. With their hunched postures and more robust bodies, these women signify working-class womanhood. Dressed more plainly as appropriate for their daily labor, they serve as a foil to the well-dressed central figure.

As the focus of the painting, the finely dressed woman stands at the crossroads between an agrarian existence behind her, signified by the small isolated cabin in the background, and the industrial life of the future, marked by the large clapboard mill with ringing bell before her. In the New England mill districts, the ubiquitous bell towers rang the workers out of bed, called them to work, and returned them home again. In organizing the workers' day, they represented the mechanization of time and work and served as the symbol of the new industrial workforce. Middle-class women eagerly participated in such industrial labor. In the early nineteenth century, they left their homes on the farms to earn money while living securely in clean and well-chaperoned boarding houses provided by the mill owners. By the 1840s, the conditions at the mills deteriorated due to increased competition from other parts of the country. As conditions worsened, wage labor for middle-class women grew unacceptable – considered coarse, uncouth, and unladylike. As a consequence, these women fled mill life. By mid-century, mill owners recruited immigrant and poor rural women to fill the need for such labor.[28]

In the dilapidated condition of the mill, marked by its broken windows, this painting gives visual form to the social tensions surrounding mill labor.

Figure 3. Winslow Homer, *The Morning Bell*, c. 1872, oil on canvas. Yale University Art Gallery. Bequest of Stephen Carlton Clark, B.A., 1903.

The grouping of women to the far right represents the new industrial work force – immigrants and the rural poor – who had no choice but to endure difficult working conditions and accept the increasingly low pay of the textile industry. Despite its bucolic setting, this painting registers with a poignant realism the stark class divisions associated with an industrializing economy.

Similarly, the rural labor in Jean-François Millet's paintings expressed to an American public a complicated, and at times contradictory, message about industrialism. Purchased by many American collectors, these images gained a widespread popularity in the years following the Civil War. Millet's *The Sower*, for example, evoked a nostalgia for republican values in a period of increased industrialism (Fig. 45). For the most part, these wistful scenes of preindustrial labor represented for American middle-class and elite audiences an affirmation of this country's agrarian origins, assuaging the social tensions inherent in new rural capitalism and a nascent consumerism. Moreover, his paintings communicated the moral and political strength of the common man, the biblical promise of the Puritan work ethic, and the grace of rustic life – essentially rehearsing yet again the union of agrarian life with republican virtues.[29]

However, as early as 1864, Millet's peasants evoked an alternative reading as signifiers of danger and subversion. Anticipating the great labor upheavals of the following decades, one writer perceived violence and class warfare smoldering beneath the placid exterior of these diligent rural laborers.

[Millet's peasants] look heavy with gross cares, hardened with increasing labor, and vindictive and brooding. You would say they are souls whose only sense is a sense of oppression, and you stand in awe of the smothered violence that waits under that stolid pace and heavy body. I do not know what to liken these peasants to. They remind me of 'field hands' on Southern plantations, their skulls are as animals, but they have none of the inoffensiveness of expression of the poor slaves. . . . They may waken any moment to assert their power and avenge their wrongs.[30]

Conveying a rather volatile attitude toward the contemporary "labor problem," this passage demonstrated the ability of Millet's images to evoke a range of interpretative responses from joyful praise of republican values to hostile disdain for a "vindicative and brooding" laboring class.

In its comparison of black slaves to poor peasants, this passage asserted the language of racial difference. It emphasized the body rather than the mind and invoked an animal rather than a human nature. In so doing, it reinforced the belief that both worker and slave were considered separate, distinct, and "inferior" races. Such open contempt for the working classes prefigured the language of Social Darwinism that infiltrated the ideology of Progressive reform and informed the critical reception of another popular European artist, Constantin Meunier, whose sculptures of laboring themes are discussed in full in Chapter 5. The admiration and aversion that Millet's painting elicited in the last half of the nineteenth century extended to the sculpture of laboring themes by Constantin Meunier popular in this country in the first two decades of the twentieth century. The work of both artists, it seemed, conveyed a nostalgic yearning for productive and satisfying labor – whether agrarian or industrial, while also serving to communicate the potential for labor unrest to an increasingly fearful middle-class audience.

In 1899, Edwin Markham brought attention to Millet's painting, *Man with a Hoe* of 1860–2 – a graphic representation of the effects of a lifetime of ceaseless labor, by publishing a controversial poem of the same name in the *San Francisco Examiner* (Fig. 4). In this poem, Markham had originally equated the French peasant with the American farm laborer in a plea for agrarian reform. Although Markham intended his poem solely as a commentary upon the hardships of farm life, it had an explosive affect upon its public. To many, the phrase "man with a hoe" assumed a much broader meaning, serving as a code for rural degradation and industrial unrest.[31] Much discussion regarding the poem ensued in the popular press; the *Oakland Tribune* even sponsored a "Hoe-Man Symposium" that same year. Using the poem as a call for social reform, socialists, clerics, and teachers who participated in the symposium argued that the factory system, inequities in distribution and production, competition, and technology – the whole gamut of industrial woes – had created a climate in which the "hoe-man" flourished.[32]

In focusing upon Millet's *Man with a Hoe*, Markham challenged the efficacy of republican agrarian myths – often embodied in the image of the sturdy, independent, and proud yeoman farmer. In contrast, this painting presented a bent and broken peasant, wizened beyond his years, who toiled at the seemingly impossible task of cultivating a rocky wasteland stretching to the picture's horizon. Markham wrote the opening stanza of the poem upon seeing Millet's world-famous painting.

> Bowed by the weight of centuries he leans
> Upon the hoe and gazes on the ground.

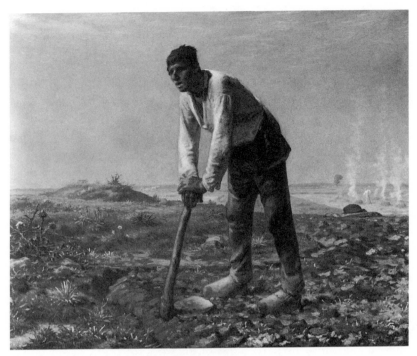

Figure 4. Jean-François Millet, *Man with a Hoe*, 1860–2, oil on canvas, 31½" × 39". Collection of the J. Paul Getty Museum, Malibu, California.

> The emptiness of ages in his face,
> And on his back the burden of the world.
> Who made him dead to rapture and despair,
> A thing that grieves not and that never hopes,
> Stolid and stunned, a brother to the ox?
> Who loosened and let down this brutal jaw?
> Whose was the hand that slanted back this brow?
> Whose breath blew out the light within this brain?[33]

Such powerful language angered those Americans who still believed in the nobility of rural work and the sacredness of the land. In response to those who resisted the call to agrarian reform, Markham adopted the view of social reformers, arguing that his poem not only embraced agrarian labor, but also indicted the evils of the industrial system. He wrote in 1900:

I soon realized that Millet puts before us no chance toiler, no mere man of the fields. No, this stunned and stolid peasant is the type of industrial oppression in all lands and in all labors. He might be a man with a needle in a New York sweat shop, a man with a pick in a West Virginia coal mine. . . .

The hoeman is the symbol of betrayed humanity, the toiler ground down through ages of oppression, through ages of social injustice. He is the man pushed away from the land by those who fail to use the land, till at last he has become a serf, with no mind in his muscle, and no heart in his handiwork. . . .

In the hoeman we see the slow, sure, awful degradation of man through endless, hopeless and joyless labor. Did I say labor? No – drudgery.[34]

Indeed, this poem represented a form of literary dissent – a protest against the changing conditions of labor in rural and urban America. As demonstrated by the powerful public response to both Markham's poem and Millet's painting, the representation of the worker, both literary and visual, served as a lightning rod in the struggle over social change. By the 1880s, the worker had assumed a variety of social guises: serving the ends of reform as the hapless victim of industrial oppression *and* bolstering the forces of the status quo as the demonized agent of anarchy and violent change.

■ ■ ■

As industrial workers experienced the deleterious effects of wage labor and the growing mechanization of the work process, the fears of social unrest grew among industrialists and the middle class in general. In 1880, the gap between skilled and unskilled workers' wages grew much wider than in 1850, producing an unbridgeable chasm between workers – a division that would come to characterize the American workforce until the present day.[35] The unemployment rate – the percentage of the work force idle at any one time – expanded with the boom and bust cycles of the new economy. The frequency of unemployment – the percentage of employees out of work at some point during the year – also skyrocketed. During the depression years of the 1870s and the 1890s, the unemployment frequency was 30 percent. Even during prosperous times, one in five workers was unemployed at some point in the year, at times for a period of three to four months.[36]

In order to understand better the social significance of labor, we must also consider its opposite condition – idleness – and its social meaning in the second half of the nineteenth century. In the wake of the 1873 depression and the 1877 railroad strikes, the term "tramp" came into existence to designate migratory and unemployed workers. As an ideological construction, it named the new phenomenom of unemployment in an industrial economy. Social scientific, charity, and relief discourses along with biological findings judged tramping (as well as pauperism and crime) as inherited traits. Moreover, a growing middle-class constituency deemed vagabondage as a sign of a declining public morality in its rejection of the civilizing qualities of work. Bolstered by the moral authority of the work ethic, legislators in New Jersey first passed antitramp measures in 1876. By the 1890s, the man who could not or who would not work became a symbol of maladjustment to industrial America and stood as a threat to the stable social structure of the country.[37]

Workingmen from all over the country rejected this encoding of idleness as moral depravity. In fact, many unemployed laborers demanded work following the financial panic of 1893 when three million Americans were left jobless. Under the leadership of Jacob Sechler Coxey, an eccentric business-

man from Ohio, an army of workingmen marched from Ohio to Washington to demand government-funded public works. Arriving in the nation's capital on May 1, 1894, "Coxey's Army", consisting of only 500 tattered and desperate men, paraded through the town. After defying a law prohibiting demonstrations on the Capitol grounds, Coxey and many of his cohorts were jailed for twenty days and fined $5.00 each for walking on the grass. With the arrest of its leader, the army soon fell apart.[38]

Coxeyism raised the spectre of social revolution in the minds of many. Although the actual numbers of the army were small, several prominent commentators described the group in the thousands and feared that this wild mob of vagabonds would disrupt the very existence of the Union. So intriguing to the American public was this act of protest that one month after Coxey's arrest in Washington, the dime novel, *On to Washington: Or Old Cap Collier with the Coxey Army*, appeared in print in the Old Cap Collier Library on May 30, 1894.[39] Posing little actual threat to the social order, Coxey's Army brought attention to mass unemployment, framing the social problem in terms of economic conditions rather than moral laxity. In uncovering the material grounds for the existence of the tramp, Coxey's Army foregrounded the potential political threat of labor activism when linked to traditional boom-and-bust economic cycles.

In the midst of the unemployment crisis of the 1890s and the attendant fear of vagabondage that had gripped the country, Johannes Gelert exhibited his life-size plaster sculpture, *The Struggle for Work*, in the Fine Arts Palace of the World's Columbian Exposition (Fig. 21). As discussed more fully in Chapter 3, this sculpture depicted three men of differing generations contending for a factory work ticket. Although the sculpture depicted a common practice in British industry, the struggle for work was all too familiar to the legions of unemployed men who roamed the streets of the Windy City in 1893 and protested their joblessness at the Chicago lakeside. In Gelert's sculpture, the strong and virile middle-aged worker, with children and wife at his feet, wrested the work ticket from the hands of a youth and an aged man, both types of workers expendable in an economy that had forsaken the hierarchy of master craftsman and apprentice. Gelert's sculpture pictured a Darwinian struggle for work and naturalized an economic system that, in effect, denied workers access to labor. Indeed, unemployment (or vagabondage) served the needs of capital; as the demand for jobs far outstripped the supply, it allowed wages to remain depressed and forced workers to compete for a scarce resource.

It was in response to the conditions of industrial capitalism that the union movement took hold. Labor organizations of skilled craftsmen had their beginnings in the 1820s in Philadelphia. However, under the auspices of the Knights of Labor and later the American Federation of Labor, the meaning of work and the status of the worker claimed a new resonance in an industrializing America. Thus, images of the industrial worker must be acknowledged

within the context of these new organizational structures that greatly empowered labor's ranks.

The Order of the Knights of Labor, founded in 1869 in Pennsylvania, developed into a national organization with vast working-class loyalty. After assuming control of the organization in 1878, Terence Powderly transformed the Knights from a secret order with elaborate initiation rites to an organization with a much larger membership base. Among those encouraged to join were blacks, segregated into their own orders, and women who comprised about ten percent of the Order's constituency. Welcoming both skilled and unskilled workers into its fold, the Knights of Labor advocated the motto "An injury to one is a concern of all."[40] In its inclusiveness, it foreshadowed the tenets of industrial unionism, first put forward in this country in 1905 by the Industrial Workers of the World. Regarded as a radical practice until the 1930s with the formation of the Committee for Industrial Organization, the Knights advocated the protection of all workers – regardless of race, ethnicity, gender, or skill level.

The Knights repudiated the notion of an irreconcilable conflict between labor and capital. Through cooperative production and land reform, the Order aimed to abolish "wage slavery." Rather than overthrow capitalism, they intended to substitute arbitration for strikes. In the aftermath of the Haymarket Tragedy of 1886 (discussed at length in Chapter 2), which highlighted class tensions in this country, the Knights began to lose favor among its constituency. Powderly, who had once exclaimed, "I curse the word class," hardened his positions into dogma. He refuted all strikes, condemned craft unionism, and denied amnesty for the Haymarket anarchists unjustly accused and convicted of conspiracy. Once faithful Knights defected to the ranks of the newly formed American Federation of Labor (AFL), founded in 1886 by Samuel Gompers.[41]

The American Federation of Labor offered many contrasts to the Knights of Labor. As craft unionists, they favored trade autonomy rather than a centralized organization and accepted class conflict as inevitable in industrial life. In direct opposition to the inclusive policies of the Knights, the AFL excluded blacks, women, and the unskilled from their ranks. Founded out of a loose organization of national trade unions, the AFL held to three core concepts: pure and simple unionism, voluntarism, and prudential unionism. Through these principles, Gompers argued for the autonomy of labor – with the union as the core of workingmen's lives. Repudiating slow and bureaucratic governmental reform, pure and simple unionism advocated rapid improvements in the lives of workers and immediate betterment of workplace conditions. Similarly, voluntarism taught workingmen to look to the union for all their needs, not to reformers or to the government. Prudential unionism, Bruce Laurie explained,

was calculated to preserve trade unionism in an unfriendly environment. It argued strongly for turning away from unskilled and semiskilled factory workers inclined to

engage in mass strikers or general work stoppages that activated the repressive machinery of government. It also encouraged unionized labor to restrict its struggles on the shop floor in the hope of reducing the possibility of government intervention.[42]

In essence, prudential unionism aimed to protect the rights of skilled workingmen in the face of hostile reactions from industrial capitalists and the federal government. Gompers wanted to halt the violence that had come to dominate labor relations since the massive railroad strikes of 1877. For this reason, he denounced mass strikes and general work stoppages and disinherited the unskilled masses whom he believed lacked "civilization," patience, self-discipline, and a realistic sense of the possible.[43]

In keeping with its core principles, the AFL took an active stance in the battle for the eight-hour day. The repressive aftermath of the Haymarket bombing squelched the powerful impetus of this movement, originally centered in Chicago. Taking a courageous stance, the AFL resumed the struggle for this popular crusade in 1888. The eight-hour day strategy intended to tackle the growing problem of unemployment, ironing out the boom-and-bust cycles by shortening the work day and employing a larger number of workers. Fought by industrialists and manufacturers, it challenged the notion of the "surplus value of labor," working against capitalist interests of accumulated profits.[44]

The eight-hour movement resonated with the contemporary moral debate on vagabondage. With its slogan, "Eight Hours for Work. Eight Hours for Rest. Eight Hours for What We Will," it advocated relief for workers from the difficult and increasingly unsatisfying nature of modern toil. Moreover, the AFL defended the importance of relaxation and recreation in workers' lives while also endorsing the moral satisfaction of labor. What seemed to be a weakening of the work ethic among the "dangerous classes" fueled middle-class opposition to this campaign. In fact, many opponents of the eight-hour day asserted that the sanitizing effects of constant labor offered workers an escape from the supposed dangers of temptation that beset them during leisure. Unlike tramps who were tempted into moral laxity and labor agitation, legitimate workers toiled exhaustively, too drained to participate in violence and revolt.[45]

Although industrialism had come to dominate the work experience of many, few paintings recorded the conditions of contemporary labor. Among them, John Ferguson Weir's *Forging the Shaft: A Welding Heat* of 1878 and Thomas Anshutz's *Ironworker's Noontime* of ca. 1881, although not addressing the union movement in any direct way, celebrated the contributions of skilled industrial workers in modern factory settings (Figs. 5 and 6). In highlighting the strenuous labor of forging steam-engine shafts for peacetime use, *Forging the Shaft* served as a companion to *The Gun Foundry* of 1864–6 in which workmen cast Parrott guns for government commission during the Civil War.

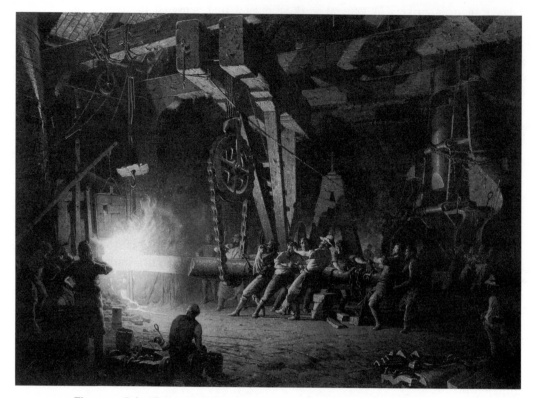

Figure 5. John Ferguson Weir, *Forging the Shaft: A Welding Heat,* 1878, oil on canvas, 52" × 73¼". The Metropolitan Museum of Art. Purchase, Lyman G. Bloomingdale Gift, 1901 (01.7.1).

Shown at the Centennial Exhibition in Philadelphia in 1876, *The Gun Foundry* represented the only industrial scene in the entire exhibition, a surprising fact given the attention to industrial display apparent at the Fair.[46]

In Weir's *Forging the Shaft*, fourteen men manipulate the shaft of an ocean liner propeller as it is heated to welding temperature in the West Point Iron and Cannon Foundry in Cold Spring, New York.[47] Weir (1841–1926) depicted the machinery and tools – the pulleys, harnesses, and various ropes and chains used in foundry work – with detailed accuracy. Although diminutive in scale, the workers appeared as unique individuals, each dressed in their protective leather aprons and workshirts with rolled-up sleeves. As the straining men recoiled from the raging heat of the open furnace, Weir made evident the strength of their brawny bodies. In fact, this painting highlighted the contribution of labor to the manufacturing process as these industrial workers – with their powerful physiques – provided the energy and skill to activate this spectacular scene.

Although the cavernous space of the foundry, bathed in raking light from the blast furnace, dwarfed the hard-working men, the heroic quality of their strenuous labor participated in this spectacle of modern wonderment. The

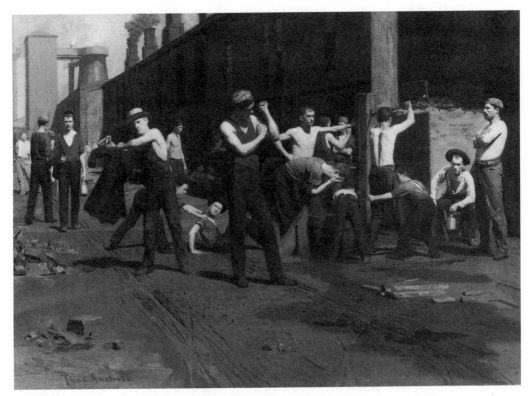

Figure 6. Thomas Anshutz, *The Ironworker's Noontime,* 1880, oil on canvas, 17" × 23⅞".
The Fine Arts Museums of San Francisco, Gift of Mr. and Mrs. John D. Rockefeller 3rd,
(1979 7.4).

dark shadows and warm glowing light transformed the industrial workplace
into a romantic den, filled with danger, drama, and excitement. In the vague
shadows of the painting's lower right corner, the chains and hoisting device
recalled the presence of a human skeleton, reinforcing the threatening yet
awesome nature of modern technology.[48] Indeed, the modern industrial la-
borer, defined by muscle and brawn, projected a majestic manliness, an ideal
that kept alive contemporary notions of the work ethic.

Thomas Anshutz's painting, *The Ironworker's Noontime* of ca. 1881 (Fig. 6),
provides an interesting comparison to Weir's *Forging the Shaft.* In both paint-
ings, the process of iron forging serves as subject; however, Anshutz (1851–
1912) rejects the highly romanticized depiction of the industrial process
presented in Weir's painting. *The Ironworker's Noontime* depicts the decidedly
unremarkable rest period of weary workers. These skilled ironworkers produc-
ing, in this case, cut nails in a Wheeling, West Virginia, plant, are the indus-
trial descendants of the blacksmiths of antebellum days – typified in Neagle's
portrait of *Pat Lyon at the Forge* (Fig. 1). In their highly choreographed postur-
ings, these industrial workers draw attention to the power of the body – a
power remythologized in the contemporary image of Vulcan, the heroic sym-

bol of the ironworker's union. Replete with traditional iconography and noble heritage, this craft tradition had witnessed a transformation into a more complex factory system.[49]

With its square-towered elevator for transporting coke, ore, and limestone, its conical blast furnace, and square-chimneyed puddling furnaces, this painting depicts an iron foundry in a highly accurate fashion. As the central focus of this painting, skilled ironworkers – puddlers, nailers, and rollers – produced pig iron for Wheeling's successful nail-making industry. These workers were decidedly *not* victims of industrialization; in fact, the puddler – the craftsman responsible for boiling the iron to the proper consistency – was among the most skilled and highest paid of all industrial workers. The young boys depicted in the painting were the apprentices – learning the practices of this elite trade.[50] In this painting, Anshutz paid homage to a proud labor force – skilled, well-paid, and highly respected, a labor force soon to be organized under the auspices of the American Federation of Labor. By emphasizing their weariness, he at once evoked the nobility of hard work and the necessity of relaxation within workers' lives while signaling his own commitment to the tenets of realism as an artistic style.

Thomas H. Pauly has argued that this painting depicted a crucial moment in the shifting patterns of the history of work. By 1880, steelmaking, with its newly perfected processes, presented a looming threat to the iron industry. With the new Bessemer blast furnace, the steel industry no longer required the skill of native-born industrial craftsmen like the puddler, for example, in the difficult task of boiling the pig iron. In its manufacture of stronger and cheaper steel products, the industry employed mostly unskilled day laborers comprised of eastern European immigrants. By 1885, Wheeling had three steel mills with three more on the way. The livelihoods of skilled ironworkers, once the aristocracy of industrial labor, were lost for good. This painting, thus, offers an important record of skilled industrial labor in the iron industry before the process of de-skilling ravaged its contemporary work force. It presents a moment when the contributions of the skilled worker to the industrial process were of foremost importance – a contribution rapidly eroding by the end of the century.[51]

The Mechanics Fountain by Douglas Tilden (Fig. 27), one of the few public monuments to industrial labor in this country, provides a sculptural counterpart to the imagery of Weir's *Forging the Shaft* (Fig. 5) and Anshutz's *The Ironworkers' Noontime*. When installed in San Francisco in 1901, this sculpture, which is discussed at length in Chapter 4, served as a monument to industrial progress in the western United States in its commemoration of the San Francisco industrialist Peter Donahue. It depicts two skilled workers maneuvering an iron plate through a punching machine while three young apprentices power the punch by attempting to activate the lever arm. The large manpowered machine dominates the composition – towering well over the heads of the skilled workmen at the press. At the base of the sculpture is a ship's

propeller, among other industrial commodities, produced by the skilled work-men in San Francisco's first foundry, the Union Iron Works.

These life-sized figures embodied the craftsmanship of the mechanic, performing tasks that required skill and knowledge of the industrial trades. Reinforcing this interest in the working-class male body (discussed more fully in Chapter 4), these figures appeared nude – godlike in their ideal physiques – despite their leather aprons. What is interesting, however, is that by the end of the nineteenth century, such terms as artisan, mechanic, or even master craftsman were no longer in common parlance despite the use of "mechanic" in the sculpture's title.[52] As a monument to modern industry, the *Mechanic's Fountain* conveyed a deeply conflicted message – a message inscribed upon the bodies of working-class men. Anachronistic in its reference to the skilled mechanic with his association to a republican past and in its depiction of a hand-powered rather than steam-powered lever punch, the monument nevertheless upheld the promise of an industrial future, championing technology as the key to progress in the western United States. Indeed, the ambivalent and conflicted message of the *Mechanic's Fountain* typified the tensions between old and new, artisanal and industrial that continued into the first two decades of the twentieth century.

■ ■ ■

Such tensions provoked fissures in the once seamless ideology of the work ethic as industrial capitalism developed and the strength of its effects were made apparent. The nobility and morality previously associated with productive labor grew more and more difficult to correlate with the experience of most industrial workers. The meaning of the work ethic assumed a more hypothetical – rather than functional – nature, independent of the activity of work itself.[53] George Grey Barnard's 1911 sculptural program for the Pennsylvania Capitol – *The Unbroken Law: Love and Labor* and *The Broken Law: The Paradise that Fails because It Is Not the Fruit of Man's Labor* – presented labor in ideal terms, as sacred and noble, removed from the exigencies of contemporary workers' lives (Figs. 7 and 8). The civic sculpture of the Pennsylvania State Capitol, functioning as part of the City Beautiful Movement of urban planning and beautification,[54] aspired to convey a highly moralistic and didactic message – a celebration of the American work ethic.

At the turn of the century, traditional civic statuary – like Barnard's sculptural program – aligned itself stylistically and thematically with academic principles and took as its purpose the expression of universal ideals and the advancement of public education to a middle-class and elite audience. Both progressive and nostalgic in its social and aesthetic aims, this type of civic sculpture combined elements of modern life with the principles of classical art. As in many mural projects of the period, such as Abbey's *The Spirit of Vulcan* also located in the Pennsylvania State Capitol, an alternation of realistic and symbolic styles prevailed (Fig. 2). Much public statuary revealed a

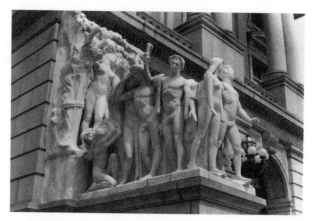

Figure 7. George Grey Barnard, *The Unbroken Law: Love and Labor,* 1911, marble, 9' h. Pennsylvania State Capitol, Harrisburg.

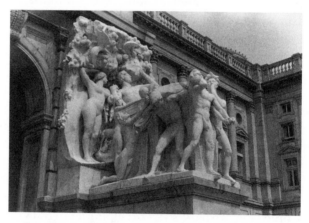

Figure 8. George Grey Barnard, *The Broken Law: The Paradise that Fails because It Is Not the Fruit of Man's Labor,* 1911, marble, 9' h. Pennsylvania State Capitol, Harrisburg.

fusion of seemingly opposite visual codes, producing a structure in which a highly detailed style and contemporary subject matter – linked semiotically with the uncertainties of modernity – often coexisted with ideal form and allegorical content – associated with the timeless and familiar principles of the past. Thus, in this liaison between abstract symbolism and detailed realism, visual representation worked to reassure the middle-class public, uneasy about rapid societal change, that new institutions of modern life would not markedly differ from those of the past. Encoded with the moral authority of the Bible and antiquity, civic statuary produced a sense of continuity with the past rather than highlighting social change as an effect of conflicts between social classes and economic forces.[55]

With these civic ideals in mind, George Grey Barnard (1863–1938) carved two groups of twenty-nine figures, each standing over nine feet high, in gray

carrara marble. He intended his sculptural program to be modern as it related to labor's role in the state's prosperity. To that end, he used live models to fashion his figures, such as Adam and Eve from *The Unbroken Law* group (Fig. 7). Thus, in the language of academic classicism, his skilled working of the marble, with its (once) detailed anatomical precision, encoded the body as a signifier of modernity.[56] Simultaneously, he wished to communicate a message of universal significance. Flanking the main entrance of the Capitol building, these sculptures articulated themes that referenced the Bible, the family, and the antique. These didactic and moralizing sculptures were meant to inspire civic loyalty among the inhabitants of this urban center while affirming labor as the core of moral life.

The north group on the Capitol facade, *The Unbroken Law: Love and Labor*, consists of eight sculptural groups with a total of seventeen nude figures (Fig. 7). It reveals the bounties awarded to those who toil in hopeful fellowship. Significantly, Adam and Eve inhabit both the bas relief to the rear of the group as well as the foremost sculptural position. The biblical narrative referenced by these figures, although ambiguous in the meaning ascribed to labor, contained the seeds of a positive attitude toward work. Despite the fact that the myth cursed Adam to a vale of toil and sorrow outside Eden, nineteenth- and early twentieth-century moralists agreed that Adam was no idler in Eden – he watched and tilled the garden while the Judeo-Christian God himself worked and rested. Thus, these moralists insisted that work was not a curse, but a blessing and delight. Further, the Protestant reevaluation of work – the calling – preached that God had called everyone to some productive work. Consequently, preachers encouraged this ideal of diligent, productive labor and inculcated it into generations of middle-class and elite Protestant families.[57]

As a complement to the *Unbroken Law*, Barnard carved the *Broken Law: The Paradise that Fails because It Is Not the Fruit of Man's Labor*, located on the south side of the Capitol entrance (Fig. 8). It consists of eight sculptural groups with a total of eleven nude figures. Each of the figures provided a direct contrast to the vignettes in the *Unbroken Law* group. They exemplify the pain and sorrow of a life lived outside the sacred realm of the family and devoid of the spiritual and material bounty betokened by a belief in the sanctity of labor.

At the 1911 dedication ceremonies for Barnard's sculptural program, the Honorable John C. Bell, Attorney General of the State, praised these sculptures as symbols of the nobility of labor.

''The Gospel of Labor'' [is] one of the sermons in stone which these statues will perennially proclaim to the officials and citizens of this State. . . . For it is religiously true that labor is the secret and guaranty [sic] of right living and real happiness. Beyond a doubt, in the last analysis, the well-being and character of the home, the state and the nation must rest upon the well-being and character of those who labor. The whole is equal to the sum of its parts; and in a civic sense, this is essentially true of a government of the people.[58]

Reaffirming the work ethic ideology, Bell argued that labor served as a bless-
ing rather than a burden – as an act of virtue integrally linked to the moral
superiority of one's character and to the spiritual development of the nation
as a whole. This speech rehearsed a belief in the redemptive properties of
labor strongest in the nineteenth century among the middling, largely Prot-
estant, property-owning classes of merchants, ministers, independent crafts-
men, and nascent industrialists. Particularly popular in the northeastern
United States, the work ethic ideology continued to dominate public and
private discourse and undergird middle-class attitudes toward success, pros-
perity, and progress throughout the early twentieth century.[59]

Indeed, when Bell spoke of the "well-being of the state and the nation,"
he was quietly alluding to the dangerous labor strife experienced by Pennsyl-
vania, in particular, and the country as a whole. To be sure, the public
evocation of the work ethic provided a means of restoring confidence in the
social order to an increasingly alarmed middle- and upper-class citizenry. As
James Gilbert explained:

By 1900 the definition of "work ethic" had become synonymous with the idea of
social order. The work ethic represented a complex ethical statement of the inter-
relationship between the individual, what he or she produced, and society. It repre-
sented an ideal situation in which individuals received, not just payment, but ethical
and aesthetic enrichment for their work as well. It was, in effect, a utopian descrip-
tion based upon an idealized past.[60]

Thus, the Harrisburg sculptures – in proclaiming the absolute importance of
the work ethic – masked the tension between an acceptance of work in its
moral purity and a suspicion of labor with its political exigencies. Only by
depicting imagery sufficiently removed from contemporary labor conditions –
that is, imagery couched in the moral language of the Bible or the antique –
could these sculptures provide suitable metaphors of economic prosperity for
a middle-class and elite audience of the early twentieth century. To a working-
class constituency, however, the work ethic communicated a more conflicted
message.

The meaning of labor in an age of growing industrialism was not nearly as
straightforward as that suggested by Barnard's dyadic sculptural composition.
It is impossible to know exactly how the working classes of Harrisburg re-
sponded to this "sermon stone." However, workers responded quite differ-
ently to the work ethic ideology in general than did members of the middle
and elite classes. The social theorist Antonio Gramsci argued that a theory of
cultural hegemony refused the simple concept of social control – the pure
domination of the belief system of one social class over another. Instead, he
proposed that the acceptance of a dominant idea, such as the work ethic, by
an oppressed class consisted of the notion of "contradictory consciousness,"
where subjects responded to powerful social messages with mixed reactions –
with both resistance and resignation.[61] This social theory posits one explana-

tion for the complicated relationship to the work ethic that American workers demonstrated in the early twentieth century.

To be sure, contradiction riddled the notion of the work ethic as the circumstances that brought the equation of work and virtue into existence faded in the face of modernity. The repetition of mindless tasks and the quickening pace of scientific management had come to regulate the lives of most industrial workers. Further, the notion of the self-made man remained a central paradox within the work ethic ideology, highlighting the tension between a belief in the dignity of labor and the ever-powerful counsel to individuals to work one's way out of manual toil as quickly as possible. Aware of this ideological disjunction, many industrial workers understood the rhetoric of the work ethic to be irreconcilable with the very lack of respect granted to them on the job. Indeed, the language of work pride – that is, the self-esteem produced by independent labor – proved incommensurate with the practical alienation of contemporary industrial employment.[62]

Nonetheless, many labor leaders, from William Sylvis, founder of the National Labor Union in 1866, to Eugene Debs of the American Railway Union and later the Socialist Party of America, deployed the work ethic in the service of labor. Sylvis, providing a rhetorical model from which Attorney General John Bell would later unwittingly borrow, asserted that labor "is the foundation of the entire political, social, and commercial structure. . . . It is the base upon which the proudest structure of art rests – the leverage which enables man to carry out God's wise purposes, . . . the attribute of all that is noble and grand in civilization." By the 1880s, this language formed part of the ritual initiation into the Knights of Labor. Initiates into the organization would recite such phrases as: "In the beginning God ordained that man should labor, not as a curse, but as a blessing"; and "Labor is noble and holy." Promoting this rhetoric into the twentieth century, Eugene Debs, in a 1904 Labor Day address, claimed, "The Toiler is the rough-hewn bulk from which the perfect man is being chiseled by the hand of God."[63] Manufactured out of pride in one's work as well as an acute sense of degradation, this belief in the dignity of labor had fortified the labor movement since its inception. Workers, pushed to their limits by the dehumanizing conditions of industrial labor and by the contemptuous treatment accorded them, maintained a firm belief in this idea – despite its internal contradictions – as a means to gain self-respect and to bolster self-confidence.

As we can see, no monolithic meaning can be ascribed to the work ethic in this country. If one understands the work ethic as a social construction produced by and serving the interests of the middle and upper classes, then labor, it could be argued, was at times complicit in its own victimization. That is to say, political practice was put aside in favor of furthering a belief in a higher moral calling ascribed to work. At other times, however, the work ethic produced a strategy through which workers developed self-respect, class consciousness, and empowerment. As Stuart Hall has explained, "What mattered

was the way in which different social interests or forces might conduct an ideological struggle to disarticulate a signifier [in this case, the work ethic] from one preferred or dominant meaning-system, and rearticulate it within another, different chain of connotations.''[64]

Barnard's sculptural program participated in this complicated process of meaning production. Commissioned by and in the service of the elite and middle classes of Harrisburg, the sculptures articulated a belief system that reinforced conservative values while assuaging fears of social disorder. To its working-class audience, alternately, the sculptural program – with its anachronistic message conveying the nobility of labor – may have provided a sense of redemptive pride. Unlike the artisanal authority manifested in the portrait of *Pat Lyon at the Forge* (Fig. 1), however, the Harrisburg commission effectively erased labor's political efficacy and promoted a transcendent ideal – a utopian ideal whose contradictions grew increasingly more evident to a contemporary public.

The Harrisburg sculptural program served as one type of labor monument – espousing noble ideals within an academic visual language. Not all public monuments to labor followed in that suit. The next two chapters address the Haymarket Affair of 1886 and the World's Columbian Exposition of 1893, two landmark events in Chicago history. Three monuments – Albert Weinert's *Haymarket Monument* of 1893, Johannes Gelert's *Police Monument* of 1889 and his *Struggle for Work*, exhibited in the Fine Arts Palace of the World's Columbian Exposition in 1893 – commemorated various interests associated with labor in a variety of sculptural styles, ranging from classicizing idealism to detailed realism. These chapters seek to study the ways in which visual culture participated in formulating contemporary belief systems about the politics of labor – the foundations of which lay, to varying degrees, in anarchism, reactionary conservatism, and bourgeois liberalism. Viewed within funerary, civic, and aesthetic environments, these monuments, as we shall see, conveyed divergent meanings to selective communities of viewers. In so doing, their role in the production of public histories will be a central focus.

CHAPTER TWO

MARTYRS AND MONUMENTS

The Haymarket Affair

May 1, 1886, brought general strikes in support of the eight-hour day
throughout the nation. Among the cities most deeply affected by this action
was Chicago, with anarchist leaders August Spies and Albert Parsons at labor's
strategic center. On May 4, 1886, near Haymarket Square on Chicago's West
Side, anarchists organized a protest meeting to support workers striking at
the McCormick Reaper's Works. Spies and Parsons calmly addressed the small
crowd; Mayor Carter Harrison attended the meeting to support the workers'
right of assembly. He departed at 10 P.M. as Parsons finished his speech, later
attesting in his trial testimony to the peaceable nature of the gathering.
Immediately after his departure, the police marched in, led by Inspector John
Bonfield and Captain William Ward who shouted: "I command you, in the
name of the people of the state of Illinois, immediately and peaceably to
disperse!" Samuel Fielden, the last speaker, claimed, "But we are peaceable.
. . . All right, we will go." At this moment, someone threw a bomb into the
police ranks. The police opened fire on the unarmed crowd, creating a melee
of blood and bullets. Within five minutes, the "riot" was over. Seven police
and an unknown number of civilians had been killed; sixty policemen had
been wounded. According to eyewitness accounts, bullets rather than bomb
fragments had caused most of the injuries. Among those police who died,
only Mathias J. Degan could be accounted as a victim of the bomb. An
estimated, fifty civilians lay dead or wounded on the streets; however, no
official account of the civilian dead was ever made.[1]

This event unleashed one of the fiercest attacks on anarchist dissidents in
American history. The Haymarket Affair culminated in an unjust trial of eight
prominent anarchists and the execution by hanging of four. *The Haymarket
Monument* (Fig. 9) commemorated the memory of these eight men who were
tried and convicted of conspiracy charges, though, as we shall see, all were
eventually exonerated. It consists of a 16-foot granite shaft, supported by a
two-stepped base, against which are positioned two life-size bronze figures.
The female figure stands in an assertive posture, displaying classicizing fea-
tures and an uncompromising gaze. Dressed in a peasant smock and apron,
she exposes her muscular arms, which mark her as working class.[2] In terms of
the monument's complicated signifying system, this female figure serves as
both an allegory of justice or, even perhaps, vengeance *and* as an embodiment

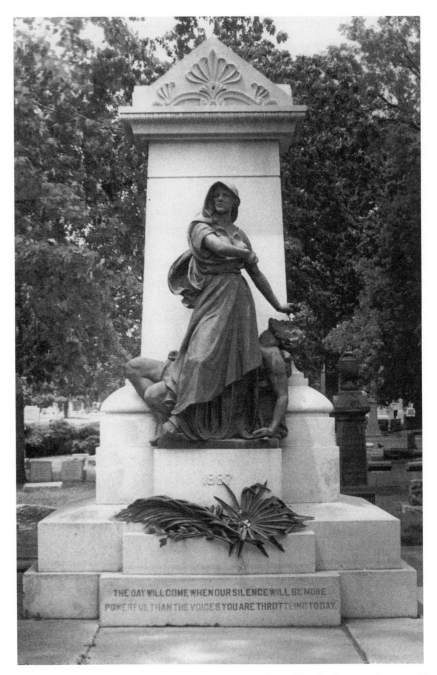

Figure 9. Albert Weinert, *The Haymarket Monument,* 1893, life–size bronze figures with 16' granite shaft. Forest Home Cemetery, Forest Park, Illinois.

of working-class womanhood. In her left hand, she grasps a laurel wreath, which she holds over the head of a supine male worker. In an allusion to the dead Christ, this image of a martyr commemorated the cause of labor to a sympathetic audience. Serving as a site of memorial ceremonies, political

meetings, and personal pilgrimages since its dedication in 1893, *The Haymarket Monument* represents an important practical symbol of resistance for American radical politics and the history of the working class.[3]

Commemorating the police forces who had participated in the Haymarket Affair, *The Police Monument* (Fig. 10) presents an image of an officer in contemporary dress holding one arm up in the air, signaling "Halt."[4] When viewed in association with its ideological counterparts, *The Haymarket Monument,* this sculpture invested the police officer with dominion over law and order, inscribing notions of authority through gesture and costume. Since its dedication in 1889, it has been the site of repeated ideological conflict. Desecrated, smashed by a runaway trolley, twice bombed, and relocated on several occasions, the monument is now carefully tucked away in the Chicago Police Training Academy and can only be viewed by special permission.

My project in this chapter is to unravel the respective histories of these monuments and to discuss their role in constructing a social memory of the Haymarket Affair. Indeed, at issue here is not only the anchoring of particular versions of history, but also the claiming and shaping of the political potential of memory. This chapter, with its special attention to *The Haymarket Monument,* participates in this very process by seeking to make public a record that has remained obscure since 1893. In contrast to *The Police Monument's* fame (or infamy), official histories have omitted *The Haymarket Monument* from social, political, and artistic consideration. This chapter presents a narrative that acknowledges and privileges the history of anarchism in Chicago – a history that is constitutive of the meanings associated with both *The Haymarket Monument* and *The Police Monument.*[5]

Further, it is my contention that these monuments, when viewed through the lens of gender, displayed a coding that both reinscribed and subverted dominant power hierarchies pervasive at the time. *The Police Monument,* in its masculine identity and recognizable gesture, gave visual form to the commanding stature of civic jurisprudence. In serving the ends of anarchism, *The Haymarket Monument* figured the feminine as a disruptive force that both resisted and opposed the symbolic authority of the state and at the same time asserted the moral authority of greater universals. Both monuments played an important role in late nineteenth-century debates concerning labor activism, social justice, and civic order, and, I shall argue, continue to influence the historical consciousness of those who view them today.

■ ■ ■

In order to best understand the social and political significance of the Haymarket Affair, it is necessary to retrace the history of German-American participation in the anarchist movement in Chicago – the premier city of the Midwest, the second largest city in the country, the seventh largest in the world, and the center of anarchist activity in the late nineteenth century. The most cosmopolitan of American cities, it had the greatest number of

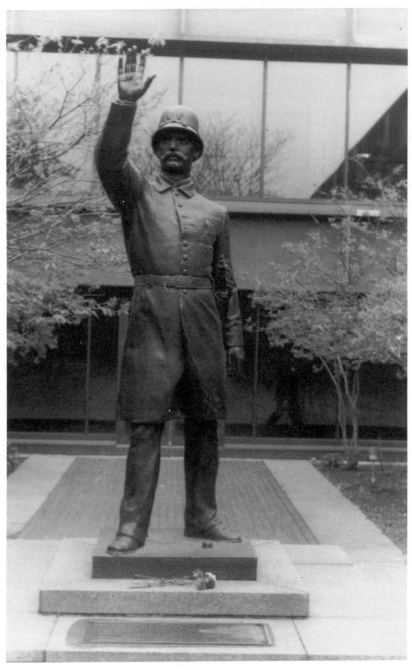

Figure 10. Johannes Gelert, *The Police Monument*, 1889, bronze, life-size. Courtyard of the Police Academy, Chicago.

immigrants in its population. In 1884, Germans comprised the most significant number at 33 percent, followed by the Irish at 18 percent.[6] Most political activists and union members in Chicago in the 1880s were of German descent. In fact, by 1886, radicalism in the United States had become identified with "foreigners," and anarchism, specifically with German-Americans.

German radicalism, with its roots in contemporary European political history, had a profound impact upon Chicago's labor activism and ultimately, the Haymarket events. The massive *Auswanderung* (emigration) from Germany to the United States, precipitated by the European political crisis of 1848–9, continued throughout the second half of the nineteenth century. The revolutions of 1848 produced political turbulences based on the demands of both the middle and working classes in France, Germany, and Italy. In Germany, the revolution was essentially middle-class, and left few of the workers' demands fulfilled.[7]

The political turmoil in Germany responded to deteriorating economic and political conditions. As a result, all classes of Germans fled to the United States, a country whose democratic principles they held to be the panacea for all social ills. Farm laborers, craft workers, peasants, wealthy merchants, manufacturers, and even landed aristocrats were among the new immigrants to this country. Given the demographic diversity of German immigration, there clearly was no monolithic experience assigned to German peoples; however, craft workers comprised the highest proportion of new settlers. Many of these newly arrived immigrants, known as German Forty-Eighters, believed in a broad plebeian democracy that sought to narrow differences in wealth and political rights among classes. In the South, where German opposition to slavery remained strong, and in the Midwest, where German population concentrated, these new settlers were seen as radical threats to American institutions as early as the 1850s despite their democratic impulses.[8]

German-Americans embraced a strong tradition of collective political activity that, in turn, produced a rich cultural legacy – a legacy recorded in *The Haymarket Monument*. The *Turnverein*, or athletic club, born in Germany in 1811 in opposition to the Napoleonic regime, had proposed a program for physical training and patriotic ideals. Brought to this country by German immigrants, the *Turner* movement strove to enact the ideal republic denied the Forty-Eighters in their homeland.[9] In reaction to the widespread brutality of Chicago police, the denial of workers' rights to assembly, and state militia units organized against them, German workers founded the *Lehr- und Wehr-Verein* in 1875, an armed association for self-defense. With its roots in the *Turner* organizations, it was closely connected with both the socialist and anarchist movements in Chicago in its goal of defending the republic and its constitution. In this move toward militancy, "the *Lehr- und Wehr-Verein*," historian Christine Heisse argues, "can legitimately be seen as one illustration of

the desperate conditions in Chicago and the tendency of Chicago's labor movement toward radicalism. . . ."[10]

The *Turner* movements brought with them a cornucopia of cultural expression that maintained links with native German traditions while developing new resources for conveying immigrant experience. Pageants, parades, and public celebrations provided a means of creating a coherent social experience for many German immigrants. Moreover, the *Turner* organizations sponsored libraries, singing societies, debating clubs, lectures, and dramatic performances.[11] It was out of this rich cultural heritage that *The Haymarket Monument* in Waldheim Cemetery originated, expressing the radical political beliefs of one segment of this German anarchist community.

In the visual arts, one painter, Robert Koehler (1850–1917), stands out as an important recorder of political events in German-American society. Koehler, whose parents emigrated from Hamburg to Milwaukee in 1854, moved to Pittsburgh in 1871, then to New York where he attended classes at the National Academy of Design. He studied in Munich between 1873 and 1875, visited New York briefly for the next four years, and then settled in Munich until 1892. Koehler painted his monumental work, *The Strike*, in 1886 (Fig. 11). Its large scale (71½ × 108½ inches) brought attention to the unusual subject – it was one of the first American paintings to document the tensions between labor and management – and its detailed realism suggested a stylistic source in the Munich school. An 1877 strike in Pittsburgh, most likely the great railroad strike of that year, served as inspiration for the painting.[12] This national railway strike, notable as the first major collision between capital and labor in American history, banished the notion of "American exceptionalism" that had held sway among business and industrial leaders who thought such a strike impossible in this country. In so doing, it raised the specter of an "American Commune" in its threatening power and duration.[13] Engraved as a two-page spread in the May 1, 1886, issue of *Harper's Weekly*, the date by

Figure 11. Robert Koehler, *The Strike*, 1886, 71½" × 107". Deutsche Historische Museum, Berlin.

labor leaders designated to demonstrate for the eight-hour day, Koehler's *The Strike* reached American homes with the news of the Haymarket bombing.[14] Thus, this painting produced a record of class tensions rarely addressed in contemporary visual culture.

The image depicts a gathering of workers at the factory owner's door. The boss – top-hatted and silk-suited – stands at the top of the stairs listening to the complaints of a worker whose wages have just been reduced.[15] Passions are high, men and young boys are hastening to this meeting where expressions and postures show defiance and anger. A figure in the foreground prominently leans over to pick up a rock. Consonant with a separate spheres ideology – the proscription of gendered social roles, the men and boys function as the active agents in the dispute while the women either stand silently with children to the periphery of the scene or attempt to dissuade their husbands from striking.[16] By contrast, *The Haymarket Monument* challenged contemporary social mores, as we shall see, by depicting a fiercely powerful female figure protecting the body of an expired worker.

A year earlier, Koehler had painted *The Socialist,* an image of an unidentified man delivering a speech with great conviction.[17] He stands before a copy of *Der Sozialist* (*The Socialist*), a contemporary Socialist newspaper published throughout the United States. With flying fist, fierce expression, and tousled hair and clothes, this image relays the intensity of commitment many German-American socialists felt toward their increasingly radical political causes. It was exactly this reputation for fiery speeches and rousing rhetoric that produced a public perception of German immigrants as preaching alien doctrines aimed at undermining American values.

Between 1880 and 1883, a revolutionary anarchist movement took shape in the United States. The social revolutionary clubs, such as the *Lehr- und Wehr-Verein,* formed the embryo of this movement. In 1884, German workers founded the Central Labor Union, an anarchist/socialist body that advocated the destruction of the system of private property by any means necessary. Unlike socialists who viewed the state as a neutral entity that could be influenced by electioneering, anarchists believed the state to be invested in the protection of private property and pinned their hopes on armed struggle to accomplish social change.[18]

Not surprisingly, Chicago developed as a center for anarchist activity. Sharp class demarcations, a wide gap between rich and poor, and severe economic crises that affected the lives of thousands of workers shaped the city's radicalism. In October 1884, for example, 30,000 people were jobless in Chicago. Moreover, the reputation for police brutality remained notorious. The press denounced agitators and subversives, upholding property rights and championing the efforts of the police who worked consistently by force.[19] Albert Parsons and August Spies, two of the men later executed in the Haymarket Affair, led the Chicago anarchists. They remained committed to a militant and revolutionary trade unionism that contrasted with the spirit of labor-

management cooperation promoted by both the Knights of Labor and the nascent American Federation of Labor. Instead, they sought to get at the root of labor's difficulties by social revolution. Called the "Chicago idea," the union, as Parsons explained, served as the nucleus of a new social system, "an autonomous commune in the process of incubation."[20] This radical labor activity climaxed with the crusade for the eight-hour day with Chicago as its political center and Spies and Parsons as its leaders.[21] On May 1, 1886, large strikes supported this measure: 300,000 strikers nationwide; 40,000 in Chicago alone. On both sides of this political issue, the movement became identified with a Chicago Commune.[22]

American labor politics resonated with the memory of the Paris Commune of 1871 – from the great railroad strikes of 1877 to the eight-hour crusade of 1886. Arguably the most significant revolutionary event of the nineteenth century, the Commune installed a radical form of government in Paris for two months following the Franco-Prussian War.[23] Although crushed by French troops who slaughtered 20,000 (and perhaps more) Parisian Communards, the Commune represented both a hopeful revolutionary model to American socialists and anarchists and a simmering threat of labor upheaval to civil authorities. Its specter informed both radical and conservative forces in all contemporary labor disputes.

After the Haymarket bombing of May 4, 1886, police rounded up hundreds of radicals and activists, particularly those of German descent. The Grand Jury indicted eight men on charges of conspiracy; murder charges were impossible since the identity of the bombthrower remained unknown. The state accused Albert Parsons, August Spies, Michael Schwab, Samuel Fielden, George Engel, Adolph Fischer, Oscar Neebe, and Louis Lingg of conspiracy, riot, and unlawful assembly. The backbone of the local anarchist movement, they served as its most efficient organizers, the editors of its journals, and its ablest speakers and writers.[24]

After a lengthy trial and appeals process, a guilty verdict was returned, and seven of the eight defendants sentenced to death. Only Oscar Neebe was spared, sentenced to fifteen years in the penitentiary. The verdict and sentence shocked many across the country. Despite requests for clemency from national and international notables, such as William Dean Howells, Oscar Wilde, George Bernard Shaw, Walter Crane, and Clarence Darrow, the extraordinary sentence stood.[25] Because Samuel Fielden and Michael Schwab appealed for clemency, they received life imprisonment; the others refused clemency believing it a sign of capitulation to an unjust accusation. Amidst mysterious circumstances, an exploding cigar killed Louis Lingg in his jail cell.[26]

The execution of the four "Haymarket Martyrs" occurred on November 11, 1887 – "Black Friday" as it was called by anarchists and sympathizers. As the four stood, hooded at the gallows, August Spies' voice rang out: "The time will come when our silence will be more powerful than the voices you

strangle today!" This was followed by Fischer and Engel who cried out, "Hurray for anarchy." On Sunday, November 13, the funeral of the anarchists took place. Twenty thousand participated in the event – the largest funeral ever held in Chicago. The burial transpired at suburban Waldeim (now Forest Home) Cemetery, a burial place accessible to thousands of immigrants whose deceased other Chicago cemeteries did not welcome. Despite the inclusiveness of Waldheim's burial policies, however, cemetery officials remained hesitant about the interment of the bodies of executed men, placing the caskets in a temporary vault. Only after the Defense Committee negotiated successfully with the officials did the caskets arrive in a permanent grave on December 18. The original memorial consisted of a broad bed divided into five compartments with the initial letters of each martyr growing in evergreen in the order in which they were laid: Spies, Fischer, Parsons, Engel, and Lingg. A small headstone was engraved with five medallions containing each name, the date of November 11, and a corruption of Spies's last words.[27] Soon after the burial, plans took effect to erect a monument to the martyrs that would permanently enshrine their memory.

The hysteria that followed the bombing and the trial proceedings pushed xenophobia and anti-immigrant sentiments to new heights in Chicago and throughout the country.[28] In fact, German-Americans responded to the bombing and to anarchist activity unevenly as German-language middle-class presses disassociated themselves from the Haymarket Eight. The foremost middle-class opinion maker, the *Illinois Staats-Zeitung*, feared a general backlash against all German-Americans because of the violent event. Hermann Raster, editor of the *Staats-Zeitung*, wrote to Governor Ogelsby of Illinois in 1887: "Our mutual friend, Gen. Ph. Sheridan is credited with the remark: 'Good Indians? pshaw! There is no *good* Indians but dead ones.' Say Anarchists in place of Indians and I subscribe to the sentiments with both hands."[29]

The popular press demonized the anarchists, aligning them with foreigners and subversion. Thus, it was not surprising that most Americans were unable to distinguish differences within the anarchist philosophy, or between anarchists and communists, or even between radicals and labor organizers of any kind. "Any dissenter might as well be an anarchist," Carl Smith argues, "and every anarchist was a public enemy."[30] Within visual culture, a particular stereotype of this political radical emerged. Herbert Gutman explains:

Since the time of the Haymarket Affair of 1886, political cartoonists reliably depicted a tatty, bearded, sinister, *foreign* figure grasping a spherical black bomb as representation of the political menace presented America by the offscouring of Europe. It was a symbol which was the lineal forebear of "The Bolshevik" (who was graphically portrayed in much the same way). . . .[31]

An engraving of the "Haymarket Riot" appeared in *Harper's Weekly* on May 15, 1886 – a two-page spread that promoted the idea of the anarchist as a

wild, gesticulating speaker, inciting the crowd to violent acts (Fig. 12).[32] Through these media representations, an image of the crazed anarchist came to dominate public opinion.

Seven years later on June 26, 1893, the day after the monument to the Haymarket martyrs was dedicated in Waldeim Cemetery, Governor John Peter Altgeld of Illinois pardoned all eight anarchists. A liberal, humanitarian, and progressive governor, Altgeld was inaugurated in January of 1893. After reading all the trial testimonies, he concluded that every aspect of the trial, from the selection of the jurors and the testimony of the witnesses to the behavior of the judge and prosecutor, was a shameless travesty of justice. His judgment of the trial and all those involved was swift, critical, and tough-minded. Altgeld paid the political price of his bold decision. With his career destroyed, he became one of the most reviled, and then celebrated, men in American politics.[33]

The events surrounding the Haymarket bombing and trial functioned as a cause célèbre in the course of labor history. For liberals and radicals, it provided labor with its first revolutionary martyrs; and for civil authorities, the trial outcome had effectively destroyed the anarchist movement in Chicago. During the World's Columbian Exposition in 1893, guidebooks to Chicago included sections on Haymarket, marked as one of the most significant locales and events of Chicago history. Listed among the sights to see – the stockyards, boulevards of the wealthy, and the World's Fairgrounds – was Haymarket Square, a newly canonized spectacle for tourists who flooded the city during the summer.[34] As constitutent parts of the history of this era, two public monuments performed their cultural work in Haymarket Square and Waldheim Cemetery. In separate but mutually dependent commemorative practices, these sculptures constructed competing social memories of the Haymarket events. But to the diverse communities responding to these monuments, memory and signification, as we shall see, was a complicated and, at times,

Figure 12. T. de Thulstrup, "*The Haymarket Riot.*" (*Source: Harper's Weekly,* May 15, 1886.)

even contradictory matter. No single interpretation can suffice; these monuments have come to represent a broad spectrum of political positions to the many people who have experienced them during their century-long history.

■ ■ ■

In January 1888, a committee of twenty-five businessmen and civic leaders, headed by Robert I. Crane, met to oversee the erection of a monument to the 180 Chicago police officers involved in the Haymarket incident. The *Chicago Tribune* sponsored the competition, offering a prize of $100 for the best design. Of the 168 sketches submitted, the design by Frank Batchelor, a former newspaperman from St. Paul, Minnesota, won the competition, the final selection having taken place at the Union League Club on September 23, 1888. The design depicted a police officer in contemporary dress holding one arm up in the air – an allusion to Captain Ward's command to the Haymarket meeting to disperse peaceably. The committee raised $10,000 by public subscription, receiving much support from the Commercial Club and the Union League Club as well as businessmen from Aurora, Elgin, and Rockford who opposed unions and the eight-hour day campaign.[35]

Johannes Gelert (1852–1923), a young Danish sculptor newly arrived to Chicago, won the commission to execute the sculpture, after having submitted his own design – an allegorical portrayal of law as a female figure holding an open book over her head – that had been previously rejected by the committee. Born in the German-Danish province of Schleswig in December 1852, Gelert studied at the Royal Academy in Copenhagen from 1870 to 1875. While in Paris from 1877 to 1878, he exhibited at the Paris Salon before settling in Chicago in 1887, when he accepted his first major commission. As we shall see in the next chapter, winning this prestigious competition led to Gelert's appointment to the international awards jury of the World's Columbian Exposition and to two sculptural commissions for the fair.[36]

Gelert modeled the sculpture upon an officer, Thomas (Toon) Birmingham, whom he had seen directing traffic on a Chicago street. Consonant with the "antiforeigner" mood that had gripped the country in the wake of the Haymarket incident, the committee members expressed horror when they saw the clay model. To their eyes, the figure looked "too Irish" and too foreign, an alien image associated with the more subversive elements of society. Despite pressure to do so, Gelert refused to change any detail of his sculptural design. Birmingham became on overnight celebrity as the inspiration for this highly publicized sculpture. Paraded around the World's Fair in 1893 as the symbol of the perfect policeman, he later died in poverty as a petty thief, suspended from the force after having been found guilty of graft in 1898 and again in 1899.[37]

The committee intended to commission a sculpture that revealed a high degree of realism, in contrast to Gelert's earlier allegorical design. The over life-size figure stands in a posture of arrested movement. Depicted within a

naturalistic vocabulary, the figure looks straight ahead with one arm relaxed at his side, the other raised in a gesture clearly understood as "Halt." The specificity of dress, exactly replicating an 1886 officer's uniform, and the familiarity of the gesture, recognizable to all who braved Chicago's crowded city streets, provided an image easily accessible to its public.[38] In fact, the *Chicago Times Herald* criticized the sculpture for being too "materialist" – too concerned with the dress and details of the police rather than with the spirit of their job and duty.[39]

Nonetheless, the detailed realism of the image did not produce a clear, unambiguous reading. Gelert chose this "robust policeman," the *Chicago Tribune* explained, because "in his countenance, which is frank, kind and resolute, he was able to catch those ideal qualities of the guardian of the peace instead of the more unpleasant ones of mere strength and insensibility."[40] Gelert had, in fact, attempted to present an image of an officer that highlighted the humanitarian qualities of civic service. When viewed, however, in the context of the Haymarket hysteria, the image of the police officer assumed an authoritarian role. Indeed, these specific historical conditions gendered the forces of law and order as masculine and consequently, I would argue, the unruliness of anarchy as feminine.

For example, a contemporary image, entitled "Justice Hurling a Bomb: A Hint to Our Citizens" from the *Graphic News,* posited the unruly forces of anarchism as feminine and the power of civil authority as male (Fig. 13).[41] The graphic figured anarchy as a female with long disheveled hair and closed eyes, hurling a large bomb labeled "Law" into a crowd of men, some of whom hold pistols and flee the impending explosion. The image expressed a warning to middle-class citizens against the dangers of mob rule. This disheveled and dangerous figure, labeled "anarchy" at her hem but written in reverse, parodied the allegorical image of Justice, typically represented as an ideal feminine form in classical garb and at times holding a crystal orb, as in Edward Simmons's 1893 mural *Justice* in the Criminal Courts Building in New York City.[42]

The representation of the bomb was central to a gendered reading of this graphic image. The bomb, inscribed as "Law," caricatured such conventional imagery as the crystal orb of Simmons's mural, a symbol of omniscient justice. In figuring the ideal of "Law" as a spherical form associated with and in the possession of this unruly woman, the bomb subverted the fundamental authority of law and order in society. Nonetheless, a near facsimile of *The Police Monument,* lording its power over the mob, appeared in the background of this graphic.[43] In an attempt to reassert control over civil chaos, the sculpture loomed above the other imagery, rising in phallic fashion out of a ringlike form of abstracted lines that represented, perhaps, the fleeing crowd. Thus, this image articulated the gendered terms of the historical conflict between the forces of order symbolized by the police officer and those of social disruption signified by anarchy.[44] To this idea we shall return shortly.

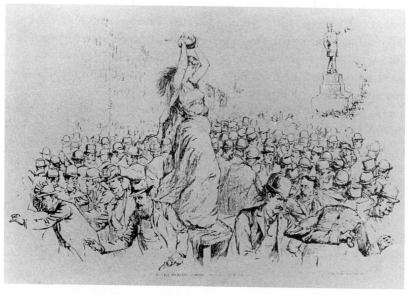

Figure 13. *"Justice Hurling a Bomb: A Hint to Our Citizens."* Chicago Historical Society, ICHi-16071. (*Source: The Graphic News* (Chicago), June 5, 1886.)

City officials dedicated *The Police Monument* on Memorial Day, May 31, 1889, in Haymarket Square. The ceremonies opened with a welcome from Robert Crane, chair of the monument committee. Frank Degan, the son of Officer Mathias Degan, killed in the 1886 explosion, pulled the drawcord to unveil the statue as the American flag fell away. On this drizzly day, between 1,500 and 2,000 people attended the ceremonies, among them about 175 uniformed police dispersed throughout the crowd. In addressing the gathering, Mayor Cregier remarked:

This beautiful shaft [*sic*], conceived and erected by our law-abiding citizens to commemorate [this] event, stands before you in this conspicuous place as a silent monitor to all who dare to come to this free land to disobey its laws[;] that we have a force, and a body of citizens to back up that force, that will see that the law must be obeyed. May [this monument] stand here unblemished so long as this metropolis shall endure. . . .[45]

In the mayor's words, the phallic monument functioned both as a commemoration of police power and as a visual threat to unruly mobs. He had hoped that the monument might stand forever in Haymarket Square. His wish was never fulfilled.

The Police Monument remained in the center of Haymarket Square until 1900. Due to crowded conditions, the city relocated the monument despite the complaints that it would lose its social significance if moved to another site.[46] The authorities reinstalled the monument in Union Park, between Randolph and Ogden streets, one of Chicago's finest outdoor settings. The

park, once described as "the Bois de Boulogne of the West Side," housed the monument until May 4, 1927, when a streetcar jumped its tracks and knocked the statue off its base, uncannily, on the forty-first anniversary of the Haymarket Riot. According to one source, the driver deliberately drove his streetcar full speed and jumped the track because he was tired of seeing that policeman with his arm raised. Relocated to an inauspicious area of Union Park, the monument faced the statue of Carter H. Harrison, the mayor of Chicago during the bombing and trial who had appeared as an unfriendly witness against the Haymarket prosecution.[47]

In 1958, the city once again moved the monument back to Haymarket Square, at the intersection of Randolph Street and the Kennedy Expressway. In order to restore its original historic location, an elaborate pedestal was built with funds raised by public subscription. Designated as an Historic Landmark by the Chicago City Council, the sculpture stood peaceably until 1968, when it became the object of a series of violent political attacks. On May 4, 1968 (the anniversary of the Haymarket bombing), protestors defaced the statue with black paint during a demonstration against the Vietnam War. On October 6, 1969, a high-velocity explosive, perhaps dynamite, blew the legs off the sculpture. Sergeant Richard Barrett, president of the Chicago Police Sergeants' Association, called the incident the work of "anarchists" and said that the bombing represented "an obvious declaration of war between the police and the Students for a Democratic Society [SDS] and other anarchist groups. . . . We now feel that it is kill or be killed." Countering the fighting words of the sergeant, Police Superintendent James Conlisk, Jr., said, "This is not war" and called Barret's remarks "irrational and irresponsible." The SDS denied any participation in the act. After $5,500 in repairs, Mayor Daley unveiled the newly refurbished statue one year later on the Haymarket anniversary, yet again symbolically and actually reasserting the forces of "order" against those of "anarchy."[48]

On October 5, 1970, the sculpture was again bombed, this time by a man identified only as a radical Weatherman in an anonymous phone call.[49] Mayor Daley decreed that the monument, after restoration, would have a permanent police detail to watch for "these evil creatures who work in the dark."[50] Once restored, the sculpture stood under twenty-four-hour guard and surveillance by a television monitoring system connected to the Police Department – all at a cost of $67,440 per year to Chicago taxpayers.[51]

At the request of several civic groups in 1972, the city yet again moved the statue to the lobby of the Central Police Headquarters on South State Street where it remained until 1976 when it was installed in its present location in the courtyard of the Chicago Police Training Center, 1300 West Jackson Boulevard. No longer visible to the public, the sculpture can be viewed only by appointment. A plaque records what has become the "official version" of this historical event:

When the speeches became increasingly inflammatory, and the crowd showed signs of becoming an unruly mob, a contingent of police officers moved toward the speaker's platform and the Captain of the police officers commanded the crowd to (peaceably) disperse. It was at this time that a bomb, thrown by an unknown person in the crowd, exploded among the police officers. Approximately 50 to 60 officers were wounded, seven of these dying as a result of their wounds. . . . The upraised arm [of the statue] signifies the position taken by Captain William Ward, just prior to the bomb blast, when he called out, "In the name of the people in the State of Illinois, I command this meeting immediately and peaceably to disperse."

Commemorating an historic event in Chicago police history, the monument constructs a social memory at once sacred to those upholding political order and reviled by those seeking to change it. Recruits and officers stationed at the Training Center fondly attend to the monument as it records the "life and death" travails of Chicago's police officers.[52] Although the monument is physically hidden, protected, and out of public view, its image serves as an official emblem of the Chicago Police Department, appearing on posters, letterheads, and the like. Indeed, through an official commemorative process sanctioned by civic authorities, *The Police Monument* – rather than *The Haymarket Monument* – continues to convey the authoritative public history of the Haymarket affair.

■ ■ ■

In response to the dedication of *The Police Monument* in 1889, anarchist sympathizers began planning a monument comparable in scale and value, one that would offer an alternative commemoration of these historic events. Immediately following the burial of the martyrs, the Amnesty Association and the Defense Committee, together with members of the Central Labor Union, formed an organization that "assume[d] the responsibility of providing for the families of the executed men and of erecting a monument to their memory."[53] Originally called the Chicago Pioneer Benefit and Aid Society, the organization incorporated on December 15, 1887, under the title the Pioneer Aid and Support Association, pledging to support not only the families of the Haymarket martyrs, but all "families and dependents of persons who lawfully uphold the interest of labor, and . . . [are] deprived of the aid and support which such persons would otherwise be unable to afford."[54] On July 18, 1889, the Pioneer Aid and Support Association inaugurated a monument fund to which all progressive workers in the country were asked to contribute. On April 25, 1890, the committee purchased eight lots in block N of Waldheim Cemetery to house the memorial.[55]

The plans for the monument met with general approval. To most anarchist sympathizers, the significance of a monument commemorating *their* history and of a site that would function as a locus of political activism proved powerful. As William Holmes argued in the pages of *The Alarm*, an influential Socialist/Anarchist publication of Chicago:

And surely [the martyrs] are worthy of the finest and most expensive monument that can be devised; . . . all tending to draw to their graves the curious as well as the sympathetic. . . .

But let us be quite sure that such a token of our regard will best meet all the requirements, that it will prove the surest way of encouraging faint hearted workers in the cause; that it will be most inspiring to lofty enthusiasm; and that it still be a potent factor in sowing the seeds of our blood-nourished principles.

The liberty loving radicals of Chicago have never had a permanent meeting place. . . . Here, then, and now, is the opportunity to erect a most fitting, a most enduring and most practical monument.[56]

The cemetery setting did not deter the "lofty enthusiasm" of this commemorative process. With few places for anarchists to assemble, they transformed the passivity and finality normally associated with burial grounds to a place of social memory, political endurance, and labor activism.

Some opposed the plans to erect a monument, mainly on practical terms. Another editorial in *The Alarm* argued, unsuccessfully, that the money should be spent on the families in need and not squandered on this unnecessary detail.[57] Writing years later, Emma Goldman documented her response to the monument despite her earlier opposition to its erection:

My thoughts wandered back to the time when I had opposed the erection of the monument. I had argued that our dead comrades needed no stone to immortalize them. I realized now how narrow and bigoted I had been, and how little I understood the power of art. The monument served as an embodiment of the ideals for which the men had died, a visible symbol of their words and their deeds.[58]

To these writers, the monument stood as a powerful force in shaping political memory – a memory sympathetic to anarchist ideals.

On October 12, 1890, the Pioneer Aid and Support Association began planing the competition that would solicit designs for the monument. The prizes were announced on December 14: $100 for first prize, $50 for second prize, and $25 for third prize. On August 8, 1891, the monument committee proceeded to review the submitted designs.[59] In the only published account of the competition, John J. Flinn described the process:

Six thousand dollars have been subscribed in this country and in Europe toward the erection of a monument in memory of the anarchists executed in this city for complicity in the bomb-throwing at Haymarket Square. . . . Thus far, there have been three models presented to the committee which seem to rank above the rest. The one which seems to give most general satisfaction was designed by young German-American of this city. The artist caught his inspiration from Freiligrath's song "Revolution," the spirit of which his creation embodies. A shaft of marble arises to the height of 16 feet. On its sides are the portraits of the five Anarchists with appropriate inscriptions, one of which contains the last words of Spies before he was executed. . . . At the base of the shaft are two bronze figures, life-size, symbolical of revolution and the revolutionist. One is that of a young woman of the

people bending over the prostrate form of the dying revolutionist and placing upon his brow the laurel wreath.

Another design presents a marble shaft rising from a group of five lions, and crowned with a marble sarcophagus from which emerges the figure of a woman symbolizing "Liberty" and carrying in one hand a torch, in the other a broken chain.[60]

On January 8, 1892, H. Hoebert and Albert Weinert (1863–1947) discussed their designs with the monument committee. By February 14, the committee had decided to offer the commission to Weinert, who signed a contract in the amount of $5,130 for his first major sculptural commission in this country. Born in Leipzeig in 1863, Weinert was schooled at the Royal Academy in Leipzig and then at the École des Beaux Arts in Brussels. At the age of 23, he traveled to the United States, arriving in Chicago in 1886, the year of the Haymarket bombing. With the design chosen and the sculptor under contract, the monument committee laid the cornerstone to the monument at Waldheim Cemetery on November 6, 1892.[61]

Facing east, the monument evokes the dawning of a new and more hopeful day.[62] On the lowest step of the base are engraved the last words that Spies uttered before his death: "The day will come when our silence will be more powerful than the voices you are throttling today." Directly above the quotation are bronze palm fronds and the date 1887. In the figural group, the female addresses the viewer assertively. She displays classicizing features and an aquiline nose, but her demeanor is stern and purposeful. Although her head is hooded and her face in deep shadow, her gaze is uncompromising. In her left hand, she holds a laurel wreath over the head of the supine male worker. Her right hand draws up her cape and holds it taut against her left breast in a gesture that connotes an aggressively protective attitude toward the dead worker. Her cloak billows out behind her, emphasizing the forward thrust of her action. Her right foot is tense, extending at an angle off the pedestal. The billowing cape, angle of the extended arm, and tensed foot produced a sculptural figure that appeared ready to march off the pedestal and into the viewer's space.

The male worker reclines on a slightly raised bier behind the female (Fig. 14). His head, thrown back and revealing an elongated neck, rests upon a pillow. His eyes are closed. Middle-aged with ideal features, he is bearded and mustachioed. His well-muscled left arm drops down near the female's left foot, resting his hand palm up. The female's skirt shields half the worker's torso, cascading between his legs and modestly concealing his groin. His tensed and muscled right leg supports a clenched fist – a symbol of defiance barely visible from behind the standing figure. The overall awkwardness of the body, extended neck, and listless position of the head suggest the horrors of death by hanging.[63]

The names of the martyrs – Spies, Fischer, Parsons, Lingg, and Engel – are

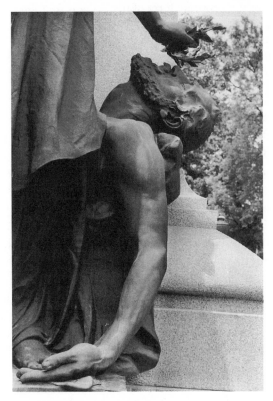

Figure 14. Albert Weinert, *The Haymarket Monument*, det., 1893, bronze. Forest Home Cemetery, Forest Park, Illinois.

engraved on the back of the monument. A bronze plaque lists the names of Schwab, Neebe, and Fielden. All but Fielden are buried at Waldheim.[64] Atop the shaft, another bronze plaque memorializes an excerpt from Governor Altgeld's pardon:

These charges are of a personal character, and while they seem to be sustained by the record of the trial and the papers before me and tend to show that the trial was not fair, I do not care to discuss the feature of the case any further, because it is not necessary. I am convinced that it is clearly my duty to act in this case for the reasons already given, and I, therefore, grant an absolute pardon to Samuel Fielden, Oscar Neebe, and Michael Schwab this 26th Day of June, 1893.

Extensive festivities marked the day of the dedication ceremony. A parade wound its way through the streets of Chicago with 3,000 marching and thousands watching. Five trains, several cable and electric cars, and numerous carriages carried the throng to the cemetery. By the *Chicago Tribune*'s conservative estimate, 8,000 people gathered to witness the unveiling of the monument.[65] With the city's streets swollen by international visitors to the World's Columbian Exposition, people of many nationalities attended the ceremonies and heard speeches in English, German, Bohemian, and Polish. Floral trib-

utes from unions in England, France, and Belgium decorated the setting. The crimson banner of the Architectural Ironworkers Union No. 2, the blue flag of the Brewery Workers Union, the red banners of the International *Manner- chor* (Men's Choir) and the city's Workingmen's Clubs (*Turners*), and an American flag decorated the platform. Red drapery cascaded from the monument. The ceremony began with Albert Weinert presenting the statue to the president of the Pioneer Aid and Support Association. The orchestra played the *Marseillaise*, while, in an uncanny echo of the unveiling ceremonies of *The Police Monument*, thirteen-year-old Albert Parsons, Jr., drew away the red curtain to reveal the monument.[66]

A complex interrelationship between the universal and the political informed the production and reception of this monument. The female figure, interpreted variously as Liberty, Justice, Anarchy, or Revolution, presented an image of a strong, powerful worker. The association with the classical – aqualine features, chitonlike skirt, contrapposto stance – signified allegory. However, the signs of class – the historical contingencies of political struggle – appeared in her dress (the apron) and posture (the extended arms with rolled up sleeves). In opposition to the solid, staid, and iconic posture of the most famous of contemporary allegorical sculptures, the *Statue of Liberty*, August Bartholdi's colossal monument dedicated in 1886 as a gift to the American people from the citizens of France, *The Haymarket Monument* embodied a new allegorical mode that functioned actively and dynamically, underscoring the epic strength of the female worker.[67]

Moreover, signs of labor, death, and martyrdom marked the body of the male worker. His strong, muscled arms and legs revealed the power of manual labor. Weinert must surely have been aware of the work of the famous Belgian sculptor of laboring themes, Constantin Meunier (1831–1905), from his stay in Brussels. Although produced after Weinert's arrival in the United States, Meunier's *Fire Damp* of 1888–9 represented an important precedent to *The Haymarket Monument* (Fig. 40). The sculpture revealed an aggrieved mother mourning over the body of her dead son killed in a mine explosion. The mother tenderly bent over the emaciated body of her son, her hands clasped at her side in a gesture of prayer. Rather than suggesting a political struggle, the image recalled scenes of the deepest pathos in Christian art, the Deposition and Lamentation over the body of the dead Christ.

Like Meunier's *Fire Damp*, Weinert also produced a clear reference to the martyrdom of Christ through the posture, scale, and gesture of the body of the dead worker. However, in proportions similar to Michelangelo's *Pietà* (Fig. 15), the worker appeared diminutive in contrast with the breadth of the female figure. Moreover, the angle of his head, the position of his legs, and the sweep of his fallen arm suggested a close association with imagery of the dead Christ. Thus, in its Christian associations, the body of the dead worker educed the memory of the martyrdom of the four executed anarchists and produced an image both inspirational and commemorative.[68]

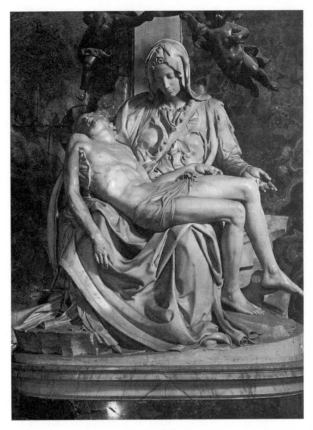

Figure 15. Michelangelo Buonarroti, *Pietà*, marble, 68½" h., 1498–1500. St. Peter's Basilica, Vatican State. (*Source:* Alinari/Art Resource, New York.)

With his European training, Weinert would also have been aware of such notable contemporary sculptors as Jean-Alexandre-Joseph Falguière (1831–1900) and Auguste Rodin (1840–1917) whose female allegorical figures, no doubt, helped shape his conception of *The Haymarket Monument*. In the wake of the Franco-Prussian War and the Paris Commune of 1870–1, French sculpture assumed an aggressively nationalistic tenure. The image of a strong, powerful female – as allegory and muse – represented the struggle, heroism, and resistance of the French people. In Falguière's *Allegory of Resistance*, the original model executed in 1870, the figure of a defiant, nude woman straddling a cannon represented the valiant forces of the French National Guard against the Prussian seige of Paris in 1870 (Fig. 16). Charged with sexual energy, the image conveyed a militant posture – chin up, chest out, and shoulders back – unusual in contemporary depictions of the feminine.[69] In its brashness and ferocity, Falguière's work modeled femininity as a carrier of defiance and provided a signifying system apparent in *The Haymarket Monument*.

Within the same historical context, Rodin produced the *Bellona* of 1878 (Fig. 17) and *The Call to Arms* of 1879 (Fig. 18) – sculptures conveying an

Figure 16. Jean-Alexandre-Joseph Falguière, *La Résistance (The Allegory of Resistance),* ca. 1870, bronze, 23" h. Los Angeles County Museum of Art. Gift of the Cantor, Fitzgerald Art Foundation.

image of the new France of the Third Republic. In representing the goddess of war *Bellona,* Rodin exposed a fierce physiognomy composed of staring eyes shielded by her helmetlike headdress, firmly set jaw, and powerful neck. Proposing an identification with the goddess of war, Weinert's figure displayed a face shadowed by a hood – at times resembling a helmet, a tense stare, and strong neck. Moreover, Rodin's *Call to Arms* depicted a fighting winged genius supporting the body of a dying warrior. Poorly received by the French public, this Genius shouted, threw out her arms, and pressed her body forward in urgent fury.[70] Feral and full of movement, Rodin's sculpture, like that of Weinert's, asserted a gender reversal – feminine power in sharp contrast to masculine passivity. Both sculptures may have elicited another available meaning – that of an avenging fury – the image of woman out of control. (We shall return shortly to this idea.)

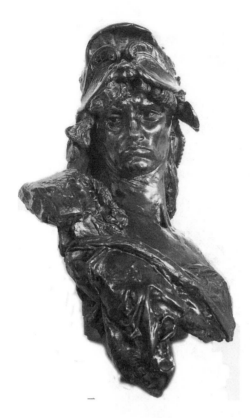

Figure 17. Auguste Rodin, *Bellona,* 1878, bronze, 32" h. Stanford University Museum of Art, 1974.63.

The powerful and defiant female figure in *The Haymarket Monument* also communicated the nurturing qualities of the maternal. Fiercely protective of her dead charge, she tenderly held her hand – as if in a sign of blessing – over the male worker's head. Inhabiting the realm of the domestic *and* the political, this feminine figure refused to capitulate to a separate spheres ideology. Thus, this image manifested a multiplicity of conflicting gender codes.

After its dedication in 1893, the monument attracted much attention from both anarchist sympathizers and the mainstream press. Emma Goldman grasped the complexity of feminine signs apparent in the figure when she wrote:

The inspired vision of the artist had transformed stone into a living presence. The figure of the woman on a high pedestal, and the fallen hero reclining at her feet, were expressive of defiance and revolt, mingled with love and pity. Her face, beautiful in its great humanity, was turned upon a world of pain and woe, one hand pointing to the dying rebel, the other held protectingly over his brow. There was intense feeling in her gesture, and infinite tenderness.[71]

Alternately, Voltarine de Cleyre, an anarchist poet and writer, described the sculpture in the preamble to her poem, "Light Upon Waldheim" of 1897, solely in terms of militancy and revolt: "The figure on the monument over

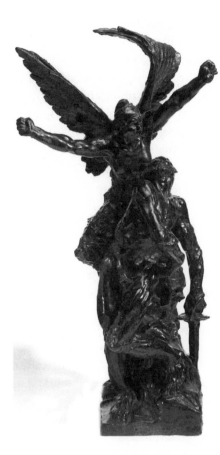

Figure 18. Auguste Rodin, *The Call to Arms,* 1879, bronze, 44½" h. Ackland Art Museum, The University of North Carolina at Chapel Hill. Ackland Fund.

the grave of the Chicago martyrs in Waldheim Cemetery is a warrior woman . . . and with her right [hand she] draw[s] a dagger from her bosom.''[72] To these anarchist sympathizers (not surprisingly, both women), the female figure – in her defiance and militancy – signaled a welcomed rather than a feared disruption of the bourgeios social order.

A complicated gender and class coding inscribed upon the figure's body marked this social disruption. Presented before a large phallic shaft, she displayed a powerful physical stature, enhanced by her aggressive arm gesture, wide stance, and layered apparel, and asserted a strong (read: highly masculinized) identity. The long cape, heavy dress, and large apron shielded her body in the manner of de Cleyre's "warrior woman." In contrast, her hair, hidden by her hood, crept onto her right shoulder in long, soft curls and her bodice, laced up the middle, was slightly unraveled, partially revealing her breasts. Thus, the subtle signs of her open bodice and soft curls defined a more feminine identity, a sexualized persona that, although identified with revolutionary republicanism, limited and contained women's power.[73]

When discussed in the mainstream press, however, the monument invoked expressions of alarm and antagonism. In describing the clay model, the *Chicago Tribune* wrote, "The design represents a woman in an attitude expressive

of contempt and fearlessness." After its unveiling, such language continued unabated. The female figure's face "expresses defiance and resolution," *The Daily Inter Ocean* explained. "One hand is clenched convulsively to her breast while the other is placing a laurel wreath on the brow of the peasant."[74] The *Tribune* identified the avenging female figure as Justice, remarking, "Justice is represented as crowning [the workingman] with a laurel wreath with her left hand, while with her right she is drawing a sword to avenge his death." Similarly, *The World* described the dangerous female as Anarchy or Revolution, "a female figure in an attitude of defiance."[75] In all these examples, the writers interpreted this representation of a powerful woman as a threat – she reached for some imaginary sword, as if usurping the phallic power allowed only to men.

Consistently labeled as defiant, the sculptural figure – representing both allegory and working-class womanhood – appeared to resist and defy the convention of passivity assigned to middle-class femininity and transgress into the masculine sphere of political activity. Similar to Delacroix's construction of a part allegory part flesh-and-blood woman in *Liberty Leading the People* of 1830, this monument recalls the powerful image of Liberty striding forcefully into the viewer's space (Fig. 19). As allegory, the figure stood clearly triumphant. As a representation of women's participation on the July Barricades, she acted as the opposite of the good bourgeoise – sexualized and marked as working class – posited outside the realm of proper femininity.[76]

The central question remains, how did the image of woman signify in this public discourse? Traditionally, the feminine image has personified nations, governments, and political ideals. However, female allegorical imagery has also represented revolutionary violence, as witnessed in the parodic image published in the *Graphic News* (Fig. 13).[77] Thus, it was no surprise that anarchists, regarded as the most disruptive of political activists, commissioned a monument of an equally disruptive image – a powerful woman demonstrating a potential for violence.

Given the power that the Paris Commune held in the contemporary imagination, viewers most likely understood the allusion to the *pétroleuses* (or female incendiaries) embedded within the monument and, for that matter, in the contemporary graphic, "Justice Hurling a Bomb" (Fig. 13). Personifying a mythic dimension of the Commune (with no basis in historical fact), the *pétroleuse* thematized the bourgeois fear of women's participation in revolutionary activities. As in the 1871 lithograph by Eugene Girard, entitled *The Emancipated Woman Shedding Light on the World, the Pétroleuse* – the woman allegedly sneaking around Paris throwing bombs into windows – represented the dangerous, unruly female who threatened to overturn the entire social order (Fig. 20). This pernicious figure challenged male authority by acting in the public sphere, attacking property, and burning down the home. As Gay Gullickson has explained:

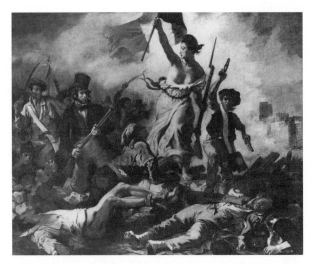

Figure 19. Eugène Delacroix, *Liberty Leading the People, the 28th of July 1830*, oil on canvas, 8' 6" × 10' 8", 1830. Louvre, Paris. (*Source:* Giraudon/Art Resource, New York.)

Figure 20. Eugène Girard, "*The Emancipated Woman Shedding Light on the World*," 1871. Lithograph by J. Lecert. Present location unknown. (*Source:* Gay L. Gullickson, "La Pétroleuse: Representing Revolution," *Feminist Studies* 17 [Summer 1991]: 240.)

Revolution was like the unruly woman: It threatened to turn the social order on its head, a social order that was assumed by its beneficiaries [bourgeois men and women] . . . to be natural. In the political arena, revolution was the ultimate threat, just as in the personal arena, women's sexuality was the ultimate threat. These were the two forces which, if they got out of control, would give power to the powerless. It is not surprising that the search for an image with which to represent the political threat of revolution results so often in the unruly woman. One fear represents the other.[78]

While French conservatives reviled women Communards as *pétroleuses*, American critics similarly vilified anarchist women. One contemporary commentator wrote that he was shocked by the "The Red Sisterhood," whom he described as "crazy women," and "the most hideous-looking females that could possibly be found," especially those who "looked as though [they] might have carried the red flag in Paris during the reign of the Commune."[79] Moreover, in 1885, the Chicago press described Lucy Parsons, wife of Albert Parsons, as "a very determined looking negress" who put down her "anarchist sucklings" long enough to speak. The newspapers often compared her to Louise Michel, the "red virgin" of the Paris Commune.[80] In a world threatened by social upheaval, there seemed nothing worse than a woman participating in revolutionary activity. Viewing the monument through the ideological veil of misogynistic antiradicalism, contemporary writers linked the horrors of the Commune to those of American anarchism by means of this forceful female figure.[81]

It was exactly this melange of conflicting signs that appealed to anarchist sympathizers. On the one hand, in adopting a powerful signifier of social disruption as their own – the defiant, contemptuous, and unruly woman – the anarchists both resisted and parodied the demonization of their political beliefs.[82] On the other hand, the calm power of *The Haymarket Monument* with its feminine figure protecting the passive, supine body of a dead male worker, challenged, in part, the threat of unruliness unleased in the image of the *pétroleuse*. Domesticity and militancy coexisted within the signifying universe of this monument. At Waldheim Cemetery, anarchists, socialists, and fellow sympathizers have responded to this image of a powerful woman by envisioning a world where power relations were not fixed. To this community, woman served as the sign of that liberatory space.

Over the years *The Haymarket Monument* has attracted many visitors.[83] In 1888, Peter Kropotkin, a noted European anarchist, declared that the "commemoration of the Chicago martyrs has almost acquired the same importance as the commemoration of the Paris Commune."[84] In the same year, *The Alarm* referred to the grave-site as the "future Mecca of all good socialists."[85] Indeed, many writers since have described this site in religious terms:

Waldeim with its hauntingly beautiful monument, became a revolutionary shrine, a place of pilgrimage for anarchists and socialists from all over the world. In the

decades immediately following its unveiling, there were years, according to an authority on Chicago, when almost as many visitors came to it in the course of twelve months as to the statue of Abraham Lincoln in the park which bears his name.[86]

The bronze statue, in the words of Lucy Robins Lang, became "the sacred center" of American radicals during the end of the nineteenth and beginning of the twentieth centuries. It meant as much to them "as the Church of the Holy Sepulcher means to the Christian, or Mecca to the Moslem, or the Wailing Wall to the Jew." She continued:

If we had listened to Lucy Parsons on a Friday, we were more likely than ever to go to Waldheim Cemetery on Sunday and look with reverence at the monument to the Anarchist martyrs. I can see it now – a woman's figure on a pedestal and the heroic figure of a man at her feet. Both daring and gentleness are expressed in his face. The woman touches his forehead with one hand, and with the other she points to him calling for his defense. I could never look on the memorial without a great surge of conflicting emotions, a deep tenderness and a stormy, rebellious resolution.[87]

Indeed, the diverse meanings attributed to this monument – described as both disruptive and calm, tender and rebellious – stand as a testimony to the complexity of the commemorative process.

To the nation as a whole and to the citizens of this midwestern metropolis, the legacy of the Haymarket Affair – the mysterious bombing, and the trial and execution of anarchists – colored the city's (rather shaky) identity as a peaceable urban environment. Through the various commemorations of this event, both *The Haymarket Monument* and *The Police Monument*, served as ciphers for the deeply divisive ideological debates of the late nineteenth century. *The Haymarket Monument*, as a popular meeting spot for political activists, played a central role in the construction and maintenance of a social and political memory that has resisted official discourse. *The Police Monument*, with its turbulent historical past, has been the locus of intense political, ideological, and personal debate while standing as the rather fragile symbol of the forces of law and order.

The World's Columbian Exposition of 1893, with its elaborate physical structures and abundant displays, was never immune from these political and social concerns. Despite the massive effort to construct a cohesive national identity, the fair failed to eradicate completely the specter of Haymarket – a fear of class tensions that fragmented the unified facade of the Exposition and the orderly life of the city and the nation. Within the public imagination, Haymarket and the World's Columbian Exposition formed part of an interlocking belief system through which many people understood their contemporary world. Thus, we turn our attention to the 1893 World's Fair, and, more specifically, to Johannes Gelert's *Struggle for Work* exhibited in the Fine Arts Palace.

THE SPECTACLE OF LABOR

The World's Columbian Exposition of 1893

While anarchists and socialists dedicated *The Haymarket Monument* in Wald-heim Cemetery (Fig. 9), Johannes Gelert, the sculptor of *The Police Monument* (Fig. 10), exhibited *The Struggle for Work* (Fig. 21) to a large audience at the World's Columbian Exposition in Chicago in the summer of 1893. In this sculpture, three white men contend for a work ticket with the central figure, who holds the prized object, the largest in scale. A woman and her two children are literally under foot, huddled below and protected by the central figure who, although bare-footed and dressed in tatty garments, serves clearly as the breadwinner. An older man clings to the worker's torso, too weak to wrest the work ticket from his raised and clenched fist. The adolescent reaches upward, grabbing the worker's muscled arm, in an unsuccessful at-tempt to garner the ticket. A small boy kneels at his father's feet.[1]

This sculptural group highlighted generational succession through the postures of the four male figures. The raised arm of the adolescent emulated the worker's defiant gesture, identifying him as the next in line to attain a coveted work ticket. The young boy's pose echoed that of the elderly man, signifying that both young and old remained marginalized, denied access to the competition for work. This generational struggle – established as a social Darwinian struggle that was made "natural" through the analogy with the cycles of life – enacted a patriarchal system in which "the struggle for work" took place over the servile body of the female figure. This widely acclaimed sculpture in plaster (now lost) stood on display in the North Gallery of the United States Section of the Fine Arts Building at the World's Columbian Exposition.

While sympathetic to the conditions of contemporary labor – particularly the devastating Depression of 1893, the sculpture, nonetheless, reinforced traditional hierarchies between labor and capital and between men and women. In contradistinction to *The Haymarket Monument* (Fig. 9), which dis-rupted traditional gender roles and thus symbolically empowered workers, the *Struggle for Work* reinscribed gender hierarchies onto a paternalistic factory system that dispensed work tickets at the owner's discretion. Despite the raised fist of labor solidarity upheld by the central figure, this sculpture produced a narrative that denied agency to workers. Similarly, this imagery

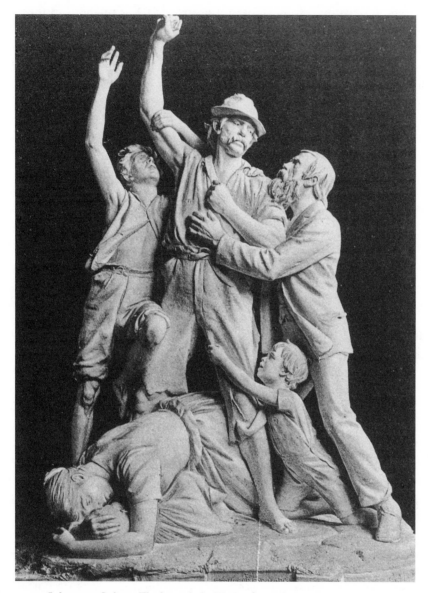

Figure 21. Johannes Gelert, *The Struggle for Work*, 1893, plaster. Present location unknown; presumably destroyed. (*Source:* Sadakichi Hartmann, *Modern American Sculpture* (life-size). New York: Paul Wenzel, [1918], pl. 40.)

presented workers as victims of an unjust, yet inevitable system – a system in which they were born and destined to die.

Haunted by the specter of the Haymarket tragedy and identified with strikes that delayed the fair's opening, labor assumed a specific identity at the World's Columbian Exposition, one that served the interests of elite and middle-class fairgoers. A constellation of discursive practices produced an ideal conception of the worker within the fair's realm. Specifically, the Labor

Congress, a week-long symposium on the state of labor relations in the country, the Model Workingman's Home and the Pullman experiment appeased middle-class fears of social disruption by constructing an image of the worker consonant with the new consumer culture highlighted in many fair exhibits. Gelert's *Struggle for Work,* as we shall see, participated in and acquired significance through this discursive field.

■ ■ ■

As one of the most elaborate and exciting events of the century, the World's Columbian Exposition – comprising the White City and the Midway Plaisance – rivaled all other world's fairs, even the extravagant Paris Exhibition of 1889. After years of planning, the World's Fair opened in May and closed in October 1893, attracting large numbers of visitors – ten to fifteen million people from all over the United States and abroad. Deeply nationalistic, the fair represented the triumph of American progress – an index of American cultural, economic, and technological development that had equalled if not surpassed that of Europe. As a product of the American Renaissance tradition, the buildings of the White City simulated marble with white plaster facings, had cornices of equal height, and revealed architectural styles typically inspired by historical motifs.

The Court of Honor stood as the centerpiece of the White City, with its artificially constructed lagoon, Renaissance-styled buildings, and colossal sculptures by Daniel Chester French and William MacMonnies. The first exposition to make use of electricity, the fair sparkled at night with reflected light to create a monument to artifice and delight. This utopian city – temporary, impermanent, and highly sanitized – produced a fantastic environment in which prosperity and social harmony predominated with little discernible trace of the economic depression ravaging the community beyond the fair's borders.

Accompanying the splendor of the White City, the Midway Plaisance – the commercial center of the fair – housed entertainments from the famed Ferris wheel to anthropological exhibits that put all manner of foreign populations on display for fair visitors. In contrast to the homogeneous design of the White City – an attempt to construct a unified ideal of American culture – the Midway reveled in difference. The exhibits produced a genealogy of diverse types. The Women's Building – highlighting gender as a category of difference – stood at the intersection of the White City and the Midway. Two Model Workingman's Homes, one at the start of the Midway and another near the anthropological displays of the White City (Fig. 22), conflated notions of class, race, and ethnicity in constructing contemporary social hierarchies.[2]

Spectacle and display were key to the pleasures experienced by fair visitors in both the White City and the Midway Plaisance. In the second half of the nineteenth century, international expositions produced successful venues for a newly emergent consumer culture. The Paris Exposition of 1855 demon-

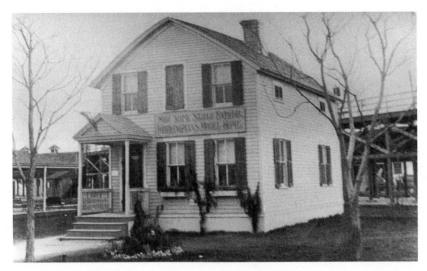

Figure 22. Model Workingman's Home, World's Columbian Exposition, Chicago, 1893. (*Source: Report of the Board of General Managers of the Exhibit of the State of New York at the World's Columbian Exposition.* Albany: James B. Lyon, State Printer, 1894, p. 396.)

strated a shift in emphasis from extolling the benefits of the Industrial Revolution with its machinery and technological processes to promoting the new consumer revolution with its wealth of commodity goods on display. In the United States, the 1893 World's Columbian Exposition marked this shift. In comparison with the 1876 Centennial Exposition held in Philadelphia, where the mighty Corliss engine took center stage as a sign of American productive power, the Chicago fair featured an overabundance of commodity goods, which in themselves represented the nation's productive capacity.[3]

As a means of legitimating this culture of consumption, the Chicago fair planners elaborately designed and installed exhibits of material goods in emulation of precious museum displays. Commodity exhibits at times simulated high-art images, as, for example, the monumental statue of a medieval knight – loosely imitating Donatello's famous *Gattamelata* – which was fabricated entirely of prunes and located in the California building.[4] Within this world of spectatorial pleasure, many Americans had their first encounter with serious art, commingling consumption, entertainment, and the aesthetic in one complex experience.[5]

Throughout the fair, workers and the working class had little visibility, but "the worker" as spectacle to be consumed by fair visitors appeared in several exhibits. Gelert's *Struggle for Work*, situated within a site constituted by leisure and consumption, depicted several generations of workers embroiled in internecine conflict over the availability of productive work (Fig. 21). This sculptural image reduced the worker to empty spectacle – his identity as producer subverted within a capitalist economy that fetishized the commodity and rendered invisible the processes of production. The Model Workingman's

Home was built directly on the fairgrounds under the sponsorship of the State of New York. It stood in the White City, not far from the Anthropological Building and directly across from the exhibition of the French agricultural colonies, serving as an example of affordable housing in which a family of five lived during the month of July.[6] Reminiscent of an anthropological curiosity, the family was on display much like the African Dahomey Villagers and Native Americans that inhabited the farthest end of the Midway Plaisance. Similarly, the Pullman exhibit, located in Louis Sullivan's Transportation Building in the Court of Honor, treated working-class culture as touristic spectacle. Consisting of a model of the City of Pullman, a planned community of railroad car workers located just outside of Chicago, the exhibit encouraged fairgoers to visit this town and view its working-class inhabitants as if attending another unique display.

■ ■ ■

Work began on the fairgrounds on January 27, 1892. Daniel Hudson Burnham, the director of the fair, supervised the construction of the buildings and the grounds.[7] He worked under a tight schedule and demanded disciplined labor from the 7,000 men under his employ. With the severe winter of 1892–3 and the many job-related accidents, 700 workers were injured and 17 men killed on the job.[8] Not surprisingly, much labor agitation took place during the fair's construction. In fact, strikes increased the cost of the exposition by one million dollars. Iron setters, electricians, and carpenters, among other workers, struck to demand the hiring of union labor, implementation of minimum wage, and an eight-hour day. The Board of Directors of the Exposition refused to acknowledge labor's demands for a union shop or fixed minimum wage, but finally did accept an eight-hour day with overtime in 1893. In response, the unions agreed to give notice before striking.[9]

With the memory of Haymarket still strong, city leaders as well as the Chicago police feared constant disturbances by the labor community. They ordered raids on peaceful union meetings, arresting union members and preventing their freedom of assembly. Police Superintendent McClaughry reported: "The Anarchists want revenge on Chicago for the execution of their breathren, and they intend to do it if possible by giving it the reputation of an unsafe place for investments or for visitors to exhibits in the World's Fair." Mayor Hempsted Washburne corroborated by stating:

My impression is that the anarchists are not now preparing to throw dynamite. They propose striking a much more deadly blow at Chicago by creating the idea that anarchy is rampant in this city and that therefore it will not be safe for people to come to the World's Fair in Chicago. . . . They . . . think that they can with impunity destroy Chicago's reputation and prosperity. Now . . . we propose demonstrating that this is a peaceable and law abiding place, that its people make the laws and then obey them, and that the government is capable of suppressing and keeping in check the disorderly element which exists here as it does in all large cities.[10]

Providing a visual antidote to such violent confrontations with police as the Haymarket bombing, Gelert's *Struggle for Work* presented diligent, yet somewhat pathetic workers, who fought among themselves for the opportunity to work (Fig. 21). Demonstrating the difficult conditions under which these workers were forced to subsist – their tatty garments and bare feet the evidence of their deprivation – the sculpture, nevertheless, failed to call into question the inequities of a capitalist system. True to its reformist spirit, it simply urged sympathy for the plight of the worker. Its paternalism served as the dominant code through which fair visitors understood this sculpture and labor relations in general.

Although American sculpture at the Fair received little attention in the press, the public and critics praised *The Struggle for Work*. A contender for a Gold Medal, the sculpture was disqualified when Gelert was appointed to the International Jury of Awards.[11] When reporters from the Chicago *Herald* compiled a list of twenty-five of "the most remarkable features of the exposition," Gelert's sculpture made the list.[12] In reviewing the sculpture section of the Fine Arts Building, the Springfield, Massachusetts, *Republican* called it: "The most powerful and original work, not only in America but in the whole exhibition of sculpture." The article continued:

This strenuous and faithful conception, representing the workingman's struggle for bread . . . is one of the strongest things ever wrought into sculpture, and whether it be called socialistic, anarchistic, or what not else, it deserves recognition for its extraordinary moral quality and significance.[13]

With its insistence upon contemporary subject matter and detailed realism, *The Struggle for Work* depicted the worker with an unusual forthrightness. None of the other 160 American sculptures on display addressed labor themes, and in the monuments that decorated the fairgrounds, as we shall see, allegorical representations of labor dominated artistic expression. In keeping with the realism of his *Police Monument* (Fig. 10), Gelert attended to the minutest detail of dress, facial expression, and gesture in *The Struggle for Work*, maintaining historical – but not necessarily geographic – specificity. In so doing, he earned the sculpture an unwitting connection to socialism and anarchism. Tamed by their presence in the White City, these political philosophies no longer posed a dangerous threat to civil society but assumed an "extraordinary moral quality and significance," as one Springfield, Massachusetts, critic explained.

The sculpture provided a highly moralizing narrative set in Manchester, England – not in the United States. The Chicago daily, the *Inter Ocean*, provided the most careful description of this labor practice to its readers:

Another powerful group in plaster where one is always sure to find a crowd is Gelert's *Struggle for Work*. It is founded on the practice in Manchester, England, where work is dull and starving folk plenty, of the people's gathering outside a factory, the foreman meantime throwing from the window tickets entitling the holder to a day's work. The central figure of the group is a workman, strong and

brawny, who has been fortunate enough to secure one of these tickets. He holds it aloft but not in triumph, for to one arm clings a lad just entering manhood madly striving for it, while on the other side a poor old man implores him to give him his chance. The strongest battle that the workingman has fought that day is the one with his better nature. He thinks of his own home, yet, as he looks into the poor uplifted face where starvation has set its mark, he seems to hesitate and half resolve to yield what he has gained, and try once more. Beneath the men, a woman lies, thrown down in the fierce struggle. Mother-like she shields and soothes her baby, even though she herself is trampled under foot. Her other little one, a boy of 6 perhaps, fights and pulls at the already tattered clothing of the workman.[14]

This critic interpreted the struggle of the workingman as a private battle of conscience, rather than a political engagement over the right to work in a time of severe economic depression. He understood the sculpture to convey a sympathy for the plight of the worker. At the same time, his interpretation denied the sculpture's relevance to the historical contingencies of labor in the United States (and particularly to the recent Haymarket events in Chicago). In positioning these struggling workers as engaged in a moral battle in England, he neutralized any threat of worker self-determination at home. Thus, Gelert's sculpture became safe for middle-class consumption at the fair.

Gelert not only exhibited several other sculptures at the fair, but also sat as an alternate on the National Sculpture Jury, which selected the works to be exhibited in the Fine Arts section.[15] He was commissioned to produce the fourteen-foot-high *Neptune* figures that surmounted the six rostral columns surrounding the central basin of the Court of Honor. Moreover, he exhibited three other sculptures in the Fine Arts Building: *The Little Architect* (plaster group) of ca. 1882, *Theseus, Victor over the Minotaur* (bronze statuette) of 1886, and *Bust of Abraham Lincoln*, heroic size (plaster) of 1892.[16] Representing allegory, mythology, and historical portraiture, these works fell within traditional sculptural categories that stood apart from *The Struggle for Work* in both subject matter and style.

As Janet Marstine has demonstrated, murals of labor and industry served nationalist interests at the fair, helping to define the World's Columbian Exposition as uniquely American in character. Throughout the fair, allegories of labor in mural painting and sculpture issued a didactic message to middle-class viewers, championing the work ethic as the moral center of American life and promoting industry as the harmonious partner to labor. In particular, female allegorical figures appeared in many fair murals, among them, Kenyon Cox's mural decorations in the Manufacturers and Liberal Arts Building. These decorative images embodied a craft ideal articulated through a classicizing vocabulary. The aesthetic refinement of these delicate female figures constructed an alternate discourse about labor, a discourse that evoked a romanticized, preindustrial past.[17]

Four prominent public sculptures, each twelve feet high and situated in

the Court of Honor, presented nostalgic depictions of the worker. Daniel Chester French (1850–1931) and Edward Clark Potter (1857–1923) collaboratively produced *Industry* (or *Labor*) (Fig. 23) and the *Teamster* (Fig. 24) located in front of the south facade of the Manufacturers and Liberal Arts Building, and *Plenty (Ceres)* (Fig. 25) and the *Goddess of Corn* (Fig. 26) situated across the lagoon outside the Agricultural Building. Like the mural painting within the Manufacturers and Liberal Arts Building, these sculptures recalled a preindustrial past, but in this case, one linked to an agrarian ideal. Praising *Industry* as a "colossal statue of labor," one guidebook insisted upon its respectful representation of rural toil:

The group consists of a sturdy son of toil, one hand clasping the long handle of an old-fashioned celtic spade, the other resting on the collar of a gigantic horse, against which he leans. . . . [He] is a splendid specimen of the agricultural laborer, long-limbed and stalwart, his bare arms show the corded muscles of practiced strength, and his long, powerful limbs seem well fitted to carry him over the rich furrows of the well-ploughed field. But it is the face that holds one's attention. This is no stolid boor, no slave of some callow lordling or country squire, but a man every inch of him, and an intelligent man at that. Full of independence, his eyes look out from beneath his broad-brimmed hat as though challenging equality with the countless thousands who come to gaze on him.[18]

This strong, independent, and intelligent worker – a testament to Jefferson's yeoman farmer – represented a distinctly American symbol by conveying the dignity of labor and the autonomy of the worker in a frontier environment.[19] Ironically, this belief in the nobility of the independent laborer's toil belied the changing course of American society, as the profound impact of industrial expansion and corporate capitalism rendered powerless and undignified the lives of many contemporary workers. Moreover, this monumental sculpture proclaimed its allegiance to a mythic frontier at the very moment that Frederick Jackson Turner at the World's Congress of Historians – one of many public conferences held at the World's Columbian Exposition – argued the American frontier had officially closed.[20] In Its heroic image of horsepower and manpower, the sculpture articulated a concept that was lacking in the sign of the commodity – the productive capacity of labor.[21]

As the companion piece to *Industry,* the *Teamster* represented one of the very few images of black laborers at the fair (Fig. 24). Leaning proudly against his workhorse, this muscular man gazed confidently across the lagoon during a moment of rest. Dressed in loose-fitting clothes, he wore a sleeveless shirt that revealed the powerful muscles of his large arms and a wide-open collar that exposed the upper portion of his chest. Both sculptures imparted a definition of masculinity encoded through the body – virility defined by heroic manual labor. However, the body of the black teamster stood more ostentatiously on display than that of his white counterpart, signaling racial difference. As we shall see in more detail in Chapter 4, the bodies of African-

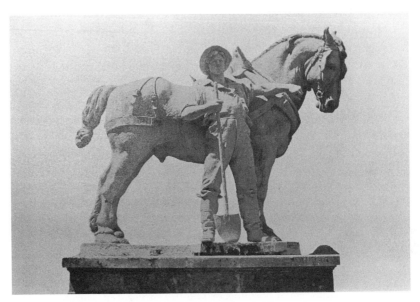

Figure 23. Daniel Chester French and Edward Clark Potter, *Industry,* World's Columbian Exposition, Chicago, 1893, destroyed. (*Source:* James W. Shepp and Daniel B. Shepp, *Shepp's World's Fair Photographed,* [1894] p. 37.)

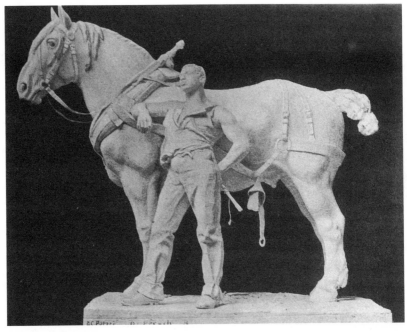

Figure 24. Daniel Chester French and Edward Clark Potter, *Teamster.* Plaster model of sculpture installed at the World's Columbian Exposition, Chicago, 1893. Presumably destroyed. (*Source:* Sadakichi Hartmann, *Modern American Sculpture.* New York: Paul Wenzel, [c. 1918]), pl. 2.)

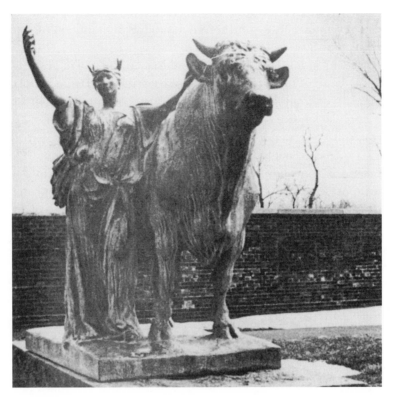

Figure 25. Daniel Chester French and Edward Clark Potter, *Plenty*. Bronze cast from working plaster model of sculpture originally installed at the World's Columbian Exposition, Chicago, 1893. Garfield Park, Chicago (installed 1909).

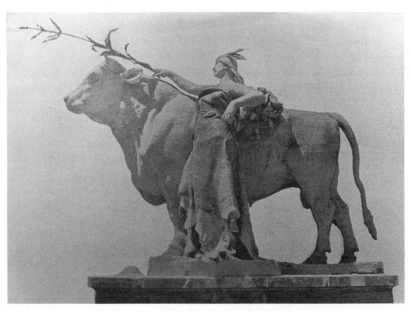

Figure 26. Daniel Chester French and Edward Clark Potter, *Goddess of Corn*, World's Columbian Exposition, Chicago, 1893, destroyed. (*Source:* James W. Shepp and Daniel B. Shepp, *Shepp's World's Fair Photographed*, 1894, p. 143.)

American and Native-American men were consistently on display in late nine-teenth-century visual culture and served as models of manhood for a predom-inately white middle-class male audience.

Not surprisingly, fair literature rarely addressed the image of the *Teamster,* omitting the issue of race from contemporary criticism. Denied access to the fair, refused an exhibition of their own, and banned from the labor force that built the fair, blacks were rendered invisible in this huge enterprise. Attending the fair as commissioner from Haiti – not as a citizen of his own country, Frederick Douglass renamed the White City a "whited sepulcher."[22] Yet, the black *Teamster,* with its position to the center of the fair, held strong symbolic significance. As a means of differentiating American from European culture, the black served as a sign of American identity despite his history of economic and political oppression.[23]

Across the lagoon stood two other plaster sculptures, *Plenty* and the *Goddess of Corn* (Figs. 25 and 26).[24] Representing the gendered opposite of their pendants, these figures posed the feminine equivalent to the agrarian fron-tiersman. Positioned beside a large bull, *Plenty* held her arms aloft, grasping wheat sheaves that typified the products of the Old World. She heralded antiquity with her laurel wreath and classical garment, reminiscent of the bold folds of Hellenistic drapery. Not unlike the classicizing figures that inhabited Kenyon Cox's mural decoration in the Manufacturers and Liberal Arts Build-ing, this delicate figure recalled an ideal of middle-class femininity defined by aesthetic refinement and leisure activity – an ideal at odds with the manual labor of pioneer women.

Her companion, the *Goddess of Corn,* held a cornstalk – the Indian's gift to the New World. She stood draped in an animal skin with feathered headdress crowning her costume. Like her pendant the *Teamster,* the Indian maiden stood as an idealized image, distanced from the anthropological exhibits of Native Americans who inhabited the Midway. As a prominent motif in nine-teenth-century art, the presence of the Native American, like the images of the frontiersmen and the African American, distinguished the uniqueness of American culture.

The *Goddess of Corn* participated in a visual tradition popular in the United States since the eighteenth century. From 1765 through the early part of the nineteenth century, the Indian princess served as a primary symbol of Amer-ica.[25] By mid-century, she appeared most notably in the decorations for the United States Capitol. Constantino Brumidi, for example, produced a fresco in 1855–6 for the Committee on Agriculture Room in which a woman with the attributes of headdress, bow, arrow and animal-skin belt personified the American continent. In 1871, he produced yet another fresco, this time for the Senate Naval Appropriations Committee Room, in which an Indian prin-cess again personified America. The *Goddess of Corn* displayed similar icono-graphic motifs – the animal-skin attire, feathered headdress, and barefooted-ness. Vivien Fryd has discussed the significance of Native-American imagery

in nationalistic terms. In describing the Capitol murals, she presented an argument also relevant to the fair statuary: "All indigenous objects [were] appropriated as American symbols; Indian history and culture [were] sifted out, leaving only objects that the United States could claim as its own identifying features."[26]

Commenting upon one of these sculptures – most likely the *Goddess of Corn* – a guidebook argued: "she is not the goddess type . . . this is a simple country-woman, such as one might see any day in the year in rural regions. How strong, yet proportionate, are the arms! How large and flexible the hands!"[27] Closely linked to the ideology of the frontier, this figure's large body – with her arms signifying the hard work of rural life – and her sharply hewn knife demonstrated heroic strength and independence rarely allowed to women. In contrast to the refined domesticity typified by *Plenty* and the compliant subservience of the female figure in *The Struggle for Work,* the Indian goddess challenged the notion of passivity typically assigned to women. The body once again signaled racial difference, as this Indian woman transgressed the permissible gender codes of white civilization.

By contrast, the female figure's body in *The Struggle for Work* encoded traditional gender hierarchies by serving as the foundation upon which the masculine struggle for work took place. As the adolescent lad braced his leg against her back, this gesture proclaimed the dominance of male activity in the world of contemporary labor. As discussed in the previous chapter, Robert Koehler's *The Strike* of 1886 had also depicted a separate-spheres ideology in his representation of a labor struggle (Fig. 11). One of the few images of labor revolt exhibited at the fair, it showed only men and boys actively engaged in the dispute.[28] Despite women's historical participation in labor and union activities, artists, with few exceptions, depicted their roles as ancillary and supportive rather than active and determinative. As a consequence, *The Haymarket Monument* with its powerful feminine protagonist has stood out as exceptional within a context of contemporary labor imagery (Fig. 9).

Complementing the rhetorical strategies of mural painting and sculpture, photography also erased most traces of contemporary labor within the representational universe of the fair. Charles Dudley Arnold, the official photographer for the World's Columbian Exposition, produced 400 construction views and 300 "official views" of the fair. The construction views comprised images of Jackson Park in transition – from unaltered swampland to cultural mecca. Several images took workers as their subjects but glorified the technological achievement of iron construction rather than the skill required to erect the structures. In fact, in the "official views" of the fair produced by Arnold, the absence of workers was quite striking. Prosaic in their detail yet grandiose in style, such photographs as *Administration Building, July 23, 1892,* suggested that the buildings built themselves, omitting any evidence of workers as a social force. Collected into a book and given to the directors of the fair, these photographs became the official images of the World's Columbian Exposition

and were carefully dispensed to newspapers, periodicals, and guidebooks. The fair directors allowed no unauthorized photography on the fairgrounds. In so doing, they controlled the dissemination of images and manipulated the public's understanding, experience, and memory of the fair.[29]

Gelert's *Struggle for Work* negotiated the distinctions between this ideal world of compliant labor – its productive capacity made nearly invisible within the fairgrounds – and the rhetoric of violence and unruliness that dominated public perception of Chicago's laboring communities since the Haymarket Affair. Burnham insulated his workers from daily demonstrations by the unemployed at the Lake Front and Jackson Park. In fact, during the construction of the fairgrounds, he tried to isolate his workers from labor organizers by installing an eight-foot fence around the park and hiring security guards unsympathetic to labor. On July 23, 1891, he wrote to his chief administrative assistant, Dion Geraldine, "Select native-born Americans [as] far as possible . . . avoid placing any labor agitators of any description on the work."[30] In his memoirs of the construction of the fairgrounds, *The Book of the Builders*, he later wrote:

Jackson Park [the site of the fairgrounds] became a center of interest . . . and the necessity of inclosing [*sic*] the grounds was soon apparent. A contract was accordingly made to build a simple board fence eight feet high around the unimproved portion of the Park, and this barrier, which was finally extended around the entire area, including the Midway Plaisance, served its purpose through the whole exposition. After its erection no serious labor conflicts occurred, although there were several large and hampering strikes during the period of construction.[31]

The fence formed an enclosure that separated labor's political invisibility within the fairgrounds from workers' attempts to represent themselves at the Lake Front. Near the fair, the Central Labor Union, a predominantly anarchist organization, addressed meetings of workers, and on the Lake Front, daily demonstrations of the unemployed revealed the devastation experienced by much of the population during the 1893 depression. Many who came to Chicago had hoped to find work at the fair – most were unsuccessful and ended up penniless, living in flophouses and in jails.[32] But those lucky enough to secure employment were immune, at least temporarily, to such tragedies. Walter Wykoff, a Princeton graduate who traveled the country working at odd jobs, later wrote in his memoirs of his experiences on the construction crew of the fair:

Guarded by sentries and high barriers from unsought contact with all beyond, great gangs of us, healthy, robust men, live and labor in a marvellous artificial world. No sight of misery disturbs us, nor of despairing poverty out in vain search for employment. Work is everywhere abundant and well paid and directed with highest skill. . . . [W]e work an eight hour day in peaceful security and in absolute confidence of our pay.[33]

Wykoff failed to mention the numerous work accidents and large number of deaths that occurred during the building of the fair. Nonetheless, the work crews did toil in a world quite separate from the desperation of the Chicago streets and the Lake Front. Like the fair visitors who marveled at the delights of the White City, these workers lived in an artificial world that allowed some modicum of comfort, security, and peace – a world unavailable to most of Chicago's working inhabitants.

▪ ▪ ▪

The Lake Front and the fair served as two distinct ideological sites that defined the nature of work and the character of workers. The Congress of Labor, a week-long series of meetings, discussions, and lectures by leading labor activists' attempted to bridge the differences between these two sites by setting a common goal dedicated to the advancement of the working person. The Congress of Labor formed one aspect of the World's Congress Auxiliary, which brought together the world's leading authorities to discuss such issues as religion, labor, history, and women, as well as other important concerns of the day. Fearing that the vast number of exhibits might obscure its larger lessons about progress, the exposition directors organized these public conferences as the "Intellectual and Moral Exposition of the Progress of Mankind." The motto of the World's Congress was "Not Matter, But Mind; Not Things, But Men," and its mission was "to review the Progress of Mankind, and state the Living Problems now awaiting Solution."[34]

The Congress of Labor opened on August 28, 1893, and closed on Labor Day, September 5, 1893.[35] Henry Demarest Lloyd, a strong supporter of the Haymarket appeals process, served as secretary of the program committee. Among the dozens of speakers who appeared at the Congress were Samuel Gompers, President of the American Federation of Labor, who spoke on "What Does Labor Want?"; Wilhelm Leibknecht speaking on "The Labor Movement in Germany"; Eugene V. Debs, the future President of the American Railway Union, discussing "The Organization of Workingmen" and its impact upon Pullman workers; Walter Crane R.A., presenting a talk on "Art, Labor and Machinery"; and President M. M. Garland of the Amalgamated Association of Iron and Steel Workers, explaining "The Real Struggle at Homestead – Its Causes and Results." Moreover, the Labor Congress extended a hand both to black and native populations of the country, inviting both Booker T. Washington, President of the Tuskegee Industrial Institute, to speak on "The Progress of Negroes as Free Laborers," and Charles C. Painter, Secretary of the Indian Rights League, to discuss "The Indian as Possible Wealth Producer."[36]

Few workers attended the opening ceremonies of the Labor Congress due to the hour – ten o'clock in the morning; however, many turned out after work to hear the evening lectures.[37] At an August 29 meeting, the novelist

Hamlin Garland attacked the fear of "vagabondage" that had come to domi-
nate the contemporary discourse on unemployment:

I have just come from the Lake Front, where I spent an hour or more mingling in
the crowd, closely scanning the features of the men and listening to their conversa-
tion and I am free to give it as my opinion that the talk about their [sic] being
'tramps,' 'bums,' etc. is veriest rot. There are a few loungers around the park that
would fit that description, but I believe 85 per cent of them are clear-eyed, rugged,
honest workingmen who find themselves suddenly out of a job with but little, if
anything, ahead for themselves and family.

Reiterating the demands of Coxey's Army in Washington that same year,
Garland called for practical programs that would put people to work – clean-
ing drainage canals, grooming parks, or simply improving the city.[38] Focusing
many of their comments on the activities taking place at the Lake Front, most
participants in the Congress of Labor hoped to make their efforts relevant to
the needs of Chicago's working people. For example, Mary E. Lease, a Kansas
Populist who spoke at the Congress, argued: "There is a great army of men
asking for work and asking for bread, and when they assert the right of free
speech here on the Lake Front of Chicago, they are clubbed down like
dogs. . . ."[39]

The Labor Congress sessions of August 30 were held outdoors at the Lake
Front. This unusual location addressed more than practical needs – to accom-
modate more people, it served as a symbolic act in which Labor Congress
participants reached out to and acknowledged the needs of the unemployed
of the city. Twenty-five thousand union and non-union workers assembled to
hear several speakers, among them Samuel Gompers and Clarence Darrow.
Gompers advised patience and perseverence on the part of workers, while
exhorting city officials to create public works programs. Most of the speakers
urged cautions optimism and advised peaceful reform. It was clear that de-
spite their sympathy with the labor agitation of the Lake Front, the Congress
of Labor participants wished to diffuse this volatile political situation. In fact,
because of the acts of an unruly few, Mayor Carter Harrison banned all future
demonstrations at Lake Front Park.[40]

The Congress of Labor ended on Labor Day when the Trade and Labor
Assembly and the Buildings Trades held a joint parade and demonstration.
The outdoor events took place at Kuhn's Park and Ogden's Grove, both on
the Chicago Lake Front.[41] Over 1,000 workers attended the Trade and Labor
Assembly picnic at Kuhn's Park where Governor John Peter Altgeld and
Samuel Gompers spoke. In honoring Altgeld, Gompers proclaimed his cour-
age in pardoning the Haymarket martyrs:

The men and women of the world owe a debt of gratitude to Governor Altgeld they
can never repay for his remarkably just and manly pardon of the men who were
convicted for participation in the Haymarket Riot. If he had indorsed [sic] anar-
chism we would have condemned him as we now praise and honor him. . . . Gover-

nor Altgeld is said to be politically dead because of his act in pardoning these men. If this is true, and I hope it is not, he has the satisfaction of being morally alive. I believe he is one of these great men who would rather be right than be president, and wherever wage earners are meeting to-day they will utter the same opinion, that he did right.[42]

The memory of Haymarket, rekindled by the recent dedication of *The Haymarket Monument* in Waldheim Cemetery, elicited strong reactions from workers and labor leaders alike (Fig. 9). Gompers, despite his support of Altgeld, distanced himself from the political activism of the anarchists, who themselves had often spoken at demonstrations in Ogden's Grove and Kuhn's Park. He offered an alternative solution to the injustices perpetuated against working people – change through peaceful reform.[43]

Many involved with the planning of the Labor Congress voiced dissatisfaction with its commitment to working people. Compared to the Congress on Religion, Women, and Education, the Labor Congress was shorter and less well-promoted.[44] Moreover, a variety of labor supporters, from anarchists to reformists, feared with apparent good judgment that the Congress might not address the real needs of the workers. Benjamin Tucker, the editor of the Boston anarchist journal *Liberty,* urged his readers to boycott the Congress. The Women's Committee of the World's Fair Auxiliary resigned during the planning stage, issuing this statement:

First – We find this programme singularly free from all those expressions and ideas upon which working people are at present founding their hopes of advancement and in the discussion of which they are most interested.

Second – We believe that upon so neutral a programme it would be impossible to secure the cooperation of the leaders representing the various labor organizations and schools of economic thought; and that a labor congress without the cooperation of such leaders would be useless.

Third – We believe that a discussion upon the very general and vague lines therein indicated would be futile and justly arouse the suspicion of laboring people as to the sincerity and good faith of the committee inviting speakers.[45]

Waffling between an activist and conciliatory stance, the Labor Congress demonstrated a marked ambivalence in its strategy toward addressing the plight of the working people. Reformist at heart, the Congress hoped to ameliorate the living and working conditions of the laboring class, but rejected any move toward changing the economic structures of the country.

As the Lake Front and the fair epitomized distinctly different ideological sites, Weinert's *Haymarket Monument* and Gelert's *Struggle for Work* provided visual evidence of labor's competing identities (Figs. 9 and 21). By subverting gender codes and appropriating signs of unruliness, *The Haymarket Monument* advocated the militant labor activism enacted at the Lake Front. Gelert's *Struggle for Work,* on the other hand, conveyed an ambivalent, and somewhat patronizing, message about the concerns of working people. With its monu-

mental scale and heroic composition, the sculpture drew attention to the struggles of working men without serving the interests of working-class solidarity. The raised fist notwithstanding, the sculpture furthered class division through its accommodation to this competition for scarce resources. Complicit with the rhetoric of paternalism displayed throughout the fair, the *Struggle for Work* kept in place rigid gender and class hierarchies, markers of the status quo.

The inaccessibility of the fair to working people demonstrated even further the conflicted nature of the class question. In the hopes of encouraging workers to attend the exposition, the fair directors constructed low-cost family dormitories and offered special cut-rate admission days.[46] Moreover, a debate raged over Sunday openings. Certain religious leaders argued that Sunday closings would unfairly discriminate against the working class who, they assumed, was in the greatest need of the spiritual and moral lessons propagated at the fair. The New York architectural critic Mrs. Mariana Griswold Van Rennselaer, championed Sunday openings, "... the one day of the week when our mind-hungry, beauty-starved, ignorant but eagerly ambitious masses could best make use of [its] civilizing and uplifting ministration." Although director Harlow Higginbotham ordered the exposition closed on Sundays for financial reasons, the courts ruled its opening.[47] Nonetheless, a visit to the fair required a major investment of time and money; only those very few workers who lived in or near the city could afford to attend.

■ ■ ■

Several exhibitions at the fair addressed working-class concerns for the benefit of middle-class viewers. The Model Workingman's Home, built directly on the fairgrounds under the sponsorship of the New York State Exhibition Committee, and the Pullman experiment, lionized in the Transportation Building as an example of worker–management cooperation, treated working-class culture as spectacle and display. Both exhibits constructed a worker identity that conformed to middle-class standards of comportment and morality while simultaneously reinscribing class difference through the power of the gaze. Like the plaster figures that comprised Gelert's *Struggle for Work*, the artificially contrived family who inhabited the Model Workingman's Home and the residents of the industrially planned town of Pullman functioned as players in a stage set, acting out a social script produced for middle-class consumption.

The Model Workingman's Home served as an example of affordable housing (under ideal conditions) for a worker earning $500 per year with a family of five (Fig. 22). This exhibit demonstrated that a capitalist could build and rent the house at a rate not exceeding $10 per month; or a workingman could afford to build it for a total of $1,000. Understanding their mission to be didactic, the Board of General Managers of the State of New York wrote:

in order to attain to the highest conditions of living it is necessary not only that the workingman earn a fair wage but that he and his be educated sufficiently to distinguish between the necessary and the unnecessary; the cheap and the shoddy; that which is truly worth having from that which gives only temporary pleasure.[48]

The white house with green blinds stood on a 25-foot lot, embellished with a little porch with vines, hanging baskets, and green window boxes. The two-story frame cottage was 20 feet wide by 28 feet deep, with a living room, kitchen, bath and water closet downstairs, and three bedrooms upstairs. Spartan living conditions by middle-class standards, this house represented better housing than most workers could ever hope to attain in their lifetimes. In fact, a pamphlet detailing the plans for the house sold for 25 cents and was in such demand that by mid-July a second edition became necessary. An artifically constituted family of five lived in the house during the month of July: a World's Columbian Exposition guard who slept in the nearby barracks and ate all meals at the house served as the husband; an Irish widow with three children lived full-time in the house. All the objects in the home, including clothing, revealed price tags. Moreover, a strict budget for nutritional foods was maintained throughout the month. As a didactic exhibit, the working-class family enacted the role of intelligent consumer, demonstrating that if workers only adopted the middle-class characteristics of thrift and economy, a $500 per year salary would satisfy all domestic needs.[49]

The final report of the Board recorded the "remarkable circumstances" under which the family lived during the month: "All the housework for a family of five persons, cooking, washing and ironing, etc., was necessarily carried on in the presence of from 500 to 2,000 persons daily. This was a strain to which [the Irish woman] was not accustomed. . . ."[50] This exhibition of an industrious, thrifty, and efficient working-class family reproduced the values of middle-class Americans, yet simultaneously functioned to distance middle-class visitors from the lives of working-class families. Constructed as an ideal type, this family served more the ideological needs of its middle-class spectators than the educational mission directed at workers. It sought both to preserve class stratification and to reassure fair visitors that workers could indeed assimilate middle-class moral standards and live an orderly life.[51]

Many reformers demonstrated a concern for improved housing conditions for workers. The Model Tenement Movement, for example, headed by a wealthy resident of Brooklyn, Alfred T. White, brought to the attention of the "intelligent and wealthy" the problem of housing for the workingman. Armed with the belief that the lack of such virtues as frugality, industriousness, and temperateness in the working classes caused their poverty and terrible living conditions, reformers hoped to elevate the worker's moral character by aiding him in achieving comfortable housing in decent surroundings. Thus, the Model Tenement Movement, as well as the Model Workingman's Home, served as evidence that the capitalist could both erect

decent homes for the poor *and* receive a reasonable return on his investment. Viewed through the eyes of these wealthy industrialists, capitalism provided the solution to the housing problem, rather than its cause.[52]

George Pullman, a major investor in the World's Columbian Exposition and luxury sleeping car magnate, built his model city Pullman to address housing problems caused by Chicago's industrialization. Constructing the town in 1880, Pullman hoped to produce an ideal environment that would attract and retain a superior type of worker to the railway car industry. Pullman inhabitants were expected to embody middle-class values of thrift, industry, and morality. They were taught to develop such "habits of respectability" as propriety and good manners, cleanliness and neatness of appearance, diligence and sobriety, and self-improvement through education and savings. Like the brick clock tower that dominated the town center, Pullman kept a regulatory eye on his workers, banning saloons from his town, for example, in order to keep his workers free of union organizers. Believing his workers to be less susceptible to the exhortations of labor agitators than the demoralized inhabitants of Chicago slums, he proclaimed "the building of Pullman is very likely to be the beginning of a new era for labor."[53]

In its first five years, this new experiment in industrial life received little criticism, except from radical political groups, such as the Chicago anarchists. Credited with producing a new type of dependable and ambitious worker in a rationally ordered environment, reformers, at first, praised Pullman as a successful model for modern industrial life. After 1885, with the high gloss of the experiment dulled, it became clear that the residents of Pullman had honest grievances: overcharging for rent, utilities, and commodities, and the deliberate interference with the private lives of town residents through surveillance by company "spotters."[54]

In 1893, the town of Pullman became a popular tourist stop, attracting more than its share of curious travelers – 10,000 foreign visitors alone during the exposition year. In fact, the first Baedeker guide to America, published in anticipation of fair tourism, advised visitors to tour Pullman. Frequent trains and trolleys connected the fairgrounds with the town, and on several occasions, George Pullman himself conducted guided tours. Constructing a fantastic environment for the benefit of tourists, he made sure that any real tensions between his office and the working inhabitants of the town were rendered invisible to the touristic gaze.[55] As James Gilbert has asserted:

to the parade of visitors who viewed the town in 1893, it must have appeared to be a comfortable and familiar prospect in which middle-class values and American traditions existed; it bore little evidence of any impact from the huge immigrant city around it. Only its population – upon close inspection – was foreign.[56]

Not surprisingly, little information existed about the residents. Visitors to Pullman regularly solicited answers to their questions from company officials, casually dismissing the working residents with a glance or cursory question.[57]

The *New York Sun* chronicled the spectacle of Pullman daily life as experienced by the touring visitor with patronizing disinterest:

After the evening meal the people made their appearance on the streets. They are presentable almost without exception and most of them are surprisingly neat in their dress and circumspect in their manners. The women and children in clothing and deportment present such a striking contrast to the people of their class in the noisy and dirty city that having seen the two modes of life, an observer may be pardoned for doubting that Pullman is made up almost exclusively of mechanics and laborers and their families.[58]

Like the inhabitants of the Model Workingman's Home, the residents of Pullman lived their lives on public display. They were subject to the curious gaze of tourists as well as the trenchant surveillance of company "spotters." Visible to passengers on the Illinois Central Railway, the town – two miles long and a half-mile wide – had as its central features the factory, town square, and Corliss engine that Pullman had purchased from the Centennial Exhibition. To Pullman's visitors, the fine brick housing of the skilled mechanics on the town's main streets signaled respectability, comfort, and safety. Unavailable for public viewing was the southern industrial area where brickworkers and the unskilled lived in shabby wood-frame dwellings. Functioning as a spectacle in which the town's residents enacted the roles of satisfied workers, Pullman appeared much more successful as a model town to tourists – the audience to which this cultural experiment was directed.[59]

George Pullman extolled the benefits of his model town at the World's Columbian Exposition. A large plaster of paris replica of the town – scaled an eighth of an inch to a foot – stood near the entrance to the Transportation Building. An adjoining annex exhibited two tracks of newly minted Pullman cars for lease to anyone who could afford such luxury. With two specially prepared illustrated pamphlets, *The Story of Pullman* and *The Town of Pullman: Its Growth with Brief Accounts of its Industries* that were distributed free of charge, Pullman advertised his planned community to fair visitors.[60] Concerned with the reception of his exhibition, he received daily reports on attendance and on potential business transactions. Despite this elaborate company promotion, Eugene Debs, when speaking at the Labor Congress, foreshadowed the great strike of 1894 by denouncing Pullman and publicizing the struggles of workers for a decent wage.[61]

Union activity had infiltrated Pullman as early as 1884. Anarchist leaders Albert Parsons, Samuel Fielden, and August Spies – banned from speaking in the town proper – addressed a meeting of the International Working People's Association in the adjoining town of Kensington. In the fall of 1885, after a reduction in wages led to strike talk, Parsons again spoke to a large contingent of Pullman workers. In covering this event, *The Tribune* described Parsons as "howl[ing] forth his denunciations of capitalists and monopolists in his usual Lake-front style."[62]

By 1894, with the founding of the American Railway Union, most skilled workers at Pullman had organized. After repeated cutbacks in pay and insufferable surveillance of the town's population, the workers struck on May 11, 1894, followed by a nationwide boycott by members of the American Railway Union. President Grover Cleveland called in federal troops over the protest of Governor Altgeld. Public sympathy resided with the strikers. The long strike ended on July 17 after union president Debs and other strike leaders were indicted for contempt. Pullman, as an ideal industrial environment, collapsed in this tragedy, never to regain its prior fame and recognition.[63] After his release from a six-month prison term, Debs returned to labor activism, holding his first public appearance at *The Haymarket Monument* (Fig. 9)[64]

As touristic spectacles associated with the World's Columbian Exposition, both the Model Workingman's Home and the Pullman experiment defined and codified assumptions and beliefs about the working person. Whether fairgoers were ogling working-class families in the flesh or in white plaster, a variety of discursive practices domesticated the "otherness" or strangeness of their lives. Gelert's *Struggle for Work* participated in this domesticating process by deferring attention from the contemporary political struggles enacted on Chicago city streets. Whether in Haymarket Square or the Chicago Lake-Front, labor protest and militancy served as a force against which fair directors and visitors marshaled all their defenses. They hoped to produce a "White City" freed from the terror of class conflict – a terror that nonetheless haunted middle-class and elite lives both inside and outside the fair's boundaries.

In other regions of the United States, such as the American West, the threat of labor unrest was not nearly as visible. Unlike Chicago, with its well-defined labor communities and history of violent confrontation between police and workers, San Francisco basked in the promise of frontier development. The ideology of Manifest Destiny remained strong in the West, engendering much optimism about technological progress and material reward – an optimism that also informed the representation of the worker. In Douglas Tilden's *Mechanics Fountain,* installed in downtown San Francisco in 1901, brawny skilled laborers, depicted at their drill press, worked in fruitful cooperation with capital (Fig. 27). Buried beneath the complacent surface of this monument, however, were traces of racial tensions and class hierarchies, all inscribed upon the bodies of these working-class men. By the turn of the century, competing definitions of masculinity – informed by issues of race and class – constituted a significant element of labor's identity. The following chapter will investigate this gendered discourse and its unique articulation within visual culture.

THE EROTICS OF THE LABORING BODY

Douglas Tilden's *Mechanics Fountain*

Although rarely read as a producer of meaning, the male body has historically functioned as both the site and nexus of cultural signification. At the turn of the twentieth century, representational strategies – visible in painting and sculpture as well as in magazines, newspapers, and advertisements – attempted to invigorate middle-class notions of masculinity through a focused attention on the bodies of working-class men. In the gendered discourses of physical fitness, the frontier, and labor, the muscular body played a central role in producing contemporary notions of manliness. Thus, middle-class masculinity assumed a variety of guises through association with the valorized bodies of athletes, the disempowered bodies of Native Americans, and the virile bodies of working-class men. This chapter will attempt to unravel the dense layering of meanings signified by the male body in a public monument to labor erected in San Francisco at the turn of the century.

The *Mechanics Fountain* by Douglas Tilden (1860–1935) is located today on the corner of Market, Battery, and Bush streets in downtown San Francisco (Fig. 27). The bronze sculpture rises approximately fifteen feet above a six-and-a-half foot granite base designed by the San Francisco architect Willis Polk. Commissioned in 1896 by the estate of James Mervyn Donahue, the monument serves as a memorial to his father, Peter Donahue, a nineteenth-century San Francisco industrialist.[1] Dedicated in 1901 before a crowd of ten thousand, the sculpture enjoyed such success as to be the focus of a proposed visit by President William McKinley, who, unfortunately, canceled his appearance at the last minute due to illness.[2] The fountain, designed with a circular stone basin forty feet in diameter, originally stood in the midst of a busy intersection. In 1973, the city removed the fountain and waterworks and situated the sculpture back a few feet to create Mechanics Park, an urban beautification project consisting of a triangular plaza with benches and trees.[3]

The sculpture shows five men of varying ages working a punch press. Two mechanics, one quite elderly and the other middle-aged, maneuver an iron plate through the punching machine.[4] Three more youthful apprentices dangle from the lever arm, struggling to activate the punch. All five men are partially nude, dressed only in leather aprons or loincloths. The lever punch stands about twice their size. At its base, two relief medallions of James Mervyn Donahue and Peter Donahue intersect – a generational pairing consistent

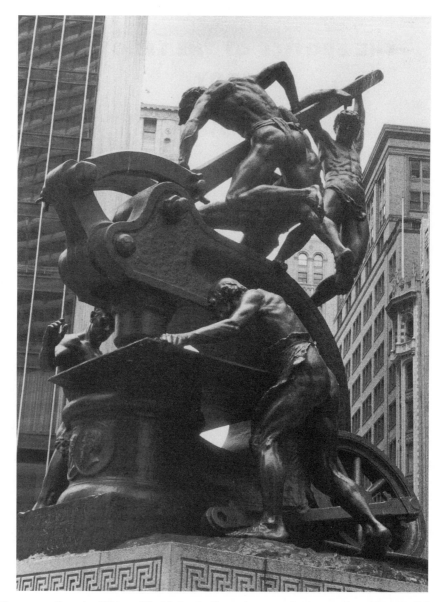

Figure 27. Douglas Tilden, *The Mechanics Fountain,* 1901, bronze and granite, 15½' h. San Francisco.

with the cycle of life suggested by the ages of the five workers (Fig. 28). Under the medallions, the inscription *Labor Omnia Vincit* ("labor conquers all") is marked. At the base of the sculpture surrounding the punch are attributes of industrialism: a locomotive wheel and connecting rod, an anvil, ship's propeller, and a cannon. On the granite pedestal is written: "Dedicated to Mechanics / By James Mervyn Donahue / In Memory of his Father / Peter Donahue." Commenting upon the reception of his sculpture, Douglas Tilden remarked: "the design has been so praised and damned that it would never have passed a

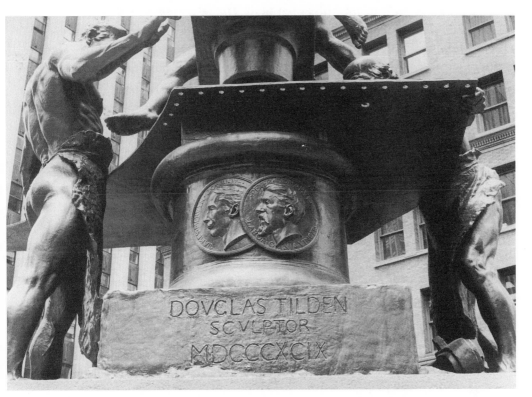

Figure 28. Douglas Tilden, *The Mechanics Fountain*, det., 1901, bronze and granite. San Francisco.

jury of artists or architects educated only along conventional lines."[5] The mixed response to the sculpture testified to its complex cultural meanings – meanings inscribed, in large part, upon the bodies of working-class men.

Douglas Tilden's *Mechanics Fountain* served as a site of several mutually constitutive discourses on labor, masculinity, and the frontier. As a monument to industrial labor commissioned by the son of a West Coast industrialist, it stood as much as a paean to industry as it did to the worker, representing the civilizing effect of progress on the Western wilderness. While heroicizing the skilled craftsman, the sculpture also depicted a working-class hierarchy. The mechanic – the independent skilled workman and moral equivalent in an industrialized era to Jefferson's yeoman farmer – toiled in harmony with the machine. The young apprentices – unskilled and immature – powered the machine with their lithe bodies. Eliding contemporary class and ethnic tensions troubling San Francisco, the monument perpetuated the myth of the white male taming the wild frontier.

The monument encoded meanings that were historically and geographically specific. In fact, several critics noted the unique stylistic characteristics of the monument – characteristics that typified its production in the West, far removed from the traditional Eastern centers of academic training. For ex-

ample, Lorado Taft, in his influential book *History of American Sculpture,* described the monument as "bizarre and restless beyond the proper limitations of monumental art," with a "lawless composition and ragged contour." He presented the monument as "the most unconventional work of sculpture in the United States," and one that "could have been done in no other city than San Francisco . . . a historic document, full of significance of time and place."[6] The dangling bodies of the young apprentices produced for the most part the jagged silhouette that Taft described. With their loincloth garb and "restless" demeanor, the apprentices suggested a connection to current stereotypes of the Native American. Thus, in both form and content, the monument helped construct an ideology of the frontier, based in part upon the association of unskilled male workers with the bodies of Native Americans. To this point, we shall return later.

■ ■ ■

Tilden's *Mechanics Fountain* formed part of a civic program that helped assert San Francisco's cultural identity in the 1890s. First settled as a Spanish-Mexican mission, San Francisco de Asis, this tiny port settlement lay in ruins by the time of the American conquest in 1846 during the War with Mexico. The Gold Rush of 1848 brought San Francisco to prominence and fueled its development from a small pioneer outpost to a bustling cosmopolitan urban center. From 1848 to 1880, San Francisco – unchallenged as the leading city of the West – stood at the height of its industrial preeminence with a population far larger than any other Western city. However, by the 1890s, Los Angeles, Portland, and Seattle began to rival this dominance as San Francisco slowed its expansion during the depression of 1893 to 1896. To counter this economic downturn, the business community moved to enhance San Francisco's reputation as a civic and cultural center.[7]

The elites of San Francisco, many of whose families had made their fortunes on the frontier, saw themselves as better educated and more discriminating than their pioneer ancestors and wished to create a more "civilized" urban existence modeled upon Eastern prototypes but also characterized by a Western distinctiveness. With the discovery of gold in the Alaskan Klondike, the annexation of Hawaii, and the troop support required by the Spanish-American War, San Francisco returned to a booming economy after 1896. James D. Phelan, mayor of San Francisco from 1896 to 1901, tapped this prosperity and channeled funds into progressive causes. Among these projects was the beautification of the city through the erection of monumental statuary that would serve as a means of creating a patriotic and civic-minded population while producing an inviting and attractive environment for business enterprises.[8]

Phelan's project to beautify San Francisco formed part of a national tendency toward urban enhancement and reform, typically labeled the City Beau-

tiful Movement. Most influential from the late 1890s to World War I, the movement represented the cultural agenda of the urban middle-class and elite. Based on an aesthetics of beauty, order, and harmony, which some scholars argue had it roots in the design of the World's Columbian Exposition of 1893, the movement hoped to improve urban existence and thereby inculcate both citizens and new immigrants with moral values and civic pride. With James Phelan at its helm, this movement had its most direct impact on San Francisco from the late 1890s to 1910. He believed in its progressive tenets – that urban beauty fostered social harmony while encouraging prosperity and growth. As a self-styled reformer, he promoted the City Beautiful Movement in San Francisco and its social effects – making citizens out of newly arrived residents concerned only with commercial ventures and personal gain. Thus, Phelan commissioned several public monuments of past leaders, men of genius, and fallen heroes that would teach California history and instill patriotism in San Francisco's local inhabitants.[9]

In 1898, Phelan set up a committee to draft a plan for the adornment of San Francisco. As the first California-born sculptor to receive recognition outside the United States, Douglas Tilden was among the nine-member panel of architects, artists, lawyers, and businessmen who served on the committee.[10] Born on May 1, 1860, to pioneer parents, Tilden lost his hearing and ability to speak at age five after suffering a bout of scarlet fever. In 1866, he enrolled in the California School for the Deaf, graduating with honors in 1879. After discovering his interest in sculpture in 1883, he left for New York to study at the National Academy of Design and the Art Students' League from 1887 to 1888. In May 1888, he sailed for Paris, where he lived for six years. Supported by W. E. Brown of the Southern Pacific Railroad Company, Tilden studied with the deaf sculptor Paul Chopin as well as the famous *animalier*, Emmanuel Frémiet (1824–1910), until the economic downturn of 1893 forced his return the following year. In 1894, he took up a teaching career – communicating to students through animated gestures and drawings – at the Mark Hopkins Institute of Art, an affiliate of the University of California.[11]

Actively supporting the arts in San Francisco, Tilden benefited from Phelan's beautification project; he was awarded the commissions for the *Admission's Day Monument*, dedicated in 1897 and standing today on the corner of Market, Post, and Montgomery streets; the *California Volunteers (Spanish-American War Monument)* dedicated in 1902 and now situated on Market and Dolores streets; and a sculpture of *Father Junipero Serra*, the founder of the mission of San Francisco, dedicated in 1907 in Golden Gate Park.[12] The first commission that Tilden received from Mayor Phelan, the *Admission's Day Monument*, originally stood on Market, Turk, and Mason streets. It depicts a miner waving a flag before a tall column on which the genius of California holds a scroll with the date of the state's admission to the union. The miner represented the pioneering spirit of the state, in particular the importance of

the Gold Rush to California history. As such, the monument satisfied the tenets of Phelan's beautification program while serving nativist aims that challenged the dominance of Eastern artistic expression in San Francisco.[13]

With the success of the *Admission's Day Monument,* Tilden won the Donahue commission. At its unveiling, Mayor Phelan accepted the *Mechanics Fountain* as a contribution to the beautification of the city and as a monument to the industrial and manufacturing interests of San Francisco. Dedicated to the memory of Peter Donahue, the monument commemorated his contribution to the development of ironworks, shipbuilding, and railroads in the San Francisco area. Donahue came to San Francisco a pioneer in 1849 and established the Union Iron Works in 1850 near the site of the monument. He was among the first great industrialists of California in the 1860s: He cast the first piece of iron on the West coast in his Union Iron Works; pioneered large-scale shipbuilding in California; produced the first West Coast – made warship, the monitor *Comanche*; founded the San Francisco Gas Works; built the first streetcar; and aided in the development of the California railway systems.[14] As one contemporary journal remarked: "Peter Donahue . . . is perhaps the most important man in the industrial history of the state."[15]

The monumental still life of industrial objects lying about the base of the sculpture signified Donahue's notable achievements. Irving M. Scott, General Manager of the Union Iron Works, praised the sculpture for its commemorative value. He claimed that the monument

shows the whole life of Peter Donahue as plainly as if it were written out before me. There is the anvil at which he first worked, the group of ironworkers illustrating the machine shops in which he laid the foundation of his fortune, the propeller which illustrates the shipping business in which he engaged and lastly the driving wheel and connecting rod, showing his railroad enterprises.[16]

There is little doubt that the great lever punch dominated the sculptural composition. In its original location in the middle of a busy intersection, the silhouette of the machine, rather than the men who worked the lever punch, served as the central focus.[17] In fact, one newspaper article omitted entirely any mention of the workers, commenting solely upon the significance of the machine: "The story of the Union Iron Works and its development is told at a glance by dignifying the great machinery which makes possible the building of battleships."[18]

Nonetheless, Tilden fashioned a fanciful machine that combined certain accurate details of a punch press – such as the lever, fixed pivot, and pivot link – with an unworkable overall design. For example, the connections between the machine parts were inappropriate – cotter pins rather than heavy bolts held the mechanism together. Moreover, most punch presses of the day were steam-driven and operated by a single skilled worker. Clearly, Tilden assembled these quasi-mechanical elements only to suggest a powerful machine rather than to detail a contemporary industrial design, as the ineffective

actions of the young apprentices dangling and swaying from the lever arm attest.[19] He produced this capricious machine, it appears, to facilitate his interest in the concerted effort of the five workers and their unique relationship to the expansion of modern technology in the American West. Moreover, as the workers who operated the machine were all male, the machine itself was coded masculine in the phallic character of the drill punch. Thus, labor, industry, and masculinity formed a conceptual network through which the San Francisco public understood the monument's contemporary significance.

The monument commemorated the union of labor and capital in this prosperous city. Collectively, the portrait busts of the industrialists, the inscription (*Labor Omnia Vincit*), the workers, and punch press produced on idealized vision of capitalism at work. In acknowledging the indispensability of labor to the industrial process, the monument paid homage to the work ethic. Further, it embodied a sanitized notion of industrialization and progress by preserving the ideological construction of manifest destiny that had propelled the harnessing of frontier resources at all costs throughout the nineteenth century.

This sculpture stands as one of the few public monuments that portrays industrial labor in this country. In 1925, Tilden acclaimed, "My *Mechanics* on lower Market Street is the greatest apotheosis to Labor in the world."[20] Having trained in Paris for six years, Tilden was well aware of the interest among European sculptors in labor monuments. Although unique in the conditions of its production, Tilden's monument falls within a sculptural tradition represented by Jules Dalou (1838–1902), Auguste Rodin (1840–1917), and, most notably, Constantin Meunier (1831–1905). As we shall see in Chapter 5, Meunier – well-known in Europe and in the United States from the 1880s onward for his *Monument to Labor* and attendant figures of miners, ironworkers, and other industrial workers – served as an important influence to those American artists concerned with labor themes. Inspired by such figures as the *Crouching Miner* from Meunier's *Monument to Labor* exhibited in Brussels and Paris in the 1880s (Fig. 39), Tilden combined a style of detailed realism with a classically inspired idealism, producing a monument both modern in its appeal yet transcendent in its homage to the dignity of labor, thus distancing the sculpture from any association with current political realities.

With the exception of Johannes Gelert's *Struggle for Work*, which was exhibited at the 1893 World's Columbian Exposition in Chicago (Fig. 21), no other monumental sculpture depicted industrial labor with such detailed realism. Allegory and metaphor typified the representation of labor in late nineteenth-century monuments as evidenced by *The Haymarket Monument*, designed by Albert Weinert and erected in Waldheim (now Forest Home) Cemetery in Forest Park, Illinois, in 1893 (Fig. 29), and *The Apotheosis to Labor*, the sculptural commission for the Pennsylvania State Capitol, sculpted by George Grey Barnard and installed in Harrisburg in 1911 (Figs. 7 and 8). Not until the twentieth century, as we shall see in Chapter 6, was the contem-

porary worker featured as a common theme in American sculpture. Such artists as Mahonri Young, Chester Beach, Abastenia St. Leger Eberle, Charles Oscar Haag, and Adolf Wolff produced small-scale statuary for a newly burgeoning American art market. To be sure, the *Mechanics Fountain* – with its juxtaposition of life-sized figures representing skilled and unskilled labor – contributed a unique visual component to American labor history.

The figure of the mechanic served as the perfect symbol of labor in the western United States, where industrialization was desirable as a sign of progress but had not yet come to dominate modern life. He represented the skilled, independent workman in a state of perpetual grace with industrialism and the machine. As the master craftsman or skilled journeyman in contemporary trades, he inhabited an intermediary position between the independent yeoman of the frontier past and the mostly immigrant proletariat of the industrialized East.[21] In fact, upon graduation from the California School for the Deaf, Tilden had imagined his ideal life as that of a mechanic, a pursuit unavailable to him, however, because of his disability.[22]

Tilden depicted his workers as Caucasian males and thereby alluded to the ethnic harmony that pervaded San Francisco's white working-class community of largely Irish, French, English, Canadian, Swedish, and northern Italian people. To this community, class rather than ethnicity served as the central category of social identity. Asians were the huge exception to this rule, as racial division marked the San Francisco labor force. When a treaty with China removed all immigration restrictions in 1868, young Chinese males – diligent, industrious, and, above all, cheap workers – were lured to this country by labor contractors who paid their passage. They supplanted white workers on major construction sites, most notably the Central Pacific Railroad, and thus caused severe anti-Chinese rioting in 1877 and 1879. After the riots, many markets – such as construction, building, and repairing vessels – installed a "whites only" policy. In 1882, the first Chinese Exclusion Act was enacted. By 1890, San Francisco housed twenty-six thousand Chinese whose wages averaged one-half of those of white workers as they labored mostly in jobs that serviced only the Asian community.[23]

The *Mechanics Fountain* celebrated the white, working-class elite of San Francisco by presenting highly skilled mechanics as participating in an industrializing process that required mental agility and physical prowess. Their exacting work emphasized the centrality of skilled labor to foundries and machine shops, the single largest industry in San Francisco and an industry well protected by strong unions. Moreover, the monument stood in the South Market area, a center for working-class life since the 1850s and the city sector most notable for its metalwork industry, iron and brass foundries, boiler works, and machine shops.[24]

In his monument, Tilden modeled these skilled workers' bodies with care and precision, combining anatomical detail with heroic perfection. The older figure, hunched over the machine as he strained to position accurately the

heavy iron plate, revealed tensed muscles and protruding tendons in his upper torso and lower limbs (Fig. 27). Surprisingly, the middle-aged crafts-man, standing poised to receive the plate, demonstrated little stress in his well-developed physique (Fig. 29). The beauty of these nearly nude, life-sized male bodies invited public scrutiny – the scrutiny, no doubt, of both men and women – despite the monument's location in the midst of a busy intersection. No evidence of responses by women or working-class men exists at the time of the monument's installation.[25] However, there is a substantial record of middle-class men's interest in the sculpture. Thus, this chapter will focus upon this particular effect in terms of the monument's specific cultural resonances in turn-of-the-century San Francisco.

Such skilled labor kept alive traditional notions of manliness, defined in large part by bodily strength that no longer seemed relevant for the profes-sional occupations in which most middle-class men engaged. The bodies of these workers functioned as metaphors or icons, communicating deeply held cultural convictions and values. They were fully displayed for the spectator – muscled limbs and developed physiques signifying virility and power in a spectacle of visual pleasure. In fact, throughout the second half of the nine-teenth century, the body increasingly became the medium that defined mas-culinity – a gendered construction confirmed not in the company of women but of men.[26]

Similarly, the strong bodies of contemporary ironworkers formed the focus of attention in Thomas Anshutz's *Ironworker's Noontime* of ca. 1881 (Fig. 6). Positioned as if on a stage set, these workers placed their exposed arms, shoulders, and upper torsos deliberately on display for middle-class consump-tion. Although most workers appeared relaxed during their noontime break – washing up and quietly chatting, Anschutz painted the central figure flexing his biceps, apparently for the delight of contemporary viewers.[27] In both painting and sculpture of the late nineteenth century, visual representation participated in a discourse that consistently offered the strong bodies of skilled manual workers as visions of manliness to middle-class and elite pa-trons.

As part of the complicated problem of homosocial relationships, the gaze is central to male experience. The visibility of the male body, functioning as a stabilizing rather than a disruptive force, produces an arena in which con-temporary notions of gender are constituted. Within this visual field, a dis-course of power circulates.[28] In the *Mechanics Fountain*, the physical power of the workers' bodies, for example, provides an ideal of psychic identification for the middle-class male viewer. At the same time, the near nakedness of the bronze figures, as opposed to the clothed state of the viewers, suggests a condition of vulnerability – a condition often associated with the representa-tion of bodies of workers and Native Americans, as we shall see.

To be sure, one must resist positing the male spectator into a fixed and stable subject position. As desire was sublimated into the psychic process of

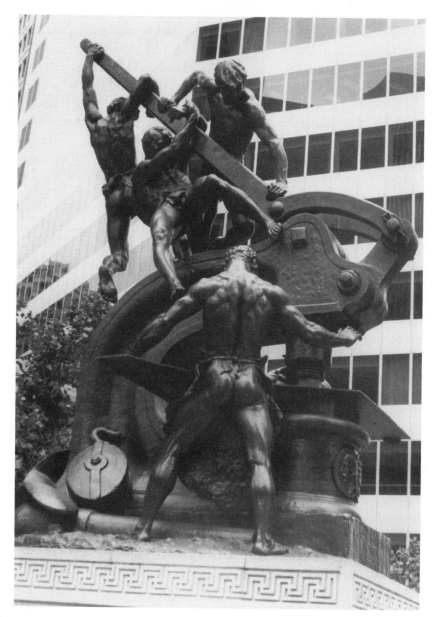

Figure 29. Douglas Tilden, *The Mechanics Fountain*, detail, 1901, bronze and granite, 15½' h. San Francisco.

identification, the middle-class male viewer experienced fears and anxieties arising from that very process of identification.[29] With regard to the viewership of the *Mechanics Fountain*, the bodies of working-class men aroused much excitement in the local press; controversy arose over the public nudity displayed in the monument.[30] As one commentator, Peter McGlynn, noted: the sculpture was "unhealthy for the young minds of San Francisco.... At the same time, I thoroughly approve of Mr. Tilden's design from an artistic

standpoint." Irving Scott, the head of the Union Iron Works, responded: "Why there is not a suggestion of immodesty about it. Anyone who would consider the nude figures of those youths, full of virile strength, immodest would strain at a gnat and swallow a camel. They are no more immodest than some figures of half-nude women that stand on our streets."[31] Thus, as the leather aprons and loincloths of the workers in the *Mechanics Fountain* called attention to that which was hidden, the groin was marked as an area of both male anxiety and pleasure. Through this coded public exchange, it became clear that the representation of the bodies of working-class men engendered confusion regarding the propriety of the homosocial gaze.

As the male body cannot be marked explicitly as the erotic object of another male look in a heterosexual and patriarchal society, eroticism and desire are sublimated beneath a veil of aesthetic disinterest. Although the aesthetics of nudity work to purify nakedness and function as a defense against desire, the erotic and the aesthetic are, in fact, mutually constitutive, thus not so easily separated.[32] Skillfully theorizing the fundamental question of the homosocial gaze, Michael Hatt has recently asserted that the homo-erotic was constructed and managed through the very medium of public sculpture:

The sculpted body of bronze or marble was an essential means of exposing and classifying the male form without at the same time exposing the flesh, its weaknesses and pleasures. Time and again, across numerous discourses, the masculine body is discussed in metaphors of stone and metal, described as hard and inviolable, de-fined as sculpture. While there were still limits to the sculptural representation of the male nude – for example, the penis had to remain hidden and, in general, before the 1880s at least, classical models had to be adhered to – statues were seen to defuse the problem of the erotic. Of course, there is a sense in which it is actually on the body of sculpture that the homoerotic is formed, that male pleasure in a male body becomes a possibility, but as erotic pleasure is given a concrete object, it is defused or displaced by the visual economy of the aesthetic. The impossible object of the homoerotic gaze in nineteenth-century America . . . is constructed and oc-cluded by the interpretable text of sculpture.[33]

The *Mechanics Fountain* is thus embedded in contradiction – as a site that both allows and refutes homosocial desire. These representations of working-class male bodies assured scopic pleasure by providing a model of manliness be-lieved lost to middle-class male viewers. The nearly nude bodies of the sculp-tural figures evoked associations with a mythic past when, it was believed, manual labor defined manliness and masculinity proved untroubled. How-ever, as ethnic homogeneity elided class tensions in the monument, so ele-ments of the aesthetic managed and contained erotic desire. Thus, one con-temporary observer could assert both the sculpture's unhealthiness for young minds *and* its artistic success. In viewing the classed body through an aesthetic lens, desire was erased, or at the very least managed, and identification with this ideal mythic worker was safely concealed in the realm of the imaginary.

At the turn of the century, a particularly acute focus on gender appeared in middle-class newspaper and journal articles, advertisements, and even art criticism, producing a discourse that many scholars have come to label as a "crisis of masculinity." This discursive strategy, with its primary focus on the male body, argued that manliness was no longer an inevitable product of middle-class life and that the ideals of independence, self-reliance, competitiveness and risk taking (essentially mythic constructions of an agrarian frontier) were becoming lost to middle-class men in an industrialized culture. In fact, changes in work patterns did occur among middle-class men between 1870 and 1910 when more sedentary occupations, such as clerical work, sales, and government employment, dominated labor patterns.

Men in the eastern United States addressed this "crisis" in a variety of ways: through an obsession with physical fitness and through a focused interest in frontier mythology. In the years following the Civil War, doctors recommended healthful exercise to their flabby and overweight male patients. Moreover, ministers advocated vigorous play as a means of teaching Christian principles. Under the auspices of the Young Men's Christian Association (YMCA), founded in 1854, for example, Luther H. Gulick (1865–1918) promoted "muscular Christianity" in the 1890s by encouraging men and boys to work out, thus developing self-improvement, health, and "magnificent manliness." James Naismith, a young minister from Canada, put together the essentials of what would become basketball in 1891, and William G. Morgan, the physical director of the YMCA in Holyoke, Massachusetts, invented volleyball in 1895 for older men who found basketball too strenuous. These activities were meant to counter what George Beard, in his 1881 best-selling book, *American Nervousness*, described as the health problem that most haunted middle-class men – neurasthenia, or the "breakdown." He argued that this disease was caused by "brain work" – reading, study, office tasks – that which most occupied the days of many middle-class men. Bombarded with advice from the medical establishment and fitness experts, late nineteenth-century men came to regard the body with ambivalence – an admixture of pride and anxiety.[34]

As late as 1913, George Bellows, in a lithograph entitled *Superior Brains: Business-Men's Class*, poked fun at white middle-class males who succumbed to this fitness craze (Fig. 30). In this image, a variety of male bodies – tall, short, stout, lean – participated in exercises with the hope of attaining a powerful physique commonly associated with athletes. In fact, this satiric graphic, with its emphasis on sport and fitness, was one of the few examples in which the middle-class male body was displayed. For the most part, men's bodies absented themselves from representation except when marked by class (the worker) and race (the Native-American or African-American body).[35]

By the 1880s and 1890s, the athlete came to inhabit a privileged position in middle-class culture and served as an important signifier of the male body. After the Civil War, sports witnessed a boom – a leisure explosion that

Figure 30. George Bellows, *"Superior Brains": The Business Men's Class*, 1913. (*Source: The Masses* 4 [April 1913].)

touched all classes – becoming part of a national culture. As Elliot Gorn explained:

To play sports seemed an archtypically American act, because they were freighted with the values of success, meritocracy, and competition; to root for a team or a champion gave one a sense of having freedom of choice; to acquire knowledge about baseball or football or boxing was to be informed about something distinctly American.[36]

This sports craze, absorbed in part under the notion of the "strenuous life," held a special resonance for the middle and upper classes. Colleges sought to inculcate the managerial ethic of efficiency and cooperation through sports by socializing their male students into the values of teamwork and aggressive competition. The Eastern elite, in particular, dwelled upon a fear of intellectual and emotional impotence in the guise of "overcivilization." Sports became a cure for this dreaded condition. Moreover, sporting activities recalled a lost rural past – a mythic frontier experience that had assured men of their masculinity.[37]

The high-art tradition openly embraced this enthusiasm for sports in the work of such artists as Thomas Eakins (1844–1916), George Bellows (1882–1925), and Douglas Tilden.[38] Thomas Eakins's paintings of athletes, such as *Max Schmitt in a Single Scull* of 1871, represented superbly fit men – their strength and vitality highlighted – who served as models of morality, virtue, and manliness to their Philadelphia middle-class audience. In fact, Eakins himself participated in many sporting activities: He swam in the Schuylkill

River by May 1, rowed with the champion oarsman Max Schmitt (even painted himself into the background of his 1871 painting), hunted plover in Jersey marshes, and regularly bicycled with his colleague Samuel Murray.[39]

Likewise, Douglas Tilden produced sculptures of athletes that provided a definition of the male character for his San Francisco patrons. He wrote in 1891, "It will always be my intention to perpetuate young California manhood in bronze and marble."[40] He felt that he had met a "point of contact" with his viewing audience because he was attuned to the passion for athletics among contemporary youth. *Our National Past-time (The Ball Player)* of 1889 – a gift of W. E. Brown, Tilden's patron, to the Art Commission of Golden Gate Park in 1891 – was installed as part of San Francisco's urban beautification program (Fig. 31). Depicting a young, handsome, athletic ball player in the act of pitching a baseball, the monument commemorated the popularity of baseball, after its introduction to San Francisco by the Cincinnati Red Stockings' visit in 1869.[41] Writing in 1931, Lorado Taft documented Tilden's commitment to athleticism by describing his sculpture as "robust work, with that love of physical strength, of the body for its own sake. . . . It is seldom that our art shows this wholesome athletic tendency."[42]

The Football Players of 1893, a gift of Mayor Phelan to the University of California, Berkeley, commemorated the college mania that football had inspired by 1880 (Fig. 32). Originally played as a combination of soccer and rugby with a round ball and no protective gear, this early form of football – originated at Harvard in 1874 – advocated violence as a means to develop such masculine traits as virility, strength, and endurance in elite, college-aged players.[43]

Tilden's sculpture illustrates the attention to the body required by sports, particularly by the grueling physical punishment of football, as one player kneels and bandages the leg of his standing teammate. Both figures, muscled and fit, produce a composition of interlocking limbs and torsos. The standing youth supports himself by leaning upon his colleague's left shoulder; he lifts his leg over the other's shoulder to rest his foot upon his friend's right thigh. The kneeling youth tenderly wraps the exposed calf. The intertwining of forms suggests the mutual dependency of these two young figures. Moreover, the bandaging process highlights the protective and caring actions of team members toward one another – a recognition of the vulnerabilities of even the fittest of male bodies. This sculpture not only champions the youths who participate in these disciplined and virile activities, but also identifies sports as a privileged site for homosocial displays of affection and desire.

Highlighting the weariness of the body after a boxing match, Tilden's *Tired Boxer* of 1890, the life-sized plaster sculpture now destroyed, depicted a seated figure in boxing shorts and unlaced shoes, reaching for his glove on the ground before him (Fig. 33). His naked upper torso was quite muscular – the individual muscles and sinews clearly apparent – despite the fatigue caused by

Figure 31. Douglas Tilden, *Our National Past-time (The Ball Player)*, 1889, bronze life-size. Golden Gate Park, San Francisco.

participation in such a violent and strenuous sport. With idealized body and aquiline facial features, Tilden modeled the figure with antique precedents in mind, such as the Hellenistic *Seated Boxer*, attributed to Apollonius of ca. 50 B.C. Awarded an Honorable Mention at the World's Columbian Exposition of 1893,[44] the sculpture tapped into the fascination that boxing held for middle - and upper - class men at the end of the century.

Originally the most popular sport among working-class males in antebellum America, bare-knuckle prize fighting was transformed into boxing by the

Figure 32. Douglas Tilden, *Football Players,* 1893, bronze life-size. University of California, Berkeley.

1880s, thus providing a degree of respectability to the sport. In fact, boxing's tawdriness formed part of its appeal to middle-and upper-class men flocking to the ring.[45] Elliot Gorn explained:

A vestige of barbarism, the revitalized sport offered a vicarious thrill of violence. . . . [The new rules] sanitized prize fighting just enough to make it a legal spectator sport, yet not so much that gentlemen at ringside would lose the taste of "real life." The ring continued to call forth images of primitive brutality, of lower-class and ethnic peoples venting their violent passions. But gloves and new rules *appeared* to curb the animality sufficiently to allow a titillating sense of danger inside safe and civilized boundaries. With electrical lighting now available in grand new stadiums, going to a fight no longer seemed an illegal ritual of the underworld but a deliciously wicked after-work recreation.[46]

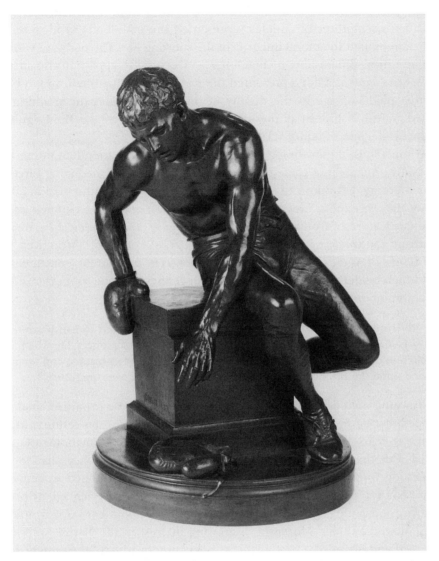

Figure 33. Douglas Tilden, *The Tired Boxer,* 1892, bronze, 29¼"h. The Fine Arts
Museum of San Francisco. Gift of Alice Vincilione and Mary L. Tiscornia, 1991 (55).

In the 1880s and 1890s, Eakins also painted a series of boxing pictures
that continued his interest in sporting and the male body. In *Taking the Count,*
1888, he depicted a referee administering the count to a crouching boxer,
Joe Mack, while his opponent, Charlie McKeever, stood poised and ready for
action. The contrast between formally clad referee and skimpily clad boxer
dominated the image. Eakins painted McKeever fully frontal, wearing only
close-fitting boxing trunks, boots, and socks. In keeping with Eakins's life long
interest in the male nude, these images of athletes invited the admiring
attention of the male audience. Thus, sports acted as a legitimating medium
through which men, whether as spectators at sporting events or viewers of

images of sports heros, took visual pleasure in the scrutiny of the male body.[47]

Tilden's sculptures of athletes represented the male body in ideal terms and championed the moral integrity of the sporting life. The body was central to the ethical dimensions of manliness – a centrality apparent also in the *Mechanics Fountain*. Tilden presented the mechanics with athletic and fit bodies that paid homage to the dignity of manual labor and the tradition of skilled craftsmanship. In all these images, the body served as a fluid signifier in the production of middle-class masculine identities.

By the 1890s, the mythology of the frontier – with its attendant interest in the Native American – came to function as an important mediating force in contemporary definitions of virility. Theodore Roosevelt, influential in advocating the "strenuous life" to his elite colleagues, encoded manliness as an inherent feature of frontier life in such writings as *The Winning of the West* of 1896 and the *Outdoor Pastimes of an American Hunter* of 1906.[48] Moreover, the Boy Scouts of America, founded in 1910, took as its mission the enactment of that which modern life lacked – frontier ruggedness. As one supporter of the organization wrote in 1914:

> The wilderness is gone, the Buckskin Man is gone, the painted Indian has hit the trail over the Great Divide, the hardships and privations of pioneer life which did so much to develop sterling manhood are now but a legend in history, and we must depend upon the Boy Scout Movement to produce the MEN of the future.[49]

Spawning such groups as the Boy Scouts, a "cult of the primitive" had developed among middle-class and elite men at the turn of the century. In response to fears of "overcivilization," these men embraced mythologies associated with the frontier and pioneer past. In some cases, they abandoned civilization for the Eastern woods or Western plains and hoped to cultivate their "natural" masculine strength. In other cases, they experienced the primitive vicariously through literary or visual fantasies about cowboys, frontiersmen, or wild animals. Moreover, a growing interest in the Native American emerged and provided a new mythic construction by which "the savage" had come to embody such masculine traits as virility, toughness, and fearlessness.[50]

The Native American had become a popular subject in painting and sculpture by the end of the century. In most images, the male figures could be identified as Native Americans by their idealized and highly eroticized bodies – fully exposed to the viewer except for the loincloth. In *The Courier du Bois and the Savage*, an 1892 illustration for *Harper's Weekly* by Frederick Remington, for example, a French trapper greets a young Indian male with a handshake (Fig. 34).[51] The opposition of fully clad frontiersman to naked savage posited the racialist divide between nature and its domination. The Native-American male as object of identification and desire inhabited representation at exactly the moment that his power had been completely diminished. Within the discourse of race, desire and domination functioned interdependently.[52]

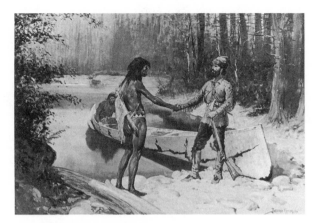

Figure 34. Frederick Remington, *The Courier du Bois and the Savage,* 1892. (*Source: Harper's New Monthly Magazine* 84 [February 1892].)

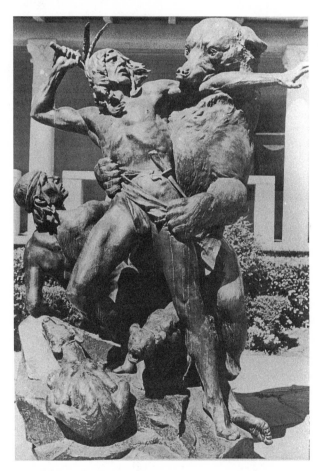

Figure 35. Douglas Tilden, *Bear Hunt,* 1895, bronze, 9' h. Berkeley.

In his nine-foot sculpture *The Bear Hunt,* erected in 1895 at the California School for the Deaf, Douglas Tilden depicted two Native-American men in mortal combat with a bear protecting her cubs (Fig. 35).[53] Consonant with contemporary conventions of representation, a Native-American man stood with body fully displayed, except for the smallest of loincloths; a second male crouched behind to witness the scene. The brave raised his tomahawk in one arm, while the bear bit into his other arm. As if in an intimate embrace, the bear wrapped its forepaws around the Native American, whose muscled torso appeared dwarfed – almost petite – when positioned against the animal's bulk. Clawing at the loincloth, the bear threatened to remove the garment forcibly.

The Native American's posture suggested that of a *gésant* – a conventional pose in which women with arms raised above their heads exposed their vulnerable bodies to male inspection. In this peculiar reversal of gender categories, the strength of the Native-American male was diminished through an association with a feminine aesthetic convention. Moreover, both figures appeared to rehearse a traditional rape scene, as documented by women such sculptures as Giovanni da Bologna's *Rape of the Sabine Woman* of 1583 – (Fig. 36). Like the figure of the Native American, the woman in Giambologna's sculpture had one arm outstretched while her assailant grabbed at her body. A third figure in both sculptures knelt and watched powerlessly, unable to stop the assault. Both compositions conjoined erotic elements with violent actions. In establishing the Native-American male body as aesthetically alluring – associated with the feminine as an object of visual pleasure, Tilden allayed fears of social disruption by containing the power of this virile physique and by maintaining white supremacy through the authority of the gaze.

In fascinating ways, the intersecting myths of masculinity and the frontier were recuperated by a postfrontier West and functioned as a means of providing identity to an elite class of Western men. Douglas Tilden's *Mechanics Fountain* participated in this mythic regime. As the bodies of the mature mechanics resembled the athletic torso, the lithe and limber bodies of the younger workers clad in simple loincloths brought to mind the representations of Native-American males, whose scantily clad bodies were commonly paraded before white audiences. In a revealing comment, Lorado Taft described the apprentices in terms often reserved for Native Americans: "The figures suspended upon the arm of the lever have the improbability and zest of demons."[54]

The young apprentices appear like monkeys (or savages) dangling from the punch press. They descend in age and size along the axis of the lever. The youngest and smallest is fully suspended from the lever arm; one foot barely rests upon the machine and the other hangs in the air. The central figure plants both feet firmly against the machine to brace himself as he pulls against the lever. The third figure pushes down forcefully on the lever with the full weight of his body. The three figures form a coherent unit – over-

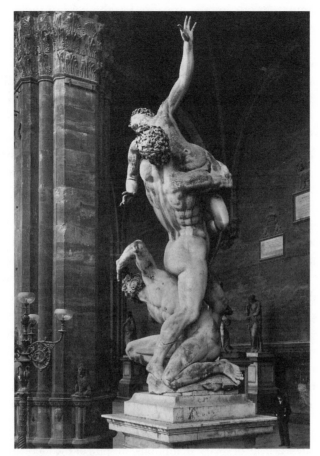

Figure 36. Giovanni da Bologna, *The Rape of the Sabine Woman,* 1583, 13' 6" h. Loggia dei Lanzi, Florence. (*Source:* Alinari/Art Resource, New York.)

lapping and touching each other – while engaged in this strenuous, yet seemingly ineffective activity. Despite the energy expended, their actions appear inconsequential – unable to budge the arm that activates the machine. The sculptural composition contains the force of these workers' bodies – although virile and strong, they lack efficacy. In associating unskilled workers and Native Americans with disempowerment, this monument participated in constructing a hierarchy of bourgeois interests at the intersection of race and class.

Tilden's *Mechanics Fountain* rehearsed a Darwinian hierarchical schema in both form and content. The unskilled apprentices emulated savages in their energetic yet ineffective activity to the top of the machine. The skilled mechanics, represented with the moral perfection of athletes, inhabited the intermediary zone of the monument – bridging bourgeois and working-class interests. And, finally, the heads of the industrialists, James and Peter Donahue, displayed in the form of interlocking medallions – reminiscent of coins

and the accumulation of capital – appeared at the base of the sculpture (Fig. 28). The disembodied heads of the industrialists asserted intellectual authority over their domain. As the medallions marked the surface of the machine, the dominant compositional element, the monument affirmed the primacy of capital. Labor, in its two-tiered classification signifying both adulation (of the skilled craftsman) and contempt (toward the unskilled worker), assumed diminutive proportions in contrast to the scale of the machine. Thus, the monument reavowed traditional hierarchies of power.

The *Mechanics Fountain* signified a dense interweaving of cultural meanings to its middle-class and elite viewers. In this monument to industrial capitalism, labor and industry served the goal of progress – the development of Western resources. Nonetheless, class codes and hierarchies were displaced in the sign of the male body. The mechanic, virile and heroic, represented an ideal of manliness feared lost to contemporary middle-class men. Through demeanor and dress, the apprentices were semiotically linked with the Native American, thus hinting at racial and class fears. In heroicizing the skilled mechanics – thereby alluding to their complacency – and rendering ineffectual the unskilled apprentices – insuring their social and political powerlessness – this monument served the interests of industry by managing the specter of labor unrest as manifested, for example, in the legacy of the Haymarket affair. Moreover, as a public monument to labor in a postfrontier West, the *Mechanics Fountain* revealed the tensions of a complicated historical moment when viewed critically through the lens of gender. As Rosalind Coward has written:

Somewhere along the line, men have managed to keep out of the glare, escaping from the relentless activity of sexual definitions. In spite of the ideology which would have us believe that women's sexuality is an enigma, it is in reality men's bodies, men's sexuality which is the true "dark continent" of this society.[55]

Rather than reflecting a preexistent historical reality, Douglas Tilden's *Mechanics Fountain* manipulated established conventions of representation to signify contemporary beliefs about the nature of workers and the meaning of work to a middle-class audience. Commissioned by and for white middle-class men, this monument, read as a cultural text, resonated with social and political meaning, fracturing the coherent unity of labor and capital intended by its industrialist patrons. Instead, the monument constructs an image of the worker consonant with existing hierarchies of race and class and makes public the unspoken assumptions of a deeply conflicted postfrontier West.

A MUSEOLOGICAL TRIBUTE TO THE WORK ETHIC

The Constantin Meunier Exhibition

The American worker was foremost on the minds of reformers, legislators, and the American public in the first two decades of the twentieth century. Significantly, within the realm of cultural production, representations of the worker had also attained a position of visibility and prestige. The Belgian artist of laboring themes Constantin Meunier (1831–1905) received much popular acclaim when his exhibition of paintings, drawings, and sculptures traveled to six Eastern and Midwestern industrial cities in 1913 and 1914. Unlike Douglas Tilden's *Mechanics Fountain* in San Francisco – a monument that highlighted the complicated condition of labor in the postfrontier West (fig. 27), Meunier's sculptures, such as *The Crouching Miner* (Fig. 37) from his *Monument to Labor* (Fig. 39), helped assuage widespread fears of industrial unrest by providing a model for the perfect modern worker: productive, efficient, and, above all, submissive. When exhibited in the United States between 1913 and 1914, these sculptural images offered relief from the stereotyped picture of radicalized and militant strikers dominating current political debates.

Meunier's visual imagery reinvigorated Protestant middle-class notions of the work ethic at a time when industrialism had radically altered the traditional nature of labor in the United States. In contrast to the classical and biblical associations of the work ethic that George Grey Barnard expressed in his sculptural program for the Pennsylvania State Capitol in 1911 (Figs. 7 and 8), Meunier produced images of modern industrial workers, stoically resigned to the hardships of their fate. This chapter will analyze the appeal of Meunier's labor imagery for an American middle-class public, and, in so doing, examine the ways in which the perceived meaning of work articulated complex and often conflicting attitudes toward labor and the laboring classes.

Dialogues on the nature of Progressive reform animated the critical and popular reception of Meunier's labor imagery. The reform movement, as historian Daniel T. Rodgers has explained, functioned less as a monolithic entity than as a set of contingent and competing interests. He writes:

Only by discarding the mistaken assumption of a coherent reform movement could one see the progressives' world for what it really was: an era of shifting, ideologically fluid, issue-focused coalitions, all competing for the reshaping of American society.[1]

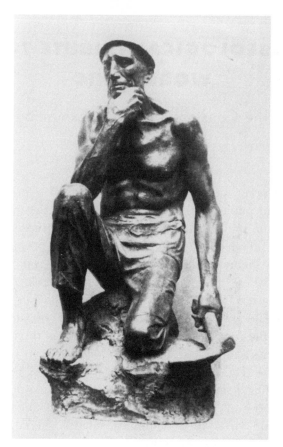

Figure 37. Constantin Meunier, *Crouching Miner,* ca. 1880–90, bronze. (From *The Monument to Labor,* Brussels. Copyright IRPA-KIK, Brussels.)

In this world of shifting ideologies, reform adopted a variety of contradictory guises, from Social Darwinism to Pragmatism and Progressivism. Such competing discourses, as we shall see, formed the ideological basis for the complex meanings ascribed to Meunier's sculpture by a contemporary American middle-class public.

Social Darwinism, for example, asserted that nature dictated a social organization in which the weak failed and the strong prospered. Herbert Spencer, an influential formulator of this social theory, sytematized the study of evolution in fields other than biology. In advocating the doctrine of the "survival of the fittest" (a phrase that he coined), he legitimized the necessity of competition in modern industrial society. Thus, his writings became essential to intellectual, social, and political discourse in the last quarter of the nineteenth century. Accordingly, laissez-faire capitalism flourished; industrialists accumulated great wealth and controlled the economy through monopoly interests; and workers were bound by a natural order to their predestined

fates. Not surprisingly, conservative sensibilities understood reform as a means to uphold a belief in a natural order.[2]

Progressivism, a vague but consistently used term during the period 1900–1917, envisioned society as freed from natural laws and immersed in constantly changing social processes. Such contemporary pragmatists as the philosopher John Dewey, the Supreme Court Justice Oliver Wendell Holmes, and the economist Thorstein Veblen espoused a belief in change, experience, and above all, possibility. For example, Dewey treated ethical questions in his writings as ancillary to the pressing social issues of the day and addressed such concerns as individualism and socialism, business and its regulation, labor relations, and the family. Progressive thinkers, rather than resigned to a predestined order, advocated reform in terms of active change.[3] In surprising ways, the Meunier exhibition satisfied *both* these competing discourses. It represented a Progressive statement in its valorization of the industrial worker at the same time that it reinscribed the fixed social hierarchies of nineteenth-century society. Within this world of conflicting ideals, Meunier's popularity flourished.

■ ■ ■

Confrontations between workers and capitalists had characterized the American labor movement throughout the late nineteenth century, as exemplified, for example, by the Haymarket Tragedy of 1886 outlined in Chapter 2. Yet, industrial strife, or the "labor problem," developed into an even greater political concern during the first two decades of the twentieth century. The unprecedented growth of unions and the proliferation of strikes during this period made labor a primary consideration among politicians, businessmen, reformers – and even, as we shall see, museum directors. From 1897 to 1904, unions grew in numbers and power while the economy boomed and unemployment languished. The number of strikes soared as union demands increased. In response to labor's strength, business launched a massive counter-offensive, establishing conservative organizations such as the National Association of Manufacturers (NAM) in 1903 that strongly opposed unionization and actively promoted non-union shops. Aided by the depression of 1908–9, these business offenses succeeded in halting temporarily labor's political clout. Nonetheless, by 1910, labor was again on the rise, but in increasing conflict with business interests. Such conflict bred intense industrial violence, as seen, for example, in the Ludlow Massacre of 1913, discussed later in this chapter.[4]

The Progressive response to such labor–management conflict found expression as early as 1900 in the National Civic Federation (NCF), which, in promoting a more rational system of industrial relations, hoped to avert the violence that plagued the era. Comprised of industrialists, union leaders, and public representatives, it encouraged responsible conservative unions and

boards of mediation in place of strikes and lockouts. Moreover, it supported a system of welfare capitalism that mandated pensions and medical insurance, as well as lobbied for such reforms as Workmen's Compensation legislation. Essentially, the NCF hoped to create an atmosphere in which labor and capital would function harmoniously.[5]

Despite such attempts at labor–management reconciliation, industrial violence served as one of the most explosive social issues of the day. Popular and reformists journals addressed this issue with solicitude, convinced that America was veering dangerously close to violent social upheaval.[6] Journalists continually employed the term "war" to describe the current state of labor–management relations. Moreover, President William Howard Taft in his State of the Union address on February 2, 1912, warned:

> [if] we continue to assume with easy-going confidence that in each new case, somehow or other, the parties to the dispute will find some solution . . . we leave the situation such that industrial disputes lead inevitably to a state of industrial war.

Having voiced this concern, he asked Congress to form the United States Commission on Industrial Relations (USCIR), a federal commission with the charge of investigating the ever-increasing conflicts between labor and capital.[7]

The commission, although formed under the Taft Administration, was reformulated when Woodrow Wilson took office in 1913. Similarly concerned about the state of industrial relations, he formed a new cabinet post, the Secretary of Labor, in that same year.[8] Wilson supervised the appointments to the U.S. Commission on Industrial Relations, which comprised representatives from labor, business, and the public. Heading the commission was Frank P. Walsh, a Kansas City lawyer committed to social justice.[9]

Among the most alarming of the labor struggles that the Commission investigated was the Colorado Coal Miners' strike of 1913–14. This long dispute typified the worst fears of most Americans – workers and law enforcement agents bathed in blood on the industrial battlefield. "There were several days when there was positive danger of national revolution growing out of this Colorado strike," the Commission wrote in response to a United Mine Workers threat to call a national strike.[10] To be sure, industrial strife had become the principal threat to domestic security.

The miners suffered intolerable conditions. They lived in squalid company housing, were severely underpaid, and were forced to shop in overpriced company stores. When the Colorado Fuel and Iron Company (CFIC), in which the Rockefeller family owned 40 percent of the controlling interest, refused to negotiate any improvements, the miners called a strike in September 1913. On October 28, the National Guard arrived at the strike site, and by November, they began escorting strikebreakers into the mines. At this point, peaceful relations between strikers and the National Guard broke down.

Ludlow, a major tent colony of between 900 and 1,200 strikers and their families, became the scene of the worst violence. On April 20, 1914, the National Guard attacked the tent colony. A battle raged for over twelve hours. Thirty-three men, women, and children were slain and their tents burned to the ground. During the melee, panic-stricken women and children hid in cellars dug under some of the tents. The following day, the charred and mutilated bodies of two women and eleven children were found in one of the cellars. The strike lasted fifteen months, ending in defeat for the strikers. In the USCIR investigation and public hearing, the commission found that the Rockefellers and CFIC were directly responsible for the violence.[11]

The strike received much press coverage, particularly after the "Ludlow Massacre." In particular, the radical Socialist journal *The Masses* followed the event in Colorado very closely with several lengthy articles written by Max Eastman.[12] Artists associated with the journal were also drawn to the horror of the events. John Sloan (1871–1951) produced a powerful graphic, *Ludlow, Colorado*, for the June 1914 cover of *The Masses* (Fig. 38). Sloan depicted a miner defiantly firing a revolver while holding the limp body of a dead child. Against the backdrop of the raging fire, this miner straddled the bodies of a

Figure 38. John Sloan, *Ludlow, Colorado*, 1914. (*Source*: The cover of *The Masses* [June 1914].)

young mother and her infant, determined to defend his right to a decent life. The spikey forms of the engulfing flames and the emaciated and skeletal body of the dead child, centrally positioned, enhanced the expressive content of the image. This searing and provocative graphic urged workers to shed their submissive demeanor and fight back against injustice in these industrial wars.[13]

The Meunier exhibition, with its numerous representations of miners, toured the country in 1913 and 1914, almost exactly coinciding with the Colorado Coal Miners' strike. Such a coincidence of dates is difficult to ignore, although no direct connection between the two events was ever suggested in the critical writing. The show closed in St. Louis amidst a barrage of newspaper coverage of the Ludlow tragedy.[14] Meunier's images of miners, however, differed significantly from those of Sloan's. The *Crouching Miner* (Fig. 37), for example, depicted a workman at rest, pickaxe in hand, fatigued, yet determined in his task. The horrors of the Colorado strike were distant from this representation of a calm and diligent miner. Indeed, Meunier's imagery held a great appeal to an American public weary of industrial strife.

In sanctifying modern industrial labor, Meunier produced images of an ideal worker that resonated with contemporary cultural mores. Like the monumental figures by Douglas Tilden, Meunier's sculpture participated in a discourse that centered upon masculinity and the male body. He represented his worker's anatomy with detailed accuracy – every vein, muscle, and sinew apparent. In his *Crouching Miner*, for example, Meunier exposed the upper torso and bare feet of the worker. Grasping the pickaxe, the sculptural figure flaunted his flexed biceps and modeled the lean and fit physique desired by many middle-class men whose sedate and office-bound jobs denied them the rewards of such physical activity. As one contemporary newspaper review put it, Meunier's sculpture "is designated as the expresser of male energy."[15]

"Meunier has glorified and idealized manual labor," wrote one Chicago newspaper. In a similar commentary to one produced for Tilden's *Mechanics Fountain* (Fig. 27), for which Meunier's sculptures served as prototypes, the Chicago article marveled that Meunier's figures were "brawny [and] Indian-like . . . a study of strength and fearlessness and purpose."[16] When viewed within the specific historical conditions of early twentieth-century America, Meunier's sculptures, although produced for a European market, encoded a set of beliefs that linked the American working-class male to Native-American culture – all in the service of producing a powerful definition of contemporary masculinity. Indeed, in the care and attention that Meunier paid to the representation of the worker, he inadvertently contributed to a visual culture that exalted notions of American middle-class manhood through an association with diligent, strong, yet acquiescent workers.

Constantin Meunier rose to public prominence in Europe in the 1880s as one of the primary spokesmen in the visual arts for the working classes. Trained at an early age as a sculptor, he quickly tired of the academic restraint

of the medium and turned to painting where he pursued his interest in developing a realist style. He studied with the famed Belgian painter of peasant scenes Charles de Groux (1826–70) and admired the work of such realist artists as Gustav Courbet (1819–77), Jean-François Millet (1814–75), and Adolph Menzel (1951–1905), thus fashioning an art that expressed a pronounced sympathy for the working classes. In the late 1870s, after receiving a commission to furnish several illustrations for *La Belgique,* a book by the prominent realist author Camille Lemmonier, he first confronted the realities of contemporary workers' lives and resolved to represent as truthfully as possible their industrial toil in his art.[17] He lived and traveled in the Borinage district (mining region) of Belgium: at Liège, Charleroi, Mons, Frameries, and Pâturages; he also lived and worked at Val Saint-Lambert among the glassblowers and later among the foundrymen and puddlers of Seraing.[18] In the 1880s, he returned to sculpture explaining, "While walking, one day, on the great pier of Antwerp I was struck by the model silhouette of one of the burden-bearers from the ships. Only sculpture, I then realized, could properly express my ideas and impressions."[19] As a sculptor and a painter, he addressed laboring themes, culminating his career with the *Monument to Labor,* unfinished at his death (Fig. 39). As one critic acclaimed, "There is no phase of industrial activity with which he did not evince first-hand familiarity. He was in every sense of the word master of his material."[20]

He witnessed not only the toil of these workers, but their meager domestic existence, as well as their all-too-frequent tragic deaths. While in the mines at La Boule, Frameries-les-Mons, he observed a scene that profoundly marked his life – the mourning of a mother over the death of her young son. In his sculpture, *The Fire Damp* of 1888–9, Meunier translated the tragedy of this

Figure 39. Constantin Meunier, *Monument to Labor,* ca. 1897–1902. Preliminary version, no longer extant. (*Source:* J. A. Schmoll gen. Eisenwerth, "Denkmaler der Arbeit – Entwurfe und Planungen," in *Denkmaler im 19. Jahrhundert Deutung und Kritik,* Hans-Ernst Mittag and Volker Plagemann, eds. Munich: Prestel-Verlag, 1972, p. 448.)

mine disaster into bronze, representing the sorrow of this mother as she bent over the emaciated body of her dead son (Fig. 40). A spiritual man, he recalled images of the deepest pathos in Christian art, such as the *Lamentation* by Giotto of 1305–6 in the Arena Chapel, Padua.[21] Meunier's image made reference to the expressively elongated body of Christ as well as to the humbled, reverential postures of the mourners. While documenting the horror of the life of the mines, Meunier soothed the grief of these miners with a profound belief in the Christian spirit.

Intensive agitation by workers throughout Europe provided the context within which Meunier produced his images of workers, first shown in Paris and Brussels in 1880. He was friends with the leaders of the newly formed Belgian Labor Party (1885) – a socialist political party to which he may have belonged. Moreover, he was sympathetic to the workers' political aims during the general strikes of 1886.[22] His close friend, Lemmonier, introduced him to the works of Peter Kropotkin, an influential Russian anarchist, who often wrote about the social responsibilities of art.[23] Kropotkin argued that art must be part of life in an ideal anarchist society, and that artists could not remain neutral in the struggle for humanity and justice. In 1885 in his *Paroles d'un Revolté,* he directed an appeal to artists, poets, and musicians for socially relevant art: "Narrate for us in your vivid style or in your fervent pictures the titanic struggle of the masses against their oppressors; inflame young hearts with the beautiful breath of revolution." He urged them to "show the people the ugliness of contemporary life" and "the ignominies of the existing social order."[24]

Although sympathetic to the working classes, Meunier never considered himself a revolutionary. Concerning his *Monument to Labor* (Fig. 39), he explained:

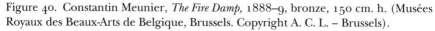

Figure 40. Constantin Meunier, *The Fire Damp*, 1888–9, bronze, 150 cm. h. (Musées Royaux des Beaux-Arts de Belgique, Brussels. Copyright A. C. L. – Brussels).

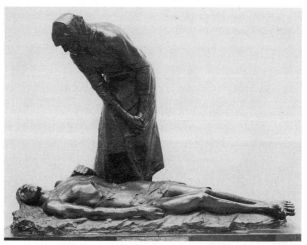

The idea incorporated in this monument is not a complaint against work – not the effort of the overburdened, overworked, and destroyed worker. It is to the contrary, work which is lived. The grand figure of the triumphant sower gives the crowning notion to the work: walking proudly with a rhythmic step, he has in his look the assurance that the grain, which must be sown, will not be without yield.[25]

Atop this monument to contemporary labor, Meunier placed *The Sower* of 1898, who with a triumphant gesture sowed the grain to nourish the generations of the future (Fig. 41). To Meunier, the sculpture stood as a symbol of the productiveness of work.[26] In acknowledging the importance of labor, Meunier considered his workers fully integrated and productive members of society, eschewing any philosophy of class conflict or social revolution.

Nonetheless, European socialists and anarchists as well as their conservative opponents often perceived his work as revolutionary.[27] In fact, Maximilien Luce (1851–1941), a noted French anarchist artist in the Neo-Impressionist

Figure 41. Constantin Meunier, *The Sower,* ca. 1880–90, bronze. (From *The Monument to Labor,* Brussels. Copyright IRPA-KIK, Brussels.)

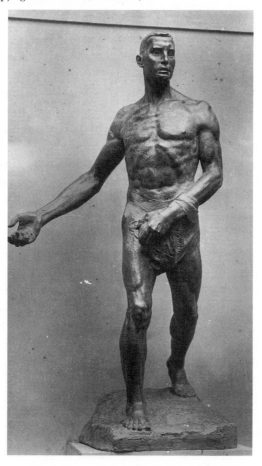

circle who in 1880 had also spent several months in the mining district near Charleroi, drew a series of sketches after the work of Meunier that appeared in the French socialist weeky, *La Sociale.* His drawing, which carefully reproduced Meunier's *Tillers of the Soil,* a bronze relief of 1892, appeared on the front cover of the March 26, 1896, issue (Fig. 42).[28] This image, in contradistinction to *The Sower,* represented the difficult task of cultivating the earth – heads bowed and bodies strained – alluding to workers as human beasts of burden at their daily chores.

As late as 1913, European critics continued to perceive a strong socialist vision in Meunier's work. *Der Strom,* a Viennese socialist monthly, interpreted his sculpture in a revolutionary light:

There [in the Belgian coal mines] it was borne in upon him that the spirit of our day is based not upon renunciation but upon resistance; not upon resignation but upon strength; not upon prayer but upon will-power; not upon historic dogma but upon social criticism, upon steeled muscles of body and mind.[29]

To certain Europeans, these works represented an intolerance to labor conditions as they existed, signaling resistance and revolution rather than conciliation and acquiescence. The dominant response to Meunier's work was quite different when shown in the United States in 1913–14. Understood within the complex web of Progressive era ideology, this art conveyed a message of calm pacifism within a period of extreme labor turbulence.

A major exhibition of sculptures, paintings, and drawings (147 objects in all) by Constantin Meunier toured the United States from November 20, 1913, to May 24, 1914. Organized by Cornelia B. Sage, director of the Albright Art Gallery in Buffalo, the show traveled to five other industrial cities: Pittsburgh, New York, Detroit, Chicago, and St. Louis.[30] "Probably no traveling exhibition of sculpture in recent years has attracted more attention or drawn a wider public appreciation than the exhibit of the bronzes by Constantin Meunier, the Belgian sculptor, who has won fame by his striking portrayals of types of laborers," wrote one contemporary journal.[31]

By most standards, the exhibition was a great success. Attendance was quite high at each venue. According to the *New York Times,* 1,500 people crowded into the galleries in Pittsburgh in the first half hour of the show – the total attendance for the first day topped 4,000 visitors. In New York, 8,000 visited the show in its first five days. Reviewing the exhibition in Detroit, one critic commented: "no exhibition has ever aroused so much interest. The appeal of the great Belgian sculptor was so universal as to reveal itself to the most uninitiated in art matters. Men and women from all walks of life came to study it, and it will long be remembered and talked of in this community."[32] Moreover, among those visitors in attendance at the exhibition were workers. Cornelia Sage wrote that "each day groups of workmen come to study and admire the wonderful sculpture" at the Albright Gallery. In describing the Pittsburgh audience, the *New York Times* concurred: "The keenest apprecia-

Figure 42. Maximilien Luce, after Meunier's *Tillers of the Soil* of 1892. (*Source:* The cover of *La Sociale* [March 26, 1896].)

tion has been shown by the men from the mines and factories of Pittsburgh, men who are the very prototypes of the laborers depicted by Meunier."[33] Only William R. French, Director of the Art Institute of Chicago, noted some displeasure with the exhibition: "For myself, I have never cared a great deal about the exhibition, but I judge it is going to be the fashion with the advanced literary critics. Meunier was a great sculptor, but his art is a poor example for youth."[34] French disagreed with critics who wrote, for example, in the *Chicago Art Institute Bulletin* of Meunier's "unusual importance" and great influence on American sculptors. In fact, unlike his brother, Daniel Chester French, he refused to hold Meunier in high regard, regretting his authority over a younger generation of artists.[35]

Among the eighty-seven sculptures that were exhibited, the reliefs from the *Monument to Labor* (Fig. 39), shown in plaster and in one-half their original size, drew much attention. Although the final form of the monument had not been decided upon at Meunier's death, the reliefs, representing a variety of

laboring endeavors, eventually adorned the sides of a large socle that supported the crowning sculpture of *The Sower* (Fig. 41).[36] Four free-standing sculptures were placed to the corners of the monument, among them, *The Crouching Miner* (Fig. 37). The high reliefs in the exhibition depicted: *Industry*, 1893–4 (Fig. 43); *The Harvest*, 1894–8; *The Port*, 1902; and *The Mine*, 1905 (Fig. 44).

The detail with which Meunier depicted contemporary industrial work impressed his American audience. In comparing Meunier's *oeuvre* to earlier nineteenth-century labor imagery, the art historian and critic Christian Brinton argued that Meunier's representations were more modern, more in keeping with the experience of contemporary workers. He wrote that such works as Courbet's *Stonebreakers* of 1849, for example, were

> not sharply individualized. There was still something theoretical about them; the idea still loomed larger than the fact behind it. . . . [W]ork was . . . an episode rather than an experience, a chance text rather than a permanent condition. . . . It was not, indeed, until the rise of modern industrialism, not until [the laborers] had gained unity and organization that these serfs of civilization captured the citadel of art.[37]

In this passage, Brinton suggested that as labor grew in power and organization, its relevance to contemporary artistic expression became more pronounced. Similarly, a writer for *The Nation* perceived the significance of Meunier's imagery as a means by which an industrial society, such as the United States, defined itself. "Such art had especially a function in helping a working age adjust itself to its newer conditions."[38] Meunier's sculptures were accessible not only to those who visited the exhibition, but also to large numbers of people who read popular journals, such as *The Craftsman, Literary Digest, The Survey*, and *Scribners' Magazine*, in which these works were widely reproduced.[39] When viewed by such a large public audience, this visual imagery actively functioned to construct a new model of the industrial worker – a model in keeping with American middle-class interests.

Meunier had defined a new aesthetic, one closely wedded to the experience of modern industrialism. His art presented a visual conception of the worker which appealed to a varied audience, one outside the realm of the traditional American art world. In a preface to a lengthy article on the exhibition, the editor of *The Independent* wrote:

> With the usual and conventional art exhibitions *The Independent* does not greatly concern itself. But now and then a collection of paintings and sculptures is shown which represents definitely creative work: work with a new spirit and a challenging meaning . . . such is the . . . sculpture of Constantin Meunier.

The author of this same article, Ada Rainey, continued:

> The modern note of industrialism and labor had invaded the realm of art. No longer is it possible to say that art is divorced from life – from the throbbing,

Figure 43. Constantin Meunier, *Industry*, 1893–4. Bronze relief from *The Monument to Labor* in one-half scale (drawn from the plaster relief that circulated in the 1913–14 Meunier exhibition in the United States). In the collection of the City of Brussels. Copyright IRPA-KIK, Brussels.

seething life of the laborer in the mines, of the toiler at the forge and the harvester in the fields. An interpreter has arisen who makes beautiful the toil of the laborer who bears the brunt of the unlovely work of the world. . . . Meunier's strong figures have proven that art can flourish in an industrial community. Art has become democratic, popular in the broadest meaning of the word.[40]

This democratic appeal served Progressive interests. Meunier's imagery recalled values that engaged contemporary middle-class and elite Americans: It recorded productivity as a function of the work ethic morality and it paid homage to industrialization and the modern worker. However, Meunier's art was also notable for that which it denied and concealed. Although produced at a time of unrest in the European labor community, it failed to record the prevailing tensions that characterized that era. When exhibited in the United States, Meunier's images served not as purveyors of historical truth, but as texts that incorporated specific attitudes and beliefs held by Progressive patrons and critics about labor and the working class.

To be sure, Meunier was praised for his factual documentation of industrial life. For example, John Spargo, the radical reformer and muckraking journalist, understood Meunier's realism as a means of evoking sympathy for the

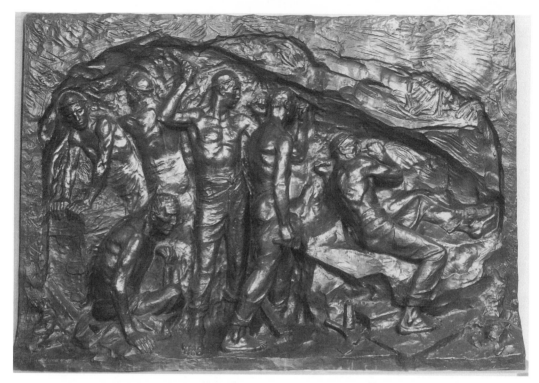

Figure 44. Constantin Meunier, *The Mine,* 1905. Bronze relief from *The Monument to Labor* in one-half scale (drawn from the plaster relief that circulated in the 1913–14 Meunier exhibition in the United States). In the collection of the City of Brussels. Copyright IRPA-KIK, Brussels.

workers when he wrote "the very fidelity to fact of his pictures [as well as his sculptures] becomes a mighty protest."[41] However, his realism must be analyzed with a critical eye. In the relief *Industry,* he presented an image of efficient productivity by skilled workers in the newly modernized glass industry (Fig. 43). With detailed accuracy, this relief depicted glassworkers tending to an emergency, as a team of workers in a dangerous operation extracted a broken melting pot from the blazing furnace. Meunier explained:

The subject of my high relief . . . is a scene in a glass factory. The glass is in a molten condition in great pots of baked clay and is exposed to the strong fire of a high oven. Now it sometimes happens that during the more or less protracted intervals one of the clay pots cracks, letting the molten glass pour out on the floor, and the pot must be repaired without delay. A troop of men kept for this particular purpose come forward with an iron wagon and carry out the pot glowing at white heat. It is a difficult task to perform, as one may realize, if one considers the weight of the pot at white heat. Confusion reigns. There is an infernal stir-up that lasts for some moments and it is this that I have tried to reproduce.[42]

The head craftsman, at the center of the relief, attired in a cap, directed the operation. The workers, varing in age and temperament, responded to the

call from throughout the foundry, some still barefoot from treading to extract air bubbles in the clay bin. The increasing mechanization of the industry in the early twentieth century, as represented by the scorching heat of the newly developed blast furnace, began to replace the specific skills of the blowers, gatherers, flatteners – the individual skilled glassworkers. Despite this de-skilling process, Meunier's relief captured the heroicism of the skilled labor-ers working in harmony with the new industrialism.[43]

In another relief from the *Monument to Labor, The Mine* (Fig. 44), Meunier represented the variety of chores required by a team of miners. The lead collier attacked the mine face, nearly prone while wedged between wall and ceiling to wrest the coal from the wall. Other miners worked the walls of the shaft, while the young boy in the background loaded the haulage cart for delivery to the counter. A tired, aged figure rested in the foreground. Corne-lia Sage, the organizer of the exhibition, described this figure's demeanor with a mixture of compassion and disdain – a conflicted attitude characteristic of Progressive reformers, as we shall shortly see:

While his comrades seek and attack the vein, one of the miners – an old man – is seated resting with a bowed head and one does not know from the lack of expression in his fixed eyes whether he is simply dreaming or in the stupid torpor of an animal relaxing from overwork. . . .[44]

This relief depicted all ages; labor defined the lives and claimed the vitality of these workers from youth until death. As in the relief *Industry,* efficient pro-ductivity – at all costs – distinguished the laboring process in these images.

Meunier's workers – diligent, efficient, and productive – communicated an American middle-class conception of the work ethic. Such a notion did not escape the attention of the critical press, as the *New York Times* reported:

The dignity of labor is an ideal that has met with much consideration among us and Meunier's thoughtful, deeply sympathetic and unsentimental presentation of labor-ers and artisans at their concrete tasks hardly can fail to impress its sincerity upon the American public.[45]

Similarly, *The Chicago Sunday Tribune* cast Meunier's workers as the visual equivalent of modern industrial titans – America's manly workers:

Reflected in these stalwart, these honest and uncomplaining figures is the spirit of the typically American man. Here in this country, of all places on the civilized globe, the message of Meunier should be understood and appreciated. For the message is the glorification of toil, the honest portrayal of the dignity and grace of work, of its force and power and possibilities, hidden though it is beneath an exterior of pres-sure and distress. . . . [Meunier's] work is the epic of modern industrialism. He is the apostle of labor.[46]

Of underlying importance to an American middle-class audience was Meu-nier's glorification of the work ethic in spite of the stresses of industrial life.

As industrial work robbed laborers of autonomy in the workplace and pride in craftsmanship, the rhetoric of the nobility of labor attempted to provide the necessary encouragement to potentially disenchanted workers. As our discussion of the sculptural commission for the Pennsylvania State Capitol confirmed in Chapter 1, the work ethic morality maintained a strong voice in industrial America despite the contradictions between work pride and practical alienation. Thus, regardless of the reorganization of the workplace, Meunier's *Industry* relief (Fig. 43) represented the smooth adaptation of workers to modern industrial operations. And, in the diligence of its colliers, the imagery of the *Mine* relief (fig. 44) was distant from the frightening realities of industrial warfare as had been occurring in the Colorado coal fields.

Although Meunier banished the political realities of labor from his imagery, the fears of industrial strife produced an ideological veil through which some American mainstream critics understood and interpreted his works. While most writers furthered a sympathetic portrait of labor and laborers, one in keeping with the American work ethic, they also tended to reinforce an acceptance of a social structure devoid of class interests. In writing about Meunier's representations of miners, for example, Brinton argued for an heroic view of labor – a view that would counter any revolutionary threat:

while every statue, every bit of bronze or plaster that left his hand bears in some measure its portion of weariness and of pathos, this art is not in essence an appeal or protest. It is a courageous acceptance of existing conditions. These miners are not supplicants, they are conquerors. . . . They rejoice in labor well performed. . . . His art is in a sense a deification of work.[47]

Nonetheless, the threat of social violence was so imminent that it permeated the vocabulary of art criticism despite the rhetoric of acquiescence often associated with Meunier's sculptures. The *Chicago Tribune* warned: "In the nobility of [Meunier's] esthetic philosophy and in the grave beauty of the modeled figures, . . . there is an invigorating joy in life, a renewed pride in labor, and *a lesson to the rebelling and dissatisfied.*"[48] The message of Meunier's art was essentially a conservative one in the United States. His art assuaged middle-class fears of social upheaval while providing an alternative model of heroic submission for the ideal American worker.

Meunier's art gave visual form to the melange of conflicting, and often contradictory, ideas concerning labor that circulated in the first two decades of the twentieth century. To an American middle-class audience, it conflated two competing ideologies concerning labor: a belief in the predestined fate of the worker and a reformest sympathy for the plight of the working class. M. Dumont-Wilden, a European writer quoted in the *New York Times* in 1913, viewed Meunier's work as a conceptualization of the natural social order:

[Meunier's art is] an exact picture of laboring humanity, the splendid presentment of the eternal struggle of man against natural fatalities – that great dolorous drama

which is of all time, but that our times, with their huge industries and congested, overheated centers of work, see, perhaps, under a grander and more terrible aspect than did bygone ages.[49]

This belief in the intractability of the social order – that is, man against nature rather than worker against capitalist boss – had also been clearly apparent in nineteenth-century realist literature as, for example, in Emile Zola's novel *Germinal,* first published in 1885 and often compared in spirit to the work of Meunier. In it, Zola described the spirit of coal miners, particularly his main characters Mahue and Maheude, with a submissiveness often ascribed to industrial workers: "However unjust their sufferings might be," Zola wrote, "when it came to action they both relapsed into the traditional resignation of their race, trembling for the morrow and preferring to bend their necks to the yoke."[50] In the United States, the popularity of Zola's novel continued well into the twentieth century. A film version of the book appeared in 1914 and a serialization of the novel was featured in the *Detroit News* to coincide with the Meunier exhibition.[51]

Moreover, critics frequently compared Meunier's work with that of the ever-popular nineteenth-century realist artist Jean-François Millet. In fact, as an admirer of Millet's *oeuvre,* Meunier must have considered the French artist's famous painting, *The Sower* of 1850 (Fig. 45), as a prototype for his own figure that crowned his *Monument to Labor.* Not surprisingly, much of the critical language that attended Meunier's exhibition of 1913 and 1914 found its sources in the narratives characterizing Millet's peasants nearly forty years earlier in this country. As one critic wrote in 1876:

[Millet's] peasants were always of the orderly and industrial class, never the *vauriens,* the ne'er-do-wells. They may be poor, but they do not therefore complain; there is in them no trace of repining or discontent. They do not consider themselves objects of charity, nor are they conscious of exciting our pity. They are not beggars, and never wear the beggar's livery. [Millet] was not the . . . panegyrist of the poor and the ignorant.[52]

Many American critics interpreted Millet's peasants and Meunier's workers as noble and long-suffering types. To others, however, these representations of workers – although resigned to their hard-working fate as well as to their lowly social position – signaled a threat of social disruption through the signs of class difference.[53]

Conflicting notions of the worker infused the thinking of many twentieth-century Progressives, including the elite patrons of Meunier's work. Cornelia Bentley Sage (1876–1936), the organizer of the Meunier exhibition, was one of many prominent figures who demonstrated great interest in Meunier's work. Born into a privileged American family and schooled at the most elite private academies, she was one of the few women to rise to a position of distinction and authority as director of a major museum in this period.[54] As director of the Albright Art Gallery from 1910 to 1925, she single-handedly

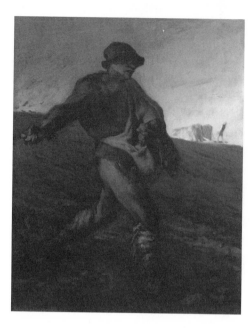

Figure 45. Jean-François Millet, *The Sower,* 1849, oil on canvas, 40" ×32½". Museum of Fine Arts, Boston. Gift of Quincy Adams Shaw through Quincy A. Shaw, Jr., and Mrs. Marian Shaw Houghton. (Courtesy of the Museum of Fine Arts, Boston.)

accomplished the daunting task of curating and traveling the extensive show of Meunier's *oeuvre* in this country. In writing to Edward Jackson, a state representative to the New York Assembly Chamber and proponent of a proposed Workmen's Compensation Bill, she acknowledged her dedication to the cause of labor:

> In securing this great exhibition for our own city, I not only selected what I thought to be art of the highest standard, those of Constantin Meunier, but I also chose the artist who worked in honor of labor and the working classes [. . . .] I wished to give this exhibition in honor of labor and trust that you will give me your support in what I am trying to do and to help to bring the people to the gallery to see this wonderful exhibition of the greatest modern sculptor, who is the only one I know in art who glorified labor through the beauty in painting and sculpture.[55]

Despite her seemingly open support for labor, she demonstrated a marked ambivalence toward the working classes. In her critical writing, she put forth a rather unflattering description of contemporary workers. As we have seen in her comments regarding the figure of the aged miner depicted in *The Mine* relief (Fig. 44) – likening his demeanor to the "stupid torpor of an animal," she judged the character of workers by dominant middle-class standards. She pursued this subhuman analogy to the worker in another article:

> [Meunier] tells of [the workers'] nature, how silent they are, how reserved and how courageous. He knows their infinite goodness, their untiring endurance, but at the same time he does not conceal the background of animal impulsion in which grow their virtues. He understands their unbelievable ignorance, their insensibility to all the superior sensations of the mind.[56]

Furthermore, in describing a canvas similar to *Miners* (Fig. 46), she expressed a latent fear of these laboring masses with their brute and savage natures:

Their heavily built bodies are drawn against a sooty sky. In the voluntary silence one feels a hatred not yet awakened, and back of this extreme severity broods already a savage energy. They are like two modern descendants of the prophets and sibyls of the Sistine Chapel, seeming to predict in their melancholy tranquility the danger of time to come. In another of these large canvases [*Puddler Resting* (Fig. 47)] one finds represented a laborer overcome by fatigue; he is seated on the ground, his lips apart, his hands falling in stupid repose. This is a startling and not easily forgotten painting of animal exhaustion.[57]

Indeed, Sage responded with revulsion and trepidation to this visual representation of class difference.

In these paintings, Meunier intended to present a sympathetic rendering of the laborers. In *Miners,* he depicted the workers as if in a solemn procession; they returned home from the mine, silhouetted against the dark industrial landscape that comprised their world. Their shadowed forms dominated the canvas, inviting a personal encounter with the audience. In this way, Meunier acknowledged the dignity and stoicism of their working-class lives.

Figure 46. Constantin Meunier, *The Miners,* n.d. Present location unknown. (*Source: Georg Treu, Constantin Meunier. Dresden: Kunsthandlung von Emil Richter, 1898.*)

Figure 47. Constantin Meunier, *Puddler Resting*, n.d. Present location unknown. (*Source:* Olga D. Nikitiuk, *Constantin Meunier 1831–1905*. Moscow: Iskusstvo, 1974.)

In *Puddler Resting*, the second painting to which Sage referred, the laborer collapsed against the foundry wall, exhausted from his chore. His slumped body, listless arms, and dazed expression served as reminders of the effects of such arduous physical toil upon the worker's health and well-being. From a presentist perspective, Meunier's workers appear too assiduous or too fatigued to rebel. Yet in Sage's perception, the workers, while virtuous and courageous, embodied an animal nature replete with a savage and violent energy – a not-so-subtle allusion to her perceived threat of industrial strife.

Nonetheless, through Sage's promotional endeavors, Meunier's sculpture acquired a wide following among elite patronage at the time. Nicholas Murray Butler (1862–1947), president of Columbia University when the Meunier exhibition was shown in New York, exemplified one type of patron drawn to Meunier's work – a public figure involved in Progressive initiatives while still committed to the existing social order with its unequal distribution of power.[58] As a member of the National Civic Federation, he participated in Progressive attempts to ameliorate the "labor problem." Yet, he persistently denied the problem of class antagonism, believing in equal opportunity for advancement among all classes. In his writings, he claimed: "There are no fixed and definite classes in the United States, and there is no proletariat here."[59]

As an ardent follower of Herbert Spencer, Butler could both justify the prevailing social order and deplore the excesses of the rich in the name of liberalism and morality. In this regard, he developed a strong attraction for Meunier's work. While on a trip to Brussels to 1912, he came in contact with Meunier's sculpture and purchased a bust, *Le Vieux Mineur* (*The Old Miner*), for the Columbia University collection. With its focus on the industrial laborer – more specifically, the diligent yet submissive laborer – Meunier's work appealed to Butler. Thus, in the spirit of progressive reform, Butler was pleased, no doubt, to host the Meunier exhibition at Columbia.[60]

Elite patrons bought a significant number of sculptures during the run of the show.[61] One commentator noted:

It is a curious fact that the work of Meunier, like the work of Millet, is now among the most valued possessions of the collector – in the galleries of the rich and great are found the works of two single-hearted men representing the laboring man at his tasks. One might expect that the millionaire would seek for paintings and sculpture that would show a life akin to his own. Is it not significant that it is not always so – that the call of the land and of work does rest with us after all?[62]

Even scions of the wealthiest families in this country demonstrated an interest in Meunier's sculpture. After viewing the exhibition in Buffalo, George W. Vanderbilt, grandson of Cornelius Vanderbilt and heir to the family fortune, purchased eight of Meunier's sculptures for his palatial home, Biltmore in Asheville, North Carolina.[63] In writing to Christian Brinton about the Vanderbilt purchase, Cornelia Sage exclaimed: George Vanderbilt "is madly enthusiastic over the Meunier collection. . . . He is crazy about the Meuniers and says that if I get such exhibitions as this here in the future, he will come up to every one."[64]

As distant as Meunier's workers' lives were from the privileges of the Vanderbilt empire, these sculptures, nonetheless, held great appeal to many wealthy patrons. Whether prosperous Progressives or wealthy industrialists, elite patrons appreciated Meunier's imagery, constructing an identity for labor suitable to their political and social needs. This fascination with representations of the worker will serve as one focus of the following chapter. Strongly inspired by the *oeuvre* of Constantin Meunier, a younger generation of American artists produced small-scale sculptures of laboring themes for the private market – an art market supported and encouraged by Progressive era elite and middle-class patronage.

Inasmuch as the Progressive audience sympathized with the plight of contemporary workers, it was the acquiescence of Meunier's workers that attracted their attention. His imagery served as a model for middle-class viewers of what the American worker should be. His iconography reassured these viewers of a stable social order despite the severe challenges to political equilibrium that prevailed during these years of violent industrial conflict. While seeming to present a Progressive vision of labor in society, this exhibi-

tion, in fact, served the status quo. Common among many of the reformist tendencies of the Progressive era, what appeared as opposition to the social order, indeed, furthered the stability of existing political, economic, and social conditions. Meunier's representations of workers fulfilled Progressive expectations while satisfying the conservative and stabilizing urges that underpinned this historical era.

THE STOKER, THE RAGPICKER, AND THE STRIKER

American Genre Sculpture in the Progressive Era

Monumental sculpture of laboring themes, as evidenced in the work of Albert Weinert, Johannes Gelert, and Douglas Tilden, addressed a wide audience and served a variety of functions (ideological, cultural, and political) in late nineteenth- and early twentieth-century America. Whether commemorating an event (the Haymarket tragedy) or important local people (the Donoghue family of San Francisco), *The Haymarket Monuments* (Figs. 9 and 10) and the *Mechanics Fountain* (Fig. 27) brought to public attention social histories informed by specific political and economic interests. Didactic in content, the *Struggle for Work* (Fig. 21) and, one could argue, the exhibition of Meunier's sculpture in this country, presented labor in terms of middle-class cultural ideals. In each case, these monuments encoded meanings relevant to specific audiences, unique to various geographical locations, and informed by particular historical conditions. By the turn of the century, a new mode of visual production – small-scale sculpture available for private purchase – proliferated, and with it, the sculptural themes associated with the working classes – the subjects of everyday life recorded in genre sculpture.

A young generation of sculptors, most notably, Mahonri Macintosh Young (1877–1957), Chester Beach (1881–1956), Abastenia St. Leger Eberle (1878–1942), Charles Oscar Haag (1867/8–1933), and Adolf Wolff (1883–1944) gained professional support from the newly formed National Sculpture Society (NSS) and the National Academy of Design, institutions that endorsed the production of monumental statuary while openly promoting the exhibition and sale of small-scale sculpture. Moreover, such commercial ventures, as the Macbeth Gallery, carried a stable of contemporary sculptors whose figures of workers and strikers, immigrants, and street children William Macbeth made available for purchase to a broad middle-class audience.

Circulating successfully within the burgeoning American art market, these sculptures of contemporary urban life appealed to a wide array of patrons. Major public collections such as the Metropolitan Museum of Art, the Newark Museum, and the Worcester Art Museum, as well as wealthy private patrons as Gertrude Vanderbilt Whitney, founder of the Whitney Museum of American Art; Mrs. E. H. Harriman, wife of the railway tycoon; and Adolph Lewisohn, president of the Anaconda Copper Company, purchased sculptures by Beach, Eberle, and Young after viewing them in new and fashionable

contemporary sculpture shows. Middle-class collectors, moreover, served as a group specifically targeted by these new arts organizations in their aim to promote the purchase and exhibition of American sculpture.

Many painters, sculptors, photographers, and graphic artists demonstrated an interest in the urban scene at the start of the twentieth century. Among the sculptors, no unified movement existed – although Young, Beach, and Eberle showed together on several occasions. In fact, a plurality of working-class subjects appeared in these sculptures, conveying a wide range of social concerns, political commitments, and ideological underpinnings. Young and Beach took as their subjects men engaged in manual labor – dignifying and honoring daily toil and evoking the popular belief in an American work ethic as defined in terms of contemporary masculinity (Figs. 51 and 52). Eberle, while participating in a variety of reform movements from suffrage to settlement houses, focused her sculptural attention on the world of working-class women – poor immigrant women toiling at their tasks and young Lower East Side girls working and playing in the city streets (Figs. 55 and 56). Haag and Wolff committed their art to the service of radical politics. Haag represented strikes and labor unions in his sculpture – labor tactics most closely associated with the Industrial Workers of the World (Figs. 60 and 61); and Wolff produced sculptural images philosophically aligned with the political theories of anarchism in the early years of his career (Fig. 64).

The shared tendency that united this group of diverse sculptors was their unmitigated allegiance to the sculptural *oeuvre* of Constantin Meunier, the Belgian sculptor of laboring themes. Each artist looked to Meunier's sculptures as inspiration for his or her own work, interpreting the relevance of his imagery in a variety of ways.[1] Moreover, contemporary critics continually reasserted this formal and iconographic connection in their writings, evoking Meunier's sculpture as the model toward which American sculptors of working-class themes should aspire. As we shall see, Meunier inspired young sculptors to a style of detailed realism that evoked a transcendent content sympathetic to the ideals of the work ethic ideology.

Among the artists most popularly aligned with working-class imagery at the turn of the century were the painters – Robert Henri, John Sloan, Everett Shinn, George Luks, and George Bellows, among others – members and affiliates of the loosely organized group, the Ashcan School. As a coalition, they were often considered "art anarchists," a term with a rich array of cultural meanings. To contemporary art critics, "anarchist" suggested the individuality of expression apparent in these artists' works, particularly their attention to the details of tenement life and common laboring themes.[2] Robert Henri, the charismatic teacher and ostensible leader of this group, proposed that immigrants, the working classes, and especially the children of these folk demonstrated a remarkable vitality, a characteristic lost in the all-too-comfortable lives of the rich. With his training as an artist/reporter for Philadelphia and New York newspapers, he advocated drawing directly from

life on the streets of New York to capture the vibrancy and immediacy of everyday events in quick fluid sketches. Through his attention to the "otherness" of the poor immigrant masses that crowded into New York's Lower East Side, Henri legitimized the introduction of such subject matter into the realm of high art. In keeping with Henri's artistic philosophy, John Sloan, a committed socialist throughout the first two decades of the twentieth century, devoted much of his imagery to depicting with compassion and forthrightness the lives of working-class men and women. His engagement with the leftist magazine *The Masses* and his participation in such political events as the Paterson Strike Pageant, as we shall see, demonstrated his involvement with the radical politics of the day. In turn, these activities informed his sympathetic representations of working people whom he incessantly drew on the streets of New York.

Everett Shinn and George Bellows often included representations of common workers in their images. Although remembered as an artist who painted dance hall damsels, Shinn also worked in the realm of public art, producing a set of murals for the Council Chamber in the City Hall at Trenton, New Jersey. With exacting detail, he depicted the two major industries of the city: steel mills and pottery works. Studying the workers in these industrial sites for six months, Shinn produced an homage to modern labor.[3] George Bellows, in his depictions of New York construction sites, included the ungainly poses of working men shoveling snow, digging ditches, or attending to a backhoe – the common day laborer as an agent of change in the ever-expanding city. With Henri, Sloan, and the sculptor Adolf Wolff, he taught art classes at the Modern School of the Ferrer Center, headquarters of the anarchist Francisco Ferrer Association, where as teachers they encouraged artistic freedom for their students – a freedom of expression often recorded on the streets of New York City.[4] Young, Beach, and Eberle formed a sculptural counterpart to this diverse painting group. Influenced by and, at times, exhibiting with these painters, they produced a plastic form comparable in both subject and style to this new visual expression.

■ ■ ■

Unlike painting, however, the opportunities to exhibit sculpture in the United States in the first decade of the twentieth century were quite scarce. There was almost no room for sculpture at the Fine Arts Society's 57th Street Galleries used by the National Academy of Design.[5] As late as 1905, the *Monumental News,* a journal dedicated to the promotion of sculpture, lamented, "Exhibitions of sculptor's works are so comparatively rare. . . ."[6] In response to this dire predicament, the sculptor Frederick W. Ruckstull and Charles de Kay, art editor of the *New York Times,* founded the National Sculpture Society in 1893, the first organization dedicated solely to the advancement of sculpture. As early as 1895, the society held its first exhibition of American sculpture.[7]

Incorporated in 1896 to promote sculptural production and encourage

the exhibition and sale of the plastic arts, the National Sculpture Society elected John Quincy Adams Ward (1830–1910), the prestigious sculptor of public monuments, to serve as its first president, an office he held from 1893 to 1905. During the last twenty years of his life, Ward dedicated much time to public and private organizations that promoted public art. He was a champion of the City Beautiful Movement and defended the central role that sculpture played in its national program. To that end, he headed the NSS committee that oversaw the sculptural decoration of the Library of Congress Reading Room as well as the building and decorating of the Dewey Arch.[8]

As a tireless advocate for the sculptural arts during his tenure as president, he shored up the organization's ranks by inviting a respectable number of women to become members of the organization. In fact, in 1906, Abastenia St. Leger Eberle was elected to the National Sculpture Society, one of seven women who had been invited to join since 1893.[9] In his welcoming remarks to women elected to the NSS, he noted:

We shall be glad to meet you at the council table of this Society. Enter the race asking no odds. Sex will not handicap you if you are true to your own instincts and feelings. Do that which your woman's mind tells you to do, regardless of what any man has done; there may be subtle phases of art for you, too fine for the coarser range of the masculine sense.[10]

To be sure, the language of sexual difference infused the rhetoric surrounding women's sculptural production. We shall return to this issue shortly.

The National Sculpture Society promoted sculptural production by standardizing procedures for competitions, enhancing the professional status of sculptors, and encouraging commissions for American sculpture in homes, public buildings, parks, and squares. Moreover, it included nonsculptural members in its organization, hoping to close "the gap between art and the great body of the people, not merely the wealthy, or the well-to-do, but the anxious hard working public."[11] The NSS encouraged the commission and purchase of sculptures for both private consumption – home and garden – and for public enjoyment – parks and squares. Through this campaign, small-scale sculpture – either reductions of monumental works or small-scale originals – were brought to the attention of an interested public. As Adeline Adams wrote, "In either case [reduction or original], [the sculpture's] cost is not prohibitive for many of our private citizens as well as for our museums. The cause of art and the delights of possession are advanced side by side."[12]

With the exception of the small-scale plasters by John Rodgers, which graced many mid- and late nineteenth-century bourgeois homes, American sculpture entered the market economy of the nineteenth century slowly.[13] However, by the turn of the century, the consumption of portable sculpture in marble and bronze took its place alongside other modern cultural developments. Indeed, monumental sculptural production in this country had always been dependent upon elite or civic patronage to subsidize the prohib-

itive cost of materials and processes. With the growth of a market for small-scale sculpture, the middle class entered the field of consumption, at times dominating patronage while also influencing and affecting sculptural production by their demands and desires. In fact, in 1912, *Collier's Weekly* ran an article entitled, "A Consumer's View of Sculpture," in which the author critiqued sculpture, identified as a "commodity," in terms of the pleasure it delivered to a "sight-consuming public."[14]

Not surprisingly, with this recent attention to sales and the market arose a fear of commercialism among art world elites – a fear that popular taste would taint the purity of artistic expression. Writing in 1902, the critic Russell Sturgis warned against the aesthetic compromises necessary in the production of small-scale sculpture in order to satisfy a popular demand. However, by 1908, Leila Mechlin surveyed the field of American sculpture and found an "outlook never fairer than it is today." She applauded the goals and aims of the National Sculpture Society – their encouragement of small-scale sculpture "by purchase and praise" – and trusted that "discriminating patronage" would ensure a high level of artistic integrity in sculptural production.[15]

Mechlin wrote these words in her review of the 1908 National Sculpture Society Exhibition held in Baltimore. By the middle of the decade, the NSS was organizing large traveling exhibitions of small-scale sculpture but had difficulty finding adequate exhibition space. In fact, the 1907 exhibition was canceled because the National Academy of Design and the Architectural League had leased the only available gallery space at the Fine Arts Building during the most advantageous months of the year. When the Metropolitan Museum refused to house this show of contemporary American sculpture, all possible exhibition spaces in New York had been exhausted. Gertrude Vanderbilt Whitney pledged her support – but to little avail – in making the exhibition a success. Finally, the NSS procured the Municipal Arts Society in Baltimore for their April 1908 exhibition in which 123 sculptors, Eberle among them, displayed works available for purchase.[16]

In 1909, the NSS organized one of its largest sculpture shows, opening at the Albright Art Gallery in Buffalo under the supervision of Cornelia Sage, one of the chief sponsors of Meunier's sculpture in this country. The exhibition traveled in 1910 to Pittsburgh, Chicago, St. Louis, Worcester (Massachusetts), and Providence.[17] In general, the press reviewed the show favorably. For example, *The Monumental News* wrote:

The collection has attracted remarkable public interest wherever it has appeared. These smaller, decorative, pictorial and sketchy little pieces seem to have more intimate appeal to the public than the larger works. The range of subjects is broader, and the treatment more unconventional than in the strictly "sculptural" or monumental pieces seen at regular exhibits.[18]

Eberle's eight sculptures of working-class subjects appeared quite at home in this exhibition of "more unconventional pieces." As sculpture enjoyed a

wider commodity value, the scope of appropriate subject matter broadened – portraits, genre scenes, and academic nudes all stood side by side in these NSS-sponsored shows.[19]

In the first two decades of its existence, the National Sculpture Society succeeded in furthering the reputation of American sculpture. Helping to produce an environment openly receptive to native sculptural production, the NSS influenced and encouraged, for example, the National Academy of Design – previously negligent toward the plastic arts – to support and award excellence in American sculpture. Within the next two years, Beach, Eberle, and Young all had won the Helen Foster Barnett Prize of $200 for the best sculpture by an artist under 35 who had not previously received an award, presented by the National Academy of Design. After becoming an associate of the NAD in 1908, Chester Beach won the prize in 1909 for his sculpture *The Nymph.* The following year, Eberle received the prize for her *Windy Doorstep* of 1910, a small-scale sculpture of a woman in windblown garments sweeping a step (Fig. 48). In 1911, Mahonri Young earned the prize for his statuette, *Bovet Arthur – A Laborer* of 1904 (Fig. 49). The Academy devoted one entire gallery to sculpture during the 1911 winter exhibition, enlarging the number of sculptures on view to 167 from only 13, for example, in 1905. Moreover, it resolved to increase the number of sculptors elected to its membership in order to demonstrate its growing support of American sculpture.[20]

One of Eberle's most lauded sculptures, *Windy Doorstep,* modeled in Wood-stock, New York, and inspired by the working women who lived in the area, illustrated her commitment to a working-class imagery and a realist style. The sculpture captures an instant in time as suggested by the figure's windblown garments. At the same time, the sculptural forms reveal a carefully arranged composition, constructed out of a beautifully orchestrated series of arcs and diagonals. In the handling of the medium, Eberle produced an active surface in which she made evident the process of modeling in clay. A legacy learned from Rodin, the deliberate tracings of the sculptural process encoded this small-scale sculpture as modern and set it apart from much monumental work displaying a more finished surface. The growing popularity of small-scale sculpture was evident in the Worcester Museum's purchase of *Windy Doorstep* in 1911 from a traveling exhibition of sculpture – an exhibition most likely sponsored by the National Sculpture Society.[21]

Eberle chose to represent a woman hard at work at her domestic chores – her eyes cast downward intently focused on her sweeping. Her hair, covered with a babushka, served as a sign of immigrant status, and her body, thick and robust, signaled her working-class identity. Her rolled-up sleeves revealed a developed musculature with veins and sinews carefully depicted. With detailed accuracy, Eberle modeled the hands and fingers of this woman – hands that were slightly enlarged and that emphasized her strength and her labor. The figure swept with a broom that had been used and reused – the bristles ragged and unkempt as they crept off the pedestal surface into the viewer's

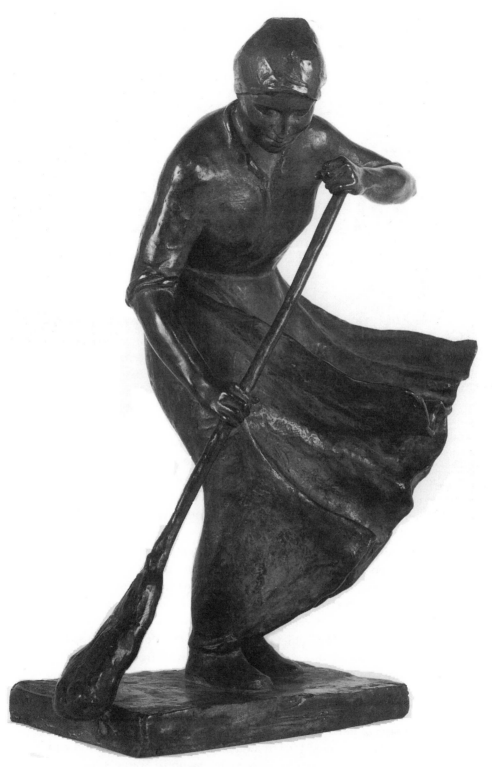

Figure 48. Abastenia St. Leger Eberle, *Windy Doorstep*, 1910, bronze, 13⅝" h. Worcester Art Museum, Worcester, Massachusetts.

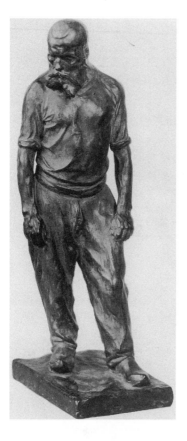

Figure 49. Mahonri M. Young, *Bovet Arthur – A Laborer*, 1904, bronze, 16" h. The Newark Museum, Newark, New Jersey. (*Source:* The Newark Museum/ Art Resource, NY.)

space. Her dress and apron were plain with no ornamental markings. However, the edges of the windblown skirt formed a lovely decorative ruffle in the composition. Labia-shaped when seen from below, this ruffled edge asserted a sign of femininity otherwise lacking in this representation of a working-class woman's body.

Eberle did not depict the petite and fragile body of bourgeois womanhood – a body satirized with good humor, for example, in the sculpture of Ethel Myers (1881–1960). In her *Miss Fifth Avenue* of 1912, a portrait impression of Mrs. Adolphe Lewisohn, the wife of a prosperous industrialist, philanthropist, and art collector, Myers depicted a thin and willowy woman – a figure of elegant proportions – whose chief concern in life entailed stylish display (Fig. 50). She was dressed in the most current fashions – from feathered hat to elaborate muff and buckled shoe; her role as decorative ornament was secured.[22] Unlike Myers' parody of feminine spectacle, Eberle focused attention on her figure's routine labor – a labor made beautiful by the graceful and agile movements of her sweeper's body.

The National Academy of Design awarded the Barnett prize to yet another sculpture with a working-class theme in 1911, Mahonri Young's *Bovet Arthur –*

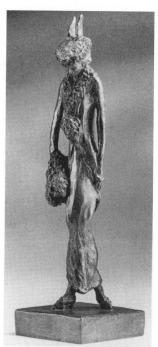

Figure 50. Ethel Myers, *Fifth Avenue Girl (Portrait Impression of Mrs. Adolph Lewisohn)*, 1912, bronze, 8¾" h. Collection of Brenda and Gary Ruttenberg.

A Laborer (Fig. 49). Produced during his second stay in Paris from 1903 to 1905, the statuette represented a frequent model and good friend of the artist. Of upper-middle-class origins, Arthur worked as a boatman in Paris after his family's financial decline, yet continued to frequent museums for his love of art. In this sculpture, Young presented his friend with specifically individuated features, which included a beard and mustache, and in contemporary work garb – the typical thin undershirt and baggy corduroy trousers of Parisian workmen.[23] Standing relaxed in a contrapposto pose, Arthur appeared tired and drained, his shirtsleeves carefully rolled up to reveal finely detailed muscular arms listless after a hard day's work. This representation of an older worker – replete with drooping shoulders, fallen head, and downcast eyes – documented the effects of a lifetime of work. As such, the sculpture stood as an homage to a weary but still dignified life of the laborer.

The Macbeth Gallery, the premier gallery of American art in the first two decades of the twentieth century, served as the commercial enterprise that most supported and promoted the work of Beach, Eberle, and Young. In fact, after the gallery exhibited *Bovet Arthur – A Laborer* in 1914, The Newark Museum purchased the sculpture for its American collection. Hoping to tap into the rapidly expanding market for American art, the Macbeth Gallery, Elizabeth Milroy has explained, "set out to attract the growing number of middle-class professionals to the Galleries, both capitalizing on and guiding their incipient interest in art, while appealing to their desire to decorate their

homes in emulation of their wealthier counterparts."[24] In so doing, the Macbeth Gallery became both financially and aesthetically invested in creating a market for small-scale American sculpture.

By 1907, Beach had had his first exhibition at Macbeth's and Eberle had begun her near twenty-year association with the gallery. In 1908, Macbeth held his first exhibition of small-scale bronzes, showing the work of Eberle, Beach, and Janet Scudder (1873–1940), a sculptor known for her decorative fountains and statuettes of playful children. The review of this show in *The Craftsman* exclaimed that "Mr. Macbeth had brought together some of the very best of our modern bronze sculptors, and to say this is to say, some of the very best sculptors of the modern world."[25]

With this first group show of small-scale sculpture at Macbeth's, two themes dominated the critical literature – themes that Robert Henri had advocated in contemporary painting. In keeping with Henri's interest in capturing the vitality of the lower classes, critics praised the sculptures by Beach and Eberle for their veracity in depicting working-class subjects. One writer described Eberle's work as "carefully studied, truthful and wonderfully modeled low life subjects . . . which she has found for the most part on the lower east side of New York. . . ."[26] In addition, Henri had made nationalism an important issue in the reputation of the Ashcan School. He argued that the National Academy of Design, in refusing to show these painters' work, had not discriminated against mediocrity, but against the artists who were truly American and attempted to represent truly American themes. In this way, he successfully inserted cultural nationalism into the discourse on contemporary art. Thus, one reviewer wrote that Eberle's sculptures of little ghetto children functioned as a "permanent expression of those things which are eventually the great art of a nation." A year later, another critic wrote, "[Eberle] is a fearless, vital worker, and her achievement is good for herself, for art, and for the country."[27] To at least these two *Craftsmen* critics, scenes of working-class life had come to constitute the very definition of a national art.

From 1908 to 1913, Macbeth continued to have yearly sculpture exhibitions at his galleries, showing the work of Eberle and Beach, and later Young in 1914. In 1910, the Macbeth shows were the only regular exhibitions of small-scale sculpture in New York – shows that complemented the traveling exhibitions organized by the National Sculpture Society. By 1912, the Macbeth Gallery expanded to an additional floor for the display of a larger number of paintings and bronzes. In his *Art Notes*, William Macbeth stressed his commitment to the exhibition of contemporary sculpture by writing: "A prominent feature [of the gallery] will be the presenting of work of our best sculptors in a room especially designed for this purpose." Although 1913 saw the last of the annual group exhibitions of small bronzes, such sculptures remained continually on view as part of Macbeth's current installations.[28]

In 1912, the Macbeth Gallery gave Chester Beach a solo show.[29] In his

review, one critic from the *Evening Post* remarked upon the growing popularity of small-scale sculpture to the American public.

An encouraging sign of the times is to be observed in the increasingly liberal interest on the part of both public and dealers in present-day sculpture. Sculpture has always been an act peculiarly difficult in the practical problems of execution, and of presentation to the public, and probably never before in America has the promising young sculptor so readily found his opportunity as to-day.[30]

In this exhibition, Beach showed a number of works, among them his most well-known (and possibly only extant) sculpture of a modern laboring theme, *The Stoker* of 1907 (Fig. 51). This sculpture represented a workman, bending in a tense, almost violent gesture of shoveling coal. His downward-turned face appeared barely visible to the viewer except for his furrowed brow and protruding eyebrows – facial features that indicated the stress of his difficult work. The shovel, with its load extending off the pedestal base, brought the act of laboring well into the viewer's space. Unlike the unique life of a laborer represented in Young's *Bovet Arthur* (Fig. 49), Beach's sculpture focused not upon individual identity and portrait type, but upon the worker as a generic class, typified through the representation of the idealized muscular male body.

This workman, with nude upper torso and broad shoulders, wore only loose-fitting pants and work boots. He manipulated the shovel handle with large hands tightly wrapped around the wooden instrument. Both arms were gigantic in size – the biceps and musculature of the forearms bulging almost to exaggeration. Beach brought attention to the body, an important marker of working-class masculinity, through the careful and precise rendering of anatomical parts, such as the shoulder blades, spinal column, rib cage, and rippled back muscles. However, in so doing, he highlighted his own academic training that exacted a smooth and sleek surface to the human body – a surface quite in contrast to the textural expressiveness of other details, such as the clothing, coal piles, and sculptural ground.

Beach showed *The Stoker* in the last important sculpture exhibit held at the Macbeth Gallery in 1914, "An Exhibition of Sculpture by Chester Beach, Abastenia St. Leger Eberle, and Mahonri Young: The Everyday Life of Common People." William Macbeth featured this special exhibition of thirty-six works by American sculptors in the months immediately following the vastly popular Meunier exhibition at Columbia University, as noted in the previous chapter. In the pamphlet accompanying the show, he argued that these sculptures produced a uniquely American tradition of modern labor imagery:

The call of the masses has been heard by painter and sculptor almost from the beginning of art history. The everyday life of common people has been the inspiration of many a notable canvas and work of sculpture.

The attention of New York has recently been particularly directed toward the

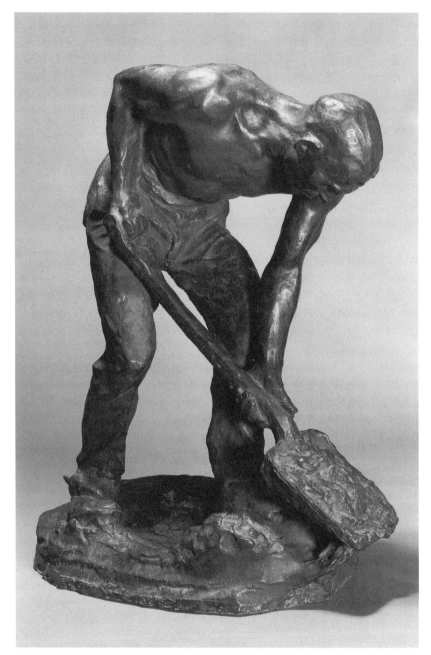

Figure 51. Chester Beach, *The Stoker,* 1907, bronze, 21⅝" h. Brooklyn Museum of Art. Presented by Sam D. Lewisohn (39.116).

plaster presentation of the toilers, through the masterly work of Meunier, exhibited at Columbia University. It is therefore, perhaps, a fitting time to show what our own sculptors have done in the same general direction.

None has accomplished greater results, or more fully caught and interpreted the spirit of the time, than have Chester Beach, Abastenia Eberle and Mahonri Young.

Each of them is thoroughly American, each has felt keenly that phase of life which has most appealed to him; each has something to say. We take pleasure in presenting this exhibition of their work in this field.[31]

This exhibition provided visual proof of the legacy of Constantin Meunier's *oeuvre* to American sculptural history. The touching pathos of many of his working figures, rendered in a style both realistic in attention to contemporary detail yet universalized in its simplified anatomical forms, produced a strong impact on an American public aware of the contemporary social problems of labor, the poor, and immigration. Many dealers, critics, and museum personnel claimed that Beach, Eberle, and Young followed in the spirit of Meunier's powerful sculptural statement. To this influential plastic expression they added a distinctly American flavor – a flavor linked to the gritty urban reality of modern society. Indeed, "reality" and, by extension, "realism" as an artistic style in this country had come to be associated with depictions of the lower classes. In fact, as early as 1904, the prominent novelist, Edith Wharton, had complained to her editor that critics felt her work too unrealistic because her narratives refused to consider the lives of laborers and "charwomen."[32] By the time of his 1913–14 exhibition in this country, Meunier's realist sculpture had come to embody the perfect expression of a modern industrial world. Not surprisingly, Beach and Young were commonly identified with "Meunierism" or singled out as the "American Meunier" in review after review. One critic further explained, "in America we have [Meunier's] counterpart in Mahonri Young . . . who . . . has thrown a new light, a particularly American light upon the same subject."[33]

Young, in fact, paid open homage to Meunier in several of his bronze sculptures. Although never directly copying the Belgian's work, Young took inspiration from Meunier's images of laborers in several instances, most notably in his *Stevedore* of 1904, produced while studying in Paris (Fig. 52). Young's *Stevedore* brought to mind Meunier's *Rock Carrier* in its depiction of a worker in action, trudging up a plank with a heavy sack of coal balanced on his neck and head. Both workers bore the strain of heavy loads, wearing protective head coverings that trailed down their backs. Except for the differences in dress – Meunier's sculpture was barefoot and nude above the waist – both sculptures displayed the act of laboring as their central concern.[34]

Young showed the body of his worker under great strain. His head was bowed and his face barely apparent to the viewer. His facial features were rough and coarse – lumps of clay comprising the drooping face and hollow eyes. The sack that he carried appeared heavy and ponderous, exerting enormous weight on his bowed neck and head. Extending off the base of the sculpture, the plank insinuated the laboring movement into the viewer's space. In a comparison with the work of Meunier, one commentator critiqued the sense of oppressive strain in Young's work.

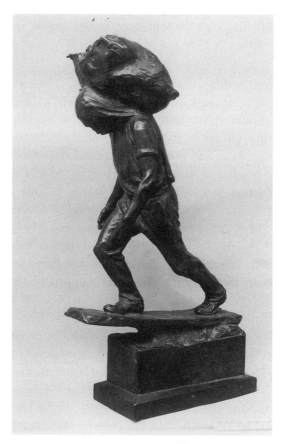

Figure 52. Mahonri M. Young, *Stevedore,* 1904, 15¾" h., bronze. The Metropolitan Museum of Art. Rogers Fund, 1914 (14.27).

Here are the familiar subjects of labor [the *Stevedore* among them], types of workmen not quite equal to their heavy tasks, overburdened, oppressed, their aspect speaking of something more than physical effort to account for their dreariness, their sagging muscles, their emaciated limbs. One would infer from these types that the artist conceiving them saw little hope for labor and identified it with disease, as Meunier, observing the toilers of the Black Lands of Belgium, did.[35]

As this critic noted, a sense of strain and exertion consistently appeared in Young's images of workers. Indeed, Young sought out the body under physical duress, pushed to the limits of human endurance. This insistence upon depicting the body under stress was rooted, as we shall see, in his Mormon upbringing that instilled in him a devotion to the redemptive qualities of the work ethic.

Born in Salt Lake City in 1877, Mahonri Macintosh Young was the grandson of Brigham Young, the Mormon leader. Demonstrating an interest in the visual arts throughout his youth, he moved to New York City in 1899 to attend the Art Students League. By 1901, he had traveled to Paris to study drawing.

After rejecting his training at the Académie Julian with Raoul Verlet during his second year, he worked independently as a sculptor, modeling laborers whom he would see on the streets of Paris. He returned to the States for a short while, then reestablished his residency in Paris in 1903 when he met Bovet Arthur. In 1905, he resumed living in Salt Lake City, moving permanently to New York City five years later.[36]

During the first two decades of his career, from approximately 1904 to 1924, Mahonri Young devoted much of his sculptural accomplishment to the representation of the worker, a theme that resonated with personal and cultural meaning for him. In his sculptures of laboring men, he gave visual form to the moral teachings of the Mormon Church and its advocacy of the work ethic. Moreover, his interest in the worker suggested an effort to impart meaning upon the growing complexities of masculine experience. Young depicted not only the worker, but also cowboys, Native Americans, and prize fighters in his sculptural *oeuvre*. In all four cases, these themes focused upon contemporary images of masculinity – an identity under seige in middle- and upper-class social quarters.[37] To be sure, Young had little interest in the political life of the worker – unions, strikes, fears of unemployment. His images formed part of a middle-class discourse on labor that both championed notions of the work ethic and offered middle-class men a traditional, preindustrial model of masculinity.

Clearly, Young based his visual conception of the worker on a personal vision rather than one inspired by his academic training, as he later explained in 1918:

I have always loved work, all kinds of work. . . . I have never lost this love of labor, and today, if I am tired or worked out, I have only to stop on the streets and watch men, or to go in my shop and watch labor to find myself refreshed and my interest in art revived. My love of work and the worker is not sociological at all; it is a sheer response to an art impulse. I like what workers do; they are the great people to me. . . . The worker is the essential man and I find him tremendously inspiring to art.[38]

With such respect for the significance of work and admiration for the worker, it is not surprising to find that Young had considered producing a monument to labor while studying in Paris. Under the inspiration of such European sculptors as Auguste Rodin, Jules Dalou, and most notably Constantin Meunier, all of whom had planned, in one form or another, monuments to labor during their careers, Young briefly considered the production of a monumental homage to labor, a project that he never implemented. In a drawing for his proposed *Monument to Labor* of 1902–3, he sanctified manual labor by encasing it within a classically inspired architectural setting – giving visual form to the mythic dimensions of the work ethic. Young modeled two sculptures, *The Laborer* and *Tired Out*, or *Fatigue*, both pictured in the drawing, as sculptural centerpieces to this intended monument. To be sure, the body under strain appeared at the heart of his sculptural expression.[39]

As Thomas Toone has pointed out, the significance of strenuosity in Young's sculptural works resulted from his Mormon heritage. Hard work and physical exertion comprised a way of life for the Mormons in their frontier settlement in Utah – a way of life Young appreciated during his youth in Salt Lake City. His grandfather, Brigham Young, preached the work ethic regularly from the pulpit and urged his community to practice it continually in daily life.[40] He often delivered sermons on the virtue of hard work, as he did, for example, in June 1873:

Follow the spirit of improvement and labor. All the capital there is upon the earth is the bone and sinew of working men and women. Were it not for that, the gold and silver and the precious stones would remain in the mountains, upon the plains and in the valleys, and never would be gathered or brought into use. . . . [I]t is the activity and labor of the inhabitants of the earth that brings forth the wealth. Labor builds our meeting houses, temples, court houses, fine halls of music and fine school houses; it is labor that teaches our children, and makes them acquainted with the various branches of education . . . and this enhances the wealth and the glory and the comfort of any people on the earth.[41]

In his fascination with the work ethic, Mahonri Young gave visual form to a central concern of the Mormon church at the same time that he furthered a powerful nationalist ideology – that hard work was the key to American success. In so doing, he both satisfied his need for personal expression and produced sculptures that appealed to a wide American public.[42]

Young exhibited his sculptures of laboring men on a regular basis. For example, he showed his *Man with a Pick* of 1915 in an exhibition of contemporary American sculpture curated by Daniel Chester French at the Metropolitan Museum of Art in March 1918 (Fig. 53). Among the Metropolitan's first forays into exhibiting recent sculpture – we must remember that the museum refused the National Sculpture Society exhibition in 1907 – it was no surprise to find the show filled with mostly conservative works as the museum was slow to acknowledge contemporary artistic tendencies. Young's *Man with a Pick* served as the sole example of the newer tendencies in American sculpture. With its focus on the male body at work, the sculpture attracted the interest of both elite and middle-class patrons by addressing significant, yet subtle, ideological concerns of the day – most notably the interrelationship between the nature of work and definitions of masculinity. The same year, Mrs. Edward H. Harriman, wife of the railway tycoon and owner of the sculpture, offered the piece to the Metropolitan, a donation that the museum graciously accepted. To Young's credit, he had three pieces in the Metropolitan Museum's collection by 1918, *Bovet Arthur – A Laborer* (Fig. 49), *The Stevedore* (Fig. 52), and now *Man with a Pick*.[43]

In his images of workers, such as *Man with a Pick*, Young conflated the contemporary discourses on the work ethic with his attendant interest in masculinity and the male body. *Man with a Pick* portrayed a workman, dressed

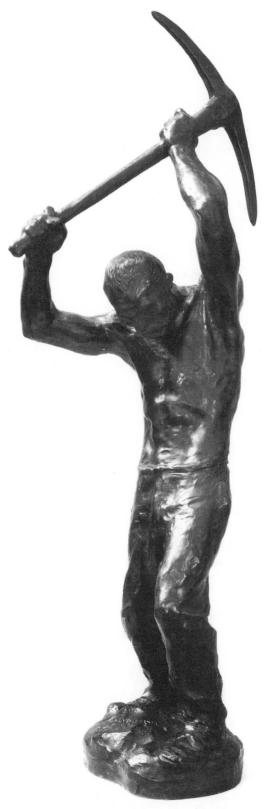

Figure 53. Mahonri M. Young, *Man with a Pick,* 1915, bronze 28½" h. The
Metropolitan Museum of Art. Gift of Mrs. Edward H. Harriman, 1918 (18.107).

only in workboots and loose pants, in the act of raising his pickaxe over his head to pound the earth before him. With arms raised, his face lay buried deep in his chest, only slightly visible to the viewer. The pickaxe was huge in scale, almost overwhelming the figure of the worker. He grasped its handle with tightened fists, revealing bulging muscles in his upper and lower arms. With his upper torso unclothed, his well-developed back and shoulder muscles were on display. Of such sculptors of laborers, Young later intoned, "You might say this is my tribute to honest toil. . . ."[44]

As one of Young's most powerful pieces, the expressive handling of the clay helped convey the excited activity of the figure. Although Young carefully presented anatomical details, he produced a body comprised of active lumps of clay, particularly in the mottled and pocked areas of the upper back and neck – the areas of most highly developed musculature. In contrast to the expressive modeling in the dress, hair, and base of Beach's *The Stoker* (Fig. 51), Young provided an equally strenuous handling of the clay on the entire surface of his sculpture. In this piece, both the drama of the physical exertion of hard labor and the palpability of the modeling of the sculptural body produced visual meaning. To Young, work functioned both to elevate and ennoble the spirit while dignifying the body as an object of visual pleasure.

Both Mahonri Young's *Man with a Pick* and Beach's *The Stoker* participated in a discourse on labor that centered on the male body. The worker represented one thematic arena in which a highly detailed, if not exaggerated, musculature of the male body could be rendered and appreciated as an object of sheer beauty. Surprisingly, the critical language of the time avoided a description of these sculptures in gendered or classed terms. Critics masked the turbulence of these workers' bodies, tensed in the act of shoveling or pounding a pickaxe, with an appreciation of their aesthetic worth. The pleasure of viewing these sculptures by a middle-class and elite audience was never impeded. A process of aestheticization neutralized the political agency of the worker and ensured a reading of these sculptures as unthreatened by class conflict.[45] Moreover, this nostalgic (almost sentimental) view of manual labor – a romanticized response to an increasingly mechanized world – produced a distinctly antiheroic image of the worker. This visual construction of labor stood in marked contrast to the titanesque imagery of industrial labor, as we shall see in the next chapter, that appeared in the years following World War I.

Indeed, Chester Beach, like Young, demonstrated little interest in the political exigencies of labor. Born in San Francisco in 1881, Beach attended technical schools on the West Coast until he took up residence in Paris where he studied at the Académie Julian for two years. Returning to New York in 1907, he opened a studio in MacDougal Alley, near Washington Square in Greenwich Village. In 1909, he was elected to the National Sculpture Society and later became its president from 1927 to 1928.[46] During his years at the MacDougal Alley studio, Beach produced several sculptures on the subject of

work, among them *The Stoker, Over the City, Out of Work, Payday,* and *Immigrants.*[47]

Adolph Lewisohn purchased *The Stoker,* the only extant sculpture in Beach's labor series, from the Macbeth Gallery. An enlightened industrialist, Lewisohn headed the Anaconda Copper Company and several other mining enterprises and built a reputation as a generous philanthropist and avid collector of fine arts and rare books. Moreover, he spoke out on a number of progressive issues, such as prison reform, child labor, suffrage, and immigration. His progressive philanthropy also extended to the arts. He offered support to the radical magazine *The Masses,* under Max Eastman's editorship, and patronized Beach during his early career when he produced his labor series. *The Stoker* remained in the collection of the Lewisohn family until 1939 when it was donated to the Brooklyn Museum upon Lewisohn's death.[48]

What compelled Chester Beach to produce a number of sculptures dedicated to the theme of work may never be known. For most of his career, he remained loyal to the tenets of academicism, as witnessed by his prizewinning sculpture *The Nymph.* But during the years 1907 to 1914, Beach gained notoriety for his sculptures of workers, which he exhibited regularly. Although one critic described *The Stoker* as having a "Socialistic point of view" when shown at the National Academy of Design, there was no evidence of Beach's engagement in labor politics. Nonetheless, his sculpture did have the power to appeal to a progressive collector like Lewisohn. Fluid in its meaning to contemporary viewers, this sculpture, for the most part, represented the worker as a popular sign of contemporaneity, in one critic's words, slightly "propagandistic," but "vigorously and honestly presented."[49]

Beach had gained access to the heady world of American sculptural production through his MacDougal Alley studio. Among his distinguished neighbors were many contemporary sculptors, such as Gertrude Vanderbilt Whitney, Malvina Hoffman, James Earle Fraser, Daniel Chester French, and A. Phimister Procter.[50] Beach, like scores of other young American artists, benefited from the enlightened artistic patronage of Gertrude Vanderbilt Whitney – a scion of the prestigious Vanderbilt family who remained committed to a legacy of cultural philanthropy. Her father, Cornelius Vanderbilt II, served on the board of the Metropolitan Museum, giving handsomely to that institution, and George, the grandson of Cornelius Vanderbilt I and uncle of Gertrude, collected numerous artworks to adorn his North Carolina mansion, Biltmore, among them eight sculptures by Constantin Meunier.[51]

Whitney hosted many exhibitions at her MacDougal Alley studio. By 1908, she had opened two galleries adjacent to her studio as permanent exhibition spaces, and ten years later, she founded the famous Whitney Studio Club at 3 West 8th Street. Committed to the advancement of a native realist style, she patronized young American painters and sculptors, among them Robert Henri and the Ashcan School painters, as well as Young, Beach, and Eberle. Through Mahonri Young's association with the Ashcan painters – both in

his proclivity for realism and his later participation in the Association of American Painters and Sculptors – he attracted the interest of Whitney, who purchased his *Man with a Wheelbarrow* in 1916 from an exhibition of "Modern Paintings by American and Foreign Artists" held at her studio. Moreover, in 1918, both Young and Beach participated in her "Indigenous Sculpture Exhibition," to which over thirty sculptors were invited. In 1919, she featured Young in a solo show at the Whitney Studio Club.[52]

Indeed, small-scale sculpture of contemporary urban life had achieved much prominence as well as popularity by the end of the 1910s. Patronized by both the elite of society – Whitney, Harriman, and Lewisohn – and the prospering middle classes, Young and Beach had achieved a level of professional success to which they had eagerly aspired. However, the special problems attendant upon women who wished such artistic stature require analysis. Among the many contemporary women sculptors working prolifically during the first two decades of the twentieth century was Abastenia St. Leger Eberle, who will serve as our prototype of the "New Woman," committed to her professional artistic career, replete with its struggles and triumphs.

■ ■ ■

With her commitment to depicting the contemporary world in a realist fashion, Abastenia St. Leger Eberle gained prominence for her small-scale sculpture of working-class subjects. Not surprisingly, she attracted the attention of Gertrude Vanderbilt Whitney, whose interest in American realism led her to purchase the delightful piece, *Girl Skating* of 1909, for her personal collection (Fig. 54).[53] Born in 1878 in Webster City, Iowa, Eberle demonstrated early in life an interest in sculpture. In 1899, she enrolled at the Art Students League in New York where she studied for three years with C. Y. Harvey, Kenyon Cox, and later the eminent George Grey Barnard. Among the best students whom Barnard had taught, Eberle often substituted for her professor when he was unable to teach his sculpture classes. In describing her skill, Barnard once stated that "nowhere in America is there a man or woman sculptor who knows the human anatomy better."[54]

Eberle was one of a growing number of women who were gaining success in an art world dominated by men. She shared a studio with Anna Hyatt (Huntington) from 1903 to 1905, collaborating with Hyatt on the monumental sculpture *Man and Bull* of 1904, a sculpture that won a medal at the St. Louis Exposition that year. (Hyatt modeled the bull, Eberle the man.) Involved in many organizations devoted to the advancement of women, she actively participated in the Women's Art Club of New York as well as several Women's Suffrage groups. In keeping with her feminist inclinations, she supported all-women art shows. For example, in 1910 she showed at the Women's Art Club exhibition at the Macbeth Gallery and at the New York School for Applied Design for Women; and in 1914 and 1915, she exhibited in the women's exhibitions held at the Gorham Gallery.[55]

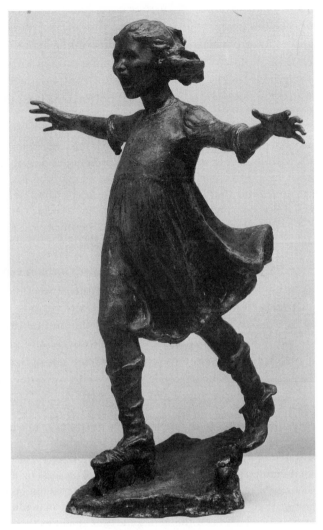

Figure 54. Abastenia St. Leger Eberle, *Girl Skating,* 1909, bronze, 33 cm. h. The
Metropolitan Museum of Art. Rogers Fund, 1909 (09.57).

The issue of all-women art shows raised much debate in the critical press.
It is noteworthy to mention that such single-sex exhibitions were controversial
only when the sculpture of women was singled out for public display. No
debate ever arose from the exhibition of all-men's work. Continuing a debate
begun at least as early as the discussions surrounding the Women's Building
of the World's Columbian Exposition, *The Craftsman* magazine took a partic-
ular interest in this topic and addressed the merits of women's independent
exhibition spaces in a series of articles dating from 1908 to 1910. In com-
menting upon the exhibition held at the New York School for Applied Design
for Women, the reviewer for *The Craftsman* appeared pleasantly surprised in
writing, "The first impression of the work was extremely interesting; as not at

all suggesting a woman's exhibit."[56] Furthermore, Mary Fanton Roberts, associate editor of *The Craftsman*, who often wrote under the pseudonym Giles Edgarton, argued rather persuasively for "equality rather than difference," to use current feminist parlance. She urged the equal treatment of women artists in sexually integrated exhibitions rather than the separate showing of women's sculptural production as compensation for past inequities. She explained:

In spite of the good work which has been noted, . . . the impression [is] that the exclusive women's exhibit is out of harmony with present-day growth and development, that women need with men but one standard of art progress, . . . Better an unfair jury than none, and that the press will cease to be amusing, supercilious, patronizing toward women in art when these matters are adjusted, and will extend to them the dignity and seriousness in criticism which the right progressive situation would demand.[57]

However, judging from the reception of the 1914 Gorham Gallery exhibition of fifty-five women sculptors, the showing of women sculptors' works was not a frequent event. One critic remarked, "it seems curious that no such representation of work in sculpture forms part of the annual displays of the National Academy."[58] Moreover, women still had to overcome much prejudicial judgment regarding their creative abilities. Often consigned to the production of decorative and delicate objects, their skills were deemed inferior to those of men. As one article suggested:

In the present state of the art of sculpture in these United States (a truly flourishing art), there may be said to be at least two of these notable facts – the great number of foreign names among the men[!], and the surprising number of young women who have attained eminence. . . . To begin, it is asserted (at least by men) that very few [women] manifest a real aptitude for big and monumental out-of-doors work; it is said that none of them has ever been able to produce a masculine figure that looked like a real male man. . . . Of the general artistic qualities there is one – not so common as it should be – in which several of them excel: that of rendering with real delicacy and charm the nude female figure.[59]

In fact, Eberle faced such obstacles in her own professional life. It was not until the end of her career in 1920 that she was finally elected to the National Academy of Design, but only as an Associate Member. Despite the support the Macbeth Gallery offered to American sculptors – particularly Beach and Young, it wasn't until 1921 (thirteen years after Beach's first solo show in 1908) that Eberle held her first one-person show at the gallery. Entitled "The East Side in Sculpture," the exhibition featured twenty-seven of her small-scale sculptures of immigrant women and children.[60]

On the other hand, the number of women sculptors actively engaged in exhibiting and attaining commissions had risen sharply in the first two decades of the century. For the most part, women's contributions to sculptural production was beginning to be acknowledged and lauded. For example,

Gardner Teall, writing in *Good Housekeeping Magazine* for a women's audience, expounded:

it may come as a surprise to know that there are in America probably more women sculptors of distinction than men. . . . Indeed we may boast that no other country in the world has so many women sculptors whose work approaches in true excellence that of American mistresses of chisel and mallet.[61]

Furthermore, Ada Rainey, in writing for the popular magazine *Century* in 1917, clearly articulated the popular myths about women's artistic production – myths that had only until recently been held as truth. She attributed the successes of women sculptors to political advances, most notably the ever-expanding power of the suffrage movement. Rainey explained:

Sculpture has never been thought a medium particularly feminine; that so many women should recently have chosen it for their own is significant. Form, the chief appeal of sculpture, has formerly been considered the weakest part of woman's artistic equipment; while she has been accorded a feeling for color, the most emotional element in art, her feeling for form has previously lain in abeyance. But it now seems that the vital changes that are taking place in ideals, in thought, and in mode of living are being reflected in the quality of work accomplished by women. As surely as the old shackles are being cast off, a new creativeness is to be discerned in their artistic work. Freedom, the creative impulse, and joy are always of divine heritage; they are the essentials of great art. That women sculptors are now blazing this path can clearly be seen. . . . [T]he creative ability in women is a factor to be reckoned with, for they are on an equal footing with men in the arts, and winning the laurels.[62]

The confidence with which Rainey wrote this passage in 1917 reflected the headiness of the historical moment. Within three years, women would gain the right to vote – a political battle, however, won by a slim majority as the Nineteenth Amendment barely received the necessary two-thirds majority to pass in Congress.[63]

To be sure, many women sculptors participated actively in the Suffrage Movement. Eberle had been a member of the Women's Political Union, an activist women's suffrage organization. In fact, she led the section of women sculptors who marched in the Suffrage Parade of 1910. In the 1911 parade, caricatured as the "Petticoat Parade," in which 3,000 marched, women paraded by occupations – with Eberle carrying the women sculptors' banner at the head of their section. As the *New York Times* described: "Musicians, sculptors, doctors, lawyers, homekeepers, cooks, milliners, artists' models, hairdressers, writers, aeronautists, janitors, mountain climbers, and tea-room proprietors will be a few of the women who will represent the present-day occupations of their sex." In honor of the large number of women sculptors involved in the suffrage movement, William Macbeth held a benefit at his gallery in 1915 for this political cause. Eberle contributed two works to the 150 paintings, sculptures, drawings, and plaster statuettes exhibited in the

show. One reviewer quipped, "It would seem that all the women in art – all the kinds of women in art, hold the cause of suffrage at heart."[64] Shored up by their feminist commitments, women sculptors, Eberle among them, recognized their significant contributions to the fine arts. They proudly identified themselves as serious artists, committed to a profession previously reserved for male members only.

Eberle led a fiercely independent life, dedicating herself to social and political causes until her health failed in 1920. She openly embraced the tenets of Progressivism and believed that civic work and private philanthropy would lead to a better existence for the common person. Her activist life, organized around women's social issues such as settlement work, a concern for children's welfare, and the antiprostitution crusade, informed the production of her sculpture.[65] In contrast to the laboring men produced by Beach and Young, Eberle modeled almost exclusively the women and young girls with whom she lived and worked on New York's Lower East Side. She brought attention to the lives and labors of working-class women, as, for example, in her *Windy Doorstep,* in which she represented a model of femininity rarely depicted in high art because of its antagonism to the hegemonic ideal of bourgeois womanhood (Fig. 48). This sculptural figure illustrated the problematic underlying the representation of women's labor through its allusion to *both* the wage labor of a servant *and* the domestic duties of a homemaker. In so doing, it attempted to reconcile the ideal of bourgeois womanhood – linked to the protected sphere of the domestic – with the experience of working-class women – whose manual toil outside the home was quite common.

In her sculpture, Eberle illustrated the specific conditions of working-class women's labor and described the childhood circumstances which led to a life of toil. She represented women cleaning, scavenging in the streets, and prostituting themselves for money. At the same time, she pictured in her sculpture the lives of young ghetto girls. In these images, she alluded to the reformist position on play and its importance to the social development of young children. She also depicted young girls providing child care – an obligation many girls fulfilled for their younger siblings. On the one hand, these images of young children were delightfully appealing in their vivaciousness and enthusiasm. On the other hand, as we shall see, they reiterated the stereotype of ghetto "kids" as exotic, and marginalized those very lives Eberle had hoped to celebrate.

Inspired by the work of Jane Addams, Eberle participated in the settlement movement, hoping to remedy some of the social ills that plagued the life of the underclasses. With her childhood music training (her mother was a musician), she first worked as a resident-counselor at the Music School Settlement on East Third Street in 1907. In offering assistance to the poor, mostly immigrant populations, Eberle and other settlement workers gained compassion and respect for the lives of these newly arrived peoples. She explained,

"I had no anarchistic theories to expound them. I did not enter their neighborhood as a disturber, but to study them and the conditions under which they live, to be near them and to learn from them, to give help when I could and where I felt the need."[66]

Settlement workers like Eberle, nonetheless, were rarely able to escape their own class biases. They set up residences in poor neighborhoods and created model households through which they hoped to inculcate middle-class values into poor slum dwellers. In an attempt to domesticate the foreign behaviors of immigrants, they preached a sense of propriety and encouraged the adoption of social traits that they knew best: orderliness, temperance, and industriousness, for example. In fact, Eberle admitted, "What many go to the South Seas to find, I found there. People who were just enough apart from me to act as symbols, yet close enough to feel their common humanity."[67] In effect, she had adopted a philosophy close to that of Robert Henri, who had encouraged artists to experience directly the pulse of the city and its exotic inhabitants.

To many contemporary artists, a major attraction of these poor neighborhoods was their accessibility to the eye. In wandering the streets of the Lower East Side, they could see what was normally hidden behind domestic interiors or under layers of clothing in bourgeois neighborhoods.[68] In describing her attraction to immigrant neighborhoods, Eberle explained:

Where people wear their clothes so long that they show their personality – where dresses show the bodies underneath and manners do not hide the soul – I found my material. I felt my full artistic power there. It was just the necessary jolt we all need to get out of our own individual ruts.[69]

Thus, in transcribing the life of poor urban women and children into a vital sculptural expression, Eberle unwittingly gave expression to the conflicted tendencies of reformist ideologies.

In 1907, Eberle set up her studio on West 9th Street in Greenwich Village. Populated by mostly Italian and Irish immigrants, this neighborhood became the source of her sculptural inspiration. Writing to William Macbeth years later, she explained:

I have always had a strong taste for life – and in those early lonely years in New York I would often stroll around the lower parts of town – losing my loneliness in the consciousness of all the pulsing throbbing life around me. So when I went to live in the settlement – it was with the one end already in view – to get personally acquainted where I had so long been an onlooker.[70]

During this period, Eberle sculpted two elderly Italian immigrant women, *Old Woman Picking Up Coal* of ca. 1907 and *The Ragpicker* of 1911 (Fig. 55), bringing attention to those who scavenged for their livelihoods on the streets of New York.[71] In *The Ragpicker*, Eberle depicted with forthrightness the abject poverty of her Washington Square neighborhood. Stooped over a rubbish

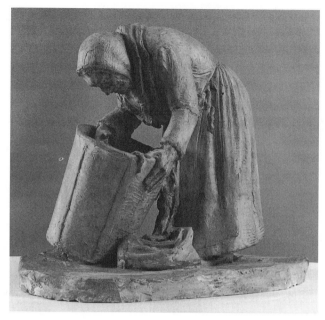

Figure 55. Abastenia St. Leger Eberle, *The Ragpicker,* 1911, plaster, 33 cm.h. Kendall Young Library, Webster City, Iowa.

bin, this old woman suggested a modern-day gleaner, collecting the waste that others had discarded. The coarseness of the subject matter mirrored themes produced by certain Ashcan School painters, such as Everett Shinn. In his pastel *The Ragpicker,* for example, a stooping male figure, face to the earth, foraged for rags amidst the detritus of a dilapidated tenement yard. The beggar, positioned directly beneath an overturned trash can, himself appeared the discarded waste of contemporary humanity.[72]

Eberle insisted upon the political engagement of her art. As a settlement worker and as an artist, she committed herself to a socially responsible life. Although she consistently claimed that her art conveyed a personal expression of beauty, its inspiration, she argued, lay always in the social. In 1913, she explained:

The artist should be *the* "socialist." He has no right to work as an individualist without responsibility to others. He is the specialized eye of society, just as the artisan is the hand, and the thinker the brain. More than almost any other sort of work is art dependent on society for inspiration, material, life itself; and in that same measure does it owe society a debt. The artist must see for the people – reveal them to themselves and to each other.[73]

Illustrating her spirit of social concern, Eberle turned her sculptural attention to the world of ghetto children – both at play and at work. She modeled young girls on the streets of New York, entertaining themselves with play and dance and shouldering the responsibility of caring for younger siblings. With

reformist zeal, she participated in the discourse of "child saving" when she brought recognition to the plight of young urban girls. Reformers understood that the streets in tenement districts were dangerous, both physically and morally. At the same time, they saw these same streets as the most common form of amusement for working-class families – as playgrounds for children and congregating points for adults after a long day of toil.[74]

In their child-saving crusades, these social workers began to see recreation and play as an important urban issue – as a way to keep children off the streets. As the latest child-development theories by G. Stanley Hall argued for the importance of play to moral and cognitive development, reformers grew convinced that proper recreation would ensure civil behavior in other social arenas. Moreover, by concentrating on children at play, they believed that they could attack at their roots societal problems, like juvenile delinquincy, by socializing children into decent roles as workers and citizens. This reforming impulse was particularly acute in reshaping the behavioral patterns of working-class young women and girls for whom the primary purpose of recreation reforms was the inculcation of middle-class standards of feminine deportment and respectability. As one social reformer put it, the child was "putty ready for the hand of the social sculptor."[75]

Within this reform context, Eberle produced her numerous sculptures of ghetto children at play. In fact, upon moving into a new studio on Madison Street in 1914, she kept two rooms – one used as a studio, the other as a playroom for neighborhood children. At first, she opened up the playroom to all the neighborhood children after school and all day on Sunday. However, the ensuing chaos caused her to limit the number of children to ten at one time and to extend invitations only to girls. It was while watching the children at play – either on the streets or in her studio – that Eberle modeled her lively sculptures of young girls.[76]

She completed her first study of New York street children, *Girl Skating*, in 1909, well before she opened her Madison Street studio (Fig. 54).[77] She modeled an active little girl, skating in the streets on only one roller skate. Her skateless foot, extended back and off the base, revealed an untied shoe; her baggy socks cascaded down both legs. She wore a simple, jewel-necked frock, ill-fitting and a bit ragged. Both her dress and her demeanor signaled the child's working-class identity. Her arms, with sleeves rolled up to the elbow, flew directly out from her body, terminating in seemingly oversized hands with fingers extended wide apart. The rushing wind swept back her hair, which paralleled the fluttering line of her windblown dress. She contorted her face with a scream – her mouth wide open in a joyous shriek. With arms akimbo, the child enacted the ebullient character typified by immigrant life.

Eberle depicted this child as "wild" and possibly "out of control." In fact, the *Girl Skating* would never be mistaken for a middle- or upper-class child who appeared consistently quiet and well-behaved in contemporary portraits

or genre images.[78] In describing the life of the city in *Harper's New Monthly Magazine*, one writer captured the quality of life typically represented in Eberle's sculptures:

The East Side is especially convenient for observation of people, because here are such shoals of them always in sight, and because their habitat of life and manner are frank, and favorable to a certain degree of intimacy of sight. . . . You may walk up and down Fifth Avenue for ten years and never see a mother nursing her latest born on the doorstep, but in Mott or Mulberry or Cherry Street that is a common sight, and always interesting to the respectful observer. When the little Fifth Avenue children are let out, if they don't drive off in a carriage, at least they go with a nurse, and are clothed like field daisies, and under such restraint as good clothes and even the kindest nurses involve. But the East Side children tumble about on the sidewalk and pavement hour after hour, under slight restraint and without any severe amount of oversight, hatless, usually, barehanded and barefooted when the weather suffers it.[79]

Eberle celebrated the life of the ghetto while also confirming racial and ethnic stereotypes popular at the time. The sense of movement in the *Girl Skating* – with its beautifully formed arcs and curves – evoked the unrestrained vitality of children's play. Eberle, herself, commented upon the sense of ''absolute abandon'' in the play of Lower East Side children.

The children on the East Side play without restraint; their griefs and their joys are expressed with absolute abandon . . . and their natural emotions are not restrained by the pretty curtsies taught by governesses. . . . They laugh loudly, they shout. They race on roller skates and dance unrestrainedly. . . . They express life.[80]

This animated exertion, typical of Eberle's sculpture of children at play, functioned as the sign of both ethnicity and class. It marked the otherness of this Lower East Side population and constructed their differences by highlighting their exotic appeal.

Eberle's concern for child welfare extended to her documentation of domestic labor among young immigrant girls. In fact, she sculpted several versions of the ''Little Mother'' theme – the caring of younger siblings by school-age girls whose mothers worked outside the home. In a late example, *Her Only Brother* of 1919, she represented a young girl, perhaps ten years old, holding a toddler in her arms (Fig. 56).[81] The girl stood somewhat sway-backed – the heavy load of the child registering in her awkward stance. In a sweet gesture, this ''little mother'' kissed the child and tended to her charge with considerable care. A common occurrence in the poor neighborhoods of the Lower East Side, the ''little mother problem,'' grew into a popular crusade and attracted the interest of Progressive reformers. They formed organizations like the Little Mother's Aid Association and the Little Mother's League to address the social consequences of this familial obligation. Both the babies and the substitute mothers, contemporary reformers charged, were the victims of this unhealthy practice. Eberle was not the only artist to participate in

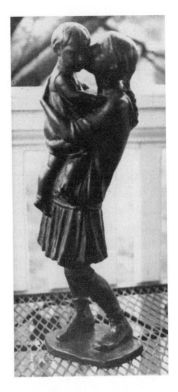

Figure 56. Abastenia St. Leger Eberle, *Her Only Brother*, 1919, bronze 24" h. Originally from the collection of Lester and Eleanor Levy and now in the family.

this reformist discourse. George Bellows, among other Ashcan artists, included a representation of a teenager holding a baby to her shoulder in his painting of the teeming Lower East Side, *The Cliff Dwellers*.[82]

It was clear to reformers that the streets were dangerous to young girls. Among the most dreaded of fates was that of prostitution or "white slavery" – a social cause that became a national obsession during the years 1900 to 1915. There was a widely held fear that syndicates of "white slavers," often typified as Russian Jews or Italians, were preying upon young women on the nation's city streets. Reformers held that women (and especially young girls) were coerced into prostitution through threats, intimidation, and force and that they were kept in brothels under conditions similar to slavery. The general outrage that attended white slavery condemned prostitution as a social evil that besmirched the precious, domesticated, and virtuous character of women living in urban areas without male protection. As one reformer put it: "in America no girl of any class is safe." This fear marked a concern on the part of middle-class reformers with the nature of public sexuality and the increased mobility and visibility of both middle-class and working-class women in the modern city.[83]

Unlike the nineteenth-century propensity to afix blame onto fallen women, Progressive reformers understood prostitution in more complicated terms, emphasizing social causes rather than moral failures. With its roots in the Purity Movement of the late nineteenth century and its focus upon the sexual

and moral purity of the individual, the white slavery problem became the target of Progressive social engineering and spawned such groups as the National Vigilance Committee and the Alliance for the Suppression and Prevention of White Slave Traffic. Indeed, the White Slave Traffic Act of 1910 – commonly known as the Mann Act – made it illegal to transport women across state lines for "immoral purposes." The report of the 1912 Special Commission for the Supression of White Slavery, produced under the auspices of the Federal Bureau of Investigation, concluded that "No man's daughter, sister, wife – if she be young and attractive – is safe from the artifices and devices of these traffickers." Indeed, many books like Reginald Kauffman's *The House of Bondage* and movies such as *The Traffic in Souls* sensationalized stories of white slavery for a tititlated public (while also pulling in large profits). The three consistent elements in these white slave narratives included child victimization, an immigrant villain, and a conspiratorial white slave ring. Indeed, the response to this social problem engendered a full-fledged moral crusade.[84]

It was in 1913 at the Armory Show that Eberle showed her most controversial sculpture, *The White Slave* (Fig. 57). The sculpture represented a young white girl, vulnerable and naked, with arms tied behind her back and head lowered. A coarse "white slaver" with mouth agape auctioned her into sexual slavery while extending his arm forward in a gesture of display. His presence overwhelmed the petite girl, forcing the child's arms behind her back in order to flaunt her young body before the crowd. His forward stance emphasized her withering posture and public shame. In effect, Eberle utilized two of the three elements central to contemporary popular white slavery narratives: the innocence of the young child and the fear of coarse and vulgar immigrants. To be sure, Eberle would never produce a more moralizing sculpture than *The White Slave*.

The figures reveal two decidedly different stylistic concerns. Eberle modeled the young female in a carefully worked neoclassical style, suggesting a self-conscious commentary on the convention of the nude. She modeled the white slaver (or pimp), by contrast, in a rough, sketchy, almost unfinished manner – his coarseness deliberately caricatured in the working of the clay. In representing the girl as pubescent and nubile, Eberle deliberately sexualized the body of this young child in order to emphasize the horror of the situation. The frankness of the representation shocked many of its viewers, among them, one man who reported that upon seeing the piece, he was transfixed before it. He explained, "I had vaguely realized this horrible thing was in the world, but it had never touched *me*. I sat there thinking for perhaps an hour. . . ."[85]

By including the male auctioneer in the sculpture, Eberle implicated the viewers of this artwork in the very prurient act that they so adamantly condemned. In gazing at the body of this young child, viewers – particularly male

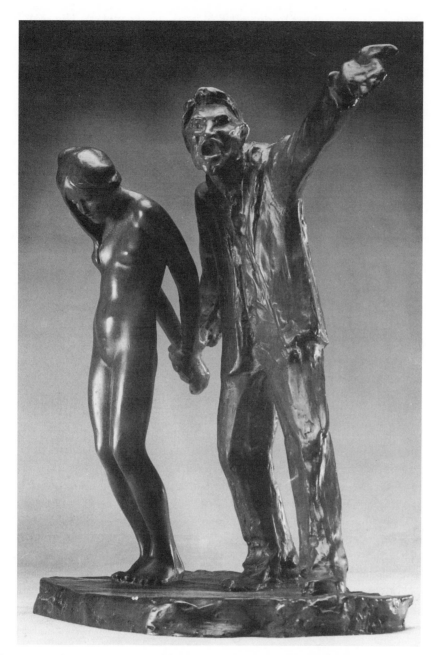

Figure 57. Abastenia St. Leger Eberle, *The White Slave,* 1913. Original plaster lost; posthumous bronze cast, 19¾" h. Collection of Gloria and Larry Silver.

viewers – enacted the role of the fictive audience before which this spectacle occurred. Through her narrative structure, Eberle decried the dreaded social evil of white slavery *and* exposed the patriarchal power of the male gaze. Sexual desire, central to the experience of beauty in viewing the female nude,

could no longer be hidden under a veil of aesthetic disinterest. The sculpture made explicit the power relations that comprised the sexualization *and* the aestheticization of the female body.

When *The White Slave* appeared on the cover of the May 3, 1913, issue of *The Survey*, a journal dedicated to the tenets of reform, it caused a sensation. Readers inundated the magazine with complaints as to the impropriety of the image, particularly as a cover illustration. Committed to exposing the evils of prostitution, the editors of the journal used an illustration of Eberle's sculpture to complement a literary account of white slavery, "My Little Sister," reviewed in the same issue. In so doing, they defended their position by describing the sculpture as "a sermon in stone." Perhaps in response to this critical barrage, Eberle transformed the sculpture the following summer. On a trip to Paris in July 1913, she ordered the female figure cut in marble, omitted the presence of the male figure, and renamed the sculpture *Pinioned*. Without the presence of the repulsive auctioneer, the sculpture lost its realist punch and moralist tone. Indeed, it no longer provided the trenchant critique of the gaze that had shocked many viewers. Instead, as Louise Noun explained, "[*Pinioned*] became just another in a long line of beautiful nude females held captive by unseen males – a favorite subject for academic sculptors – such as *The Greek Slave* of 1847 by Hiram Powers and *White Captive* of 1858 by Erastus Dow Palmer."[86]

An advocate for poor and dispossessed women, Eberle assumed an activist stance in her artistic practice. She saw her sculpture engaged in social reform – while always maintaining a personal commitment to artistic integrity. Unlike Beach and Young, who expressed no interest in the political realities of labor, Eberle approached the social problems of working-class women with a reformist sensibility. Never arguing for radical revolution, she believed in the viability of Progressive reform. It was in the sculpture of Charles Oscar Haag and Adolf Wolff that revolutionary politics played a larger role. These sculptors, staunch supporters of labor, produced images of workers in control of their destinies – active rather than passive in the face of economic hardship and political opposition. Constituting a radical tradition in sculptural production during the Progressive era, these sculptures gained little visibility in an art world dominated by middle-class and elite interests.

■ ■ ■

A radical tradition in cultural production flourished during the first two decades of the twentieth century, functioning as a counterpart to the progressive imagery of the Trenton murals by Everett Shinn, and, of course, the sculpture of Abastenia St. Leger Eberle. In print media, pageantry, and the visual arts, for example, a political expression surfaced that promoted a revolutionary social vision. In the pages of the radical cultural journal *The Masses,* edited by Max Eastman, and in the production of the famous Paterson Strike Pageant, the worker took center stage as the agent of social

change, fighting the injustices of a capitalist system. Contributing to this visual culture, Charles Oscar Haag and Adolf Wolff produced sculptural images that labor activists and political revolutionaries adopted as symbols of the class struggle.

In radical publications of the day, the worker assumed the role of an autonomous agent, active in response to social injustice and united in political struggle through union membership. The graphic artists of *The Masses,* a journal devoted to working-class culture, developed a labor iconography concerned with the totality of workers' lives – at work and at play. Similarly, graphics published in *Solidarity* and the *Industrial Worker,* both official organs of the Industrial Workers of the World, favored a diverse iconography of labor.[87] John Sloan, for example, produced a compelling cover for the June 1914 issue of *The Masses* (Fig. 38). In this image, "Ludlow, Colorado," a striking miner fought back – holding the body of a dead child and firing a revolver at the Rockefeller company forces who had brutalized the strikers and their families in a bloody yearlong dispute.[88]

Paterson Silk strikers represented their own political struggle in an elaborate 1913 pageant. They reenacted in dramatic format significant moments of resistance while articulating broader issues concerning labor, unions, and class conflict. Within this radical cultural tradition – to which the sculptural production of Charles Oscar Haag and Adolf Wolff belonged – workers and artists sympathetic to the concerns of labor-produced social imagery that advocated political action to a small but devoted audience.

The Industrial Workers of the World (IWW) led the Paterson strikers' protest against an industrywide speedup of production. An industrial union organized in 1905 by Big Bill Haywood to support all workers – skilled and unskilled, native-born and immigrant, the IWW promoted direct action in the form of the strike, and, at times, adopted a strategy of industrial sabotage. Its endorsement of such activities alienated the IWW from more mainstream labor organizations, most notably, the Socialist Party of America led by Eugene Debs and the American Federation of Labor headed by Samuel Gompers. The Socialists, repudiating capitalism and "wage slavery," worked for change through the political process – electing public officials in the hopes of bringing about social change. The AFL, protecting only trained craftsmen, chose a strategy of cooperation with capital in order to create a productive relationship between skilled workers and the owners of the means of production.[89]

The IWW, in its refusal to accommodate the political and economic structures of capitalism, offered a truly revolutionary alternative to workers. Not surprisingly, this radical labor movement raised the specter of Haymarket to many concerned citizens and politicians. As the *New York Times* reported, IWW activity was "the most serious demonstration that the revolutionary element [had] made in this country since the demonstration in Chicago in 1886."[90] Like the Haymarket anarchists who had called for one large union

to protect unskilled as well as skilled workers, the IWW organized all workers. Many were eastern European immigrants – unskilled and semiskilled workers – who, by 1909, comprised nearly one-third of the entire labor force in the principal industries of the country, including the silk and cotton mills. By contrast, organized labor, led by the AFL, began a campaign to restrict the influx of foreign labor in 1906 that was spurred by big business's open promotion of immigration. Thus, the Industrial Workers of the World, populated by "unruly foreigners," came to represent political instability and anarchy, a legacy traced to the hysteria surrounding the Haymarket Affair.[91]

In defining a radical tradition within cultural production, the Paterson Pageant engaged the interests of the working class through the power of self-representation. In contrast to depicting "the worker" as a sign of middle-class interests and ideologies, it provided a public spectacle within which working-class concerns took center stage. With the assistance of John Reed, a journalist writing for *The Masses,* Mabel Dodge, a wealthy Greenwich Village bohemian, and IWW leaders, such as Haywood and Elizabeth Gurley Flynn, the pageant hoped to publicize the strike cause and raise money for its coffers. The strikers, for the most part, financed the event, held in Madison Square Garden on June 7, 1913. John Sloan created the 200-foot-wide backdrop that appeared on the Hippodrome-like stage constructed for the pageant. Sloan recreated a Paterson silk mill, most likely the Doherty Plant, depicting "the windows aglow with the artificial light in which the workers began their daily tasks."[92] Robert Edmond Jones produced the design for the cover of the program – a now famous Wobbly emblem. Red in color, the image displayed a muscular worker climbing over and out of a factory with one hand and one foot emerging from the frame. The assertive demeanor of the worker escaping into the viewer's space suggested the philosophy of direct action that the IWW promulgated.[93]

The pageant attracted a large, mostly working-class audience of 15,000. On the day of the pageant, 800 workers from Paterson arrived in New York and marched up Fifth Avenue waving red banners. Overseeing the production of the pageant, John Reed directed the strikers in six scenes that the workers had chosen to enact. The first scene of the pageant showed the silk workers going to work ("The mills alive – the workers dead," the caption in the program read) and their rushing out of the mill and into the audience to begin the strike ("The workers begin to think"). The second scene depicted the strikers picketing ("The mills dead – the workers alive"). The third scene reenacted the funeral of one of the dead, Vincenzo Modestino, with a moving and tragic funeral procession through the audience. The singing of strike songs comprised the fourth scene. The fifth scene represented May Day 1913 in Paterson, when the strikers' children were sent away from their homes to the safety of sympathetic families in New York City. The sixth scene served as a strike meeting with speeches by labor leaders ("No court can declare the law thus made unconstitutional"); the strikers, with their backs to the audi-

ence, listened to rousing speeches by Haywood, Flynn, and Carlo Tresca, among others. The direct participation of the audience – mostly workers – in the pageant made the event a success. The audience served not as passive observers to a fictive scene, but as active participants in a cultural reenactment of political struggle.[94]

Although condemned by some, including Flynn, because it failed to raise the necessary funds for the strikers, the Paterson Strike Pageant served as an important symbolic statement. Produced by workers, with the help of radical activists, the pageant made visible a narrative of working-class history that otherwise would have remained undocumented. As Linda Nochlin has so persuasively argued:

A combination of visual spectacle and dramatic performance, the pageant can weld together two seemingly disparate forces, the subject and object of the dramatic metaphor. . . . [T]he "actors" remain themselves and yet at the same time play their roles as symbols of broader issues. . . . [T]he repetition of the speeches of the strike-leaders and the dramatic simplification and compression of events which may have been unclear when experienced in actuality all made the striking workers conscious of the meaning of what they had lived through. In participating in the pageant, they became conscious of their experience as a meaningful force in history, and of themselves as self-determining members of a class that shaped history.[95]

This radical cultural expression turned traditional pageantry on its head. With its broad popularity, the conventional pageant functioned as "mass art par excellence" in these early decades of the twentieth century. In most cases, it served nationalistic aims: to Americanize immigrants, pacify them, and instill them with patriotic fervor. Percy MacKaye, the founder of the pageant movement in the United States, called these events "the drama of democracy," as they generated civic and national pride in immigrants who witnessed national legends and symbols brought to life through allegorical expression. The representation of political concerns in the Paterson Strike Pageant contrasted decisively with the "civic loyalty" proclaimed by most pageants, such as the 1913 Labor Day pageant produced by the city of Chicago at a playground in Palmer Park. In place of the activist stance enacted by workers in the Paterson Pageant, the Chicago production framed a tableau in which Labor and Capital joined hands to symbolize their united commitment to harmony and progress.[96] Indeed, the Paterson Strike Pageant stood as an oppositional voice within this popular American tradition.

Similarly, Charles Oscar Haag and Adolf Wolff sought to make manifest the interests of labor in their small-scale sculptures of workers and strikers. In so doing, they proclaimed an allegiance to and heritage in working-class culture. In fact, one writer stated in 1917 that Haag was "pronounced by some to be our leading labor sculptor."[97] Haag was born in Norrkoping, Sweden, in 1867, and at an early age experienced the drudgery of manual labor. At the age of twelve, after the death of his mother and a family financial

crisis, he worked for a while in a faience factory. With some savings and a growing commitment to the sculptural arts, he enrolled in the School of Industrial Arts in Gothenburg, Sweden, and at seventeen traveled to Stockholm; Berlin; Winterthur, Switzerland; and Paris, where he lived for eight years. It was in Paris where he learned of the sculpture of Constantin Meunier to whom his work would owe a great debt. To support his study of sculpture, Haag labored in many factories throughout Europe, where his commitment to the proletarian struggle took shape. In 1903, he emigrated to the United States, penniless, after years of toil and poverty.[98]

Haag established himself as a sculptor soon after his arrival, maintaining a studio in New York City from 1903 to 1904, then moving to an artist's colony near Coytesville, New Jersey, in 1907 and later to a farm in Silvermine, Connecticut. In 1906, he exhibited several sculptures of labor and working-class themes in an exhibition at the New Gallery on 15 West 30th Street, a small cooperative gallery. Among those works exhibited was *The Immigrants* of 1905, his first sculpture produced in this country. It depicted several weary and apprehensive figures: four men, one woman holding an infant, and an idealized figure (to which we shall return) trudging into an immigration facility, probably Ellis Island (Fig. 58).

All the men – both young and aged – except the central figure, were burdened by their bundles; one woman, eyes downcast, cradled an infant at her breast. Haag depicted these immigrants with careful detail, documenting their specific facial features, mustaches, and workers' caps. In the central male and female figures, however, Haag signaled a note of optimism. He heroicized the male figure – the largest of the group – whose upraised left arm and hand, a focal point of the composition in its exaggerated scale, conveyed his strength and his role as a new world worker. A babushka-clad woman swaddling her baby stood to the right of this figure. Although reaffirming a separate spheres ideology – the man as worker, the woman as nurturer, Haag simultaneously reinforced the equality of the sexes through a common trope: the parallel stance of the male and female figures, a stance also apparent in his *Accord*. (Fig. 59).

Haag had modeled *The Immigrants* from firsthand experience – as both a worker and an artist finding a livelihood in his adopted home. To the rear of the sculpture stood the most fascinating of the figures: a young woman with long flowing hair wearing a simple sheath. With vaguely defined features, she carried a portfolio in her arms. To Haag, her presence suggested a working-class muse. In fact, the figure was nearly invisible to the viewer from the front of the sculpture, hidden behind the huddled mass of the immigrants. She existed as a specter – the spirit that guided Haag in his artistic endeavors in this new land.[99] He explained:

This group that I finish – I am in that. It is personal. . . . They carry their burdens from one country to another. I know them. I travel with them. I am one of them all

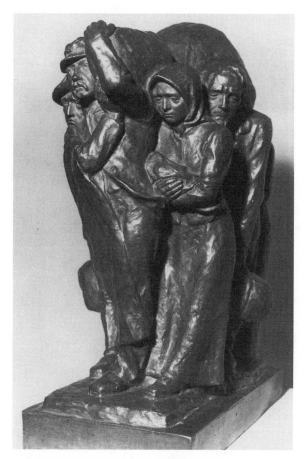

Figure 58. Charles Oscar Haag, *The Immigrants,* 1905, bronze, 18½" h. American Swedish Historical Museum, Philadelphia.

my life . . . an emigrant. . . . I am a potter by trade. My father before me is a weaver. . . . All my life, in Sweden, Switzerland, France, I live with the class that is mine. I struggle and suffer as each laborer struggles and suffers. So, when I am a sculptor, I try to give expression to the laborer in my art.[100]

Haag was one of the first sculptors to represent the theme of immigration, although Beach later produced a small plaster, *The Immigrants,* which he showed at Macbeth's in 1914. Interest in this social phenomenom attained such heights that by 1915 Gertrude Vanderbilt Whitney sponsored an exhibition, "The Immigrant in America," at her expanded MacDougal Alley studios. Working in conjunction with the National Americanization Day Committee, she offered $500 prizes for the best works of painting and sculpture that represented "America as the place for the fusion of the different races, traditions, and forces into a vital and unified whole." Serving the needs of a "melting-pot" ideology – typical, also, of contemporary pageants, this contest and its parent exhibition served "as a patriotic call to the artists of this country

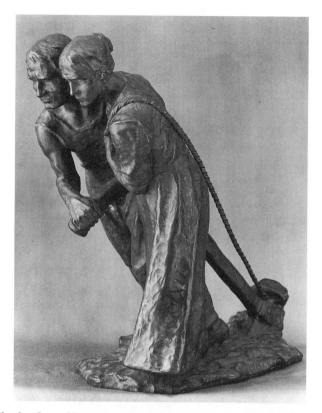

Figure 59. Charles Oscar Haag, *Accord,* 1905, bronze, 13" h. The Metropolitan Museum of Art. Gift of Several Gentlemen, through John Spargo, 1906 (06.1227).

to inspire both native and foreign-born citizens with a better mutual understanding of setting forth the ideals of a united America." Henri, Sloan, Charles Dana Gibson, Chester H. Aldrich, James E. Fraser, Frank X. Leyendecker, and Paul Manship served on the jury. This successful show drew 250 persons daily on the weekends and a well-publicized visit from Theodore Roosevelt. With the admission fees ranging from $0.25 to $1.00, Whitney donated the proceeds to various Americanization campaigns.[101]

This burgeoning interest in the immigrant gained Haag's sculpture some notoriety. After being shown in a 1916 exhibition at the Art Institute of Chicago, critics saw his sculpture as part of a "new Americanism." As one writer observed, "All of his figures which seem to us so quaintly foreign are now interpreted as the naive expression of an Americanism which we have not perhaps appreciated, for they are all studies of those who have come to us from Europe to toil as pioneers in the development of a new land."[102] With fully 17 million immigrants having entered this country between 1900 and 1917, this issue stood on the forefront of many people's minds. Such commentary suggested a nascent expression of "100 percent Americanism" – a complex social doctrine that, in demanding total conformity to national ide-

als, gained much currency during the war years. In viewing Haag's immigrants as homogenized natives, this critic likened these figures to "pioneers" and proposed a distinctly American identification and heritage for them.[103] Through such cultural institutions as pageantry and art exhibitions, for example, this process of "assimilation" provided a way to construct an identity for the immigrant that proved less threatening to an increasingly xenophobic nation.

As a tribute to its powerful expression of the immigrant experience, John Spargo, who himself had arrived from England in 1901, lobbied authorities to have the *Immigrants* installed on a monumental scale at Ellis Island. Spargo, an enthusiastic supporter of Meunier's sculpture and a radical reformer who wrote *The Bitter Cry of Children* in 1906, a muckraking exposé against child labor, argued in a 1905 *Craftsman* article that Ellis Island was "the most appropriate site for [the sculpture] in the whole world." The project, unfortunately, was never realized.[104]

With tireless zeal, Spargo attempted to find institutional homes for *The Immigrants* and for a sculpture that it appeared he owned, *Accord* of 1905 (Fig. 59), a depiction of a peasant man and woman pulling a primitive plow. With aplomb, he wrote the director of the Metropolitan Museum, Caspar Purdon Clarke:

It was my good fortune to know Constantin Meunier personally, and I have no hesitation saying that Haag is an equally great, or even greater, artist.

One of his small bronzes, *Accord,* in my possession seems to me worthy of a place in the museum. . . . Above all, Haag has lately done what I consider to be the greatest distinctly American group yet produced in this country, a fine group called *The Immigrants.* Nothing could be truer to life as I have seen it at Ellis Island than this noble group.[105]

Amid much discussion at the museum, the trustees accepted *Accord* as a gift from Spargo and rejected *The Immigrants* when offered by the artist. Such rejections would come often to Haag in these years. He had no money to cast his sculptures in bronze; he modeled them in clay, cast them in plaster, then set them away in his studio, where they remained unobserved except by a few admiring friends, like Spargo.[106]

However, it must be noted that Haag contributed to his own poverty. He often refused to deal resonably with museum officials, at times behaving cantankerously in their presence. Moreover, he asked exorbitant prices for his sculptures, in effect, pricing himself out of the contemporary market for American sculpture. To what extent this behavior was due to his eccentrism or to his political beliefs will always remain unclear. His disdain for privilege and authority remained strong throughout his life. One critic wrote sympathetically:

[Labor] is a noble and all too infrequent subject for an artist of power. . . . Those who usually buy works of art are precisely those who do not wish to be reminded of

the substructure of distorted and unsightly humanity – coarse, crude, and elemental.[107]

Accord was Haag's only sculpture to be purchased by a major museum. Although produced in the United States, the sculpture referred to the rural labor that he associated with his native Sweden. He explained that "I call it 'Accord' because I think the sexes come nearest together in the peasant class. In their daily work at the plow, in the field."[108] As the woman and man worked the plow together – both strained equally in their task. The male figure held the plow with his muscled right arm; his large left hand grasping the handle. His body leaned dramatically forward – to emphasize the burden of pulling the heavy implement. The woman pulled a rope tight around her shoulder as she helped maneuver the plow through the fields. Her body formed the shape of an arc – shoulders and legs forward, hips pulled backward by the strain. The parallel lines of their right legs, propelling each figure forward, gave visual form to the equality of the sexes – a principle that Haag pictured throughout his *oeuvre*.[109]

In its depiction of preindustrial labor, the sculpture recalled the reverential spirituality associated with Millet's peasant workers, a characteristic that appealed to museum officials. In this way, it differed dramatically from later images of labor that Haag produced. More typical of Haag's representations of labor were two sculptures, *The Strike* (Fig. 60) and the *Labor Union* (Fig. 61), both of 1905. In these sculptures, Haag depicted labor in revolt – workingmen actively engaged in direct political action. As a participant himself in labor struggles in Europe, Haag championed union solidarity and the strike as an effective tactical weapon.

In *The Strike*, he depicted three miners huddled with picks at rest, anxiously awaiting strike news. Attentive, alert, and poised for action, these figures stood responsive to their current plight and empowered to affect their destiny. Dressed only in work pants and hoods, these workers revealed their naked upper torsos. However, unlike Young's *Man with a Pick* (Fig. 53) or Beach's *The Stoker* (Fig. 51), Haag's strikers did *not* reveal exaggerated musculature under Herculean strain. In fact, as mentioned earlier, it was the male body on display – this process of aestheticization – that neutralized any message of political agency. Haag's sculpture suggested empowerment – an act of social justice about to take place. He explained, somewhat optimistically:

I believed the great human types were here in the new world of democracy [America], and I want them for my work. And now [that] I am here, there is a difference, I find, between the laborer of Europe and his brother in America: in Europe the peasant is the symbol of resignation, of patience, and hopeless suffering and it is the sculptors who have given him sympathetic treatment reveal him. In this country it is not so. Here labor is aggressive, dominant, strong, a type that, for the artist, is scarcely to be found in the peasant of Europe. So, to the sculptor who would give it his life, there is a new world to be discovered and given to art among the toilers of America.[110]

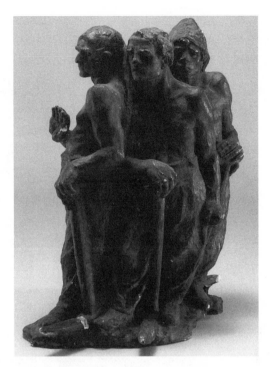

Figure 60. Charles Oscar Haag, Model for *The Strike*, ca. 1905. Original lost, painted plaster, 13⅝" h. Augustana College Art Collection, Sofia Haag Trust.

Haag portrayed his workers as "aggressive, dominant, and strong" through thematic means – the depiction of a strike and through his formal choices – the male body poised and alert, rather than aestheticized with bulging muscles for pleasureful viewing. In depicting his figures as dynamic agents in the world, he gave visual form to the concerns and experiences of working-class constituencies.

In his iconic image, *Labor Union*, Haag advocated worker solidarity in the form of collective action. He depicted three immigrant workers, each with highly individualized features, who swore an oath of union solidarity on an overwhelming sledgehammer, the symbol of their toil (Fig. 61). The rhyming of their gestures and the intensity of their gazes evoked a noble bearing and advocated a profound commitment to the labor cause. Haag placed their strong arms centrally in the composition, signifying the physical and political strength of American labor. Writing in 1907, Crystal Eastman, a radical reformer who championed Haag's sculpture, saw in this work an expression of her own revolutionary politics. She wrote:

[three men] stand with their right hands clasped one above the other on the handle of a sledge, and in their strong features and purposeful faces there is expressed not so much defiance as steadfastness. They seem to be united by their common hope. We are made to see in this group the nobility that comes to everyday men when

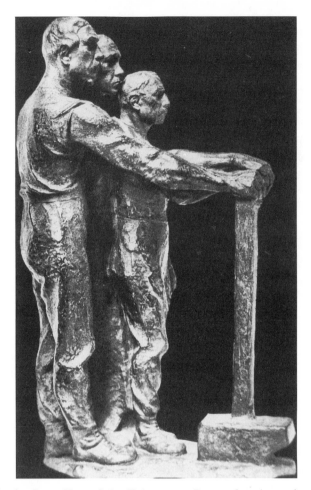

Figure 61. Charles Oscar Haag, *Labor Union*, 1905. Present location unknown. (*Source:* Crystal Eastman, "Charles Haag: An Immigrant Sculptor of His Kind," *The Chautauquan* 48 [October 1907]: 257.)

they have for a time lost sight of individual pain, and are standing together for some common good.[111]

Indeed, both *The Strike* and *Labor Union*, in their tightly wedded multifigural compositions, suggested the authority of collective action, the effectiveness of industrial unionism, and an affinity with the ideology of the Industrial Workers of the World. To a contemporary audience, the association of *The Strike* with the tactics of the IWW was unavoidable; similarly, Haag's emphasis on the detailed features and individualized ethnic identities of the workers in *Labor Union* suggested the potential of union solidarity among immigrants. Although there is no evidence of Haag's membership in the IWW, his sculpture aligned itself with the most radical of contemporary politics.[112]

Several labor unions viewed Haag's *Labor Union* favorably. In 1911, John P. Frey, editor of the *International Molders Journal*, observed that Haag was the

"first sculptor to conceive and execute a group to organized labor." He recognized the power of Haag's sculpture in bestowing dignity, autonomy, and political agency upon workers. Years later, in 1929, when the American Federation of Labor organized a competition for a memorial to Samuel Gompers, Haag submitted a model of *Labor Union* to the committee and carried on a five-year correspondence with William Green, president of the AFL. As discussed further in the conclusion to this book, the AFL, whose conservative practices protected only skilled white male workers, rejected Haag's model with its representation of immigrant workers and its association with the radical politics of the IWW. This episode represented a bitter emotional defeat for the artist.[113]

Haag submitted models for several other public monuments during his career. During a brief move to Chicago in 1909, he accepted a commission from William Bross Lloyd for a memorial to his father, Henry Demarest Lloyd, a champion of labor and an advocate for civil rights (Fig. 62). A lawyer and journalist for the *Chicago Tribune,* Henry Demarest Lloyd retired in 1885 to devote himself fully to the promotion of social justice. He voiced outrage at the verdicts and sentences handed down during the Haymarket Trial, and as a result, he suffered many indignities, among them, disinheritance from his family's fortune. Moreover, he served as secretary for the program committee of the Labor Congress held at the 1893 World's Columbian Exposition. A life-sized bronze sculpture of a weary, ill-paid worker served as Haag's tribute to Lloyd. Seated with head in hand, this dejected worker represented the tribulations of the poor. An excerpt from Lloyd's writings appeared upon the base: "No tenements for some and castles for others. . . . Society should give every man not his daily bread, but a chance to earn his daily bread. . . . All Property is property in man." Entitled *Corner Stone of the Castle,* this memorial was installed in 1914 on the Lloyd Estate in Winnetka, Illinois. Purchasing *The Strike* for their private collection, the Lloyd family served as one of Haag's few committed patrons.[114]

In 1914, Haag entered a sculptural competition to honor the memory of John P. Altgeld, the Illinois governor who, as discussed in Chapter 2, exonerated the Haymarket martyrs. A close friend of both Clarence Darrow and Henry Demarest Lloyd, Altgeld was admired as a man of political courage and personal conviction. In his small-scale plaster model for an unexecuted monument, Haag presented a male nude, vulnerable yet resilient in character, seated with a noose under his left foot – a symbol that recalled the execution of the four anarchists (Fig. 63). Entitled *Democracy (Memorial for John P. Altgeld),* the sculpture evoked a sympathetic humanism – Altgeld at the crossroads of his life as he prepared to make the unpopular decision of granting amnesty to the three remaining jailed anarchists.

The competition procedure was long and tedious. After the monument committee, appointed by the Illinois legislature, had held two separate competitions without satisfactory results, they requested that Haag submit a

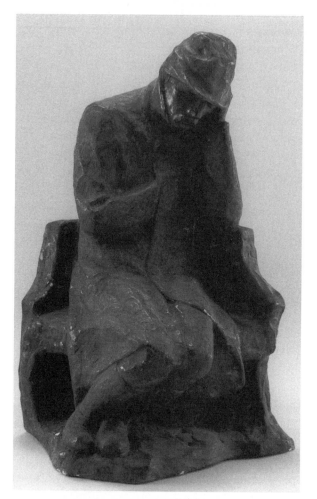

Figure 62. Charles Oscar Haag, model for *Corner Stone of the Castle*, ca. 1909, painted plaster, 11⅝" h. Augustana College Art Collection, Sofia Haag Trust.

sketch. Although the committee was sympathetic to Haag's conception, a scathing art review in a May 1910 *Chicago Tribune* condemned the committee for their choice of a nude male figure to serve as a public memorial. (Once again, the male nude stood at the center of controversy!) As a result, the legislature rejected Haag's submission and appointed Gutzom Borglum to the task of producing the monument. Paternalistic in conception, Borglum's memorial presented a standing figure of Altgeld with a worker's family at his feet, a composition that misrepresented Altgeld's defiant yet respectful support of labor. Installed in 1915, the monument stands in Lincoln Park near Lake Shore Drive in Chicago.[115]

In addition to his sculptures of laboring themes, Haag also produced designs for public fountains, intended for parks and children's playgrounds. Like Eberle, he was concerned with the lives of the poor and attempted to

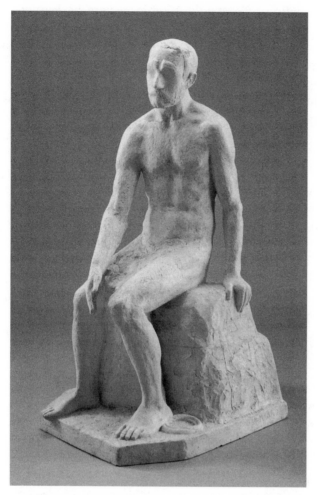

Figure 63. Charles Oscar Haag, *Democracy (Memorial for John P. Altgeld)*, 1914. Plaster model, 24½" h. Augustana College Art Collection, Sofia Haag Trust.

improve their urban environment through artistic means. Haag produced several fountains, among them *The American Fountain (Indian Drinking at a Brook)* in Jamestown, Pennsylvania, currently extant. By late 1910, he shifted his interest from sculpture of laboring themes to a glorification of nature and the mythical spirits that he believed inhabited the natural world. His wood carvings of gnomes and spirits dominated his creative production for the remainder of this life.[116]

Unlike the eccentric and somewhat erratic path of Haag, Adolf Wolff committed his life to political engagement, advocating first an anarchist, then later a communist ideology, as we shall see in the following chapter. Born in Brussels in 1883, he emigrated to the United States while still a child and later began study at the National Academy of Design in New York. After returning to Brussels to study at the Académie Royale des Beaux Arts, he

entered the studio of Constantin Meunier, where he learned the power of socially concerned art. Wolff was quite ambitious in his career, intending many of his small sculptures for production on a monumental scale. However, to date, only four extant works are known; the remainder come down to us through reproduction.[117]

As a committed anarchist, Wolff engaged in a political philosophy with a wide-ranging identity. With individual freedom at its core, anarchism, as a political movement, refused any centrist party organization or strict codified rulings. Moreover, as a social philosophy, it appealed to many literary and visual artists in both Europe and America between 1890 and 1920, among them Robert Henri and George Bellows.[118] During the years 1912 to 1913, Wolff conducted art classes at the Modern School of the Ferrer Center, the leading anarchist center in New York. With Henri, Sloan, and Bellows, he taught the children of workers as well as many adults, including Man Ray and Max Weber, two promising young art students.

The Ferrer School had reached its peak of influence in 1912. Christian Brinton (who would write the essay on Meunier for the 1913–14 American exhibition) spoke at Saturday evening discussions, along with Alexander Berkman, Emma Goldman, Elizabeth Gurley Flynn, Lincoln Steffins, Hutchins Hapgood, Upton Sinclair, and Edwin Markham. By 1915, the center came under constant attack for its pacifism. In 1918, the Center closed and the school relocated to Stelton, New Jersey.[119] It was in this heady environment that Wolff was encouraged to commingle his commitment to art and to radical politics.

Wolff saw himself as a poet, sculptor, and revolutionary. His poems, although not outstanding, were published by sympathetic political journals, such as the *Modern School Magazine* and the *The International Socialist Review*.[120] His sculpture differed in style from the other plastic expressions that we have studied in its deployment of a modernist artistic vocabulary. Uninterested in the social realism of his mentor Meunier, Wolff adopted the language of modernism to signify individuality and freedom, the basic tenets of his anar-

Figure 64. Adolf Wolff, *Temple of Solidarity*, 1914. Present location unknown. (*Source: The International*, March 1914.)

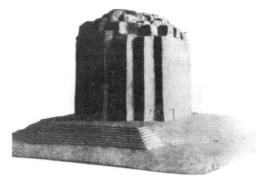

chist philosophy. In 1913, he proclaimed: "The only thing truly our own, the only thing that is sacred private property is our individuality, and he who tries to put his hands on it is a thief, perhaps the only kind of thief without any justification."[121]

In his *Temple of Solidarity* of 1914, for example, Wolff produced an abstracted homage to worker unity (Fig. 64). In contrast to the detailed realism of Haag's sculpture, this piece was described by one critic as "a social-symbolic-architectural-cubist sculpture."[122] Representing a model of an enormous meeting hall of the future, the abstracted forms of the building conveyed its purpose by recalling a prototypical crowd of men gathered in a public assembly. Rendered with the geometric lines and flat planes of a cubist vocabulary, the architectural-sculptural model conveyed notions of unity and solidarity with simplicity and directness.

To be sure, Wolff's political commitments were unambiguous. In 1914, for example, he participated in IWW meetings and demonstrated for the unemployed in New York's Union Square with anarchist leaders Alexander Berkman and Carlo Tresca, and IWW leader Big Bill Haywood. Arrested and convicted for inciting to riot, he received a suspended sentence provided he refrain from political activity. Undeterred, he traveled to the estate of John D. Rockefeller, Jr., in Tarrytown, New York, to protest the massacre of striking miners and their families in Ludlow, Colorado, the previous year – the bloody labor dispute memorialized by John Sloan in his graphic "Ludlow, Colorado" (Fig. 38). Throughout the decade, he returned to court on a variety of charges, all of which stemmed from his political activities.

Adolf Wolff continued his politically engaged artistic activities into the 1920s and 1930s. The following chapter relays the fate of working-class themes in sculptural expression until the establishment of the Works Progress Administration/Federal Arts Project of 1935. Generally a conservative political climate, the postwar period boasted a glorification of the individual skilled worker in American sculpture. With the birth of the Soviet Union in 1917, a small number of artists turned to Soviet culture as an alternative model. Later, the John Reed Clubs, a cultural organization founded in 1929, encouraged and promoted a communist ideology with its focus on working-class culture. To be sure, representations of the worker helped articulate a variety of ideological positions on the cultural battlefield of the "new capitalism," the designation for the new, postwar industrial economy.

CHAPTER SEVEN

ICONS OF LABOR

Capitalism, Communism, and the Politics of Sculpture, 1917 to 1935

The meaning of labor stood at the center of political debates in the United States during the 1920s and 1930s and representations of the worker served a variety of ideological interests – from organized labor to industrial capitalism to the radical proponents of communism. During the robust economy of the 1920s, a new spirit of optimism pervaded imagery of the skilled industrial worker, ennobling and "glorifying" (to use a term from the contemporary critical literature) the role of labor in American society. Surprisingly, this labor imagery exemplified the concerns of both management *and* labor in its depiction of a small elite core of industrially skilled tradesmen, a class of workers ever diminishing due to technological progress. Equally notable were the absences within this representational universe – the factory, its assembly line, and Taylorized work force of semiskilled operatives who functioned as cogs in this industrial system.

A constellation of images – the sculpture of Max Kalish (1891–1945), the paintings of Gerrit Beneker (1882–1934), the photographs of Lewis Hine (1874–1940) and Margaret Bourke-White (1904–71) as well as mass-media illustrations – represented skilled workers as partners in the industrial process. Reproduced widely in popular journals as well as labor and management publications, such images, as Max Kalish's *New Power*, for example, enjoyed a broad audience consisting of skilled and unskilled workers, organized labor, and industrial management (Fig. 65). Championed by the American Federation of Labor during an era of diminishing power, these images were read as signs of work pride in their designation of labor as an heroic and self-determining endeavor. One may imagine (since no primary documentation exists) that these very same images represented to the newly arrived immigrant and otherwise unskilled worker standards of respected craftsmanship to which they could someday aspire. Concurrently, the growing ranks of industrial management also deployed such imagery – often commissioned by corporate capitalism and published in shop journals – to assuage the alienation many workers experienced on the job. Further, these depictions shouldered yet another duty in responding to the challenges posed by Communism's new economic order. They valorized American skilled labor in order to compete with this burgeoning socialist society in which the worker served as the keystone of industrial production.

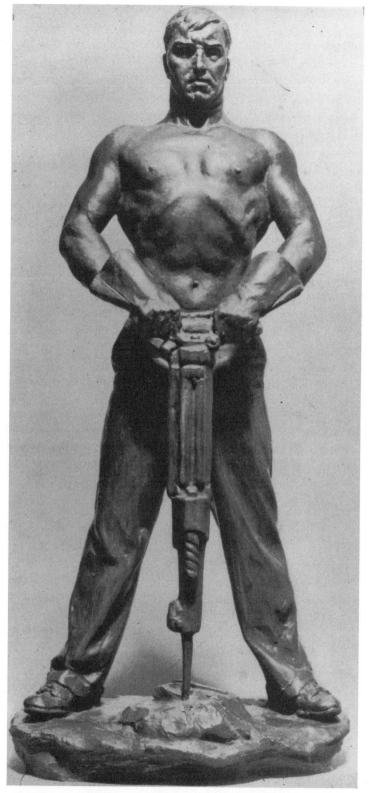

Figure 65. Max Kalish, *New Power*, ca. late 1920s. Present location unknown. (*Source:* Emily Genaur, *Labor Sculpture by Max Kalish, A.N.A.* New York: Comet Press, 1938.)

While images of the skilled heroic worker were widely disseminated to American audiences, few representations offered any challenge to this near hegemonic construction. Unskilled workers, mostly immigrants, blacks, and women who comprised the mass of the American labor force in the 1920s, served as subjects to only a small number of sculptors in the 1920s – Saul Baizerman (1889–1957) and Adolf Wolff. Their images formed part of a radical labor discourse most powerfully represented by graphic artists of the leftist magazines the *Liberator*, the *Daily Worker*, and *The New Masses*. Though less known and far less popular, these images posed an alternative understanding of the role of the worker in capitalist society – an alternative, as we shall see, that formed the basis of the proletarian content many left-leaning sculptors of the 1930s, such as Aaron Goodelman (1890–1978), expressed under the auspices of the John Reed Clubs (1929–35).

This chapter turns our attention to visual culture – sculpture, painting, photography, and mass-media imagery – as a mediating presence in the debates between competing labor communities and the interests of industrial capitalism. It is important to understand that these images function not as truth – that is, as "reflecting" some preexistent reality – but as an assortment of visual codes embedded with cultural assumptions that seek to produce and normalize specific ideological positions. As Stuart Halls explains:

Representation is a very different notion from that of reflection. It implies the active work of selecting and presenting, of structuring and shaping: not merely the transmitting of already-existing meaning, but the more active labor of *making pictures mean*.[1]

Thus, a primary argument of this chapter is that visual representation actively worked to shape labor relations in the 1920s.

Moreover, in understanding visual representation as part of a semiotic system – that is, a process by which meaning becomes culturally encoded – the viewer participates actively in the process of interpretation. Signification is polysemic, and at times, even contradictory. In fact, through the circulation of signs or visual codes – through mass media, sculpture, painting, and photography – meaning refuses stability; its cultural significance remains under constant negotiation from varying sectors.[2] It is this very process of negotiation that will be the central focus of this chapter.

The specific form and content of worker imagery in the 1920s and early 1930s hinged upon debates about labor as either an individual or collective endeavor. I argue that images of the heroic worker, in their detailed realism, both acknowledged the contribution of the craftsman in a new technological age and fostered a spirit of independence among workers concerned with their own individual achievement within the discursive framework of "new capitalism." Ironically, this language of "capitalist realism," as coined by Terry Smith, came very close to the style of Socialist Realism, a visual language codified in 1932 but actively representing heroic technological workers in the

Soviet Union throughout the 1920s.[3] This polysemy of meaning regarding labor imagery suggests the elasticity of readings available to viewing audiences who – within diverse historical conditions, in this case, American capitalism and its seeming opposite, Soviet Socialism – understood similar visual treatments very differently. Several significant dissimilarities can be noted however between the American and Soviet models of workers – scale and social function, for example. The Soviet sculptures, like the famous *Worker and the Collective Farm Woman* of 1937 by Vera Mukhina, stood over 36 feet high and played a highly public role in contemporary Soviet society.[4] By contrast, American sculptural imagery of the heroic worker, like Max Kalish's *New Power*, only about three feet high, was produced expressly for private consumption within a capitalist art market (Fig. 65).[5]

Sculptural images in sympathy with the underclasses in this country, such as Saul Baizerman's *The Digger* of 1923, for example, rendered in a simplified, modernist vocabulary, suggested the aggregate of workers and the collectivity of the laboring process (Fig. 75). Self-consciously fashioned in a highly abstracted visual language, this sculptural representation lacked the transparency of the realist style and offered a more clearly imaginative – or one could argue utopian – image of the worker. Implying an alternative attitude toward labor, one more in favor of socialist rather than capitalist goals, these images found little favor in an age when industry and capitalism were lionized. In fact, these works anticipated the proletarian revolutionary consciousness of the 1930s, a consciousness, as we shall see, both espoused and promulgated by the radical artistic centers of the John Reed Clubs.

■ ■ ■

As labor entered into partnership with industry and technology in the 1920s, a new image of the skilled industrial worker emerged in the visual arts. The contemporary worker came to be depicted as powerful and confident, engaged in an harmonious accord with the modern machine. In one such image, *New Power*, a sculpture dating from the late 1920s, Max Kalish substituted the pneumatic drill for a manual tool and empowered this virile worker with a symbol of industrial might (Fig. 65). With its strong vertical presence between the wide-legged stance of the worker, the phallic imagery of the drill clearly associated sexual prowess with technological strength. As we have seen throughout this book, labor and masculinity have formed a mutually constitutive discourse, signaled here, once again, by the traditional imagery of the near-naked and clearly eroticized male body of the worker. In this image, the bare-chested industrial worker consummated his physical task with an air of triumph and victory. Man and machine were wed in a unified harmony – partners in the advance of modern-day progress.[6]

Kalish rendered his figure with a blend of classical idealism and detailed realism that came to typify the image of the American worker throughout the decade. As Kalish once declared: I do "not copy nature, but perfect it."[7] With

its muscular torso and bare chest, the sculpture willingly recalled the heroic and powerful nudes of antiquity. Yet in the detailed accuracy of the work clothes and pneumatic drill, it called close attention to the accouterments of the worker's skilled trade. Such specificity conveyed the contemporaneity of the worker's task and lent an air of "authenticity" to the sculpture, obscuring the mediating role of representation.[8] As one critic noted in 1927, "The synthetic sculpture of Max Kalish represents the glorification of the American Laborer. . . . [These sculptures] will someday serve an historical function as records of the modus operandi of A.D. 1927."[9] Thus, to at least one reviewer's mind, Kalish's heroic laborers could actually serve as historical evidence of the growing stature of the skilled worker in the 1920s.

Born in Poland in 1891, Kalish emigrated with his family to the United States at an early age. Raised in Cleveland, Ohio, he trained at both the Cleveland School of Art and in the machine shops of the city. In 1910, he moved to New York, where he continued his studies at the National Academy of Design with Sterling Calder and Isidore Konti; in 1912, he studied in Paris with Paul Bartlett, whose own interest in labor was manifested in his pedimental sculpture for the House Wing of the United States Capitol,[10] and received access to Rodin's studio for weekly critiques. But his artistic concerns never strayed far from the industrial heartland of Cleveland, where he returned to live and work in 1913. Kalish explained, "I live in Cleveland, an industrial city, and was impressed with the movement, grace and beauty of the workers. I said, 'That is what I will create. It is something of the present, of America.'" Praised by many as "the Walt Whitman of Bronze," Kalish received many accolades for his sculptures of industrial laborers.[11] Indeed, in his focus upon contemporary industry and the worker, Kalish – like Whitman – brought attention to the ordinary by making it heroic. In so doing, he participated in a nationalist discourse that placed progress and technology to the center of American identity – an identity given visual form in the 1920s through the trope of the skilled industrial worker.

It was true that many skilled workers reaped the benefits of expanding production and rising national incomes. The middle class absorbed more and more of these workers as higher wages and shorter working hours allowed more leisure time and more discretionary income for direct participation in the newly emergent consumer society. During the decade, there was a qualitative leap in living standards provided by consumer durables that now became accessible to the workingman. Not all workers, however, had equal access to this consumer culture as the spread in wage differentials between skilled and unskilled workers was truly astounding. Nonetheless, for the skilled industrial worker as well as for the entire middle class, the rising materialism of the era provided a sense of lasting economic security, and an indomitable spirit of optimism.[12] Such confidence appeared in the majority of labor images of the 1920s.

Nothing better symbolized America's attitude of technological optimism

than the erection of vast skycrapers during the decade.[13] The skilled construction workers who helped build these huge structures were often depicted as popular heros, contributing to America's growth and prosperity. In the visual arts, these workers were among the most visible labor subjects depicted in the 1920s, and like the very skycrapers on which they worked, these laborers served as potent symbols of industrial progress. Moreover, the building trades were very successful during the decade, and their workers, protected by extremely selective trade unions, benefited greatly from the rising prosperity. In fact, the construction and automobile industries formed the basis of the economic boom of the decade.[14] Thus, it was not surprising that such images of skilled workers appeared regularly as illustrations in contemporary journals. For example, *Forbes, Literary Digest,* and later *Fortune* often published images of skilled construction workers by Kalish, Gerrit Beneker, and Lewis W. Hine. Indeed, the popular press adopted this vision of the heroic worker and widely disseminated it to American readers.

These popular images portrayed the skilled construction workers as independent, confident, and alert partners to industry. In *The Builder* of 1920, Gerrit Beneker rendered his construction worker, hard hat in hand, gazing upward in reverential awe at the product of his skilled labor (Fig. 66).[15] The worker stood high above a mighty industrial riverscape of blast furnaces, smoke stacks, and steamships, a champion in his contribution to modern technological society. Similarly, a photograph by Lewis Hine from his "Empire State Building, New York City" series of 1930–1,[16] captured a moment when a steelworker guided the placement of a column section (or I-beam) high above the vast panorama of the city (Fig. 67). More than any other building project of the era, the Empire State Building, which towered nearly a quarter of a mile in height, symbolized the furthest reaches of contemporary technological achievement. Hine captured the excitement that this project engendered, presenting the workers on the Empire State Building as modern titans – masters of the modern industrial world.

In 1926, *Literary Digest* ran a feature story on Max Kalish entitled "The American Worker Glorified in Bronze," and used his sculpture, *The Steelworker,* ca. 1926, as one of its four main illustrations (Fig. 68).[17] The large reproduction, centrally positioned upon the opening page of the article, had as its caption "An Apollo of the Skyscrapers." Kalish presented a highly trained worker, directing the placement of steel beams on a construction site. Although perched high above the city on the steel skeleton of a soaring skyscraper, he appeared relaxed and confident, comfortable in his contrapposto stance, holding with ease the hoisting chain that steadied him. His open, active posture conveyed an attitude of competency and control, underscoring his directorial capacity and engagement with the technological process. In the *New York Post,* a reviewer claimed that "Kalish's laborers are those which old world immigrants dreamed of becoming when they thought of America as the promised land."[18] To be sure, these images provided the

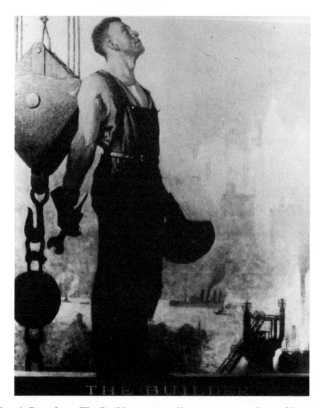

Figure 66. Gerrit Beneker, *The Builder,* 1920, oil on canvas, 40" × 36". Present location unknown. (*Source: Gerrit A. Beneker 1882–1934, Painter of American Industry.* Boston: Vose Galleries, n.d., pl. 7).

prototype of the American workman in the 1920s and helped construct a nationalist discourse associated with the skilled worker.

Kalish's workers differed from those images produced during the previous decade. As discussed in the Chapter 6, Mahonri Young and Chester Beach depicted, for the most part, manual workers struggling with their tasks in an evocation of a preindustrial work ethic. In 1917, Young modeled one of his only sculptures of a skilled construction worker, *The Rigger* – a composite of different workers whom he had observed outside his studio window (Fig. 69). He explained:

I first saw the action when a carpenter picked up a block and fall to use in stretching a wire fence. I made a sketch of the action in red chalk at the time, then when I started to model it I realized how much more effective it would be on the steel construction of a building. So I placed it on the steel girders as you now see it. I called it "The Iron Worker." South of my studio . . . a new steel building was erected . . . it passed my windows and finally shut out the light. I made drawings of it all the way. When the steel reached my windows the steel men used to come and sit in them. One of the men spoke about "The Iron Worker" . . . he was a "rigger" . . .

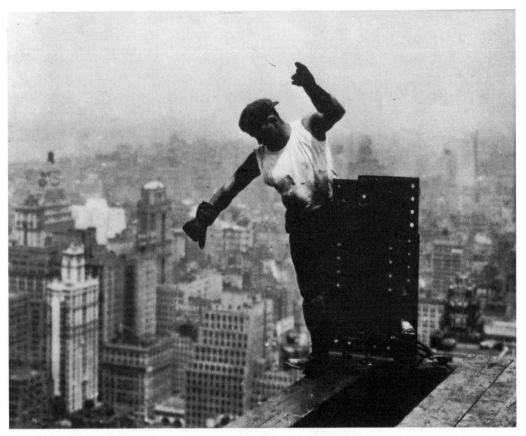

Figure 67. Lewis Hine, *Empire State Building, New York City,* 1930–1. From the Collection of Walter and Naomi Rosenblum.

men who put up the derricks and drive the first rivets. And that's how "The Iron Worker" became *The Rigger*.[19]

Despite the contemporaneity of the subject matter, Young's representation of the construction worker refused the herculean dimension of Kalish's sculpture. Young depicted his worker in a strained posture – bent and struggling to move the heavy rigging. His sleeveless shirt revealed heavily muscled arms – the left arm stretching diagonally across his body and pulling his shoulder down by the weight of the gear. His face showed strain, his mouth drooping due to his physical exertion. Unlike the masterful pose and gesture of Kalish's *Steelworker* who stood in control of the technology around him, Young's *Rigger* straddled an I-beam, overwhelmed by the construction machinery around him. By the 1920s, the relationship of worker to laboring process took on new meaning in visual representation. Modernity – as inscribed in the laboring process – envisioned the skilled worker as overcoming the physical stresses of his job. Indeed, the work ethic – the spiritual elevation associated with

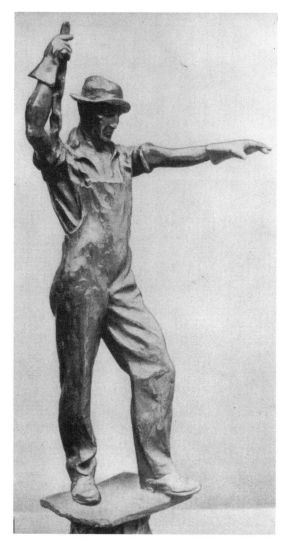

Figure 68. Max Kalish, *Steelworker*, ca. 1926. Present location unknown. (*Source:* Emily Genaur, *Labor Sculpture by Max Kalish, A.N.A.* New York: Comet Press, 1938.)

manual labor – seemed an anachronism, no longer relevant in this technological age.[20]

The confident and energetic manner in which skilled workers were depicted came to be identified with a new image of labor defined by industrial capitalism in the 1920s. The productive, efficient, cooperative, and, above all, satisfied worker formed part of the rhetoric by which industry characterized the American skilled labor force in this decade. Labor and industry were typified as partners in reaping the benefits of the current prosperity. The historical contingencies affecting skilled labor in this period, however, countered this rhetoric. The craft tradition was on the wane; the Taylorization of the work force – the breakdown of once complicated and intricate jobs into

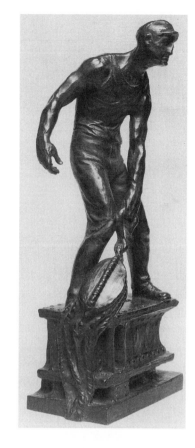

Figure 69. Mahonri Young, *The Rigger,* 1917, bronze, 62.3 cm. h. Founders Society Purchase, Elizabeth Champe Fund. (Photograph© The Detroit Institute of Arts.)

component parts by the stopwatch of scientific management – threatened the careers of many of the nation's most skilled workers; and Fordism – the newly emergent process of mass production engineered for mass consumption – laid to rest any residual belief in the moral imperative of the work ethic. As Robert and Helen Lynd wrote in their famous study of 1929, *Middletown,* "Inventions and technology continue rapidly to supplant muscle and the cunning hand of the master craftsman by batteries of tireless iron men doing narrowly specialized things over and over. . . . [Machines are] merely 'operated' or 'tended' in their orderly clangorous repetitive processes by the human worker."[21]

With industry's concern for increased efficiency and output, its motto became "a happy worker is a productive worker"; thus, management provided employees with immediate and substantive benefits through a system of welfare capitalism. Moreover, employers devised schemes to increase productivity and decrease conflict with labor through a number of sophisticated management strategies. Among the most important was the promulgation of a corporate ideology that intended to produce worker loyalty by alleviating the alienation caused by increased plant size and the de-skilling of work. By 1927, the Harvard School of Business Administration produced the Haw-

thorne experiments, which pioneered the "human relations" approach to management, an attempt to confront the problem of worker morale. As Peter Siexas explained, "Personnel counseling, which grew out of the dissemination of the understanding of the 'Hawthorne effect,' as this phenomenon came to be known, aimed to make the worker feel significant and recognized, without making any basic changes in the organization of production."[22] With the aid of these management strategies, industry received efficient and swift production from its workers, guaranteeing increased profits.[23]

Kalish's images were closely associated with this notion of the productive worker. In fact, the vocabulary of current industrial labor relations permeated the critical literature on Kalish's sculpture. In discussing *The Steelworker*, Henry Turner Bailey described it "as the efficient type" in his *Literary Digest* article of a few months later (Fig. 68).[24] Moreover, he quoted from a 1926 exhibition catalogue in which Kalish's workers were described as

what an American workman should be. Not a dull peasant, not a hopeless clod . . . but an alert, thoughtful, ambitious person, not content with things as they are, but having convictions, and ideals . . . a robust optimistic person, consciously on the way to something better.[25]

It is not surprising that the American Federation of Labor embraced this notion of labor – a notion that directly refuted the characterization of labor as "a dull peasant" or "hopeless clod," gleaned from Edwin Markham's 1899 poem, "Man with a Hoe." In 1921, the *American Federationist* – the official journal of the AFL – reproduced a graphic, "No Longer the Man with the Hoe," in which a large, brawny, and dynamic worker in overalls championed over the bent and wizened figure of the "dull peasant" (Fig. 70). Working in

Figure 70. "No Longer the Man with the Hoe." (*Source: The American Federationist* 28 [August 1921]: 645.)

cooperation with industry, the American workman saw himself represented as having opportunities to advance and prosper. Indeed, to skilled labor, efficiency, technology, and prosperity were ideologically united, an idea given visual form in another *American Federationist* graphic of the following year, "Forward," in which three figures – a confident worker, a feminine personification of progress, and Uncle Sam – strode arm in arm into the future.[26] To be sure, these graphics, together with such images as Kalish's *Steelworker,* helped construct and perpetuate an optimistic labor discourse in the 1920s.

Although distinctly known for workers as "triumphant type[s],"[27] Kalish also produced sculptures of the poor, the tired, and the unemployed. In his sculpture, *End of the Day* of 1930, Kalish depicted an older laborer in work clothes, dragging his jacket upon the ground (Fig. 71).[28] With specific facial features – deeply set eyes, wrinkled face, and mustache – and strong but hunched shoulders, this figure represented a weary and dejected worker. His long muscular arms hung listlessly, no longer engaged in productive activity. In this sympathetic sculpture, Kalish dramatized the plight of the older worker in American society.

It was often a great struggle during this decade for older workers to hold on to their positions. In the name of increased productivity, management had begun to place a greater premium on speed and nimbleness – qualities associated with younger workers, than on experience and judgment – the hallmark of the mature worker. With age limitations on hiring widely adopted, older workers, aged 35 to 50, often found employment difficult to obtain.[29] With the increased mechanization of industry and the concomitant implementation of scientific management of personnel, increased efficiency became the goal of business and industry, regardless of its consequence for the labor force. As one Middletown worker, the head of a machine shop, explained:

I think there's less opportunity for older men in industry now than there used to be. The principal changes I've seen in the plant here has been the speeding up of machines and the eliminating of the human factor by machinery. The company has no definite policy of firing men when they reach a certain age nor of hiring men under a certain age, but in general we find that when a man reaches fifty he is slipping down in production.[30]

For those skilled workers who remained employed, welfare capitalism provided immediate and substantive advantages – but such gains had their price. In providing such benefits as profit sharing, group life insurance, retirement pensions, free clinics, as well as rising salaries, industry assumed a more humanitarian role toward its workers by attempting to minimize the human problems caused by industrialization. In so doing, it gained the strong loyalty of labor. Inherent in this paternalistic attitude, however, was an anti-union sentiment that originated with the American Plan of 1919, outlawing union shops as un-American because they curtailed the worker's freedom to pursue

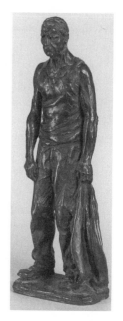

Figure 71. Max Kalish, *The End of the Day*, 1930, bronze, 15½" h. National Museum of American Art, Smithsonian Institution, Gift of Max Kalish.

employment wherever he wished. To business, the union shop with its process of collective bargaining smacked of Bolshevism and other subversive concepts of collectivism. In the wave of nationalism that followed the end of World War I, union practices stood as threats to the traditional American notion of rugged individualism. In effect, business wished to prevent class consciousness and union organization among labor's constituents.[31] In welfare capitalism's grand scheme, workers' allegiance to the company replaced allegiance to the union.

Skilled workers gained the most immediate rewards from welfare capitalism, but all workers lost an important element of self-determination. Totally dependent on the employer's good will, the worker relinquished ultimate control of his destiny through his denial of unionization and the collective bargaining process, for management maintained full authority over the terms of employment. A labor representative attended management meetings but held slight power in the decision-making process. Although little more than a forum to air grievances and ideas, employee representation appeased the workers' need for control in the workplace.[32]

The American Federation of Labor adopted a policy of reconciliation with business during the 1920s. Union membership had declined from its all-time high in 1920 of over five million to just over three million in 1929. With business opposing labor at every turn, labor leadership in the AFL grew increasingly cautious and conservative. Criticized by contemporaries as the aristocracy of labor, the AFL continued to show little concern for organizing the unskilled and protected only the skilled craftsmen. Without regard to the unity of the labor movement, individual trade unions addressed only the

specific needs of their own constituency. Advocating a nonadversarial relation-
ship with management, these conservative "business unionists" of the AFL
asserted that cooperation was the path toward the individual worker's suc-
cess.[33]

With the union movement in decline, the social and political climate of
the time fostered the traditional notion of American individualism. In a
society where President Coolidge's comment "The business of America is
business" ennobled American entrepreneurship and the stories of Horatio
Algier proliferated, individual achievement – not collective action – defined
the path to success. Whereas the work ethic ideology had earlier invoked
spiritual redemption as the reward for hard work, as demonstrated in George
Grey Barnard's sculptural program for the Pennsylvania State Capitol (Figs. 7
and 8), consumerism now became the basis for this emphasis on singular
advancement and material gain. Indeed, technological progress, rising con-
sumption and personal achievement became the hallmarks of "new capital-
ism."

Much of the labor imagery produced within the context of "new capital-
ism" celebrated the individual contribution of specific workers rather than
the collective effort of the working class. Lewis Hine, in a conscious decision
to produce "interpretive" rather than "social" photographs after World War
I, created a series of "Work Portraits," which he published in the reform
journal *The Survey* and its later incarnation, *The Survey Graphic*. In this body of
work, his "apotheosis to labor,"[34] he represented the skilled worker in mod-
ern industrial society, recording his subjects as unique individuals, competent
and intelligent in the performance of their specific trades. The "Work Por-
traits" focused upon "Railroaders," "Power Makers" (skilled machinists at
work), "Harbor-Workers," "Coal Miners," and "Hands" (skilled craftsmen –
woodworkers, silversmiths, etc.), among others.[35] Through such commissions
in which he depicted "industry from the human angle," Hine demonstrated
his continuing interest in and respect for laboring communities.[36]

Published in the first "Work Portrait" series in *The Survey* – "The Railroad-
ers," Hine's photograph of *The Brakeman*, reproduced in a full-page format,
depicted an experienced railroad worker at his job (Fig. 72). This series,
"The Railroaders," was inaugurated "at a time when the whole economic life
of the country has been at stake in the clash between the railroads and the
unions," *The Survey* explained. These photographs, the article continued,
"give personality to the day's news."[37] With jobs slashed on the railroads in
the wake of the postwar depression, tensions were high between unionized
skilled workers and management – a tension that exploded in a strike of
1922.[38] Indeed, both Hine and *The Survey* editorial staff hoped to humanize
the image of labor at a moment when union activity was viewed with suspicion.
With the monumental presence of this single figure dominating the photo-
graph, Hine prized the creative productivity of this skilled tradesman, de-
scribed in the caption as "mak[ing] order of confusion" in his directing of

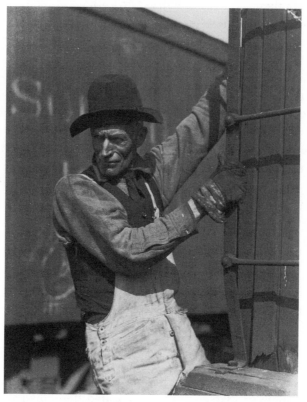

Figure 72. Lewis Hine, *The Brakeman*, 1921, gelatin silver point. (Courtesy of George Eastman House.)

freight trains onto the proper tracks.[39] When viewed within the discursive frame of "new capitalism," *The Brakeman* reinforced the image of skilled labor as confident and self-determined – an image embraced by both industry and organized labor. In depicting members of such elite trade unions as the railroad brotherhoods, Hine exalted the most privileged members of the work force, those who profited greatly from cooperation with capital.

Such images contrasted sharply with Hine's earlier reform photographs whose intention was to expose the social wrongs of industrial capitalism. In his photographs of previous decades, Hine documented groups of unskilled industrial workers – often immigrants – and captured a spirit of community and class solidarity that was markedly absent from his images of the 1920s. He also photographed intimate portraits of immigrant workers that allowed uncanny access to individuals routinely denigrated as dangerous types.[40] In *The Brakeman,* the worker appeared isolated within his environment – the significance of cooperation with other workers omitted. Further, in highlighting the worker's individual contribution within the work force, the photograph erased the presence of the union and labor solidarity – the very forces that enabled skilled workers to maintain their impressive stature within wel-

fare capitalism. Although these images were capable of empowering the worker in this increasingly antilabor era, they also refused to probe the broader context of the industrial capitalist system – the uneasy relationship between ownership, labor, and power.

Hine tried, unsuccessfully, to introduce his "Work Portraits" in the form of a lantern slide presentation to both workers and managers. Through such presentations, he hoped to foster a climate of respect and cooperation between labor and management. Reinscribing the progressive ideals of the "joy in work" and the "dignity of labor," these photographs championed the worker in the new machine age. Hine explained several years later to his editor at the *Survey Graphic* that it was important to correct some misconceptions about industry through his photographs:

One is that many of our material assets, fabrics, photographs, motors, airplanes, and whatnot "just happen," as the product of a bunch of impersonal machines under the direction perhaps, of a few human robots. You and I may know that it isn't so, but many are just plain ignorant of the sweat and service that go into all these products of the machine.[41]

Nonetheless, in his attempt to bring the contributions of labor before the public, Hine produced images that, unwittingly, enhanced the aims of capital – picturing independent workers within a harmonious working environment. Not surprisingly, such images held great appeal to industry.

From 1923 to 1927, Hine worked regularly for the Western Electric Company. He found it difficult to locate employment in the 1920s, an era in which his reformist zeal was no longer appreciated. In contributing photographs to an employee magazine, the *Western Electric News*, he hoped to represent sympathetically this community of workers. As a key tool in employee-management/relations, the magazine worked to imbue company employees with a sense of importance and artisanal pride as well as loyalty to the company. As Peter Seixas explained, Hine's concern with the dignity of workers by the 1920s had become "a sophisticated managerial strategy [that] could use that concern for corporate ends."[42] Hine's photographs were caught in the discursive minefield of documentary realism – an ideological trap that ensnared the skilled craftsman whose autonomy labor lauded – within the corporate structures of paternalism and welfare capitalism.[43]

Similarly, Beneker worked as an artist in residence at Hydraulic Pressed Steel in Cleveland from 1919 to 1921, where management commissioned him to paint a series of portraits of workers and scenes of factory life that were subsequently reproduced in their company magazine. In these images, the individual skilled worker, presented as isolated within his workplace or against a solid background, stood in control of his machine or as a monumental presence confronting the viewer with a work tool in hand. In *The Steam Fitter*, Beneker presented his worker as a powerful figure, his broad frame more than filling the space of the canvas and proudly displaying his

wrench, the symbol of his industrial trade (Fig. 73). This figure stood as an exemplar of independence and productivity, one of many inspirational images that the company circulated to its five thousand skilled and unskilled employees throughout four plants.[44]

Not surprisingly, the workers at Hydraulic Pressed Steel took great pride in these portraits. As Beneker explained in an essay he wrote for *Scribner's Magazine*:

I've been in [the workers'] homes to dinner, and time after time they have told me what that [company] magazine meant in their home. They asked for more copies to send to the "old country." . . . They had these cover portraits framed in their parlors and dining-rooms, and tacked up about the plant.

The dignity and respect with which Beneker depicted these workers earned him their trust. He continued:

Management soon found out that men would tell me more than they would tell any one else about the shop. So they put the artist [Beneker] on the industrial relations advisory board, and many a time I have helped both workman and management to understand each other better. . . .[45]

In this particular circumstance, these images performed their cultural work in a very direct manner. According to Beneker, the commissioned paintings/illustrations actively mediated between the interests of capital and those of labor – their visual resonance helping to facilitate worker–management relations.

Within this "new capitalist" universe, industry and organized labor actively solicited images of workers by Hine, Beneker, and Kalish. Along with the Western Electric Company, the Empire State Building Corporation also employed Hine to produce promotional photographs of the building's construction, as seen in his "Empire State Building, New York City" series (Fig. 67).[46] After leaving Hydraulic Pressed Steel, Beneker worked for the Canton Sheet Steel Company in Canton, Ohio, the General Electric Company in Schenectady, New York, and the Rogm and Haas Chemical Company in Philadelphia.[47] To corporate patronage, the work by Hine, Beneker, and Kalish dispelled the memory of embittered battles, collectively fought, between labor and management in earlier decades and represented comfortable and complacent workers who benefited from labor's cooperation with industrial capitalism.

At the same time, organized labor also endorsed these representations of workers. The AFL exhibited three of Beneker's paintings in their exhibit booth at the 1926 Sesquecentennial Exposition in Washington, D.C. In his opening editorial in the October 1926 *American Federationist*, William Green, head of the AFL, argued that these paintings expressed "the goal of our organized labor movement." In defining that goal, he later exhorted that "the trade union be permitted to give constructive service through cooperation with management to do better work as the means to gaining reciprocal

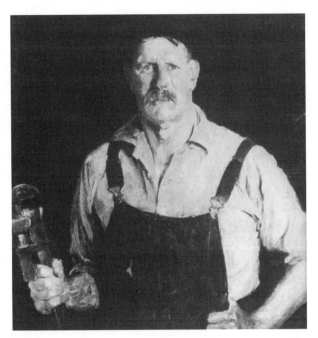

Figure 73. Gerrit Beneker, *Steam Fitter*, 1921, oil on canvas, 32" × 30". Present location unknown. (*Source: Gerrit A. Beneker (1882–1934), Painter of American Industry*. Boston: Vose Galleries, n.d., pl. 21.)

advantages."[48] Through both word and image, the *American Federationist* upheld the principle of cooperation with management throughout the decade.

Beginning in 1928, the *American Federationist* enacted an editorial policy whereby visual imagery – paintings, sculptures, photographs, and prints – were reproduced on the frontispiece of each issue. Works by Beneker, Hine, and Kalish were featured, as well as photographs by Margaret Bourke-White. Images from Hine's "Empire State Building" and "Work Portrait" series, among others, were reproduced. Similarly, Max Kalish's *Spirit of American Labor*, ca. 1927, appeared as the frontispiece of the February 1933 issue (Fig. 74).[49] Not surprisingly, a bold self-confidence enhanced the stalwart presence of all these workers. Kalish's sculpture demonstrated a forceful bearing in its wide stance and active gesture. Clutching his wrench while assertively rolling up his sleeves, the worker wielded an air of determination and commitment, a model of the independent American worker. Moreover, Warren S. Stone, the head of the Brotherhood of Locomotive Engineers, bought several sculptures by Kalish that he prominently displayed in his office.[50] To be sure, these images of skilled industrial workers articulated the AFL's belief in the dignity of labor. Within the struggling union movement, these representations epitomized the ideal of self-reliant skilled labor – a reassuring image in a period of labor's declining political power.

Following the stock market crash of 1929, business and government shifted

their positions regarding labor relations. The promise of technology and the optimism engendered by the new machine age had come to a grinding halt as economic and social chaos reigned. Vast numbers of workers, both skilled and unskilled, became the victims of this failed system. Indeed, both government and industry turned their attention to the plight of the worker – President Coolidge advocated the "Doctrine of High Wages" and industry complied in keeping pay scales up. As opposed to the earlier belief in the beneficence of machine production, human production now took center stage. In order to increase the number of available jobs, extreme measures were taken. For example, Representative Hatton Sumners of Texas urged the Patent Office to cease giving patents to labor saving devices. In the winter of 1930, the city of Newark abandonned machines for hand excavation; Minneapolis ordered the use of picks and shovels; in Boston, men used the shovel not the plow for snow removal.[51] Indeed, the meaning of labor within a modern capitalist society had come under siege. No longer secure in its partnership with technology, labor needed to be redefined in light of capitalist failures.

Fortune magazine, launched in 1929 – one month after the crash, was in the forefront of this endeavor, producing critical and at times insightful articles on American business practices. The magazine argued for a new modern type of business organization; in fact, it helped refashion "new capitalism" as it reaffirmed the role of the worker in American society.[52] In a feature story published in 1931, "American Workingman," the editors argued:

. . . the American wage-earner at once moves to the center of the industrial stage. He has been hitherto a somewhat bothersome human element in a problem which could otherwise be reduced to precise economic terms. His life outside the factory was no true concern of industry. His wages were important only as they prevented labor trouble on one side without cutting into profits on the other. His replacement by machinery was pure gain. His fear of unemployment and his sense of insecurity was [*sic*] his own hard luck. But to the new capitalism, the wage-earner is a completely different person. He is a purchaser, a partner and the key to production. His life outside the factory is of the first importance. His wages are dictated not by fear of labor troubles, but by ambition for a market and desire for willing cooperation. His replacement by machinery is a matter of national concern if it results in loss of employment, and his sense of insecurity is a national weakness. He is, in other words, at least as important to the new capitalism as his Russian equivalent is to Communism: and he is important in terms of his own choice rather than in terms of his obedience and docility.[53]

The sculpture of Max Kalish, the paintings of Gerrit Beneker, and the photographs of Margaret Bourke-White served as illustrations to this article.[54] Bourke-White produced images, such as a *Gorham Silversmith* (to which we shall return); Kalish's builders and Beneker's intimate portraits also complemented the lengthy text.

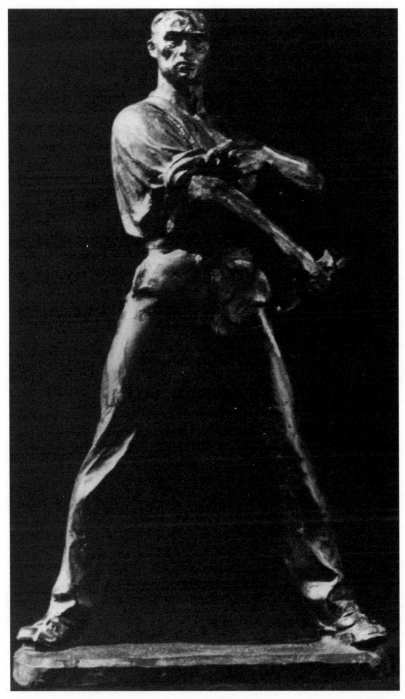

Figure 74. Max Kalish, *The Spirit of American Labor,* ca. 1927. Present location unknown. (*Source:* Emily Genaur, *Labor Sculpture by Max Kalish A.N.A.* New York: Comet Press, 1938.)

Within the context of a failing economic system, these images elevated the role of the American worker to an heroic stature, at least in part, to compete with the glorified position of the worker in Soviet society. Throughout the *Fortune* essay, the specter of a productive and successful Soviet economic system haunted these writers in their attempt to confront the collapse of the American dream. The article continued: "The economic duel will be fought if it is fought at all between a radical capitalism and with its purpose to make men productive in order that they may be free, and an experimental Communism with its purpose to enforce men in order that they may be productive. And the judge of the outcome will be American labor." With the Soviet economy in the middle of its first five-year plan and with its work force and production rapidly expanding, the *Fortune* editors lamented, "The glorification of labor has become, in our day, a communist prerogative."[55]

The images of Kalish, Beneker, and Bourke-White, reproduced in this article, served as symbols of nationalistic pride that stood strong in the face of a competing economic system. The photographs by Bourke-White, however, clearly dominated the article; eleven of her photographs in contrast with five sculptures by Kalish and two paintings by Beneker appeared in the essay. The *Fortune* editors chose to ignore her streamlined images of mechanical perfection (with or without the presence of workers) that the *American Federationist* was publishing at this time and instead turned their attention to her photographs of crafts production – glassblowing, barrel making, and silversmithing. In order to enhance the portrayal of American capitalism, the editors solicited images of skilled craftsmanship that was very much an anachronism by this time.[56] Within this layout, *Fortune* elided the problems of a capitalist economy – the failure of industrial production – by highlighting the skill and autonomy of the craft worker. By contrast, the *American Federationist* pictured labor as consistently engaged in technological production – never abandoning the promise of industrial progress. In so doing, big business and organized labor – both doggedly antibolshevik – achieved the same ends. They portrayed American workers as "free," happy, and satisfied counterparts to the "obedient and docile" workers in a communist economy.

■ ■ ■

Few alternatives to the image of the contented American worker prevailed in the visual culture of the 1920s. With the political left in total disarray and radicals of all stripes under constant surveillance by local police and federal authorities, communism and its political affiliates in the United States remained underground.[57] Only small radical magazines, such as the *Liberator*, the *Daily Worker*, and later the *New Masses*, featured graphic illustrations critical of the capitalist system.[58] Associated with the tenets of the Communist Party, these small journals provided a dissenting (or counterhegemonic) discourse to the "free, happy, and satisfied" worker discussed before.

As the immediate predecessor to these publications, *The Masses*, a radical

magazine published in the previous decade, prefigured many of the political debates of the 1920s. It offered an alternative view of capitalist progress by presenting images of technology as a threat to the autonomy of the worker – robbing him or her of independence and power in an automated workplace. As Rebecca Zurier has explained, certain "cartoons equated skyscrapers with 'commercial greed,' efficiency with a sinister engine, and portrayed World War I as the ultimate product of the capitalist machine."[59] Such a critique was central to the oppositional voices of the 1920s.

Few sculptors, most notably Saul Baizerman and Adolf Wolff, provided alternative representations of the worker in terms of form and content – images that were nearly invisible within the popular press of the day. In his series of sixty statuettes of workers and city dwellers, *The City and the People,* Saul Baizerman intended a monumental homage to labor. Presiding over this sculptural community was an image of the modern metropolis, a sculptural portrait of the city of New York. Rather than focusing upon the individual achievements of heroic skilled workers, Baizerman sought to depict the community, the environment, and the labor of America's working class – predominately unskilled immigrant workers. In depicting his figures in a modernist vocabulary of simplified forms, he fashioned the unskilled worker's engagement with the laboring process by fusing worker and tool into one indivisible unit.

Not surprisingly, Baizerman received little attention in this country when he exhibited the first thirteen statuettes from the series in 1921.[60] As a result, he brought his work to Europe, exhibiting in London, Paris, and several cities in Russia, where his works attracted significant critical praise. Conveying a proletarian consciousness and hope for a workers' revolution, his portrayals of unskilled workers were only recognized by a receptive American public in the 1930s. Despite this attention, his plan for a monumental sculptural project dedicated to labor was never realized.[61]

Born in Russia in 1889, Baizerman spent much of his youth engaged in revolutionary activities. As a teenager, he marched in the mass demonstrations in Odessa in 1905 and was jailed. The following year, after fleeing Odessa, Baizerman and his brother robbed a bank in order to contribute to the revolutionary coffers. He was again arrested and this time received a substantial prison term. After serving one and a half years, he escaped with the help of his father and fled to the United States, arriving in New York in 1910. With sculptural training in Russia and in New York at the National Academy of Design, the Beaux-Arts Institute of Design, and the Educational Alliance Art School, he embarked upon his sculptural series, *The City and the People.*

Baizerman's early experiences in his Russian homeland were formative to his artistic expression. Committed to the fledgling Bolshevik cause in the first decade of the century, he saw himself and his family as one with the great mass of Russian workers. Even after emigrating to the United States, he remained an ardent supporter of the "New Worker's Society" in Russia, where he returned for a visit in 1924. As with many immigrants whose expe-

riences with radical European thought had shaped their political outlook, Baizerman maintained a sympathy and loyalty to working-class concerns in the United States. Counting himself among the ranks of America's urban proletariat – he had worked in factories and at various manual jobs during the 1910s – he took the new urban working class, swelling in population in the first quarter of the century, as the subject of his "Labor Series." Baizerman wrote, "Never through this period [1910–30] did I forget that I was a worker. And I hope someday to be able to express the workers' lives, spirits, aspirations, struggles and sufferings, as only one of their own can."[62]

Moreover, it was the sculpture of Constantin Meunier that provided a model for his artistic aspirations. Drawn to labor themes very early in his career, he had studied Meunier's sculpture while still in Russia. En route to the United States in 1909, he stopped in Antwerp to view firsthand some of Meunier's sculpture;[63] and in 1914, he most likely attended the Meunier exhibition held at Columbia University, as discussed in Chapter 5.

Baizerman portrayed manual workers as physically and emotionally subsumed by the laboring process. Inspired by a somewhat romanticized version of Marxian thought, he believed that labor constituted an integral part of workers' lives and infused even the humblest of tasks with meaning. Such a view of the laboring classes was closely related to early writings on proletarian culture in this country. In "Towards Proletarian Art," published in *The Liberator* in 1921, Michael Gold, the future editor of the *New Masses,* was, arguably, the first to call for a militant working-class culture in this country. Gold looked to the principles of the Soviet Proletcult – a proletarian culture whose aims extended class war to every phase of Russian culture – as the model for revolutionary cultural activity. In a lyrical and almost mystical celebration of the modern worker, Gold pronounced the proletariat, Eric Homberger states, as "the heroic possessors of Life."[64] Such an interpretation of working-class life was not far removed from that expressed in Baizerman's "Labor Series."

In *The Digger,* a statuette of 1923–25 from *The City and the People* series, Baizerman depicted a common day laborer who, physically consumed by his manual chore, toiled with a simple shovel rather than an industrial tool (Fig. 75). In portraying the worker and his shovel with massive, simplified forms, he reduced the figure to a series of flattened planes and geometric angles, merging the man with his laboring tool through the arrangement of parallel diagonals in the handle, arm, and leg of the sculpture. Describing his unique interpretation of the worker at his task, Baizerman wrote, "As I followed my models through the streets of the city, often for days, I wondered what forms could express the life of him, his sorrows and joys, his work that penetrates his whole being, making him a part of it."[65] Using a modernist vocabulary, Baizerman constructed an imaginative version of the worker that valorized unskilled labor while evoking, as we shall see, contemporary discussions concerning artistic production in the new Soviet Union.

This sense of meaningful integration of life and work differed in attitude

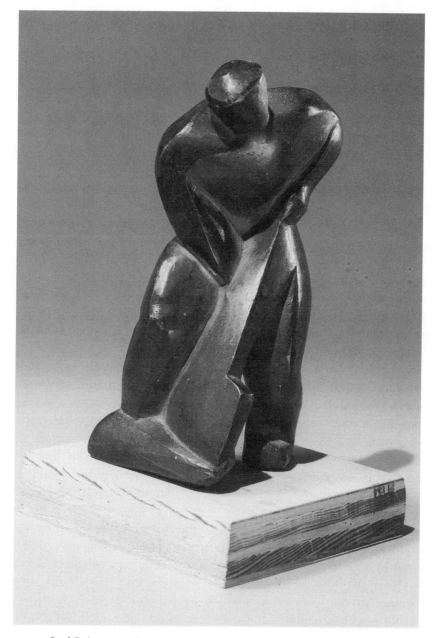

Figure 75. Saul Baizerman, *Digger*, 1923–5, bronze, 5" h. From *The City and the People* series. Hirshhorn Museum and Sculpture Garden, Smithsonian Institution, Gift of Mrs. Saul Baizerman, New York, June 14, 1979.

from the quality of domination and triumph appearing in other contemporary labor imagery, most notably, Kalish's *New Power* (Fig. 65). The gendered discourse of labor played a less prominent role as Baizerman refused the spectacle of the male body. The abstracted sculptural language of his figures did not solicit the erotic gaze; instead, it demanded an intellectual engage-

ment – that is, the visualization of (his idiosyncratic version of) Marxist labor theory. As Kalish, for example, equated the mastery and control of skilled labor with a masculinist sexual discourse, Baizerman imagined the possibility of a laboring process that was life-enhancing – somehow "unalienated" within contemporary society. In so doing, he chose to recreate fancifully in bronze the lives of unskilled immigrant workers – normally absent from visual representation and distant from the decade's pervasive sense of well-being.

Indeed, not all Americans shared equally in what was believed at the time to be a truly lasting prosperity. Unskilled workers benefited little from the booming economy as work conditions remained consistently poor among the masses of immigrants, blacks, and women who had little industrial training. In his "Labor Series," Baizerman acknowledged this class of unskilled workers, who, insufficiently rewarded for their toil, never shared in the economic prosperity common to the rest of society. Immigrants from eastern Europe, their numbers severely curtailed by 1924, were replaced by blacks and rural whites who fled the agricultural depression in the South and West and settled in metropolitan areas as common day laborers and unskilled and semiskilled factory workers. With this constant pool of unskilled labor readily available, unemployment remained high and wages low, ensuring economic deprivation for a large portion of the laboring population.[66]

Construction work united many of Baizerman's common manual laborers. Unlike those images of builders by Kalish, Beneker, and Hine, Baizerman's workers – digging, hauling, and lugging on construction sites – contributed in a less glamorous manner to the building of American cities. In rendering a *Hod Carrier,* the lowliest member of a construction crew, Baizerman depicted a stiffly postured worker who carried brick and mortar in his hod to the skilled masons working on the building (Fig. 76). Rendered with the simple angularity implicit in the hod, the figure's anatomy echoed the geometric shape of his tool, as worker and chore were fused into one inextricable unit.[67] In essence, Baizerman wished to preserve the dignity of the unskilled worker by maintaining an Old World, preindustrial ideal of manual labor that held little meaning for America's commitment to technology, efficiency, and progress. Out of step with the ideology of "new capitalism," Baizerman conflated an homage to the work ethic – which he adopted in his new American homeland – with a belief in the collective efforts of workers in a utopian socialist system.

The contrast between Baizerman's manual workers and the highly trained industrial laborers often depicted in contemporary visual culture pointed to the distinctive hierarchy that comprised the working classes in the 1920s. The elite, highly trained workers, such as Kalish's *Steelworker,* actually represented only a relatively small portion of American workers (Fig. 68). In fact, this juxtaposition of labor imagery suggested a conflict, intensely debated since the inception of the American labor movement, concerning the issue of skilled versus unskilled labor and union protection. In the construction indus-

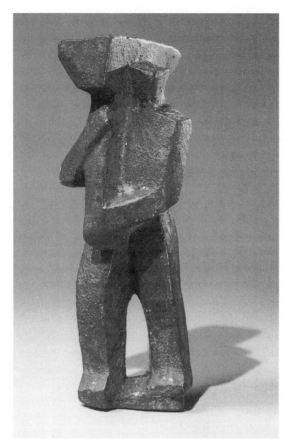

Figure 76. Saul Baizerman, *Hod Carrier,* n.d., painted plaster, 7¼" h. From *The City and the People* series. Hirshhorn Museum and Sculpture Garden, Smithsonian Institution. Gift of Mrs. Saul Baizerman, New York, June 14, 1979.

try, the trade union movement remained very strong despite the overall weakening of organized labor in the 1920s. Trade unions restricted membership in order to keep the demand high for their skilled workers, who, as it turned out, were largely white, American-born, male wage earners. Immigrants, blacks, and women were often refused entry through flagrantly racist and sexist admittance policies.[68] The 1931 *Fortune* article, "American Workingman," pointedly addressed this issue:

The discrepancy between skilled and unskilled wages in America is one of the most curious and at the same time one of the most typical characteristics of the American industrial scene. In most industrial countries there is no social and class distinction between skilled and unskilled workers. But in America there is not only a social distinction but a racial distinction. (p. 62)

Indeed, unskilled labor, kept apart from the elite trade unions, remained unorganized as a collective force and victimized by the vicissitudes of a capi-

talist economy – until 1935 with the formation of industrial unionism in this country.

The world that Baizerman represented in his "Labor Series" was a modern urban environment, imaginatively conceived in his bronze statuette, *The City* (originally entitled *The Vision of New York*) of 1922 (Fig. 77). In this sculpture, he gave visual form to the experience and sensation of the new urban metropolis from the perspective of its working inhabitants. Evoking the chaotic quality or urban life, this abstract sculpture, assymetrically designed, consisted of vertically soaring forms, reminiscent of both actual and fantastic skyscrapers, and low rectangular structures, suggestive of older tenement buildings. Contrasting with the verticality of the architectural forms, modern technological devices, such as an I-beam, subway track, fragmented suspension bridge, and industrial crane, projected horizontally from the core of the sculpture. Interspersed amidst these abstracted and recognizable urban elements were factory smokestacks and city docks, allusions to the urban work environment. Baizerman designed the sculpture for viewing at all angles, conveying a sensation of simultaneity common to the experience of the urban dweller.

Having witnessed New York's radical urban transformation since his arrival in the city in 1909, Baizerman captured in his sculpture the quality of continual change that the phenomenal urban growth in the years 1910 to 1930 produced.[69] By exaggerating the scale of such sculptural elements as the steel I-beam and the industrial crane, he conveyed the prevalence of modern construction in the urban environment. Moreover, he visually merged the forms of newly built skyscrapers and their steel-frame skeletons with the industrial machinery of urban growth. For Baizerman, these images celebrated the nature of modern life and the exhilaration of technological expansion.

However, in his compositional arrangement, Baizerman made clear the complex character of New York as both an established historic city and an expanding metropolis. To the center of his urban melange, he positioned a bifurcated skyscraper, resembling the soon-to-be-built Chrysler Building, and several adjoining smokestacks that divided his urban landscape into two distinct sections. To one side of his irregularly designed sculpture, Baizerman depicted modestly scaled tenement buildings that represented the older parts of the city. Dominated by the powerful structure of the expanding modern metropolis, these small buildings suggested the Lower East Side neighborhoods inhabited at the time by immigrant communities. To Baizerman, the city was both an exhilarating and overwhelming environment, conveying powerful tensions associated with technological progress.[70]

In choosing the subjects for *The City and the People*, Baizerman often portrayed immigrants who, like himself, were accustomed to an Old World European culture rather than the mechanized environment of urban America. The large immigrant populations, arriving in the first two decades of the century, were subject to the dramatic clash of cultures that New York's rapid

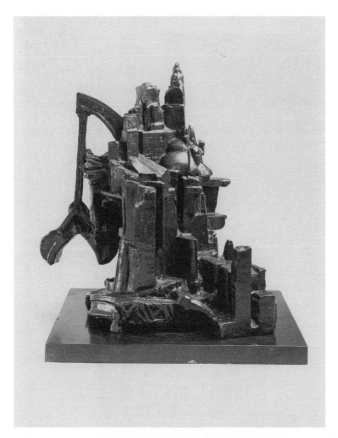

Figure 77. Saul Baizerman, *The City (Vision of New York)*, 1921, bronze, 13½" h. From *The City and the People* series. The Museum of Modern Art, New York. Mary Sisler Bequest. (Photograph © Malcolm Varon, New York. Courtesy of The Museum of Modern Art, New York.)

expansion had produced. As new American workers, most were industrially unskilled and found employment as common manual laborers. Such sculptures as *The Crippled Sharpener*, 1920–2, portraying an aged scissors grinder whom Baizerman had actually observed, retained the remnants of an Old World culture that millions of southern and eastern European immigrants had brought to this country (Fig. 78). In this particular example, Baizerman depicted an Old World craftsman whose trade was still in demand in urban centers. Indeed, Baizerman's *Crippled Sharpener* represented the dying legacy of this craft tradition in the 1920s. Most other immigrant craftsmen, however, found little use in America for their respective trades. They abandoned their native skills, like blacksmithing, bookbinding, or even shoemaking because industrialism had preempted the need for these crafts.[71] These Old World artisans had become the New World unskilled.

In the *City and the People*, Baizerman presented an alternative view of the American workers, one informed by his Old World Russian heritage and by a

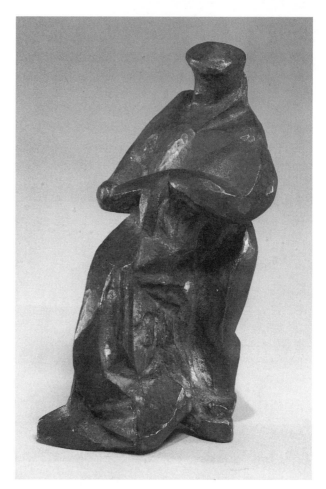

Figure 78. Saul Baizerman, *Crippled Sharpener*, 1920–2, bronze, 5⅛" h. From *The City and the People* series. Hirshhorn Museum and Sculpture Garden, Smithsonian Institution. Gift of Mrs. Saul Baizerman, New York, June 14, 1979.

utopian vision of a new collective society. In style, subject matter, and monumental aspiration, his sculptures depicted labor as a communal and collective experience, a social philosophy that contrasted with the individualism presented in popularly reproduced labor imagery in the United States. In his own sculptural series, he developed a style that suited his political aims. He eschewed the language of realism with its attendant emphasis upon the individual and gave visual form to the notion of the collective through deploying an abstracted and generalized formal vocabulary.

With *Cement Man* of 1924, Baizerman created a symbol for the aggregate of workers rather than a specific image of the individual craftsman (Fig. 79). In creating a concentrated and compact formal arrangement, Baizerman indelibly merged the rounded forms of the cement bag with the worker's anatomy, infusing the laboring process into his daily life. Moreover, he elimi-

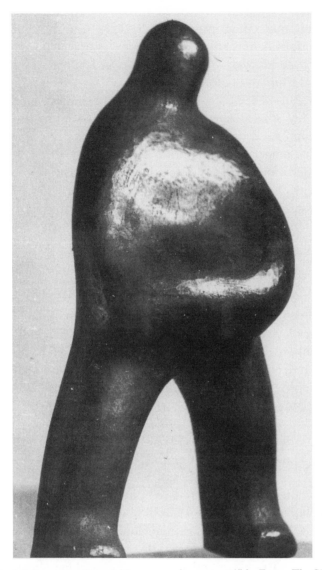

Figure 79. Saul Baizerman, *Cement Man*, 1924, bronze, 5½" h. From *The City and the People* series. Hirshhorn Museum and Sculpture Garden, Smithsonian Institution. Gift of Mrs. Saul Baizerman, New York, June 14, 1979.

nated the details of factual representation and reduced facial features to a series of planes, thus stressing the worker's anonymity. In describing this sculpture, Baizerman wrote, "The movement creates . . . the essence of him. It is not merely a man of bodily parts clothed in what not, but an embodiment of the mass of men who ever build and pour."[72]

Not until the "Labor Series" was shown in New York in the 1930s did Baizerman's sculpture attain a receptive public. Edwina Spencer commented upon this notion of "collectivity"[73] in the foreword to a 1933 exhibition pamphlet: "In each figure of his Labor Series is a concentration of power

that makes it a symbol of millions of workers – digging, lifting, building, suffering – patiently toiling through life."[74] Linked to the communist ideals of collective effort, Baizerman's "Labor Series" attracted an audience sympathetic to the American left – an audience, as we shall see, brought together under the leadership of the John Reed Clubs.

Baizerman followed closely the contemporary events of his homeland through reading Russian-language newspapers and journals. In fact, since 1917, when John Reed visited Russia to document the revolution in process, many American newspapers and radical journals avidly followed the construction of this new socialist state.[75] The concept of collectivism, central to this new socialist ideology, attracted Baizerman as well as other American communist sympathizers. In a 1920 essay on proletarian culture, Aleksandr Bogdanov, the founder of the short-lived Proletkult, wrote: "Collectivism . . . is making its mark on the content of works of art and even on the artistic form through which life is perceived."[76] Increasingly, in the early years of the Revolution, abstraction or revolutionary futurism became identified with proletarian expression in the Soviet Union. In 1918, the artist Natan Altman wrote: "A futurist picture lives a collective life: . . . try to distinguish an individual face in a proletarian procession. Try to understand it as individual persons – absurd. Only in conjunction do they acquire all their strength, all their meaning."[77] Indeed, such avant-garde artists as Kasimir Malevich, Wassily Kandinsky, and Vladimir Tatlin put their abstract art at the service of the new socialist state; for a few short years, 1917 to 1925, the language of modernism gave visual form to the goal of communal enterprise and served the new Soviet social order.[78] Influenced by these developments, Baizerman, most likely, adopted this abstracted sculptural style to convey his own proletarian message.[79]

In his ambitious plans for a public labor monument, Baizerman responded to the Proletkult's call for the "socialization of art." Through street art, mass festivals, and public monuments commissioned by the new Soviet state, proletarian art engaged the masses. Such projects were intended, in Max Eastman's words, "to turn beauty and art into a 'universal joy' – a joy to the whole city's population."[80] To this end, Baizerman wished to invite public participation in his own proposed monumental project. Intending his sculptures to be nearly life-size in scale, positioned on low bases, and interspersed within a public setting, he planned to make this monument physically accessible to the viewing audience. Moreover, with the monument consisting of a community of working-class figures, it would give visual form to the notion of the collective – that each figure formed part of a greater whole. Deliberately dispelling the notion of individualism from his proletarian sculptures, Baizerman proposed a monument to working-class life – a monument that would express in formal as well as iconographic terms a utopian social vision characterized by equality and cooperation among workers.[81]

In the 1920s, few sculptors joined Baizerman in expressing sympathy for

these new communist ideals. Adolf Wolff, as noted in the previous chapter, was a professed anarchist in the years before the war, but by 1917 had joined the ranks of the Communist Party. Throughout the 1920s, he maintained an active commitment to radical politics, and with the execution in 1927 of the two Italian anarchists, Nicolo Sacco and Bartolommeo Vanzetti, he was called to model the urn that held their ashes. In emulation of an earlier design, he produced a vessel, pyramidal in shape with a large clenched fist capping its summit. As a symbol of labor solidarity and resistance, the fist provided a powerful memorial to the martyrdom of these two men. The outrage that attended their execution was an important factor in mobilizing radical political activity in the 1920s.[82]

The John Reed Clubs served as the energized center of radical cultural production in this country. Wolff became an active member in 1929, the year the organization was founded in honor of the journalist and forefather of the American Communist Party. The clubs had a specifically cultural agenda – supporting writers and artists interested in promoting a revolutionary proletarian movement. When the novelist Richard Wright first ascended the dark dingy staircase leading to the Chicago John Reed Club headquarters, he was most impressed with the presence of the murals. In describing the offices, he wrote, "A few benches ran along the walls, above which were viewed colors depicting colossal figures of workers carrying streaming banners. The mouths of the workers gaped in wild cries; their legs sprawled over cities."[83] Such dynamic imagery attracted Wright to the organization. For a few short years, these clubs would provide for practicing artists an avenue for political debate, creative experimentation, and socialist comradery available nowhere else.

Attempting to implement the tenets of the Soviet Proletcult program, the Clubs sought to create a proletarian culture in the United States. The Preamble to the club expressly stated its aims:

Recognizing that the genuine and ultimate interests of all artistic, intellectual and cultural work, and of the workers engaged therein, are in harmony with the interests of the revolutionary workers in the irreconcilable struggle between the workers and the capitalists as two contending classes; and concluding from this that it is necessary to create and develop a new movement of such cultural workers, both national and international in scope, . . . and to encourage the development of proletarian art, literature and general culture, the John Reed Club, so named in honor of that memorable revolutionary intellectual, is organized. . . . [84]

By 1930, the John Reed Clubs had acquired the role of mediator between the Soviet Union and its followers in the United States, becoming the "vanguard of the revolutionary movement on the art front."[85]

The fascination with Russia took on a new urgency as the Depression triggered a massive crisis of capitalism. For many intellectuals and artists, such as those associated with the John Reed Clubs, their engagement with the Soviet Union held many preconceptions. To be sure, a utopian vision of life

in a progressive and just Soviet society dominated contemporary thinking. To many, as Richard Pells has explained, the Soviet Union was a "state of mind," a mixture of fantasy and fact that motivated political involvement in social change in this country.[86] Baizerman's "Labor Series," with its unique combination of visionary labor politics and experimental visual forms, participated in this radical discourse and found a receptive home in the heady revolutionary atmosphere of the John Reed Clubs.

Formed in the year of the stock market crash, the clubs seemed to prefigure the Marxist doctrine of the inevitable collapse of capitalism. By 1930, thirty clubs were in existence throughout the country with a membership of over 1,200; the New York branch served as the national headquarters. The cultural agenda of the clubs was aimed at a mixture of workers and intellectuals thereby attempting to cultivate an audience and patronage system for radical political expression in this country.[87]

The John Reed Clubs fostered a number of cultural programs during their six-year tenure. In 1930, the New York branch inaugurated the John Reed Club School of Art. In furthering the mission of the Club, this new institution, according to its catalogue of courses, was "the only school of art in this country which aims to prepare the student to express in his work the social conflicts of the world today. The courses are designed to train students to take practical and active part in the development of an art which will advance the interests of the working class."[88] Moreover, the John Reed Clubs organized many exhibitions and symposia before disbanding in 1935. With the formation of the Popular Front Against War and Fascism that same year, the clubs' proletarian agenda would no longer seem relevant when the United States and the Soviet Union joined forces in their mutual fight against world fascism.

In 1931, the John Reed Club organized an exhibition, "Revolutionary Art in the Capitalist Countries," that traveled to the Museum of New Western Art in Moscow the following year. Wolff showed a number of works in this exhibition, among them *Coal Miner on Strike* of 1931 (Fig. 80), *The Lynch Law* of 1931, and *Negro (Arise Oppressed of the World)* of 1931.[89] He produced a new style of sculpture in the 1930s, abandoning the abstract vocabulary of his anarchist pieces, as discussed in Chapter 6, and adopting a visual language more in keeping with the tenets of Soviet Socialist Realism, the official visual language of the Communist Party. In *Coal Miner on Strike*, he utilized a streamlined realism that conveyed a didactic spirit. The coal miner, shaking his enlarged fist at the world, evinced both resistance and militancy through an arrangement of powerful and massive sculptural forms. The Soviet state purchased these three sculptures when displayed in the exhibition as part of its effort to collect, exhibit, and study revolutionary art in capitalist countries. Reviewing the exhibition in the *New Masses,* Boris Ternovetz wrote, "the first clear idea about the strength and extent of the whole movement [of revolu-

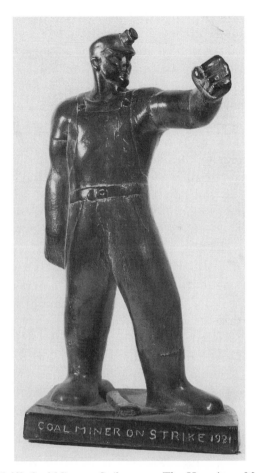

Figure 80. Adolf Wolff, *Coal Miner on Strike,* 1931. The Hermitage Museum, St. Petersburg.

tionary art in the United States] and the character of individual artists came with the collective exhibition of the John Reed Club organized in Moscow by the Museum of Modern Western Art.'' The museum arranged to show the exhibition in two different sites – to a working-class audience at the Kautchuk factory and the galleries of the museum.[90]

The John Reed Clubs maintained a close affiliation with Soviet cultural policies. The degree to which these affiliations controlled the club's policies has been a matter of scholarly debate for the past several decades, particularly among literary critics and historians.[91] Within the world of visual culture, most artists – painters, sculptors, and printmakers – refused to uphold the doctrine of socialist realism as articulated in the 1930 Kharkov conference. Such a lockstep policy represented an anathema to their beliefs in artistic freedom and creativity. Although a series of resolutions adopted at Kharkov were the basis for the club's political aims, the leadership of the JRC did not receive

their orders from Moscow.[92] As far as any coherent policy can be discerned, the early JRC exhibitions promoted a critical assault on bourgeois values while valorizing an engagement with an international working-class culture.

The "Social Viewpoint in Art" exhibition, in which over 100 American painters and sculptors, among them Adolf Wolff, exhibited 200 works, was shown at the JRC gallery in 1933. The show received a great deal of critical press – both favorable and unfavorable. Reinforcing the clubs' belief in artistic freedom and downplaying its political character, an *Art Digest* critic wrote, "The chief proponent of the idea that artists in forming a revolutionary phalanx can still exercise fully all their aesthetic faculties is the John Reed Club of New York." By contrast, Anita Brenner of *The Nation* argued for the political import of the exhibition. She wrote that this show was "as significant as the historic Armory exhibit," in its introduction of a broad range of artistic expressions that "emphasize social distress rather than sensory pleasure."[93]

Indeed, the role of "aesthetics" in proletarian expression was the focus of much discussion among practicing artists. For the most part, artists associated with the John Reed Clubs wished to serve the party specifically in their capacity as artists, that is, both style and content conveying their political commitments. Most concurred that artistic excellence must come before any defined political content.[94] Indeed, Meyer Schapiro, writing as "John Kwait" in the *New Masses*, critiqued the exhibition because "more than half the objects shown express no revolutionary ideas; and of the rest, only a few re-enact for the worker in simple, plastic language the crucial situations of his class." Schapiro dismayed that the exhibition offered the artist "no bearing, no technical aid, no definite model of action."[95]

The philosophy of the JRC encouraged artists to produce work that was partisan, controversial, and unambiguous in its political meaning while deploying whatever style that was "artistically and socially vital." For example, the 1933 pamphlet that accompanied the "Hunger, Fascism, and War" exhibition exclaimed:

We can not say what style, manner, school or form is best suited to the artistic expression of the struggles of the oppressed. That is the artist's problem. We do say however, that it is not sufficient merely to record the scene, to describe it or illustrate it. The artist to be artistically and socially vital must use his art forms to comment, to satirize, to condemn or praise. He is never passive. He takes sides, not only thru [sic] his subject matter, but in his treatment. He is on one side or the other of the historic class struggle. The John Reed Club Gallery shows and encourages artists who take the side of the revolutionary working class in its fight against hunger, fascism and war.[96]

In this exhibition, it seemed, Schapiro's (Kwait's) earlier criticism was taken to heart. Most of the works included in the show seemed to address political issues in a pointedly direct fashion.[97] These discussions, no doubt, helped

cause a slight shift among club members toward active engagement with the revolutionary process.

In keeping with the spirit of activism supported by this philosophy, the JRC scheduled a Miners Exhibition in 1934 – an exhibition "of works of artists who have been motivated by the militant upsurge of the workers"[98] – in this case the United Mine Workers who together with John L. Lewis were leading the fight for industrial unionism. Working in close association with the union, the JRC arranged a traveling exhibition to be sent to several coal mining towns in the United States – the first art exhibition ever shown directly to miners and their families.

By the time of the Revolutionary Front Exhibition of 1934, a growing critique from within the left had come to prominence. Rather than applaud the subject matter of the show in its expression of "social distress rather than sensory pleasure," as did Anita Brenner in 1933, critics now attacked the "negative rather than positive aspects of the working class" depicted in the show. Jacob Kainen, writing in *Art Front,* the journal of the Artists' Union, explained:

as a political expression, [the exhibition's] emphasis is on the negative rather than on the positive aspects of the working class outlook. The rich values the workers have brought to the surface of life, their power, health and potentiality, have been overlooked by most of the exhibitors. The canvases seem sad, drab, and crushed. Such an outlook shows only half of the situation and, as such, leads to only half the truth. The heroic effort of the proletariat in struggle must make itself felt in an exhibition of this nature, if the artists' work is to be within hailing distance of the class-struggle front.[99]

Despite the official rhetoric of the John Reed Clubs, artists and critics, in fact, held a variety of political positions. Although in sympathy with Communist ideals, many openly supported the New Deal policies, recently proposed by President Roosevelt. This cacophony of political belief and artistic expression predominated within the clubs until their disbanding in 1935.

One of the last major exhibitions – and the most comprehensive showing of sculpture – at the John Reed Clubs was the Working Class Sculpture show of 1935 in which Wolff, Baizerman, and a number of other sculptors, among them Herbert Ferber, Nat Werner, and Aaron Goodelman, lent pieces. Baizerman showed *The Digger* from *The City and the People* series (Fig. 75). In its collectivist ideology, romanticized sympathy for the "joys and sorrows" of the toiling masses, and monumental aspiration, this sculpture embodied, as one critic observed, the "proletarian ideology that is coloring artistic expression today."[100]

Aaron Goodelman, like Baizerman, was one of many sculptors praised for their proletarian expression. After joining the John Reed Club in 1933, he showed in many of its exhibitions. In the 1935 Working Class Sculpture show,

for example, he exhibited *Man with Wheelbarrow,* among other sculptures (Fig. 81). In the manner of Baizerman's blocky and abstracted figures (which he produced in hammered bronze), Goodelman carved this figure directly in stone. In a highly simplified vocabulary, he depicted a worker hunched over a wheelbarrow, pushing his heavy load. The facial features and anatomical details were highly schematized – the entire figure suggesting the solid block from which it was carved. In its universalized statement, the sculpture evoked the notion of the collective; in its ponderous nature, it referred to the laboring process itself – the difficult task of carving directly in stone. Thus, through a direct carve technique and abstracted visual language, Goodelman evoked proletarian concerns in both the form and content of the sculpture.[101]

Among the sculptors who came to prominence in the 1930s, Goodelman demonstrated a particular interest in the worker. As one critic wrote, "Out of back-breaking nights hauling and heaving as a 'dock-walloper' along New York's waterfront, Aaron J. Goodelman has brought to life in materials as sturdy as his sculptured subjects the unsung heroes of labor."[102] Born in Ataki (Bessarabia), Russia, in 1890, he studied art in Odessa before pogroms forced him to flee to the United States. In New York, he first attended Cooper Union art classes at night, while he worked on the docks during the day. From 1913

Figure 81. Aaron Goodelman, *Man with Wheelbarrow,* ca. 1933, stone, 21" h. National Museum of American Art, Smithsonian Institution, Gift of Mrs. Sarah Goodelman.

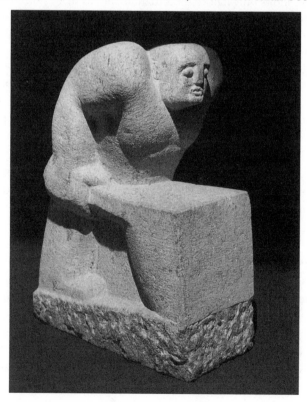

to 1914, he studied in Paris at the Académie des Beaux Arts, and then, at the outbreak of the war, returned to New York to continue his studies at the Beaux-Arts Institute.

Like Baizerman, Goodelman followed events closely in his native land and committed his sculpture to working-class issues. He wrote:

In order to give art a sincere realistic message, we must imbue it with our personal experiences in the proletariat movement. In our lives we will be realistic participants of the working class, for it's this class which provided the meat for man, the shelter for his protection, the material for his wants. It is the heart of man, en masse, without which we should perish.[103]

In this statement, the glorification of the proletariat – that legendary homage to the working classes first encountered in the writings of Michael Gold – gained a strong resonance in the artistic expression and political beliefs of radical artists associated with the John Reed Clubs. A far cry from the individualism heralded by organized labor and capitalism alike in the 1920s, this attention to the collective within a distinctly American context came to dominate social and political thought in the 1930s.

From Roosevelt's New Deal with its public arts projects to the formation of the Committee for Industrial Organization, the nature of work and the identity of the worker in the 1930s took on a new and charged significance. Throughout this book, we have witnessed how different patronage systems have invested labor monuments and small-scale statuary with a variety of ideological meanings. Monuments to labor, such as the *Mechanics Fountain* in San Francisco and the sculptural program for the Pennsylvania State Capitol in Harrisburg, were erected with private and civic support respectively to commemorate the public contributions of labor within diverse communities (Figs. 7, 8, and 27). At the turn of the century, traditional art world benefactors such as William Macbeth and Gertrude Vanderbilt Whitney financed the production of small-scale imagery of the laboring classes primarily for sale within a middle-class art market. Corporate capitalism appropriated imagery of the independent skilled worker in the 1920s and through publication in company magazines deployed it toward their own economic ends. Radical labor groups, such as the Pioneer Aid and Support Association of Chicago (in the 1880s) and later the John Reed Clubs (in the 1930s), advocated new languages of resistance as part of their iconography and visual vocabulary. In the Conclusion to this book, we next take as our focus the way in which the American Federation of Labor chose to represent itself in a public monument to labor in 1933 – at the very moment when industrial unionism challenged its ideological authority.

ORGANIZED LABOR AND THE POLITICS OF REPRESENTATION

The Samuel Gompers Memorial

This book opens in the 1880s, the decade of the founding of the American Federation of Labor, and closes in 1935 with the inauguration of the New Deal's Works Progress Administration and the establishment of the Committee for Industrial Organization. It is no coincidence that labor imagery of the industrial worker found plastic expression in the decade of the 1880s. The coalescence of economic and political forces that helped to produce the AFL also undergirded the sculptural production discussed throughout these chapters. The identity of labor as a skilled and heroic endeavor – an identity championed by the craft unionist philosophy of the AFL – held a privileged position within visual representation since the 1880s although it had been challenged at times by competing, but less powerful, ideological forces.

By 1935, a new principle of labor organization took hold, the organizing of all workers – skilled and unskilled – into industrial unions. When the New Deal mural and sculptural projects addressed labor as their subject – and they did so with great regularity, it was this new conception of labor that guided visual representation. Although informed by historical traditions, the image of the industrial worker took on new meaning in the late 1930s, a meaning that incorporated, as Barbara Melosh has explained, "two aspects of democratic ideology: individual autonomy and collective endeavor."[1] It is the emphasis on the collective – once considered subversive to American thinking – that is new, infusing New Deal government programs and extending its application within the new structures of the CIO. I argue that *The Samuel Gompers Memorial*, erected in 1933, represented in visual form the traditional tenets of craft unionism – a vision at odds with the mass labor organizing of the 1930s (Fig. 82).

It is fitting that we close this book with a study of *The Samuel Gompers Memorial* by Robert I. Aitken (1878–1949), dedicated on October 8, 1933, in Washington, D.C. Samuel Gompers (1850–1924), one of the most influential forces within organized labor, began his career in the Cigarmakers Union, rising to the rank of vice-president in 1887. Several years earlier in 1881, he had founded the Federation of Organized Trades and Labor Unions – a national organization that brought workers together by craft or trade. This organization, given a new name in 1886 – the American Federation of Labor – offered an alternative to the mixed assembly based on region that the

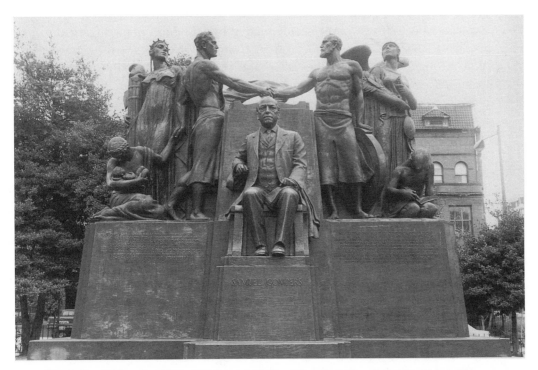

Figure 82. Robert I. Aitken, *The Samuel Gompers Memorial,* 1933, bronze and granite, 16'h. Washington, D.C. (Courtesy of Dan Younger Photography.)

Knights of Labor, an industrial union, had established in 1869.[2] Gompers remained installed as president of the American Federation of Labor almost consistently until his death in 1924. In an editorial, *The American Federationist* – the journal of the American Federation of Labor – explained, "The dedication of a memorial to Samuel Gompers brings to mind a life that was coextensive with the founding and early years of our American Federation of Labor."[3] Thus, in erecting a monument to its past president, the AFL produced a visual record of its own historical legacy.

■ ■ ■

The unveiling of *The Samuel Gompers Memorial* took place on October 8, 1933, before a crowd of 7,500 spectators in a small park on Massachusetts Avenue and 10th Street. Both President and Mrs. Roosevelt were in attendance, seated on the platform with Robert I. Aitken, the sculptor of the monument, and William Green, the President of the AFL, among other dignitaries. The Samuel Gompers Memorial Committee, headed by Green and staffed by other principals of the AFL, had planned the dedication ceremonies to coincide with the national convention, occurring the first two weeks of October. The committee had also insisted upon a morning ceremony, to avoid a conflict with the afternoon World Series game held at nearby Griffith Stadium.[4]

The bronze and granite monument, standing sixteen feet high, consisted of a seated portrait of Gompers, surrounded by six figures depicting various aspects of labor. Excerpts from three of Gompers' speeches were engraved upon the base. The seal of the AFL – the clasped hands of labor and the slogan – *Labor Omnia Vincit* – adorned the back of the monument. Enthroned to the center of the monument was Samuel Gompers, dressed in contemporary garb with papers lying on his lap. He was pictured in a posture of alert attention, as if about to speak or act. The historical accuracy with which Gompers was depicted served as a foil to the idealized imagery that surrounded him. Symbolizing domesticity, education, justice, and the unity of the labor movement, these figures thematized the principles that informed the founding of the AFL.

Among the most notable personalities to speak at the dedication was President Franklin Delano Roosevelt. The president took this opportunity to applaud the "unselfish patriotism" of both capital and labor. However, he singled out the recalcitrants – a minority of radical labor organizers whom he encouraged to join forces with the AFL. "There are hot-heads who think that results can be obtained by noise and violence; there are insidious voices seeking to instill methods or principles which are wholly foreign to the American form of democratic government."[5] In effect, Roosevelt cautioned the Communist Party organizers who, at this time, opposed both the policies of the New Deal and the exclusive craft unionism of the AFL. Not until 1935, with the inauguration of the Popular Front, did Communist sympathizers ally themselves with New Dealers to support the formation of a new type of union organization, the Committee for Industrial Organization.

Roosevelt saw himself as a friend of labor and planned to attend the AFL conference in early October. At one point, he had thought it too partisan to attend the dedication ceremonies.[6] In his address, however, he defended the national tribute to Gompers as well as his own participation in the day's events.

It is fitting that in the Capital of the Nation a statue should stand through the ages, to remind future generations of the service to that Nation of a patriot who served his country well. It is fitting that the Government, through its representatives, should take part in the dedication of this monument. It is fitting that I should appear here in my official capacity; but it is also fitting that I should be here in my personal capacity, as one who has always been proud of the personal friendship which he held for many years with Samuel Gompers.[7]

Framed more as a personal tribute than an official position on labor, Roosevelt's participation in the ceremonies, nonetheless, signaled his support for the concerns of labor. In his remarks, William Green, president of the AFL, presented a united front with Roosevelt, putting aside the organization's many

disagreements with federal policy. Green attested (somewhat disingenuously) that "the principles embodied in the National Recovery Act were substantially those for which Mr. Gompers fought throughout his long career."[8]

In fact, the AFL with Green at the helm (an ex-miner who assumed leadership of the AFL in 1924 and remained in office until 1952) was slow in embracing Roosevelt's New Deal programs. Gompers's legacy of "voluntarism" (as discussed in Chapter 1) caused the union movement to view relief and welfare legislation with suspicion.[9] The federation wanted to convey an impression of strong, self-sufficient laborers. Representations of work and the worker within the pages of the AFL's *American Federationist* revealed this ideological perspective. As it had throughout the prosperous 1920s, the journal continued to reproduce images of powerful and confident workers well into the decade. Max Kalish's *Spirit of American Labor*, illustrated in the February 1933 issue, attested to this focus (Fig. 74). Only by January 1935 did the journal publish an image that suggested the dire situation many workers faced. A photograph by Lewis Hine, captioned "Give Her an Income in Old Age," picturing an old dejected woman, with head folded into her lap and begging for pennies on the sidewalk, served as the frontispeice to the issue.[10] The presence of such an image undermined the rhetoric of confidence and independence thematized in recent issues. Unlike the other images by Hine previously reproduced in the *American Federationist*, this photograph, although undated in the magazine caption, was taken twenty-three years earlier as a social reform image. In these pages, organized labor began to acknowledge the severity of the depression through visual imagery – if not editorial commentary.

The AFL, at first, rejected many New Deal programs designed to alleviate economic depression, mistrusting any increase in government involvement in the economy. During their 1930 convention, the idea of instituting national unemployment insurance was vetoed for fear of turning workers into "wards of the state." Moreover, the AFL criticized some portions of the National Industrial Recovery Act (NIRA) of June 1933 believing it would thwart "genuine" or craft-based union organization. Before 1935 when the courts found it unconstitutional, the NIRA had established an industrial code system and temporary public works programs in the hopes of restoring economic prosperity. Most importantly for labor, Section 7(a) gave workers the right "to organize unions of their own choosing" and to engage in collective bargaining. Thus, under the auspices of the NIRA, workers created new local unions, many of which followed an industrial unionization model. Section 7(a) also exempted business from antitrust laws and allowed them to stabilize their industries through price fixing if they agreed to conform to minimum wages, maximum hours, child-labor laws, and collective bargaining. Roosevelt favored direct aid to workers and instituted the Federal Emergency Relief Agency in 1934 headed by Harry Hopkins. In establishing work relief, the

federal government hoped to reinvigorate the work ethic by restoring respect for work and the workingman before family and community life disintegrated further.[11]

Roosevelt hoped to balance the needs of management and labor while also developing social legislation to help the worker. Fearing the intransigence of employers, he remained ambivalent about a mass labor drive. However, he understood that unless the AFL built powerful industrial unions, it could not command the respect of either industry or government. Committed to a hierarchy of labor, the AFL found industrial workers – many of whom were unskilled immigrants – an embarrassment to their organization. Placed in federal labor unions before assigned to specific AFL affiliates, they were treated with contempt by the skilled workers of northern European stock. William Collins, the AFL representative to the State of New York, admitted, "My wife can always tell from the smell of my clothes what breed of foreigners I've been hanging out with."[12]

The year 1933, in which *The Samuel Gompers Memorial* was dedicated, saw the first stirrings of industrial unionism – a concept that would transform the labor movement in the twentieth century. John L. Lewis of the United Mine Workers began to garner support from a reluctant Roosevelt. Meanwhile, his New Deal policies, such as the NIRA, spurred a resurgence of labor activity. In 1932, for example, 324,210 workers engaged in work stoppages – the same as in 1925. However, by 1934, nearly one and a half million workers participated in direct job actions.[13]

By 1935, major concessions for labor had been won. Senator Robert F. Wagner and later Lloyd Garrison of the Wisconsin Law School and Philadelphia attorney Francis Biddle developed a body of law that ensured the right of labor to organize and bargain collectively. Although the right to organize formed an important element of the NIRA, that legislation – decreed as unconstitutional in the courts in 1935 – did not provide for enforcement. The Wagner Act was different; it was one of the "most important contribution[s] to Labor's quest for economic justice," the *American Federationist* argued. The fight was not an easy one. Roosevelt initially opposed the bill in hopes of winning the support of big business. And, not surprisingly, strong opposition came from the right, including the influential rantings of Father Couglin as well as anti-union activity by employers.[14]

On another front, John L. Lewis launched a revolt against craft unionism from within the ranks of labor. He received support from a broad political spectrum united by the Popular Front wherein radical labor unions led by Communist Party organizers allied with liberals and New Dealers to support his efforts at industrial unionism. Mass-production workers, seeking to become organized, received little or no support from the AFL, Lewis charged. Publicly castigating organized labor, he urged the AFL to live up to its principles – to aid and protect the weak. With Sidney Hillman of the Amalgamated

Clothing Workers Union and David Dubinsky of the International Ladies Garment Workers Union, among others, Lewis formed the CIO, the Committee for Industrial Organization, on November 9, 1935.[15] Within the charged political atmosphere of the 1930s, the Left saw the organization of industrial unions in ideal terms – as the making of a politically conscious proletariat committed to overhauling the profit system and enacting community and social control. For the most part, workers organized for very practical reasons – to gain a share of capitalism's wealth. Nonetheless, the labor movement – in the form of the Committee for Industrial Organization – appeared the most progressive political force in the nation at the time.[16]

The Samuel Gompers Memorial, planned in the late 1920s and erected in 1933, stands as a monument to the craft unionism of the skilled worker, a movement that Lewis castigated as retrograde and out of touch with existing realities. The historical legacy of the American Federation of Labor, however, should not be underestimated. Its craft unionism had served labor well. With its roots in the Jeffersonian model of the noble yeoman and independent artisan, the AFL, under Gompers' leadership, instilled a sense of dignity and solidarity within the labor movement in the face of growing industrial threats. By the 1930s, however, the American labor force was comprised of mostly unskilled and semiskilled workers and a new model of union organization challenged the AFL's long-held tenets. The monument attested to the past achievements of Gompers in the early years of the AFL rather than to its present position.[17] Dedicated on national ground, *The Gompers Memorial* commemorated the historical achievements of labor rather than its future course.

During his own lifetime, Gompers had wished to erect a monument to labor. At the close of World War I, he contacted Charles Moore, the chair of the Commission of Fine Arts – the office that oversaw all public statuary in the nation's capital – with plans for such a memorial. A bill was introduced to Congress but no action was ever taken on it. It was not until after his death in December 1924 that such a plan would come to fruition through the auspices of the Samuel Gompers Memorial Committee. The committee sought permission from the federal government to erect a memorial near the American Federation of Labor building on Massachusetts Avenue and 10th Street in Washington, D.C. Both the House and Senate passed the bill with the stipulation that the Commission of Fine Arts oversee the project. By January 1929, the committee had mobilized. The membership of affiliated unions solicited funds in the amount of $133,584.12 for the erection of the monument.[18]

The committee requested designs from a number of sculptors, among them Charles Oscar Haag, an immigrant sculptor who, as discussed in Chapter 6, had dedicated the early part of his career to depicting labor in collective action. In a letter to interested sculptors, the committee articulated the requirements for the project without stipulating any particular composition or style.

The Gompers Memorial Committee is not committed to any special or particular form or design. It is of the opinion, however, that [the monument] should consist of a bronze figure of Mr. Gompers in which he would be presented in a character-istic form, and this bronze figure to be associated with a granite monument of suitable dimensions expressive of labor and particularly those outstanding phases of labor with which Mr. Gompers was associated during his entire lifetime. . . . [19]

The only other stipulation of the committee was that the sculptor, whomever was chosen, would contract only with union labor – stonecutters and bronze chasers, for example, were required to be affiliates of the American Federa-tion of Labor.[20]

Haag submitted *Labor Union* of 1905 as his model for *The Gompers Memorial* but was not present to discuss the design with the committee (Fig. 61).[21] Mrs. Lola Mavrick Lloyd, daughter-in-law of Henry Demarest Lloyd and patron of Haag's work, wrote to the committee: "I hope you will look through the enclosed pamphlet about Chas. Haag's work before the meeting of your Art Committee decides on the Gompers Monument. Always original, he has al-ready done notable things on labor subjects. As his friend and patron, I am glad to call your attention to his work."[22] Haag's *Labor Union* did not fulfill the requirements for the memorial outlined by the committee – no portrait of Gompers appeared in the sculpture, for example. Moreover, the imagery alluded to industrial unionism and the potential of union solidarity among immigrants with its emphasis on the detailed features and individualized ethnic identities of the workers. It is no surprise, therefore, that the commit-tee rejected Haag's model.

The competition ended in disaster. The committee selected a design by the sculptor Alexander Zeitlin and architect Robert Lafferty – an eight-foot-high portrait of Gompers surrounded by "three figures of Labor" in an elaborate parklike setting with reflecting pool and lights. Second prize went to Charles Keck and third prize to George F. Bodwell.[23] The Fine Arts Com-mission rejected the winning design on the basis of its lack of feasibility for the site. With no one knowledgeable about artistic matters on the Samuel Gompers Memorial Committee, the competition, the Fine Arts Commission argued, was doomed to failure. In a meeting with the committee, Charles Moore, chairman of the Commission of Fine Arts, put in no uncertain terms the problems with the selection process:

In the first place it is our business to give our advice. Congress specifies we should. It is not a favor, it is our business. In the second place we are entirely in sympathy with you. We want to get for you the best you can get. We feel the present design is hopeless. We feel the people who prepared the design are not competent to erect one for Mr. Gompers. . . . It is understood that Mr. Lafferty be advised that his design has been rejected, and that he be asked to submit photographs of the work he has done, also that Charles Keck, who received the second prize, be requested to submit photographs of the work he has done.[24]

In planning a second competition, the Fine Arts Commission had provided a list of sculptors from whom the Gompers Memorial Committee requested a portfolio of photographs. A panel of experts – consisting of Charles Moore; H. P. Laemmerer, secretary; and Adolph A. Weinman, president of the National Sculpture Society – reviewed the photographs and selected Charles Tefft; Charles Keck, the second prize winner in the original competition; and Robert I. Aitken. The memorial committee subsequently chose Aitken to submit a proposal for the monument.[25]

Before proceeding to a discussion of Aitken's design, it is necessary to review the model submitted by Charles Keck for the original competition.[26] The Executive Committee Minutes of the AFL described the model as follows:

The model is in the form of a pedestal at the top of which is a group representing two workers with clasped hands with the figure of Minerva, goddess of wisdom, standing behind them in an attitude of approval. Immediately under the group at the top of the pedestal in bas relief is a replica of the seal of the American Federation of Labor showing the clasped hands. At the base of the pedestal there is a seated figure representing the figure of President Gompers.

Mr. Keck stated that the group at the top carried out the symbol of friendship and fraternity as implied in the clasped hands of the seal of the American Federation of Labor. He stated that the statue of President Gompers was placed in a secondary position. The sculptor said in doing so it was with the thought that Mr. Gompers was not as big as the Federation itself and that he never thought that he was. The group at the top was to symbolize what the seal stands for and what President Gompers sought to accomplish through the American Federation of Labor.[27]

In comparing this verbal description of Keck's model with the monument conceived by Aitken, it seems clear that similarities existed. Certain motifs suggested by Keck, such as the clasped hands of labor, the goddess Minerva, the seated figure of Gompers positioned below the allegorical forms, and so on, appeared in the final design. How such an appropriation could have taken place remains a mystery. Perhaps the memorial committee shared the photograph of Keck's model with Aitken, suggesting the inclusion of these motifs in the final design. Nonetheless, since no written elaboration of Aitken's monument exists, the iconographic analysis offered by Keck may indeed be useful in our study of *The Gompers Memorial.*

Robert Aitken had a prestigious career as a sculptor, producing a number of important public monuments throughout the United States. Born in San Francisco, he was the prized student of Douglas Tilden, sculptor of *The Mechanics Fountain* (Fig. 27). By the age of 18, he had absorbed the lessons of his teacher at the Mark Hopkins Institute of Art and, opening a studio of his own, had gained professional stature as a practicing sculptor. He left for Paris

in 1905, exhibiting a number of ideal works in the Salon. After returning from Paris in 1907, Aitken won the first Helen Foster Barnett Prize for the best piece of sculpture by an artist under 35 in the 1908 winter exhibition of the National Academy of Design. By the following year, he was elected an associate member of the Academy. Aitken's reputation was sealed at the Panama Pacific International Exposition of 1915 when he produced the *Fountain of the Earth*, the sculptural centerpiece of the fair.[28]

Aitken presented his model for *The Gompers Memorial* to the committee and the Fine Arts Commission on October 12, 1930, notifying those in attendance that it would require two and a half years to complete the project. The model was approved with suggestions from the Fine Arts Commission. The most pronounced disagreement centered around the figure of Gompers himself. Aitken had proposed a life-sized seated figure; the commission suggested a bust. "It goes much better with the symbolic figures thereby avoiding any incongruity," Charles Moore argued in a letter to the secretary of the AFL. Aitken and the committee insisted upon a seated portrait of Gompers in contemporary dress. The commission finally relented.[29]

The committee members intuitively understood that an ideal bust of the president would not be appropriate. Such an image would place Gompers' legacy outside the realm of history and politics – enshrining him in some transcendent sphere. Depicted as alert, attentive and knowledgable (as noted by the papers on his lap), Gompers was figured as a man of practical affairs. The language of realism – in its claim to authenticity and contemporaneity – stood as a foil to the presentation of ideals in the remaining six figures of the sculptural group. This very disjunction of sculptural modes – a disjunction criticized by the Fine Arts Commission – stood at the interpretive center of the monument. Gompers was depicted as the historical actor – the active agent in charge; the skilled workmen behind him, for example, remained outside the realm of historical agency – symbols of unity, cooperation, and solidarity.

These brawny, nearly naked skilled workmen are the progeny of Tilden's heroic workers in his *Mechanics Fountain* (Fig. 27). As discussed in Chapter 4, Tilden produced many sculptures that valorized male bodies, particularly those of workers, athletes, and Native Americans. Aitken was surely aware of Tilden's famous monument on Market Street in San Francisco, having begun his study with Tilden in 1894, the year the sculptor received the commission. In 1901, the year that the *Mechanics Fountain* was dedicated, Aitken assumed the post of professor of sculpture at the Mark Hopkins Institute of Art, replacing Tilden who had resigned the position.[30]

The motif of the workers with clasped hands suggests a melange of influences from Keck and Tilden. Keck had originally suggested the presence of two workers engaged in a firm handclasp. Aitken finessed this concept by depicting the two figures dressed only in leather aprons – the traditional symbol of nineteenth-century skilled mechanics and an idea first envisioned

by Tilden in his *Mechanics Fountain*. Similarly, Aitken depicted two generations of workers – a younger man to whom his maturer counterpart imparted the wisdom of their trade. The younger worker, with his anvil, held the hand of a seated woman behind him. The older worker placed his hand upon a wheel to his rear. They gazed intently at one another; their hands met in a firm clasp over the head of Gompers. These powerful skilled workmen framed the seated figure of the president and conveyed the idea of union solidarity and fraternity.

But surely the bodies of these working-class men signified as well. They marked masculinity in a particular way while signaling the political hierarchy of the AFL. Aitken rendered the perfected bodies of these men with a careful attention to anatomical detail, picturing every muscle as firmly developed. Clad only in leather aprons, these workers embodied a nineteenth-century craftsmanly model. As a nostalgic ideal of masculinity, these workers – like Tilden's mechanics – invited the attention of viewers. Although no records exist of a critical response to the monument, one may assume that a working-class and middle-class male audience responded positively to this masculine ideal, particularly at this moment of historic economic distress.[31] Indeed, such heroic ideals of manliness took on an urgency in the 1930s when jobs were scarce and life insecure. Such a gendering of labor, Barbara Melosh has noted, reached across class lines by addressing a contemporary crisis of masculinity experienced by both working-class and middle-class men.[32]

As objects of this public gaze, however, these working-class male bodies suggested a condition of vulnerability in their near nakedness when compared to both the fully clothed viewer *and* the formally clad figure of Gompers, whose authority was manifested not through brawn, but through intellect and decisive political action in the world. As argued previously in Chapter 4, these working-class male bodies – on full display – allowed for spectatorial pleasure and homosocial desire – a desire neutralized and sublimated through the power of the aesthetic. Clearly a visual tension existed between viewing the subject of the monument – Samuel Gompers – and the scopic pleasure experienced by gazing upon the nearly nude bodies of the workers. In this way, the monument may have unwittingly succeeded in its aim: to place Gompers in a secondary position, as Keck had suggested, "as Mr. Gompers was not as big as the Federation itself and . . . he never thought that he was."

On the other hand, I would argue that the monument does in fact reify the political hierarchy of the AFL. Although it is the very unity of the workers that empowers Gompers – a unity made manifest in the sign of the handclasp, the workers themselves do not serve as historical actors – they are figured in the realm of the ideal. With his contemporary dress, alert posture, and paperwork, it is Gompers alone who leads the workers and enacts change. Furthermore the sculptural composition suggests an allusion to an apotheosis – a visual convention in which a human being is elevated to immortality. Standing behind Gompers and the skilled workmen are two classical figures whose

allegorical status posits a universal domain. The female figure on the left wears a diadem on her head (like the famed *Statue of Liberty*) and holds a fasces – a symbol of unity, on top of which sits a helmet – an attribute of Minerva, the goddess of wisdom. Her counterpart to the right, a winged genius, carries arrows and swords. Enthroned within this setting, the figure of Gompers hovers between historicity and the realm of myth and legend.

To the far sides of the monument are two seated figures – a mother with child and a young lad reading a book – both dressed in classical robes. A figure of domesticity, the mother cradles a child in one arm and holds her other hand outward in union with the younger worker. Her lowered placement and marginal position with regard to the other sculptural figures instantiates her inferior status. Organized labor openly embraced this gender hierarchy of separate spheres as a matter of practical policy. Furthermore, a separate spheres ideology had become conventional within the iconography of labor monuments, as witnessed, for example, in Johannes Gelert's *Struggle for Work* of 1893, in which a masculinized contest for jobs takes place over the prone bodies of a woman and child (Fig. 21). To contemporary viewers, this marginalization – as represented in formal and iconographic terms – took on a stronger social resonance as certain state legislatures banned married women from the work force in the 1930s.[33]

The final figure depicted in the monument is a young lad – a future worker – who, seated with bent head, is deeply absorbed in his book. Representing the importance of education to the labor force, the young child ponders the mysteries of technological knowledge as an up-to-date model of a train engine lies behind him. To a 1930s audience, the presence of the young boy with book in hand signified the principle of education and training as passed on through generations of skilled workers within the craft union movement.[34]

As the seated figure of Samuel Gompers dominates the front of the monument, a large bronze seal of the American Federation of Labor adorns the back. With its traditional symbol of the handclasp, it reinforces the message of unity and fraternity expressed by the heroic workers. Inscribed in the granite pedestal, three of Gompers' quotations – inspiring moderation and deliberation – reflected his cautious practice in labor relations. One reads:

No lasting gain has ever come from compulsion. If we seek to force, we but tear apart that which, united, is invincible. There is no way whereby our labor movement may be assured sustained progress in determining its policies and its plans other than sincere democratic deliberation until a unanimous decision is reached. This may seem a cumbrous, slow method to the impatient but the impatient are more concerned for immediate triumph than for the education of constructive development.

In both word and image, the monument marked the AFL's distance from the heady atmosphere of change and reform that swirled around it. Instead, it acknowledged the remarkable accomplishments of an historic organization

and its dignified leader. The now-famous labor imagery of the New Deal, although steeped in historical tradition, can best be understood within the context of a new spirit of labor, one embodied in the tenets of the Committee for Industrial Organization.

Among the many relief programs inaugurated by Roosevelt's New Deal were those that addressed cultural production: the Public Works of Art Project of 1933, the Treasury Section of Painting and Sculpture of 1934, the Federal Theater Project of 1935 and the Works Progress Administration/ Federal Arts Project of 1935, federally funded initiatives that supported the visual arts and theater during the Depression. Indeed, the representation of the worker, the aged, the poor, and the unemployed became commonplace in 1930s culture. First among social causes, though, was labor – the fixation of a nation on the concept of work when so many were unemployed. The issue of jobs (and joblessness) became central to cultural expression – even institutionalized by these federally funded programs. Public murals and sculptures and Federal Theater (FT) productions consistently acknowledged the core value of work. In the FT production *Class of '29*, a character articulated the centrality of the work ethic to a 1930s community: "Work is essential," he stated, "more essential than love, that's what all these young people need. Work."[35]

Within New Deal visual culture, the image of the industrial worker took center stage. Borrowing from the tradition of worker imagery discussed in this book, public images were deployed to new ends – most notably, but not always, as propaganda for federal programs. In so doing, the image of the heroic worker bolstered the notions of American individualism and self-sufficiency at the same time that it promoted the expanding role of the state in social welfare – a particularly Americanized version of collectivism. Similarly, the emphasis on the industrial worker – skilled and unskilled – acknowledged the craftsmanship championed by the AFL while also asserting the commonality of industrial unionism as embodied in the CIO. Although public art projects never directly addressed the union movement, an understanding of labor within the shifting politics of the New Deal informed the reception of much of this imagery.

This is not to say that the meanings attached to New Deal labor imagery were in any way fixed or limited. In fact, as Barbara Melosh has argued, spectators interpreted images of heroic workers in a variety of ways: as homages to American individualism, endorsements of the New Deal programs, celebrations of the labor movement, testaments to working-class solidarity, and even as evidence of a nascent class struggle. Within this cultural and political context, *The Samuel Gompers Memorial*, with its transcendent vision of labor, was at odds with contemporary depictions of work produced during the later 1930s. It represents an end of an era – invoking past glories rather than future triumphs.

Although it is the decade of the 1930s that is best known for its attention

to the worker and the concerns of labor, this book has demonstrated that a tradition of sculptural imagery engaged with laboring themes has, since the 1880s, actively contributed to contemporary social, political, and aesthetic discourses. Though most of the sculptors in this book are little known or largely forgotten, they produced a body of work in which labor was often constituted as "manly" and the work ethic mediated both production and reception. It is the job of this book and others to restore this vital visual culture to the study of labor history, gender studies, and American art history.

NOTES

Introduction

1. Paul Willis argues further that "it should be clear that not only can work be analysed from a cultural point of view, but that it must occupy a *central* place in any full sense of culture. Most people spend their prime waking hours at work, base their identity on work activities, and are defined by others essentially through their relation to work . . ." ("Masculinity and Factory Labor," in *Culture and Society: Contemporary Debates*, ed. by Jeffrey C. Alexander and Steven Seidman [New York: Cambridge University Press, 1990]: 184).

2. Nicholas K. Bromell, *By the Sweat of the Brow: Literature and Labor in Antebellum America* (Chicago: University of Chicago Press, 1993): 2. Tillie Olsen concurs with this statement in her groundbreaking essay on Rebecca Harding Davis in the edited collection of Davis's work, *Life in the Iron Mills and Other Stories,* ed. by Tillie Olsen (New York: Feminist Press, 1985): 88.

3. Daniel R. Rodgers, *The Work Ethic in Industrial America 1850–1920* (Chicago: University of Chicago Press, 1978): 68. See also Morton Cronin, "Currier and Ives: A Content Analysis," *American Quarterly* 4 (1952): 317–30; Leo Marx, *The Machine in the Garden: Technology and the Pastoral Ideal in America* (1964; rpt. New York: Oxford University Press, 1967); idem, "The Railroad-in-the-Landscape: An Iconographical Reading of a Theme in American Art," *Prospects* 10 (1985): 77–117; and idem, *The Railroad in the American Landscape, 1850–1950,* exh. cat. (Wellesley, MA: Wellesley College Museum of Art, 1981).

4. William Dean Howells, "The Man of Letters as a Man of Business" (1891), *Literature and Life: Studies* (New York: Harper and Company, 1911): 2, as quoted in Rodgers, *The Work Ethic,* p. 69. In a fascinating exception to Howells's assertion, Rebecca Harding Davis entreats the reader to make an imaginary visit to a contemporary iron mill. In the beginning pages of *Life in the Iron Mills* (1861), the narrator states: "Stop a moment. I am going to be honest. This is what I want you to do. I want you to hide your disgust, take not heed to your clean clothes, and come right down with me, – here, into the thickest of the fog and mud and foul effluvia. I want you to hear this story." (As in note 3, p. 13.)

5. John Quincy Adams, "Art and Crafts in American Education: The Relation of Art to Work," *Chautauquan* 38 (September 1903): 50, 52.

6. Kirk Savage, "The Politics of Memory: Black Emancipation and the Civil War Monument," in *Commemoration: The Politics of National Identity,* ed. John R. Gillis (Princeton: Princeton University Press, 1994): 130–1.

7. Bromell, *By the Sweat of the Brow,* p. 4.

8. Raymond Williams, *Keywords: A Vocabulary of Culture and Society,* rev. ed. (New York: Oxford University Press, 1983): 177, 178.

9. John Bodnar, *Remaking America: Public Memory, Commemoration, and Patriotism in the Twentieth Century* (Princeton: Princeton University Press, 1992): 14–15; Popular Memory Group, "Popular Memory: Theory, Politics, Method" in *Making Histories:*

Studies in History – Writing and Politics, ed. by Richard Johnson, Gregor McLennan, Bill Schwarz, and David Sutton (Minneapolis: University of Minnesota Press, 1982): 207.

10. James R. Green, "Workers, Union, and the Politics of Public History," *The Public Historian* 11 (Fall 1989): 15.

11. William J. Adelman of the Illinois Labor History Society, the association that currently owns and maintains the monument, described the various political groups who often utilized the memorial site. (In conversation with the author at the monument site, June 2, 1992.) Among the organizations that utilize the *Haymarket Monument* as an identifying symbol (or logo) is the Inventory of American Labor Landmarks, a project sponsored by the Labor Heritage Foundation, Washington, D.C.

12. James E. Young, *The Texture of Memory: Holocaust Memorials and Meaning* (New Haven: Yale University Press, 1993): 13.

13. Ibid., p. xi; see also Maurice Halbwachs, *On Collective Memory,* ed. and trans. by Lewis A. Coser (Chicago: University of Chicago Press, 1992).

14. Young, *The Texture of Memory,* pp. 6–7.

15. My belief that the monument has had little meaning or visibility for the middle classes of San Francisco was corroborated by Archie Green, a labor activist and historian of the San Francisco laboring community. He alerted me to the fact that the monument has now become a symbol of labor pride among contemporary male workers. (In conversation with the author, George Mason University, Fairfax, Virginia, April 15, 1994.) For a discussion of labor landmarks and their contemporary public, see Archie Green, "Labor Landmarks: Past and Present," *Labor's Heritage* 6 (Spring 1995): 26–54. For a description of the Inventory of American Labor Landmarks and National Park Service Theme Study of Labor Landmarks, see "What Is a Landmark?," *Labor's Heritage* 6 (Spring 1995): 54–64.

Chapter 1

1. Harry R. Rubenstein, "Symbols and Images of American Labor: Badges of Pride," *Labor's Heritage* 1 (April 1989): 42; Richard Oestreicher, "From Artisan to Consumer: Images of Workers 1840–1920," *Journal of American Culture* 4 (Spring 1981): 53.

2. John Neagle (1796–1865) followed in the footsteps of his teacher, Bass Otis, who had created one of the earliest industrial scenes, *Interior of a Smithy* of 1815. For a discussion of this painting, see Lois Dinnerstein, "The Iron Worker and King Solomon: Some Images of Labor in American Art," *Arts* 54 (September 1979): 113; Ransom R. Patrick, "John Neagle, Portrait Painter, and Pat Lyon, Blacksmith," *Art Bulletin* 33 (September 1951): 187–92. A second version of the painting – that which hung in the home of Pat Lyon – was completed in 1829; it now resides in the Pennsylvania Academy of the Fine Arts. The painting, *Interior of a Smithy,* by Bass Otis is reproduced in Patricia Hills, "The Fine Arts in America: Images of Labor from 1800 to 1950," in *Essays from the Lowell Conference on Industrial History, 1982 and 1983,* ed. by Robert Weible (North Andover, MA: Museum of American Textile History, 1985): 131.

3. Dinnerstein, "The Iron Worker and King Solomon," pp. 113–14; Patrick, "John Neagle," pp. 189–90.

4. Quoted in Patrick, "John Neagle," p. 189.

5. Although women's roles in industrial capitalism has varied, the high art tradition has tended to reinforce the domestic and the clerical, for example, in the work of John Sloan and Isaac Soyer. For a discussion of women's labor in early twentieth-century American painting, particularly the Fourteenth Street artists, see Ellen Wiley Todd, *The "New Woman" Revised: Painting and Gender Politics on Fourteenth Street* (Berkeley: University of California Press, 1993). Women's industrial work, usually in the form of unskilled labor, entered the lexicon of visual imagery primarily through

the photographs of sweatshop workers by Lewis Hine that served as critical commentary during the era of Progressive reform. Not until World War II did images such as Norman Rockwell's *Rosie the Riveter* offer women in industrial labor as a standard motif. For a detailed analysis of this image, see Melissa Dabakis, "Gendered Labor: Norman Rockwell's *Rosie the Riveter* and the Discourses of Wartime Womanhood," in *Gender and American History Since 1890*, ed. by Barbara Melosh (New York: Routledge, 1993): 182–207.

6. James Gilbert opens his book, *Work Without Salvation: America's Intellectuals and Industrial Alienation, 1880–1910* (Baltimore: Johns Hopkins University Press, 1977), with the sentence, "America is and always has been a nation defined by devotion to work" (p. vii).

7. Daniel R. Rodgers, *The Work Ethic in Industrial America 1850–1920* (Chicago: University of Chicago Press, 1978): 125; see also Bryan J. Wolf, *"The Labor of Seeing*: Pragmatism, Ideology, and Gender in Winslow Homer's *The Morning Bell*," *Prospects* 17 (1992): 273–319, for an informative and insightful discussion of shifting notions of work in nineteenth-century America. Wolf also discusses at length the problematics of visuality as articulated by this painting.

8. On the Protestant work ethic, see Max Weber, *The Protestant Ethic and the Spirit of Capitalism*, trans. by Talcott Parsons (New York: Charles Scribner's Sons, 1952); for a discussion of the calling, see pp. 79–81; see also P. D. Anthony, *The Ideology of Work* (New York: Tavistock, 1977): 39–42. With its roots in antebellum America, this concern with individual achievement remained central to American thinking through, at least, the 1920s – a subject more fully addressed in Chapter 7 of this book.

9. Gilbert, *Work Without Salvation*, pp. 4–6, and Rodgers, *The Work Ethic*, pp. 30–3. David Roediger argues in his fascinating book, *The Wages of Whiteness: Race and the Making of the American Working Class* (New York: Verso, 1991), that "whiteness" was a way in which white workers responded to a fear of dependency on wage labor and to the necessities of capitalist work discipline. He maintains that the notion of slave labor and "hireling" wage labor proliferated in the United States at the same time that independence had become a powerful masculine ideal. Thus, "whiteness" was a way of differentiating the negro and his "enslavement" from working class identity and wage labor.

10. *The Portable Karl Marx*, trans. in part by Eugene Kamenka (New York: Penguin Books, 1983): 134–5.

11. Anthony, *The Ideology of Work*, pp. 114–15, 140–1. For interesting discussions concerning the intersection of Marxist theory and the visual arts, see Albert Boime, "Ford Madox Brown, Thomas Carlyle, and Karl Marx: Meaning and Mystification of Work in the Nineteenth Century," *Arts* 56 (September 1981): 116–26, and Donald Drew Egbert, "Socialism and American Art," in Donald Drew Egbert and Stow Persons, eds., *Socialism and American Life*, vol. 1 (Princeton: Princeton University Press, 1952): 621–755.

12. Eileen Boris, *Art and Labor: Ruskin, Morris and the Craftsman Ideal in America* (Philadelphia: Temple University Press, 1986): xiv, 11.

13. Ibid., p. xii.

14. Gilbert, *Work Without Salvation*, p. 85.

15. Ibid., p. 90; Boris, *Art and Labor*, pp. xiv, 139, 150–2; Miles Orvell, *The Real Thing: Imitation and Authenticity in American Culture, 1880–1940* (Chapel Hill: University of North Carolina Press, 1989): 159–66. Gustav Stickley argued that unions set "a premium upon inefficiency by demanding good pay for poor work and by defending incompetent and malingering workmen" (Boris, *Art and Labor*, p. 151).

16. Bruce Laurie, *Artisans into Workers: Labor in Nineteenth-Century America* (New York: Noonday Press, 1989): 35–7.

17. Ibid., p. 49.

18. Randall C. Griffen, "Thomas Anshutz's *The Ironworkers' Noontime*: Remythologizing

the Industrial Worker," *Smithsonian Studies in American Art* 4 (Summer/Fall 1990): 134.

19. *Leaves of Grass by Walt Whitman, the 1892 Edition* (New York: Bantam Books, 1983): 31. In "Song of the Exposition," Whitman again gives praise to the ironworker: "There by the furnace, and there by the anvil, / Behold thy sturdy blacksmiths swinging their sledges, / Overhand so steady, overhand they turn and fall with joyous clank, / Like a tumult of laughter" (p. 165).

20. Betsy Erkkila, *Whitman the Political Poet* (New York: Oxford University Press, 1989): 3, 306; Elizabeth Johns, *Thomas Eakins: The Heroism of Modern Life* (Princeton: Princeton University Press, 1983): 145 n 4, 152; Michael Moon, *Disseminating Whitman: Revision and Corporeality in Leaves of Grass* (Cambridge: Harvard University Press, 1991): 15–16, 24; George Blyn, "Walt Whitman and Labor," *The Mickle Street Review* 6 (1984): 22. Miles Orvell has argued that this engraving, based on a daguerreotype of Whitman, may also indicate "certain tensions within Whitman." With his neatly trimmed beard and expensive beaver hat, this portrait gave visual form to "the contradiction between his working-class sympathies and his elite literary ties, his identification with the common people and his sense of apartness" (*The Real Thing*, pp. 12–13).

21. *Leaves of Grass by Walt Whitman*, p. 9.

22. Erkkila, *Whitman*, p. 275; *Leaves of Grass by Walt Whitman*, p. 161.

23. *Leaves of Grass by Walt Whitman*, p. 162.

24. As quoted in Blyn, "Walt Whitman and Labor," p. 25.

25. In the collectivity of voices that are heard in his poems, Whitman strove for a new expression of solidarity with the masses. As Betsy Erkkila explained, "Whitman was working toward a wholly new concept of artistic expression, an art originating not in the particularities of individual experience but in the collective consciousness of the masses, in which nobody speaks or holds the stage alone" (Erkkila, *Whitman*, p. 270).

26. The dating of this painting is controversial. See Wolf's summary of the debate, "The Labor of Seeing," 314 n 1.

27. Ibid., pp. 283–4. *The Bridle Path, White Mountains* is illustrated on p. 285.

28. Ibid., pp. 284–9; Rodgers, *The Work Ethic*, pp. 153–4.

29. Laura Meixner, " 'The Best of Democracy': Walt Whitman, Jean-François Millet and Popular Culture in Post-Civil War America," in *Walt Whitman and the Visual Arts*, ed. by Geoffrey Sill and Roberta K. Tarbell (Brunswick, NJ: Rutgers University Press, 1992): 29–30.

30. "Art in Boston," *Round Table* 25 (June 1864): 26, as quoted in Meixner, "The Best of Democracy," p. 31.

31. The ideological resonance of the "man with a hoe" continued well into the twentieth century. The American Federation of Labor distinguished its workers from the "hoe-man" type in a 1921 cartoon (Fig. 70). See Chapter 7 for a fuller discussion of this graphic image.

32. Meixner, "The Best of Democracy," p. 46; idem, "Popular Criticism of Jean-François Millet in Nineteenth-Century America," *Art Bulletin* 65 (March 1983): 102–5; and most recently, idem, *French Realist Painters and the Critique of American Society, 1865–1900* (New York: Cambridge University Press, 1995).

33. As quoted in Meixner, "Popular Criticism of Millet," p. 103.

34. Edwin Markham, "Labor: Hopeless and Hopeful," *The Independent* 52 (February 8, 1900): 354. See also Markham, "How and Why I Wrote 'The Man with the Hoe,' " *Saturday Evening Post* 172 (December 16, 1899): 497–8.

35. See "US report finds a growing gap between high-, low-pay earners," *Boston Globe*, June 3, 1994, pp. 1, 16.

36. Laurie, *Artisans into Workers*, pp. 128–9.

37. Michael Denning, *Mechanic Accents: Dime Novels and Working-Class Culture in America* (New York: Verso, 1987): 149–50; Gilbert, *Work Without Salvation*, p. 23.

38. Laurie, *Artisans into Workers*, p. 188; Carlos A. Schwantes, *Coxey's Army: An American Odyssey* (Lincoln: University of Nebraska Press, 1985).

39. Gilbert, *Work Without Salvation*, p. 24; Denning, *Mechanic Accents*, pp. 154–5.

40. Laurie, *Artisans into Workers*, pp. 141–61. See also Leon Fink, *Workingmen's Democracy: The Knights of Labor and American Politics* (Chicago: University of Illinois Press, 1985).

41. Laurie, *Artisans into Workers*, pp. 152, 217.

42. Ibid., p. 177.

43. Ibid., p. 198.

44. Ibid., p. 187.

45. Rodgers, *The Work Ethic*, pp. 11–12, 159–60.

46. Dinnerstein, "The Iron Worker and King Solomon," p. 114. Weir painted the original version of *Forging the Shaft* in 1867, only to reproduce it with a more complicated composition after the original was destroyed in a fire in 1869. (Betsy Fahlman, "John Ferguson Weir: Painter of Romantic and Industrial Icons," *Archives of American Art Journal* 20[2] [1980]: 2–3, 5–6; and idem, *John Ferguson Weir: The Labor of Art* [Cranbury, NJ: Associated University Presses and the University of Delaware Press, 1998].)

47. Fahlman, "John Ferguson Weir," p. 5.

48. In a letter to Mary French of January 29, 1866, Weir wrote of his growing interest in the industrial sublime: "And I sometimes sit before my picture [*Forging the Shaft*] thinking how much finer I will have the next, how mysterious I will make it, how less of labor and more of mind I will show, and endeavor to make it just the spookiest place that ever was with ghouls for men, and sudden gleam of light, as if it was in Pandemonium, and mischief was brewing in the furnace." (Quoted in Betsy Fahlman, "Guest Editorial," */A: Journal of the Society for Industrial Archeology* 12[2] [1986]: 1.)

49. For an excellent contextual study of this painting, see Thomas H. Pauly, "American Art and Labor: The Case of Anshutz's *The Ironworkers Noontime*," *American Quarterly* 40 (September 1988): 333–59. For an alternative, yet equally provocative, reading of this painting, see Griffen, "Thomas Anshutz's *The Ironworkers' Noontime*": 129–45 as in note 18. See also Francis J. Ziegler, "An Unassuming Painter – Thomas P. Anshutz," *Brush and Pencil* 4 (September 1899): 277–84.

50. Pauly, "American Art and Labor," pp. 347–8.

51. Ibid.; see also David Montgomery, *The Fall of the House of Labor* (New York: Cambridge University Press, 1987), for an excellent discussion of the process of de-skilling in the American labor force.

52. Laurie, *Artisans into Workers*, p. 113.

53. Rodgers, *The Work Ethic*, p. 126.

54. The City Beautiful Movement will be discussed in more detail in Chapter 4.

55. Michele Bogart, *Public Sculpture and the Civic Ideal in New York City, 1890–1930* (Chicago: University of Chicago Press, 1989): 221–4; David Glasberg, "History and the Public: Legacies of the Progressive Era," *Journal of American History* 73 (March 1987): 970–1.

56. As Michele Bogart explained, American sculptors incorporated a "modern spirit" in their work by "bas[ing] the facial features and body types of their figures increasingly on live models rather than . . . imitat[ing] classical sculpture" (Bogart, *Public Sculpture*, p. 224); "George Grey Barnard on the Vicissitudes of a Sculptor," *The New York Times*, November 27, 1910, pt. 5, p. 8; Ernest Knaufft, "George Grey Barnard: A Virile American Sculptor," *The American Review of Reviews* 38 (December 1908): 690.

 Unfortunately, the sculptures today do not convey their original subtle modeling and careful working. In fact, they appear somewhat insipid and drained of most detail. Due to two restoration processes, the first during Barnard's lifetime and documented in correspondence, the surface working of the sculptures has been all but lost – sandblasted away with only a trace of the intricate detail that Barnard had

intended. (Philadelphia Museum of Art Archives, The George Grey Barnard Papers, Series III: Sculpture, 1902–38, Subseries C: Harrisburg and Others, 1902–37, George Grey Barnard to George Whigelt, New York, May 21, 1929. See also Whigelt to Barnard, October 2, 1928, and December 13, 1928.)

At present, the sculptures are undergoing yet another restoration – this time with the help of modern conservation techniques. The State of Pennsylvania has allocated two million dollars for the project. (Ruthann Hubbert-Kemper, Pennsylvania Capitol Preservation Committee, in conversation with the author, June 6, 1993.)

57. Rodgers, *The Work Ethic*, pp. 2, 6, 8–9.

58. *Dedication Ceremonies of the Barnard Statues* (Harrisburg: Legislative Commission in charge of Dedication Ceremonies, 1912): 23–4.

59. Rodgers, *The Work Ethic*, pp. xi, 14–16.

60. Gilbert, *Work Without Salvation*, p. ix.

61. Defined by Antonio Gramsci, cultural hegemony is "the 'spontaneous' consent given by the great masses of the population to the general direction imposed on social life by the dominant fundamental group; this is 'historically' caused by the prestige (and consequent confidence) which the dominant group enjoys because of its position and function in the world of production." (Antonio Gramsci, *Selections from the Prison Notebooks,* ed. and trans. Quentin Hoare and Geoffrey Nowell Smith [New York: Internation, 1971]: 12. Also quoted in T. J. Jackson Lears, "The Concept of Cultural Hegemony: Problems and Possibilities," *American Historical Review* 90 [June 1985]: 569, see also pp. 570–4.)

62. Rodgers, *The Work Ethic*, pp. xv, 14, 180.

63. Quoted in ibid., pp. 175, 176, and 177; see also pp. 155, 168, and 174. For a discussion of the monument to William Sylvis, see Archie Green, "Labor Landmarks: Past and Present," *Labor's Heritage* 6 (Spring 1995): 35.

64. Stuart Hall, "The Rediscovery of 'Ideology': Return of the Repressed in Media Studies," in *Culture, Society and Media,* ed. by Michael Gurevitch et al. (New York: Methuen, 1982): 78.

Chapter 2

1. The number of police killed in this action varies from source to source. My assessment of the situation is informed by the explanation put forth by Paul Avrich, who argues that "Contrary to the general impression, most of the injuries had been caused by bullets rather than by bomb fragments. In fact, of the seven policemen who died before the trial, only [Mathias J.] Degan can be accounted an indisputable victim of the bomb." Avrich continues, "Another fact is equally noteworthy. All or nearly all of the policemen who had suffered bullet wounds had been shot by their fellow officers and not by civilians in the crowd." *The Haymarket Tragedy* (Princeton: Princeton University Press, 1984): 197–210, quotes on pp. 206 and 208.

2. For a lengthier discussion on the intersection of class and gender in the representation of working women, see my "Gendered Labor: Norman Rockwell's *Rosie the Riveter* and the Discourses of Wartime Womanhood," in *Gender and American History since 1890,* ed. by Barbara Melosh (New York: Routledge, 1993): 182–207.

3. Buried in the vicinity of the monument's bucolic setting are a number of notable historical personages who dedicated their lives to the pursuit of social justice: Lucy Parsons, Elizabeth Gurley Flynn, and Emma Goldman, to name only a few.

4. Both monuments have been identified as "The Haymarket Monument" in the historical records. More recently, the anarchist monument has been titled "The Haymarket Martyrs Monument" by certain interested groups. For the purposes of clarity, I shall identify the anarchist monument as The Haymarket Monument and the monument commissioned by the city of Chicago as *The Police Monument.*

5. It must be noted that most official documents and original source materials regard-

ing *The Haymarket Monument* have been lost. Whereas Chicago archives are brimming with primary documentation regarding *The Police Monument,* no such wealth of information exists with regard to the anarchist memorial. A slow and painful sifting through of archives in Chicago, Ann Arbor, and New York (as noted in what follows) provided the basis for the analyses available in this chapter. Kenneth E. Foote briefly mentions *The Haymarket* and *The Police Monument* in his recent book, *Shadowed Ground: America's Landscapes of Violence and Tragedy* (Austin: University of Texas Press, 1997): 133–140.

6. James Gilbert, *Perfect Cities: Chicago's Utopias of 1893* (Chicago: University of Chicago Press, 1991): 2, 26; Bruce C. Nelson, *Beyond the Martyrs: A Social History of Chicago's Anarchists, 1870–1900* (New Brunswick, NJ: Rutgers University Press, 1988): 22.

7. In opposition to the absolutism that reigned in all German states prior to 1848, the revolt called for improved civil rights, a constitution that accorded the middle class greater participation in political and economic policymaking, and a united Germany that would encourage patriotism and economic prosperity. The workers demanded a twelve- rather than a fourteen-hour day, education supported by the state, unemployment insurance, consumer coops, workers' housing, and equality for women. In the end, the middle class abdicated support for the workers, satisfied with the attainment of their own demands. For fuller discussions of the 1848 revolutions, see Carl Wittke, *Refugees of Revolution: The German Forty-Eighters in America* (Philadelphia: University of Pennsylvania Press, 1952): 18–22; Priscilla Robertson, *Revolutions of 1848: A Social History* (New York: Harper and Bros., 1952): 108–40; and Theodore S. Hamerow, *Restoration, Revolution, Reaction: Economics and Politics in Germany, 1815–1871* (Princeton: Princeton University Press, 1963).

8. Bruce C. Levine, "In the Heat of Two Revolutions: The Forging of German-American Radicalism," in *Struggle a Hard Battle: Essays on Working-Class Immigrants,* ed. by Dirk Hoerder (DeKalb: Northern Illinois University Press, 1986): 19–46; John Higham, *Strangers in the Land: Patterns of American Nativism 1860–1926,* 2nd ed. (New York: Atheneum, 1963): 8–9; Hartmut Keil, "German Working-Class Radicalism in the United States from the 1870s to World War I," in Hoerder, ed., *Struggle a Hard Battle,* p. 75.

9. One of the important contributions to American political and cultural history that German Forty-Eighters brought to this country was the institution of the *Turnverein,* or athletic club. These clubs aimed to develop a sound, well-coordinated body, a mind sensitive to liberty and patriotism, and an intellect disciplined in the political struggle for a unified Germany. Driven underground in Germany by Metternich, the liberal *Turnverein* tradition flourished in the United States. Members of the clubs embraced a large spectrum of social and political views: revolutionary communism, atheism, pantheism, ardent nationalism, middle-of-the-road reform, and so on. In the 1870s, the American *Turner* organizations turned their attention to political and economic reform, championing greater rights for women, labor reform, the eight-hour day, and child labor laws (Wittke, *Refugees of Revolution,* pp. 147–61). The *Turners,* by and large, embraced socialism as a means of minimizing privilege and guaranteeing everyone prosperity and education (Levine, "In the Heat," p. 32).

10. In its peak year of 1879, membership averaged between 668 and 1,000 members. Although one of the *Verein*'s functions was to protect workers' meetings from intrusion, they never once entered into a confrontation with police. Their role was mainly symbolic – to head parades sponsored by socialist unions and clubs. Outlawed in 1886 after the Haymarket incident, the *Vereins* elicited violent reactions from the middle-class press despite their relatively small size and passive history. Christine Heiss, "German Radicals in Industrial America: The *Lehr- und-Wehr-Verein* in Gilded Age Chicago" in *German Workers in Industrial Chicago, 1850–1910: A Comparative Perspective,* ed. by Hartmut Keil and John B. Jentz (DeKalb: Northern Illinois University Press, 1983): 206–18; quote on p. 211.

11. See chapter on "The *Turner*," in Wittke, *Refugees of Revolution*, pp. 147–61.
12. Patricia Hills and Abigail Booth Gerdts, *Working American*, exh. cat., District 1199, National Union of Hospital and Health Care Employees and the Smithsonian Institution Traveling Exhibition Service, 1979, pp. 35–6; Lois Dinnerstein, "The Iron Worker and King Solomon: Some Images of Labor in American Art," *Arts Magazine* 54 (September 1979): 116–17.
13. When the Baltimore and Ohio railroads announced a 10 percent cut in wages in July 1877, general strikes paralyzed the entire East Coast railway system, spreading throughout the country into seventeen states. The strike rendered obsolete the theory that the United States, in contrast to Europe, was devoid of sharp class divisions and immune from the threat of socialism and the dangers of social upheaval. Avrich, *The Haymarket Tragedy*, pp. 26–7, 35–6. See also Richard Slotkin, *The Fatal Environment: The Myth of the Frontier in the Age of Industrialization, 1800–1890* (New York: Atheneum, 1985): particularly chap. 19, "The Indian War Comes Home: The Great Strike of 1877"; and Carl Smith, *Urban Disorder and the Shape of Belief: The Great Chicago Fire, the Haymarket Bomb, and the Model Town of Pullman* (Chicago: University of Chicago Press, 1995): 106–11.
14. Hills and Gerdts, *Working American*, p. 9.
15. According to an account of the painting by William Finley, quoted in Dinnerstein, "The Iron Worker," p. 116.
16. For a discussion of the literary representation of German women workers, see Carole J. Poore, *German-American Literature 1865–1900* (Bern: Peter Lang, 1982).
17. For a reproduction of this painting, see Hills and Gerdts, *Working American*, p. 35.
18. Nelson, *Beyond the Martyrs*, pp. 41–4, 171–2.
19. Hartmut Keil, "The German Immigrant Working Class of Chicago, 1875–1890: Workers, Labor Leaders and the Labor Movement," in *American Labor and Immigration History, 1877–1920s: Recent European Research*, ed. by Dirk Hoerder (Urbana: University of Illinois Press, 1983): 159, 161.
20. Anticipating anarcho-syndicalism by twenty years, the "Chicago idea" rejected centralized authority, disdained traditional electoral politics, and made the union the center of revolutionary struggle and the nucleus of a future society. Avrich, *The Haymarket Tragedy*, pp. 72–3, 85–6; quote on p. 73.
21. Until late in 1885, Parsons, Spies, and other anarchists distanced themselves from this crusade, seeing it as a stop-gap measure that compromised the greater struggle of destroying capital. However because of its overwhelming popularity, they actively joined the movement as one way into mobilizing the masses of workers and disseminating their ideas about radical unionism. Ibid., pp. 182–3.
22. For material on the May Day strikes, see ibid., pp. 181–6. For discussion of the impact of the Paris Commune on American politics, see ibid., pp. 16–17, 31–5, 44, 138–40, 145, and 185; and Nelson, *Beyond the Martyrs*, pp. 142–3.
23. Samuel Bernstein, "American Labor and the Paris Commune," *Science and Society* 15 (Spring 1951): 144–62; George Haupt, "La Commune comme Symbole et Comme Exemple," *Le Mouvement Social* pp. 79 (April/June 1972): 205–26.
24. Avrich, *The Haymarket Tragedy*, pp. 234–5.
25. The Socialistic Labor Party and the American Federation of Labor, led by Samuel Gompers, strongly urged Governor Oglesby for leniency. Labor, Gompers insisted, "must do its best to maintain justice for radicals or find itself denied the rights of free men." See ibid., pp. 279, 309, and for a full list of those who supported clemency, pp. 334–55. Quote on p. 347.
26. Ibid., pp. 356–78. In *Urban Disorder and the Shape of Belief*, Carl Smith asserts that Lingg committed suicide, p. 124.
27. Avrich, *The Haymarket Tragedy*, pp. 383, 395; quote on p. 393; William J. Adelman, *Haymarket Revisited*, 2nd ed. (Chicago: Illinois Labor History Society, 1986): 104–5; *Chicago Tribune* clipping, Haymarket Scrapbook, Special Collections, Columbia Uni-

versity, p. 122; Henry David, *The History of the Haymarket Affair,* 2nd ed. (New York: 1936; rept. New York: Russell & Russell, 1958): 464; Lizzie Swank, "Our Memorial Day," *The Alarm,* June 16, 1888.

28. Higham, *Strangers in the Land,* p. 54. In fact, Paul Avrich wrote:

> For a large segment of the population the anarchists had ceased to be human beings. They had become the incarnation of evil, monsters endowed with infernal powers, onto whom businessmen and ordinary citizens alike projected all that they dreaded and detested. The anarchists responded in kind. Stripping their opponents of their humanity, they reduced them to animals and insects. (p. 177)

29. Hartmut Keil, "The Impact of Haymarket on German-American Radicalism," *International Labor and Working Class History* 29 (Spring 1986): 16–19; quote on page 18. As Carl Smith explains, "This was an especially live metaphor at the time, since during the Haymarket trial came the news of the capture of Geronimo near the Arizona-Mexico border . . ." (*Urban Disorder,* p. 150).

30. Ibid., p. 112; see also his discussion of the "foreigner," pp. 148–55. Paul Avrich cites the response to the Haymarket Affair as the first red scare in American history. See chap. 15, "Red Scare," in *The Haymarket Affair,* pp. 215–40.

31. "Anarchist Publications," in *The American Radical Press 1880–1960,* ed. by Joseph R. Conlin (Westport, CT: Greenwood Press, 1974): 371.

32. Carl Smith has described this image as "a very accurate picture of how the event was perceived in the popular imagination, which had come to see social and political protest, class warfare and cataclysmic violence . . . as a single phenomenon." *Urban Disorder,* p. 125.

33. Avrich, *The Haymarket Tragedy,* pp. 417–24.

34. Ibid., pp. xi–xii, 454; Gilbert, *Perfect Cities,* pp. 64–9.

35. "The Haymarket Riot Monument," lecture by Clement M. Silvestro, Director of the Chicago Historical Society, May 1965, in the Haymarket Monument File, Chicago Historical Society; *Chicago Tribune,* December 14, 1888, and May 26, 1889, pt. 4, p. 26; William J. Adelman, "The True Story Behind the Haymarket Police Statue," in *Haymarket Scrapbook,* ed. by Dave Roediger and Franklin Rosement (Chicago: Charles H. Kerr, 1986): 167; Adelman, *Haymarket Revisited,* p. 39.

36. Ira J. Bach and Mary L. Gray, *A Guide to Chicago's Public Sculpture* (Chicago: University of Chicago Press, 1983): 135, 230; *Chicago Times Herald,* March 3, 1901, in *Chicago Art Institute Scrapbook* 13: 159; "Johannes Sophus Gelert," *American Numismatic Society, Catalogue of International Exhibition,* 1910, pp. 109–11, and other miscellaneous clippings in Artist's File, New York Public Library.

37. Bach and Gray, *A Guide to Chicago's Public Sculpture,* p. 230; Adelman, *Haymarket Revisited,* p. 39; idem, "The True Story Behind the Haymarket Police Statue," p. 167.

38. Repair marks are evident below the jacket where explosions blew the legs off twice in explosions. Thus, the legs and feet have the least amount of naturalistic detail. The circumstances of these explosions are discussed later in the chapter.

39. *Chicago Times Herald,* July 9 and 12, 1899, in *Chicago Art Institute Scrapbook* 12: 63 and 66.

40. *Chicago Tribune,* December 14, 1888.

41. *Graphic News* 1(14) (June 5, 1886): 220, Chicago Historical Society Photographic Archive.

42. For a lengthier discussion of this image and other female allegorical figures, see Bailey Van Hook, "From the Lyrical to the Epic: Images of Women in American Murals at the Turn of the Century," *Winterthur Portfolio* 26 (Spring 1991): 63–81. A reproduction of Simmons's *Justice* is on p. 75. See also, idem, *Angels of Art: Women and Art in American Society, 1876–1914* (University Park: Pennsylvania State University Press, 1996).

43. Although the graphic was published in 1886, the sculptural image in the background reveals an uncanny resemblance to the official *Police Monument* installed in 1889.

44. Carl Smith offers an alternative reading of this graphic. He argues that the image of Miss Liberty hurling a bomb is one example of the "rhetoric of reversal" apparent throughout the literary and visual accounts of the Haymarket events (*Urban Disorder*, p. 145). I agree that an ironic reversal takes place, but one that is rooted in a parody of the visual codes of the day. Anarchy takes the form of Miss Liberty and subverts notions of law and order that are inscribed through the image of the policeman in the background. "The trope of the ironic reversal," Smith asserts, "was the distinctive feature of Haymarket as imaginative and rhetorical event. It was in substantive ways at the heart of the anarchist challenge to the assumptions on which their trial and the social order were based" (ibid., p. 143). My thesis in this chapter also invokes the "trope of the ironic reversal" but one that gains signification through a gendered critique of the imagery.

45. *Chicago Tribune*, May 31, 1889, p. 1.

46. Idem, August 20, 1893, p. 31, and May 24, 1900, p. 5; *Chicago Post*, May 26, 1900, in *Chicago Art Institute Scrapbook 12*: 112.

47. Throughout the late nineteenth and early twentieth centuries, streetcar workers demonstrated a radical consciousness and labor activism, organizing strikes with regularity and ferocity. Thus, it is not surprising that a streetcar driver would attempt to destroy *The Police Monument* (David Scolby, "Transit Strikers and the Contesting of Urban Public Space, 1870–1920," unpublished paper delivered at the 1991 American Studies Association Meetings, Boston). Adelman, "The True Story Behind the Haymarket Police Statue," p. 168; Bach and Gray, *A Guide to Chicago's Public Sculpture*, pp. 32–4; John Drury, "The Policeman's Monument," *Chicago Sun-Times*, November 12, 1950.

48. The monument was designated an historical landmark on May 9, 1969 (Haymarket Monument File, Chicago Historical Society). Adelman, "The True Story of the Police Haymarket Monument," p. 168; *Chicago Sun-Times*, October 8, 1969. Both the Fraternal Order of Police and the Chicago Patrolmen's Association pledged $500 each for renovating the sculpture (*Chicago Tribune*, May 5, 1970).

49. The anonymous caller claimed the blast as "in honor of our brothers and sisters in the New York prisons. Power to the People." Quoted in Andrew H. Malcolm, "Oft-Bombed Chicago Statue Moves Indoors," *The New York Times*, February 12, 1972; *Daily News*, October 5, 1970.

50. *Chicago Sun-Times*, October 6, 1970.

51. *Daily News*, January 5, 1971; "Moving Day Nears for Haymarket Statue," *Chicago Tribune*, January 13, 1972; Jack Mabley, "Haymarket Cop Monument to Dull Brass," *Chicago Today*, May 30, 1971. As one reporter accurately quipped, the monument had become "a symbol of this city's embattled Police Department" (Malcolm, "Oft-Bombed Chicago Statue Moves Indoors," *The New York Times*, February 12, 1972).

52. The police personnel at the academy demonstrated to the author a fondness for the memorial. Several officers noted the history of the work – even the name of the statue's model, Sgt. Birmingham. "They'll have to helicopter in to get it," one officer remarked protectively. In a display case in the main lobby of the academy, the plaque describing the Haymarket event accompanies a photograph of the monument and of a slain officer, James E. Doyle, killed in the line of duty on February 5, 1980. (In conversation with the author, Chicago Police Training Center, spring 1993.)

53. Unidentified clipping, *Chicago Tribune*, Haymarket Scrapbook, Special Collections, Columbia University.

54. The three original trustees were Mathias Schmiedinger, a member of the Central Labor Union and president of the German Baker's Union, Peter Knickrehm, and

Jacob Scharmer. Nelson, *Beyond the Martyrs*, pp. 181, 209; Pioneer Aid and Support Association file, Chicago Historical Society; and *The Alarm*, December 31, 1887. Quote from Pioneer Aid and Support Association file.

Widows received $8.00 a week plus $2.00 each for the first two children and $1.00 for the third. Lucy Parsons, the wife of Albert Parsons, received $12.00 per week. The association supported the families for eight years. Carolyn Ashbaugh, *Lucy Parsons: American Revolutionary* (Chicago: Charles H. Kerr, 1976): 155–6.

55. Minutes of the Pioneer Aid and Support Society, pp. 27, 82, Labodie Collection, University of Michigan; *Remember the Eleventh of November* (Chicago: Pioneer Aid and Support Association, 1927), in Tamiment Library, New York University; and phone conversation with William Adelman, April 28, 1992. There is some indication that the cemetery authorities opposed the erection of a monument: "It was strongly hinted that the authorities of Waldheim Cemetery, the one in which it was proposed to bury the 'reds,' and over their graves erect a monument, were seriously considering whether it was not their duty to refuse a resting place for the anarchists' remains within their enclosure. At least they will not allow the monument" (unidentified newspaper clipping, Haymarket Scrapbook, p. 169, Special Collections, Columbia University).

56. "Our Chicago Letter," November 24, 1888. *The Alarm: A Socialist Weekly* began publishing in October 1884 under the editorship of Albert and Lucy Parsons. After three months, it shifted to a fortnightly publication. It was shut down after the Haymarket event, to reappear in its Chicago edition from November 1887 to January 1889. With Dyer Lum as its editor, it continued publication in New York City. Nelson, *Beyond the Martyrs*, pp. 118–19.

57. "What Monument?," *The Alarm*, November 24, 1888.

58. Emma Goldman, *Living My Life*, vol. 1 (New York: Alfred A. Knopf, 1931): 221–2.

59. Pioneer Aid and Support Association Minutes, pp. 100, 103, and 111. The monument committee consisted of Louis Fambrok, William Urban of the *Arbeiter Zeitung*, Dr. Ernst Schmidt, Herr Kaune, Mathias Schmedinger, Theodore Mess, and Thomas Greif (*Chicago Tribune*, November 6, 1892, p. 6).

60. John J. Flynn, *Chicago, the Marvelous City of the West: A History, an Encyclopedia, and a Guide* (Chicago: Flinn and Sheppard, 1891): 396. I am indebted to William Adelman for providing me with this reference.

61. Pioneer Aid and Support Association Minutes, pp. 116 and 118; *Mantle Fielding's Dictionary of American Painters, Sculptors, and Engravers*, rev. ed. (1983), s.v. Albert Weinert; "Albert Weinert, 84, Told U.S. History in Sculpture," unidentified obituary notice in Artist's File, New York Public Library; *Chicago Tribune*, November 6, 1892, p. 6.

62. In conversation with William Adelman, Forest Home, Illinois, June 2, 1992.

63. Thanks to Clifton Olds of Bowdoin College for this observation.

64. Avrich, *The Haymarket Tragedy*, pp. 446–8.

65. The admission ticket commemorated the unveiling ceremonies: "Erected by the working people of Chicago in the memory of the labor struggle of 1886 and its victims: Aug. Spies, Alb. Parsons, Louis Lingg, Adolphe [*sic*] Fischer, and Geo. Engel" (Ashbaugh, *Lucy Parsons*, p. 151).

66. Avrich, *The Haymarket Tragedy*, pp. 413–14; Adelman, *Haymarket Revisited*, pp. 105–7; and *Chicago Tribune*, June 26, 1893, p. 7.

67. The United States dedicated the *Statue of Liberty* three weeks after the Haymarket defendants presented their last speeches to the court (Ashbaugh, *Lucy Parsons*, p. 103). For a critical analysis of this monument, see Maria Warner, *Monuments and Maidens: The Allegory of the Female Form* (New York: Atheneum, 1985); Kaja Silverman, "Liberty, Maternity, Commodification," *New Formations* 5 (Summer 1988): 69–90; Barbara A. Babcock and John J. Masaloon, "Everybody's Gal: Women, Boundaries and Monuments," in *The Statue of Liberty Revisited*, ed. by W. S. Dillon and N. G.

Kotler (Washington, D.C.: Smithsonian Institution Press, 1994): 79–99; and, most recently, Albert Boime, *The Unveiling of the National Icons: A Plea for Patriotic Iconoclism in a Nationalist Era* (New York: Cambridge University Press, 1998): 82–136.

Bailey Van Hook discusses this new allegorical mode, arguing that it represents elements of the "New Woman." Her description of these images compares favorably with *The Haymarket Monument:* "The women are presented standing with their bodies set at an angle so the twist or turn of their torsos conveys a dynamic aspect. Central figures often move forward, drapery flowing backward against an unseen resisting force, hands upraised in a rhetorical gesture, facial expression intense, directly confronting the viewer with their gaze" (Van Hook, " 'From the Lyrical to the Epic,' " pp. 74–6).

68. Christian imagery played a large role in the rhetoric of trade unionists, anarchists, and socialists despite their tendency toward free thinking. In evoking the figure of Jesus Christ, a model to emulate and inspire, labor leaders sanctified and legitimized their political goals. Herbert Gutman, "Protestantism and the American Labor Movement: The Christian Spirit in the Gilded Age," in *Work, Culture and Society in Industrializing America,* 2nd ed. (New York: Vintage Books, 1977): 79–119.

69. Peter Fusco and H. W. Janson, eds., *The Romantics to Rodin: French Nineteenth-Century Sculpture from North American Collections,* exh. cat., Los Angeles County Museum in association with George Braziller, Inc., 1980, catalogue entry by Peter Fusco, pp. 256–7.

70. *Romantics to Rodin,* catalogue entries by Ruth Butler, pp. 331–3.

71. Goldman, *Living My Life,* p. 221.

72. Alexander Berkman, ed., *Selected Works of Voltarine de Cleyre* (New York: Mother Earth, 1914): 66.

73. My conclusions in this chapter are indebted to Joy Kasson's analysis of Harriet Hosmer's *Zenobia* in her *Marble Queens and Captives: Women in Nineteenth Century American Sculpture* (New Haven: Yale University Press, 1990): 141–66. For a discussion of French republican imagery, see Maurice Agulhon, *Marianne into Battle: Republican Imagery and Symbolism in France, 1789–1880,* trans. by Janet Lloyd (New York: Cambridge University Press, 1981).

Similarly, in Elihu Vedder's Library of Congress mural *Anarchy,* critics attacked the nude female figure of anarchy as "brawny," a term commonly applied to males (Van Hook, " 'From the Lyrical to the Epic'," p. 79).

74. *The Chicago Tribune,* November 6, 1892, p. 6; *The Daily Inter Ocean,* June 26, 1893, p. 5.

75. *The Chicago Tribune,* June 26, 1893, p. 7; Henry David, *The History of the Haymarket Affair* (New York: Farrar and Rinehart, 1936), also identifies the figure as Justice, p. 491; *The World,* June 28, 1893, in the Labodie Collection, University of Michigan.

76. As Marcia Pointon argues: "once a woman is associated with violent confrontation even if she is symbolic or token rather than individual or participatory, the accusation of prostitution is frequently leveled at her" (Marcia Pointon, *Naked Authority: The Body in Western Painting 1830–1908* [New York: Cambridge University Press, 1990]: 73). Eric Hobsbawm, "Man and Woman in Socialist Iconography," *History Workshop* 6 (1978): 123.

77. See also Neil Hertz, "Medusa's Head: Male Hysteria under Political Pressure," *Representations* 4 (Fall 1983): 27.

78. Gay L. Gullickson, "*La Pétroleuse:* Representing Revolution," *Feminist Studies* 17 (Summer 1991): 243–6, quote on p. 260; and idem, *Unruly Women of Paris: Images of the Commune* (Ithaca, NY: Cornell University Press, 1996).

79. Michael J. Schaack, *Anarchy and Anarchists: A History of the Red Terror and the Social Revolution in America and Europe* (Chicago: F. J. Schulte, 1889): 208–9.

80. Ashbaugh, *Lucy Parsons,* pp. 60, 63.

81. The image of the wild unruly woman as political threat followed in a tradition most recently developed during the 1848 revolutions and continued in the representations of Bolshevik women by the German *freikorps*. Writing in the *Siècle* on the competition for the image of the Republic in 1849, Louis Desnoyes explained:

> Most of the competitors depicted veritable viragos, furies, shrews, enraged female devils with dishevelled hair and ragged clothing. Their look was fiery, their mouths hurled abuse . . . they scrambled . . . over piles of paving stones, beams, stove-in barrels and overturned coaches as if the Republic had ever to be storming eternal barricades! The *Republic* is neither rebellion, sedition nor revolt, not insurrection nor revolution; it is quite the contrary, the end of all that.'' (Quoted in Agulhon, *Marianne into Battle*, pp. 76–7.)

For a similar description of working-class women, see also A. Dauger's description of Adlophe Leleux's *The Departure* of 1850 in his ''Salon de 1851,'' *Le Pays*, February 14, 1851, quoted in T. J. Clark, *The Absolute Bourgeois: Artists and Politics in France 1848–1851* (Greenwich, CT: New York Graphic Society, 1973): 23.

In describing German *freikorps* fantasies of Boshevik women, Klaus Theleweit writes:

> The description of the proletarian woman as monster, as a beast . . . hardly derives from the actual behavior of women . . . Rather, it can be traced to an attempt to construct a fantastic being who swears, shrieks, spits, scratches, farts, bites, pounces, tears to shreds, who is slovenly, wind-whipped, hissing-red, indecent; who whores around, slaps its naked thighs, and can't get enough of laughing at these men. Even worse than the worst male communist, is a female communist. (Klaus Theleweit, *Male Fantasies: Women, Floods, Bodies, History*, Vol. 1 [Minneapolis: University of Minnesota Press, 1987]: 67, 78.)

82. As Natalie Zemon Davis has theorized:

> The image of the disorderly woman did not always function to keep women in their place. On the contrary, it was a multivalent image that could operate, first, to widen behavioral options for women within and even outside marriage, and second, to sanction riot and political disobedience for both men and women in a society that allowed the lower orders few formal means of protest. Play with an unruly woman is partly a chance for temporary release from the traditional and stable hierarchy; but it is also part of the conflict over effort to change the basic distribution of power within society. (Natalie Zemon Davis, ''Women on Top,'' *Society and Culture in Early Modern France* [Stanford: Stanford University Press, 1975]: 131.)

83. Forest Home Cemetery receives many calls requesting information about the monument. (Conversation with Pat Julian, Forest Home Cemetery, Forest Park, Illinois, June 2, 1992.)

84. Quoted in David, *The History of the Haymarket Affair*, p. 534.

85. *The Alarm*, November 17, 1888.

86. Lloyd Lewis and Henry Justin Smith, *Chicago: The History of Its Reputation* (New York: Blue Ribbon Books, 1929.): 166.

87. Lucy Robbins Lang, *Tomorrow Is Beautiful* (New York: Macmillan, 1948): 27, 31, and 291.

Chapter 3

1. The sculpture was exhibited in a life-size, plaster format. If cast in bronze, the cost was to be $30,000. The sculpture's whereabouts is unknown and it is presumed destroyed. Brandon Brame Fortune and Michelle Mead, ''Catalogue of American Paintings and Sculptures Exhibited at the World's Columbian Exposition, Revised and Updated,'' *Revisiting the White City: American Art at the 1893 World's Fair*, exh. cat. (Washington, D.C: The National Museum of American Art and the National Portrait Gallery, Smithsonian Institution, 1993): 365.

2. The bibliography on the World's Columbian Exposition has grown dramatically since its centennial anniversary in 1993. I shall cite in this note only some of the

most recent publications. Please see the following for a more complete list of citations. *Revisiting the White City*; Peter B. Hales, *Constructing the Fair: Platinum Photographs by C. D. Arnold of the World's Columbian Exposition,* exh. cat. (Chicago: Art Institute of Chicago, 1993); Neil Harris, Wim de Wit, James Gilbert, and Robert Rydell, *Grand Illusions: Chicago's World's Fair of 1893,* exh. cat. (Chicago: Chicago Historical Society, 1993); James Gilbert, *Perfect Cities: Chicago's Utopias of 1893* (Chicago: University of Chicago Press, 1991). For a brief discussion of Gelert's *Struggle for Work* when exhibited at the fair see Michael Leja, "Modernism's Subjects in the United States," *Art Journal* 55 (Summer 1996): 65–73.

3. Russell Lewis, "Everything Under One Roof: World's Fairs and Department Stores in Paris and Chicago," *Chicago History* 3 (Fall 1983): 29–34.

4. I would like to thank Diane Dillon for making available to me her excellent analysis of spectacle at the World's Columbian Exposition, " 'The Fair as a Spectacle': American Art and Culture at the World's Columbian Exposition," unpublished manuscript.

5. Neil Harris, "Museums, Merchandising and Popular Taste: The Struggle for Influence," in *Material Culture and the Study of American Life,* ed. by Ian M. G. Quimby, (New York: Norton, 1978): 145–6; see also Walter Benjamin, "Paris, Capitol of the Nineteenth Century," in *Reflections: Essays, Aphorisms, Autobiographical Writings,* ed. by Peter Demetz, trans. by Edmund Jephcott (New York: Harcourt Brace Jovanovich, 1978): 146–63.

6. Little is known of the other Model Workingman's Home located at the start of the Midway next to the Irish Village except for its documentation by photograph. I would like to thank Julie Brown for bringing to my attention this photograph and clarifying the confusions between the two Model Workingman's Homes.

7. Daniel Hudson Burnham and Francis Davis Millet, *The Book of the Builders,* 1 (4) (May 19, 1894): 25, in the Robert A. Feer Collection of World Fairs in North America, Rare Books and Manuscript Department, Boston Public Library. Hereafter cited as Feer Collection, BPL.

8. Ray Ginger, *Altgeld's America: The Lincoln Ideal versus Changing Realities* (New York: Funk and Wagnalls, 1958): 11. Robert Rydell cites 5,919 medical and surgical cases and over 30 deaths reported during the construction period. Rydell, "A Cultural Frankenstein? The Chicago World's Columbian Exposition of 1893" in Harris et al., *Grand Illusions,* p. 166.

9. See Thomas S. Hines, *Burnham of Chicago: Architect and Planner* (New York: Oxford University Press, 1974): 103–4; Janet C. Marstine, "Working History: Images of Labor and Industry in American Mural Painting, 1893–1903," Ph.D. diss., University of Pittsburgh, 1993, pp. 1, 25–36.

10. "Want to Injure the World's Fair," *Chicago Herald,* n.d. See also "Greif Asks an Injunction," *Chicago Herald,* n.d., and "They Endorse the Raid," unidentified newspaper clipping. All clippings are located in the Joseph Labodie Scrapbook, Labodie Collection, University of Michigan. Mayor Washburne served in office from 1891 to 1893.

11. Johannes Gelert file, National Sculpture Society, New York.

12. Douglas Tilden's *The Baseball Player,* discussed in the following chapter, also made the list (Fig. 31). Carolyn Kinder Carr, "Prejudice and Pride: Presenting American Art at the 1893 Chicago World's Columbian Exposition," *Revisiting the White City,* p. 105; undated newspaper clipping, Fine Arts Scrapbook, World's Columbian Exposition, Chicago Historical Society.

13. Quoted in *The National Cyclopaedia of American Biography,* pp. 9, 58–9. Charles Henry Dorr wrote that the work "met with wide popular approval." "A Danish-American Sculptor: The Work of Johannes S. Gelert," *The Architectural Record* 33 (April 1913): 334.

14. *Inter Ocean,* July 9, 1893, p. 27. Thanks to Janet Marstine for bringing this citation to my attention.

15. The jury consisted of Daniel Chester French, Boston; Lorado Taft, Chicago; and

Robert Bringhurst, St. Louis. The alternates were John J. Boyle, Philadelphia; Carl Rohl-Smith, Chicago; and Gelert. *Official Catalogue of Exhibits, Part X, World's Columbian Exposition: Department K, Fine Arts* (Chicago: W. B. Conkey, 1893): 4 in the Feer Collection, BPL. Gelert also served as Vice-Chairman of the Committee of the World's Congress Auxiliary on a Congress of Sculptors. Lorado Taft served as chairman. World's Congress Auxiliary: Official Programs, reports, and so on, in the Newberry Library, Chicago.

16. F. D. Millet, "The Decoration of the Exposition" *Scribners Magazine* 12 (December 1892): 702; David F. Burg, *Chicago's White City of 1893* (Lexington: University of Kentucky, 1976): 181; and James Spencer Dickerson, "Sculpture of the Columbian Exposition," *The Graphic Chicago*, World's Fair Series No. 5: Sculpture of the World's Columbian Exposition (December 10, 1892): 7:66, in Feer Collection, BPL. The sculptures that Gelert exhibited at the fair are reproduced in *Revisiting the White City*, p. 365.

17. See Marstine, "Working History," pp. 61–124. For a more general discussion of female personifications at the Fair, see Judy Sund, "Columbus and Columbia in Chicago, 1893: Man of Genius Meets Generic Woman," *Art Bulletin* 75 (September 1993): 443–467.

18. James W. Shepp and Daniel B. Shepp, *Shepp's World's Fair Photographed* (Philadelphia: Globe Bible Publishing, 1893): 36, in Feer Collection, BPL.

19. For a discussion of the "Noble Yeoman," see Sarah Burns, *Pastoral Inventions: Rural Life in Nineteenth-Century American Art and Culture* (Philadelphia: Temple University Press, 1989): 99–122. See also Chapter 1 of this book for an extended discussion of the relevance of the agrarian worker to the work ethic ideology.

20. Held in conjunction with the ninth annual meeting of the American Historical Association, the World's Congress of Historians formed part of an intellectual project in connection with the World's Columbian Exposition. See what follows for more information on this institution. Turner read "The Significance of the Frontier to American History" at the meeting. A key historical text for modern historians, the paper received moderate attention at the time. Burg, *Chicago's White City of 1893*, pp. 256–7.

21. For a discussion of paintings of the World's Columbian Exposition – some of which include these sculptures as artistic motifs, see Margaretta M. Lovell, "Picturing 'A City for a Single Summer': Paintings of the World's Columbian Exposition," *Art Bulletin* 78 (March 1996): 40–55.

22. Alan Trachtenberg, *The Incorporation of America* (New York: Hill and Wang, 1982): 220. See also the pamphlet, "The Reason Why the Colored American Is Not in the World's Columbian Exposition," distributed by Ida B. Wells, 1893, in the World's Columbian Exposition Files of the Chicago Historical Society. Frederick Douglass, Wells, and others contributed essays to the pamphlet. Wells writes in the Preface: "[The colored people] have contributed a large share to American prosperity and civilization. The labor of one-half of this country has always been, and is still being done by them. The first credit this country had in its commerce with foreign nations was created by productions resulting from their labor. The wealth created by their industry has afforded to the white people of this country the leisure essential to their great progress in education, art, science, industry and invention."

23. For an interesting comparison between the *Teamster* and the black soldiers pictured in Augustus St. Gaudens' *Shaw Memorial*, see Albert Boime, *The Art of Exclusion* (Washington, D.C.: Smithsonian Press, 1990): 211–12.

24. Replicas of these sculptures were installed in 1909 at the western entrance to the Flower Garden in Garfield Park near Madison Street and Hamlin Boulevard. See James L. Reidy, "Sculpture at the Columbian Exposition," *Chicago History* 4 (Summer 1975): 106; Ira J. Bach and Mary L. Gray, *A Guide to Chicago's Public Sculpture* (Chicago: University of Chicago Press, 1983): 312–13.

25. See E. McClung Fleming, "The American Image as Indian Princess, 1765–1783,"

Winterthur Portfolio 2 (1965): 65–81, and idem, "From Indian Princess to Greek Goddess: The American Image, 1783–1815," *Winterthur Portfolio* 3 (1967): 37–67.

26. Vivien Green Fryd, *Art and Empire: The Politics of Ethnicity in the United States Capitol, 1815–1860* (New Haven: Yale University Press, 1992): 169–70, quote on p. 170. The 1855–6 fresco is reproduced in pl. 103. Moreover, Enrico Causici's *Landing of the Pilgrims* of 1825 in the U.S. Capitol Rotunda also reveals corn as a national symbol. Reproduced in ibid., pl. 14.

 It is interesting to note that in the original plaster model of the *Goddess of Corn*, (illustrated in *Modern American Sculpture* by Sadakichi Hartmann, New York: Paul Wenzel, [c. 1918]: pl. II), the figure holds a hunting knife and her robes fall into a lion's head. In the sculpture exhibited at the fair (and reproduced here), the figure became more tamed: No knife nor lion's head appeared in the final staff version that graced the Court of Honor.

27. Shepp and Shepp, *Shepp's World's Fair Photographed*, p. 42; see also "The Decorative Sculpture at the Fair," *The Dial* 15 (November 1, 1893): 255–6; and Will H. Low, "The Art of the White City," *Scribners Magazine* 14 (October 1893): 511.

28. Ripley Hitchcock, ed., *The Art of the World Illustrated in Paintings, Statuary, and Architecture of the World's Columbian Exposition* (New York: Appleton, 1895): 1: 95 in the Feer Collection, BPL.

29. For a full discussion of these photographs, see Peter Hales, *Silver Cities: The Photography of American Urbanization, 1839–1915* (Philadelphia: Temple University Press, 1884): 131–61; idem, "Photography and the World's Columbian Exposition: A Case Study," *Journal of Urban History* 15 (May 1989): 247–71; and idem, *Constructing the Fair: Platinum Photographs by C. D. Arnold of the World's Columbian Exposition*, where, in contrast to my analysis, Hales argues for the central role of the worker in these images. For a reproduction of Arnold's image, see idem, *Constructing the Fair*, p. 29. See also, Julie K. Brown, *Contesting Images: Photography and the World's Columbian Exposition* (Tuscon: University of Arizona Press, 1994).

30. Burnham Papers, Burnham and Ryerson Libraries, Art Institute of Chicago as quoted in Hines, *Burnham of Chicago*, p. 104.

31. Burnham and Millet, *The Book of the Builders*, p. 27. One commentator responded to the fence as follows: "Here we have on the land side of the Fair the usual assemblage of cheap shows, lemonade vendors, and the like which line the unsightly fence and make up what a friend has dubbed the Sideway Unpleasant. The fence is hard to pardon in a land were energy is predominant, desire to do the best not wanting, and *staff* abundant. A high white wall enclosing the substantial fabric of their dream would have done much to give the western approach something of the festal magnificence which the architects have given to the entrance by the peristyle at the lake side" (Low, "The Art of the White City," p. 506).

32. Walter A. Wyckoff, *The Workers: An Experiment in Reality, The West* (New York: Charles Scribner's Sons, 1900): 277; Carlos A. Schwantes, *Coxey's Army: An American Odyssey* (Lincoln: University of Nebraska Press, 1985): 26–8.

33. Ibid., p. 248.

34. Robert W. Rydell, *All the World's a Fair: Visions of Empire at American International Exposition, 1876–1916* (Chicago: The University of Chicago Press, 1984): 41, 68; "The World's Congress Auxiliary of the World's Columbian Exposition of 1893: General Programme of the Series of World's Congresses to be held at Chicago in Connection with the World's Columbian Exposition of 1893," October 1892, n.p., in Feer Collection, BPL; and Trachtenberg, *The Incorporation of America*, pp. 213–14.

35. The General Divisions of the Department of Labor included: Historic Development of Labor; Labor Organizations; Conflicts of Labor and Capital; Labor Economics and Legislation; Woman's Work and Wages; Domestic Economy; Child Labor; Education, Public Opinion and Progress ("The World's Congress Auxiliary of the World's Columbian Exposition of 1893," n.p.).

36. Carl Smith, *Urban Disorder and the Shape of Belief: The Great Fire, the Haymarket Bomb, and the Model Town of Pullman* (Chicago: University of Chicago Press, 1995): 226. For more information on these meetings, see the "Programme of the Labor Congress" in the World's Columbian Exposition files of the Chicago Historical Society.

37. "Congress of Labor," *Inter Ocean,* August 29, 1893, p. 3.

38. "How to Lend Aid," *Inter Ocean,* August 30, 1893, p. 3. See Chapter 1 for a fuller discussion of vagabondage, Coxeyism, and the eight-hour-day crusade.

39. She continued that if men could not settle the labor problem, she advised them to stay home and nurse the babies and darn the stockings and leave it to the women. "Mrs. Lease on Labor," *Inter Ocean,* September 1, 1893, p. 8.

40. Reid Badger, *The Great American Fair: The World's Columbian Exposition and American Culture* (Chicago: Nelson Hall, 1979): 100–1; Schwantes, *Coxey's Army,* p. 29. At the Labor Day meeting, Mayor Harrison attempted to explain his ban on meeting at the Lake Front: "I was glad enough to see [the workers] march until several men were foolish enough to turn over one of Uncle Sam's mail wagons. . . . When I heard of that occurrence I stopped marching on the streets during these troublesome times. To-day no more orderly crowd ever marched to a church or to a wedding than did the laborers who joined in the big procession" ("The Day at Odgen's Grove," *Inter Ocean,* September 5, 1893, p. 2).

41. "To Be A Grand Event," *Inter Ocean,* September 2, 1893, p. 4.

42. "Gathering at Kuhn Park," *Inter Ocean,* September 5, 1893, p. 2.

43. For a more thorough discussion of Gompers' principles as articulated through the American Federation of Labor, see Chapter 1.

44. Marstine, "Working History," p. 33 n.28.

45. Benjamin R. Tucker, "Boycott the World's Fair Congress," *Liberty* (Boston) 9 (March 18, 1893): 2. The Women's World Congress Committee on Labor was chaired by Mrs. J. D. Harvey; Jane Addams and Ellen Starr, among others, sat on the committee (World's Congress Auxiliary: Official Programs, reports, and so on, in the World's Columbian Exposition Files in the Newberry Library, Chicago).

46. A stay at the fair would cost workers from $28 to $38 per week, plus an additional $38 train fair with a berth from New York City (Marstine, "Working History," pp. 59–60).

47. Helen Horowitz, *Culture and the City: Cultural Philanthropy in Chicago from the 1880s to 1917* (Chicago: The University of Chicago Press, 1976): 111. Quote from Badger, *The Great American Fair,* p. 98.

48. Katharine Bement Davis, "Report on the Exhibit of the New York State Workingman's Model Home," in *Report of the Board of General Managers of the Exhibit of the State of New York at the World's Columbian Exposition* (Albany: James B. Lyon, State Printer, 1894): 394–5, in Feer Collection, BPL.

49. Ibid., pp. 397–8; Joseph W. Barnes, "How to Raise a Family on $500 a Year," *American Heritage* 33 (December 1981): 92–4.

50. Davis, "Report on the Exhibit," p. 425.

51. For an intriguing discussion of the Model Workingman's Home, see Gilbert, *Perfect Cities,* p. 117, although he mistakenly places the New York exhibit on the Midway. Many questions remained unanswered by this well-meaning initiative. Although the Model Workingman's Home represented the best housing available for workers under ideal conditions, most workers would never be able to afford it. An annual income of $500 was budgeted to support this household; however (in 1893), the average industial worker, who labored nearly 60 hours a week, earned between $444 and $480 a year. Moreover, the $500 budget supported only basic living expenses; what of costs associated with education, amusement, illness or old age? (Barnes, "How to Raise a Family," p. 92; Davis, "Report on the Exhibit," p. 442.)

52. Stanley Buder, *Pullman: An Experiment in Industrial Order and Community Planning 1880–1930* (New York: Oxford University Press, 1967): 35–40. See also Jacob Riis,

How the Other Half Lives: Studies Among the Tenements of New York, rpt. (New York: Dover, 1971), a document that contributed to this tenement reform movement. Riis applauded White's contribution to the crusade; see pp. 228–9.

53. Buder, *Pullman,* pp. 44, 92; quote from p. 61; Gilbert, "Perfect Cities," p. 153.

54. Buder, *Pullman,* pp. 68, 129.

55. Gilbert, *Perfect Cities,* pp. 135–6, Buder; *Pullman,* p. 147; see also Carl Smith's discussion of Pullman in *Urban Disorder and the Shape of Belief,* pp. 177–232; for information on the Baedeker guide, see p. 223.

56. Gilbert, *Perfect Cities* p. 137.

57. Buder, *Pullman,* pp. 93–4.

58. *New York Sun,* December 9, 1883, quoted in Buder, *Pullman,* p. 94.

59. Buder, *Pullman,* pp. 51, 54, 59, 61, 95; Gilbert, *Perfect Cities,* p. 136, 148, 166–7.

60. Larry Peterson, "Producing Visual Traditions among Workers: The Uses of Photography at Pullman, 1880–1980," *Views: The Journal of Photography in New England* 13 (Spring 1992): 4; Buder, *Pullman,* pp. 45, 147.

61. Ginger, *Altgeld's America,* p. 55.

62. Smith, *Urban Disorder,* p. 204. Parsons, Spies, and Felden were all convicted of conspiracy in the Haymarket bombing trial. See Chapter 2 for a full discussion of this event and its aftermath.

63. Buder, *Pullman,* pp. 152–187; Smith, *Urban Disorder,* pp. 232–50.

64. See Archie Green, "Labor Landmarks: Past and Present," *Labor's Heritage* 6 (Spring 1995): 26–54.

Chapter 4

1. Douglas Tilden received a contract dated December 19, 1898, from James D. Phelan, Mayor of San Francisco. A sum of $24,500 was allotted for all expenses related to the production of the monument. Douglas Tilden Papers, Bancroft Library, University of California, Berkeley.

2. Gladys Tilden Papers, Bancroft Library, University of California, Berkeley.

3. Mildred Albronda, *Douglas Tilden: Portrait of a Deaf Sculptor* (Silver Springs, MD: T. J. Publishers, 1980): 33.

4. The elderly man was modeled upon Henry B. Crandall, the first teacher in the California School for the Deaf, which opened in 1860 – a school that Tilden attended as a young boy. Douglas Tilden Papers.

5. Undated entry, Gladys Tilden Papers.

6. Lorado Taft, *The History of American Sculpture* (1903 rpt; New York: Arno Press, 1969): 534, 535, 536. See also Frank Jewett Mather, Jr., Charles Rufus Morey, and William James Henderson, "The American Spirit in Art" in *The Pageant of America,* vol. 12, ed. by Ralph Henry Gabriel (New Haven: Yale University Press, 1927): 201, for a discussion of the *Mechanics Fountain* as specifically Western in character.

7. Gunther Barth, *Instant Cities: Urbanization and the Rise of San Francisco and Denver* (New York: Oxford University Press, 1975): 95–8, 118; Judd Kahn, *Imperial San Francisco: Politics and Planning in an American City, 1897–1906* (Lincoln: University of Nebraska Press, 1979): 2, 5, 8, 11, 26–7, Lawrence C. Larsen, *The Urban West and the End of the Frontier* (Lawrence: The Regents of Kansas, 1978): 7; and Kevin Starr, *Inventing the Dream: California Through the Progressive Era* (New York: Oxford University Press, 1985): 180.

8. To show its gratitude for its newly stimulated economy, the city of San Francisco erected a monument to Admiral Dewey in its most elegant downtown plaza, Union Square. Kahn, *Imperial San Francisco,* pp. 30, 65, 71–2. See also Lucille Eaves, *A History of California Labor Legislation* (Berkeley: University of California Press, 1910): 59.

9. William H. Wilson, *The City Beautiful Movement* (Baltimore: Johns Hopkins University Press, 1989): 1; Michele H. Bogart, *Public Sculpture and the Civic Ideal in New York City, 1890–1930* (Chicago: University of Chicago Press, 1989): 56–61; Kahn, *Imperial San Francisco*, pp. 57–9; and Barth, *Instant Cities*, p. 153.

 Phelan was committed to the promotion of art and culture throughout his life. He served as vice-president of the California World's Fair Commission in 1893 and the manager of the California exhibition at the World's Columbian Exposition. Moreover, he held the presidency of the Bohemian Club and the San Francisco Art Association from 1894 to 1895. William Issel and Robert W. Cherny, *San Francisco, 1865–1932: Politics, Power and Urban Development* (Berkeley: University of California Press, 1986 pp. 109–10).

10. James D. Phelan to Douglas Tilden, November 15, 1898, Gladys Tilden Papers; Kahn, *Imperial San Francisco*, p. 66.

11. All biographical information is from Albronda, *Douglas Tilden*.

12. Tilden argued in the pages of the *Overland Monthly* for expanded art patronage among San Francisco elites and the establishment of a public museum of fine arts. See "Art, and What California Should Do About Her," *Overland Monthly* 19 (May 1892): 509–15. Moreover, he helped organize the Society of Arts and Crafts and served as one of its directors. The goals of this group were "to bring together a body of men actively engaged in the arts of painting, sculpture, architecture, music and literature, that they might make a concerted action, influence the general taste, protesting against what is poor and unworthy, insisting upon a higher standard of art in public buildings, monuments and all public works." Albronda, *Douglas Tilden*, p. 29. For illustrations of these monuments, see pp. 121, 136, 142, 144.

13. In 1977, the city moved the monument to the intersection of Market, Post, and Montgomery streets as part of the latest ($24.5 million) beautification program, the Market Street Redevelopment Project. Albronda, *Douglas Tilden*, pp. 121, 144; Kahn, *Imperial San Francisco*, p. 65. The success of the *Admission's Day Monument* prompted Phelan to commission Tilden to create a model of the Spanish explorer Vasco Nunez de Balboa to be placed at the western end of Golden Gate Park so it would look out toward the Pacific Ocean. Tilden never cast the model in bronze as the war with Spain made it an untimely project. Albronda, *Douglas Tilden*, p. 32.

14. "The Donahue Fountain Unveiled by the Mayor," *The Evening Post*, May 15, 1901, p. 2; *A Sketch of the Life of Peter Donahue, of San Francisco, 1822–1885* (San Francisco: Crocker, 1888); and Richard H. Dillon, *Iron Men: Peter, James, and Michael Donahue, California's Industrial Pioneers* (Point Richmond, CA: Candela Press, 1984).

15. *Mechanics Institute Library Bulletin* 1 (June 1901): 4, Mildred Albronda Papers, Bancroft Library, University of California, Berkeley.

16. "The Question that Agitates the Executors," unidentified newspaper clipping, Douglas Tilden Scrapbook, p. 30, Gladys Tilden Papers.

17. Thanks to Patsy Vigderman for this astute observation.

18. "Sculptor Tilden's Design for the Donahue Fountain," unidentified newspaper clipping, Douglas Tilden Scrapbook, p. 28.

19. My thanks to Edward Mann and Charles Woodman of the Charles River Museum of Industry, Waltham, Massachusetts, for their helpful assessments of the practicality of Tilden's punch press.

20. Quoted in George B. West, "Noted Artist Rises Anew After 20 Years," *San Francisco Call* 138 (September 1925), Gladys Tilden Papers.

21. For a detailed discussion of the term "mechanic," see Sean Wilentz, *Chants Democratic: New York City and the Rise of the American Working Class, 1788–1850* (New York: Oxford University Press, 1984).

22. Albronda, *Douglas Tilden*, p. 7.

23. Herbert Gutman, "Work, Culture and Society in Industrializing America, 1815–1919," in his *Work, Culture and Society in Industrializing America* (New York: Vintage

Books, 1977): 40; Kahn, *Imperial San Francisco*, pp. 17, 25–6; Michael Kazin, *Barons of Labor: The San Francisco Building Trades and Union Power in the Progressive Era* (Urbana: University of Illinois Press, 1987): 14–21; Larsen, *The Urban West*, p. 39; David Lavender, *California: A Bicentennial History* (New York: W. W. Norton, 1976): 125–6.

24. Larsen, *The Urban West*, p. 39; Kahn, *Imperial San Francisco*, p. 22; Kazin, *Barons of Labor*, p. 24; and Bruce Dancis, "Social Mobility and Class Consciousness: San Francisco's International Workmen's Association in the 1880s," *Journal of Social History* 11 (Fall 1977): 84.

25. See the Introduction to this book for a discussion of the recent interest in this monument by working-class men of San Francisco.

26. Michael Hatt, "Making a Man of Him: Masculinity and the Black Body in Mid-Nineteenth Century American Sculpture," *Oxford Art Journal* 15 (1) (1992): 24, 27; Elliot J. Gorn, *The Manly Art: Bare-Knuckle Prize Fighting in America* (Ithaca, NY: Cornell University Press, 1986): 142. Since this essay was first delivered (in a much shorter version) as a conference paper at the American Studies Association meetings in Baltimore in 1991 and subsequently published in the *American Quarterly* in 1995, a number of important critical writings on masculinity have emerged. Most important for the purposes of this book is Gail Bederman's *Manliness and Civilization: A Cultural History of Gender and Race in the United States, 1880–1917* (Chicago: University of Chicago Press, 1995). See also Michael Leininger, "Masculinity: A Selective Bibliography of Print Materials in English," in *The Masculine Masquerade: Masculinity and Representation,* ed. by Andrew Perchuk and Helaine Posner (Cambridge, MA: MIT List Visual Arts Center and The MIT Press, 1995), pp. 135–57.

27. For two very different discussions of this painting, see Randall C. Griffen, "Thomas Anschutz's *The Ironworkers' Noontime:* Remythologizing the Industrial Worker," *Smithsonian Studies in American Art* 4 (Summer/Fall, 1990): 129–45; and Thomas H. Pauly, "American Art and Labor: The Case of Anshutz's *The Ironworker's Noontime,*" *American Quarterly* 40 (September 1988): 333–59. See also Chapter 1 of this book for an extended analysis of this painting.

28. Michael Hatt, "Muscles, Morals, Mind: The Male Body in Thomas Eakins' Salutat," in *The Body Imaged: The Human Form and Visual Culture Since the Renaissance,* ed. by Kathleen Adler and Marcia Pointon (New York: Cambridge University Press, 1993): 62–3.

29. For a discussion of men as object of the male gaze, see Norman Bryson, "Géricault and 'Masculinity'," paper delivered at the NEH Institute, Rochester, New York, July 1989, and published in Norman Bryson, Michael Ann Holly, and Keith Moxey, eds., *Visual Culture: Images and Presentations* (Hanover, NH: Wesleyan University Press and the University Press of New England, 1994): 228–60; Robert J. Corber, "Reconstructing Homosexuality: Hitchcock and the Homoerotics of Spectatorial Pleasure," *Discourse* 13 (Spring–Summer 1991): 58–83. See also Eve Kosofsky Sedgwick, *Between Men: English Literature and Male Homosocial Desire* (New York: Columbia University Press, 1985), and idem, *The Epistemology of the Closet* (Berkeley: University of California Press, 1990); and Judith Butler, *Gender Trouble: Feminism and the Subversion of Identity* (New York: Routledge, 1990).

30. Gladys Tilden, "A Sketch of Douglas Tilden's Life," p. 16, unpublished manuscript, Gladys Tilden Papers.

31. Peter J. McGlynn, "Shall the Donahue Statuary Be Made to Wear Trousers?," unidentified newspaper clipping of 1898, Douglas Tilden Scrapbook, p. 29; "The Question that Agitates the Executors," undated newspaper clipping, Douglas Tilden Scrapbook, p. 30.

32. Steve Neale, "Masculinity as Spectacle: Reflections on Men and Mainstream Cinema," *Screen* 24 (4) (1983): 2–16; Rosalind Coward, *Female Desires* (New York: Grove

Press, 1985): 225–33; Robert Haywood, "George Bellows' *Stag at Sharkey's:* Boxing, Violence and Male Identity," *Smithsonian Studies in American Art* 2 (Spring 1988): 3–17.

Michael Hatt has recently written about the problematics of the homosocial gaze: "In problematizing the homosocial gaze, asking . . . how it is regulated, a theoretical framework is needed that can deal with issues of what can and cannot be said, of blankness and text, of accessibility and interpretability. . . . I use the term [homoerotic] to designate a displacement of desire into a position which both allows and refuses desire; that is, it is a position which clearly contains the possibility of desire between men, but which, in making that containment evident, actually constructs the possibility of the desire it refutes. Importantly, it provides us with a theoretical model which can articulate a desire between men that can be conceived as something other than an ostensibly self-evident homosexuality" ("Making a Man of Him," p. 31).

33. Hatt, "Making a Man of Him," pp. 31–2. See also Alex Potts, "Male Phantasy and Modern Sculpture," *Oxford Art Journal* 14 (2) (1992): 24–48. For another discussion of the male body as hard and inviolable, see Klaus Theweleit, *Male Bodies: Psychoanalyzing the White Terror*, vol. 2 of *Male Fantasies* (Minneapolis: University of Minnesota Press, 1989).

34. Gorn, *The Manly Art*, pp. 179–80; Peter Filene, *Him/Her/Self: Sex Roles in Modern America*, 2nd ed. (Baltimore: Johns Hopkins University Press, 1986): 75; Benjamin G. Rader, "The Recapitulation Theory of Play: Motor Behaviour, Moral Reflexes and Manly Attitudes in Urban America, 1880–1920," in *Manliness and Morality: Middle Class Masculinity in Britain and America, 1880–1940*, ed. by J. A. Mangan and James Walvin (New York: St. Martin's Press, 1987): 126–7; E. Anthony Rotundo, "Body and Soul: Changing Ideals of American Middle-Class Manhood, 1770–1920," *Journal of Social History* 16 (Summer 1983): 29; and Paul Boyer, *Urban Masses and Moral Order in America, 1820–1920* (Cambridge, MA: Harvard University Press, 1978): 113.

35. Peter Lehman, "*In the Realm of the Senses:* Desire, Power, and the Representation of the Male Body," *Genders* 2 (Summer 1988): 91–110; Tania Modleski, "The Incredible Shrinking He(r)man: Male Regression, the Male Body and Film," *Differences* (2) (1990): 55–76. For two fascinating discussions of the black male body in Thomas Ball's *Emancipation Group* of 1875 and John Quincy Adams Ward's *The Freedman* of 1863, see Hatt, "Making a Man of Him" and Kirk Savage, *Standing Soldiers, Kneeling Slaves, Race, War and Monument in Nineteenth-Century America* (Princeton, N.J: Princeton University Press, 1997).

36. Gorn, *The Manly Art*, p. 226.

37. Roberta Park, "Biological Thought, Athletics, and the Formation of a 'Man of Character,' 1830–1900," in Mangan and Walvin, *Manliness and Morality*, pp. 7–35; Gorn, *The Manly Art*, p. 185–7; Rader, "The Recapitulation Theory of Play," p. 130; Donald Mrozek, *Sport and American Mentality 1880–1910* (Knoxville: University of Tennessee Press, 1983).

38. Eadweard Muybridge (1830–1904), photographer and scientist, studied human movement at the University of Pennsylvania from 1884 to 1885. He produced 100,000 negatives of a wide array of sporting activities, such as running, broad jump, throwing and catching a baseball and football, rowing, wrestling, and boxing. His work influenced Eakins' own motion studies and was significant for many other contemporary artists concerned with movement and the human anatomy. (Mrozek, *Sport and American Mentality 1880–1910*, pp. 195–6.) For Muybridge's influence on Eakins, see Ellwood C. Parry, III, "Thomas Eakins's 'Naked Series' Reconsidered: Another Look at the Standing Nude Photographs Made for the Use of Eakins's Students," *The American Art Journal* 20 (2) (1988): 58.

39. Carl S. Smith, "The Boxing Paintings of Thomas Eakins," *Prospects* 4 (1979): 404–5. For an illustration of *Max Schmitt in a Single Scull,* see Elizabeth Johns, *Thomas Eakins: The Heroism of Modern Life* (Princeton: Princeton University Press, 1983): pl. 2. See Hatt, "Muscles, Morals, and Mind," for a particularly fascinating discussion of Eakins' interest in sport and the male body.

40. Douglas Tilden to Archibald Treat, director of the Olympic Club, Paris, April 24, 1891, Mildred Albronda Papers.

41. Albronda, *Douglas Tilden,* pp. 19–20; Robert Knight Barney, "Of Rails and Red Stockings: Episodes in the Expansion of the 'National Pastime' in the American West," *Journal of the West* 17 (July 1978): 61.

42. Quoted in "Douglas Tilden," *Deaf Mute's Journal* (March 19, 1931), Gladys Tilden Papers.

43. Albronda, *Douglas Tilden,* p. 25; Gorn, *The Manly Art,* p. 180; Benjamin G. Rader, *American Sports: From the Age of Folk Games to the Age of Televised Sports,* 2nd ed. (Englewood Cliffs, NJ: Prentice Hall, 1990): 101–3.

44. Albronda, *Douglas Tilden,* p. 119. For an illustration of the *Seated Boxer,* see Horst de La Croix, Richard G. Tansey, and Diane Kirkpatrick, *Gardner's Art Through the Ages,* 9th ed. (New York: Harcourt Brace Jovanovich, 1991): pl. 5–86.

45. Gorn, *The Manly Art,* pp. 12–13, 196.

46. Ibid., pp. 222–3.

47. For a discussion of Eakins' boxing paintings, see Smith, "Boxing Paintings," and Hatt, "Muscles, Morals, and Mind." For a discussion of Eakins' interest in the nude body, see Kathleen A. Foster and Cheryl Leibold, *Writing About Eakins: The Manuscripts in Charles Bregler's Thomas Eakins Collection* (Philadelphia: University of Pennsylvania, 1989), Parry, "Thomas Eakins' 'Naked Series' "; Whitney Davis, "Erotic Revision in Thomas Eakins's Narratives of Male Nudity" *Art History* 17 (September 1994): 301–41; and Randall C. Griffen, "Thomas Eakins' Construction of the Male Body, or 'Men Get to Know Each Other Across the Space of Time'," *The Oxford Art Journal* vol. 18 no. 2 (1995): 70–80. For a reproduction of *Taking the Count,* see Haywood, "George Bellows' *Stag at Sharkey's,*" p. 9.

48. Theodore Roosevelt, *The Winning of the West* (New York: Current Literature Publishing, 1896) and *Outdoor Pastimes of an American Hunter* (New York: Charles Scribners and Sons, 1903). See also G. Edward White, *The Eastern Establishment and the Western Experience: The West of Frederic Remington, Theodore Roosevelt, Owen Wister* (Austin: University of Texas Press, 1989).

49. Daniel Carter Beard, *Boy Scouts of America* (1914), p. 293, quoted in Jeffrey Hantover, "The Boy Scouts and the Validation of Masculinity," in *American Man,* ed. by Elizabeth and Joseph H. Pleck (Englewood Cliffs, NJ: Prentice Hall, 1980): 293.

50. E. Anthony Rotundo, "Learning about Manhood: Gender Ideals and the Middle-Class Family in Nineteenth Century America," in Mangan and Walvin, *Manliness and Morality,* pp. 40–2; and Roderick Nash, "The American Cult of the Primitive," *The American Quarterly* 18 (Fall 1966): 520–2.

51. Remington's graphic originally illustrated an article by Julian Ralph, "A Skin for a Skin," *Harper's New Monthly Magazine,* LXXXIV (February 1892): 393.

52. For a discussion of the representation of Native Americans within the discursive formation of the "frontier," see Alex Nemerov, "Doing the 'Old West:' The Image of the American West, 1880–1920," in *The West as America: Reinterpreting Images of the Frontier, 1820–1920,* ed. by William H. Truettner (Washington, DC: Smithsonian Institution Press, 1991): 284–343. For the connection between the worker and the Native American, see Richard Slotkin, *The Fatal Environment: The Myth of the Frontier in the Age of Industrialization 1800–1890* (New York: Atheneum, 1985). For an analysis of race in terms of "the crisis of masculinity" in the 1890s, see Gail Bederman, "Civilization, the Decline of Middle Class Manliness, and Ida B. Wells' Anti-Lynching

Campaign (1892–1894)" in *Gender and American History Since 1890,* ed. by Barbara Melosh (New York: Routledge, 1993): 207–40, and idem, *Manliness and Civilization.*

53. On a visit to San Francisco on May 13, 1893, President Theodore Roosevelt received a souvenir from the city in the form of an eight-inch gold replica of Tilden's *Bear Hunt* – a fitting tribute to a proponent of the strenuous life on the wild frontier (Albronda, *Douglas Tilden,* p. 39). James Phelan presented the statuette with the following words: "And why did we choose the bear? . . . This territory was not won without struggle, and that represents in itself the dangers and perils of pioneer life, and the bear was – we have great respect for him – one of the earliest settlers. . . . He died rather than submit to captivity. . . . [This sculpture honors] the great position you hold as a champion of the strenuous life which is our life in the West" (*San Francisco Chronicle,* May 14, 1903, pp. 2, 7, Mildred Albronda Papers).

54. Taft, *The History of American Sculpture,* p. 535.

55. Coward, *Female Desires,* p. 227.

Chapter 5

1. Daniel T. Rodgers, "In Search of Progressivism," *Reviews in American History* 10 (December 1982): 114.

2. For a full discussion of Social Darwinism and its dissenting views, see Richard Hofstadter, *Social Darwinism in American Thought,* rev. ed. (Boston: Beacon Press, 1955).

3. William L. O'Neill, *The Progressive Years* (New York: Harper and Row, 1975): 94; Hofstadter, *Social Darwinism,* pp. 123–43.

4. Bruno Ramirez, *When Workers Fight: The Politics of Industrial Relations in the Progressive Era, 1898–1916* (Westport, CT: Greenwood Press, 1978): 8. For a general description of labor in this period, see David Brody, "The American Worker in the Progressive Era," in his *Workers in Industrial America* (New York: Oxford University Press, 1980): 3–48; Melvyn Dubofsky, *Industrialism and the American Worker, 1865–1920,* 2nd ed. (Arlington Heights, IL: Harlan Davidson, 1985); and David Montgomery, *The Fall of the House of Labor* (New York: Cambridge University Press, 1987).

5. Dubofsky, *Industrialism,* pp. 86–7. For detailed critiques of the NCF, see Gabriel Kolko, *The Triumph of Conservatism: A Reinterpretation of American History, 1900–1916* (New York: The Free Press, 1963), and James Weinstein, *The Corporate Ideal in the Liberal State, 1900–1910* (Boston: Beacon Press, 1968).

6. A Meunier sculpture, *The Puddler,* served as an illustration to a 1909 article for *The Survey,* "A Year's Work: Accidents and their Cost," by the radical reformer, Crystal Eastman, in which she lambasted Pittsburgh industry and the "valuations put on men in Pittsburgh – Actual amounts paid as compensation by employers to twenty-seven workmen premanently injured in Allegheny County, April, May, June, 1907." Crystal Eastman, "A Year's Work Accidents and their Cost," *The Survey* 21 (March 6, 1909): 1142A.

7. Graham Adams, Jr., *Age of Industrial Violence, 1910–1915* (New York: Columbia University Press, 1966): 25–32, quotation on p. 32. This commission was not the first of its kind. In 1898, President William McKinley appointed a commission to investigate industrial and labor conditions following the severe depression of 1893–8. (Ramirez, *When Workers Fight,* p. 3).

8. Wilson had initially entered public life on a probusiness ticket, refusing to support women's suffrage and child labor reform. In 1910, he attempted to gain labor's favor by defending the rights of trade unionists but failed. By 1916, however, he had forged a strong liaison with labor by supporting child labor laws and workmen's compensation. Melvin Dubofsky, "Abortive Reforms: The Wilson Administration and Organized Labor, 1913–1920," in *Work, Community and Power,* ed. by James E.

Cronin and Carmen Sirianni (Philadelphia: Temple University Press, 1983): 202–3; O'Neill, *The Progressive Years*, pp. 131–2.

9. Among the representatives who sat on the commission were Samuel Gompers, president of the American Federation of Labor; members of the National Civic Federation rather than large industrialists; and historian John R. Commons from the public sector. The commission deliberately excluded extremist voices – neither the National Association of Manufacturers nor radical labor (or socialists) were represented. Dubofsky, "Abortive Reform," pp. 204–5; Weinstein, *The Corporate Ideal*, p. 190; and for a detailed account of the formation of the commission, see Adams, *Age of Industrial Violence*, pp. 50–75.

10. Dated May 14, 1914; quoted ibid., p. 47.

11. For details of the strike, see ibid., pp. 153–73; Priscilla Long, "The Women of the Colorado Fuel and Iron Strike, 1913–194," in *Women Work and Protest: A Century of U.S. Women's Labor History*, ed. by Ruth Milkman (Boston: Routledge and Kegan Paul, 1985): 62–85; and idem, "The Voice of the Gun: Colorado's Great Coalfield War of 1913–1914," *Labor's Heritage* 1 (October 1989): 4–24.

12. See, for example, "Class War in Colorado," *The Masses* 5 (June 1914): 5–8; "The Nice People of Trinidad," *The Masses* 5 (July 1914): 5–9; and "To a New Subscriber," *The Masses* 6 (April 1915): 6.

13. In 1918, the United Mine Workers erected a monument to those killed in the Ludlow massacre. Commissioned by and for the interests of labor, the monument records both the historical agency of the union and the sorrow of the workers' bitter struggle. The *Ludlow Memorial* consists of a tall shaft before which stand a miner and a woman holding a child to her breast. The miner stands relaxed, dressed in work clothes, with an open-necked shirt and rolled-up sleeves. His posture suggests a calm but resilient demeanor as he gazes out into the future. The woman, reminiscent of a classical mourning figure, wears a gracefully draped long sheath and leans against the tall shaft while resting her head against one hand in meditation over those who perished. On the shaft behind the figures reads the inscription, "In Memory of/ The Men, Women and Children/Who Lost Their Lives/In Freedom's Cause/At Ludlow, Colorado/April 20, 1914/Erected by the/United Mine Workers of America." The monument was unveiled and dedicated on the field of Ludlow on Memorial Day, May 30, 1918. It stands today on a desolate stretch of Highway 25 north of Trinidad, Colorado. "In Remembrance," *United Mine Workers Journal* 29 (May 16, 1918): 6; "Memorial Day at Ludlow," *United Mine Workers Journal* 29 (June 6, 1918): 4; H. M. Gitelman, *Legacy of the Ludlow Massacre: A Chapter in American Industrial Relations* (Philadelphia: University of Pennsylvania Press, 1988): 240. For an illustration of the *Ludlow Memorial*, see Archie Green, "Labor Landmarks: Past and Present," *Labor's Heritage* 6 (Spring 1995): 31.

14. The *St. Louis Dispatch* openly assailed both Governor Ammons of Colorado and the Rockefellers for the tragedy. See, for example, "The Colorado Massacre," *St. Louis Displatch*, April 25, 1914, p. 8.

15. Unidentified newspaper clipping, *Record Herald* (Chicago), July 9, 1905, Scrapbook, Ryerson Library, Art Institute of Chicago.

16. "Chicago Sees Work of Belgian Millet," *Inter Ocean*, March 26, 1914. See Chapter 4 of this book for a further discussion of the issues of masculinity, the worker, and the male body.

17. Camille Lemmonier, *La Belgique* (Paris: Hachette et Cie, 1888). On Meunier's artistic training, see *Art et Société en Belgique, 1848–1914*, exh. cat., Palais des Beaux-Arts de Charleroi, October 11–November 23, 1980; *Belgian Art 1880–1914*, exh. cat., Brooklyn Museum, New York, April 23–June 29, 1980; and Eugenia W. Herbert, *The Artist and Social Reform: France and Belgium, 1885–1898*, 2nd ed. (New York: Arno Press, 1980).

18. Christian Brinton, *Modern Artists* (New York: Baker and Taylor, 1908): 87; Samuel

Howe, "Constantin Meunier: A Sculptor of the People," *Craftsman* 8 (July 1905): 442.

19. Quoted in "The Artist Who Exalts Labor," *Review of Reviews* 33 (April 1906): 500.

20. Brinton, "Constantin Meunier's Message to America," *The Studio International* 51 (January 1914): 154.

21. For an illustration of Giotto's *Lamentation,* see H. W. Janson, *History of Art,* 3rd ed., revised and expanded by Anthony J. Janson (New York: Abrams; and Englewood Cliffs, NJ: Prentice Hall, 1986): fig. 491.

22. Sura Levine, "Monumental Transformations: Constantin Meunier's *Monument to Labor,*" a paper presented at the College Art Association Meeting, Washington, D.C., 1990. Sura was kind enough to let me read a copy of her paper.

23. J. A. Schmoll gen. Eisenwerth, "Denkmaler der Arbeit – Entwurfe und Planungen" in *Denkmaler im 19. Jahrhundert Deutung und Kritik,* ed. by Hans-Ernst Mittag and Volker Plagemann (Munich: Prestel-Verlag, 1972): 257.

24. Donald Drew Egbert, *Social Radicalism and the Arts* (New York: Alfred A. Knopf, 1970): 220–6, quotes on p. 226. Kropotkin also spoke eloquently about the *Haymarket Monument* in Waldheim (now Forest Home) Cemetery (Fig. 2-1). See Chapter 2 for Kropotkin's comments.

25. Schmoll gen. Eisenwerth, "Denkmaler der Arbeit," p. 260. Translation by the author.

26. Ibid., Cornelia Bentley Sage, "Constantin Meunier – An Appreciation," *Scribners' Magazine* 55 (April 1914): 537.

27. Schmoll gen. Eisenwerth, "Denkmaler der Arbeit," p. 257. However, not all socialists believed in the revolutionary message of Meunier's art. Emil Vandervelde, the Belgian socialist deputy, wrote in the *Neue Gessellschaft* (Berlin): "Did Meunier follow the socialistic tendency when he evoked these figures in clay? We believe not. As was the case with Millet, he had no political purpose, and it would not be in accord with the truth to attribute motives to him which he evidently never possessed. This is the very sign of genius, that it is much more the manifestation of an instinct than the expression of a conscious, reasoning will." Quoted in "The Proletarian Art of Constantin Meunier," *Current Literature* 39 (September 1905): 274.

28. Other drawings by Luce of Meunier's work appeared in the following order: *The Puddlers, Bricklayers, Miners in the Vein, The Puddler, The Hammerman, Return of the Miners, The Fire Damp, Crouching Miner,* and *The Sacrifice.* Micheline Hanotelle, *Paris/ Bruxelles: Rodin/Meunier* (Paris: Le Temps, 1982): 175–6. See also *The Artist and Social Reform,* pp. 187–91. Meunier's relief, *Tillers of the Soil,* is currently located in the Musee d'Orsay, Paris. For a reproduction of this sculpture, see Hanotelle, *Paris/ Bruxelles,* p. 160.

29. Quoted in "Meunier and Belgian 'Socialist' Art," *Review of Reviews* (American) 48 (December 1913): 743.

30. The exhibition showed in Buffalo at the Albright Art Gallery from November 20 to December 22, 1913; in Pittsburgh at the Carnegie Institute from December 27, 1913, to January 18, 1914; in New York at the Avery Library, Columbia University, from January 27 to February 15, 1914; in Detroit at the Museum of Art from February 20 to March 14, 1914; in Chicago at the Art Institute from March 24 to April 19, 1914; and in St. Louis at the City Art Museum from April 26 to May 24, 1914.

31. "Meunier Sculptures Find Popular Favor," *The Monumental News* 26 (1914): 659.

32. *New York Times,* January 18, 1914, sec. X, p. 15; "Constantin Meunier," *Bulletin of the Detroit Museum of Art* 8 (April 1914): 21. Despite the apparent interest among workers in this exhibition, no record remains of their thoughts and attitudes toward Meunier's sculpture. This essay is premised upon the critical reception of American middle-class audiences.

33. Cornelia B. Sage to Edward Jackson, December 6, 1913, in the Constantin Meunier

papers, Albright-Knox Art Gallery Archives; *New York Times,* February 3, 1914, p. 2; see also "Buffalo Fine Arts Academy," *The Lotus Magazine* 5 (February 1914): 290.

34. William R. French to Cornelia B. Sage, October 24, 1913, the William R. French papers, Art Institute of Chicago Archives.

35. "Current Exhibitions," *Chicago Art Institute Bulletin* 7 (April 1914): 7, Ryerson Library, Art Institute of Chicago. See also Chapter 6 of this book for a further discussion of Meunier's influence on a generation of young American sculptors.

36. Sura Levine has recently argued that Meunier never intended the hierarchical structure of the cubic form but a concave or hemispheric shape that he believed allowed for a more egalitarian placement of the figures. "Monument Transformations: Constantin Meumier's *Monument to Labor,*" CAA presentation.

37. Brinton, *Modern Artists,* p. 82. For an illustration of Courbet's *Stonebreakers,* see Janson, *History of Art,* fig. 867.

38. "Industrial Labor in Art," *The Nation* 98 (January 15, 1914): 54.

39. "Constantin Meunier: The Belgian Sculptor Who Has Immortalized Modern Labor Conditions in his Art," *The Craftsman* 25 (January 1914): 315–23; "Meunier Preaching to Americans," *Literary Digest* 48 (January 17, 1914): 106–7; Samuel Howe, "Meunier: Sculptor of Labor," *Survey* 31 (February 7, 1914): 569–74; and Sage, "Constantin Meunier," pp. 535–8.

40. Ada Rainey, "Meunier – Sculptor of Industry," *The Independent* 77 (January 26, 1914): 126.

41. John Spargo, "Constantin Meunier: Painter and Sculptor of Toil," *The Comrade* 1(10) (1902): 246.

42. Quoted in Cornelia B. Sage, "Constantin Meunier: An Exhibition of the Works of the Great Belgian Sculptor," *Art and Progress* 5 (February 1914): 122.

43. Howe, "Meunier: Sculptor of Labor," p. 573. For a description of the glass industry in this country, see Francis G. Couvares, *The Remaking of Pittsburgh: Class and Culture in an Industrializing City, 1877–1919* (Albany: State University of New York Press, 1984), esp. pp. 9–31, 84–5.

44. Sage, "Constantin Meunier: An Exhibition" p. 122.

45. "The Meunier Exhibition," *New York Times,* January 25, 1914, sec. V, p. 15.

46. "Meunier: The Sculptor of the Proletarian," *Chicago Sunday Times,* March 22, 1914, sec. V, p. 6.

47. Christian Brinton, *Constantin Meunier,* exh. cat., New York, Avery Library, Columbia University, 1914, pp. 57–9; slightly revised version in Brinton, *Modern Artists,* pp. 93–4.

48. *Chicago Tribune,* March 22, 1914, sec. V, p. 6. Emphasis added by author.

49. "Meunier's Remarkable Sculpture to Be Shown Here," *New York Times Magazine,* November 4, 1913, p. 14.

50. Emile Zola, *Germinal* (New York: Viking Penguin, 1986): 210.

51. For example, *Detroit News,* March 7, 1914, p. 7.

52. Edward Wheelright, "Personal Recollections of Jean-François Millet," *Atlantic Monthly* 38 (September 1876): 275, as quoted in Laura F. Meixner, *An International Episode: Millet, Monet, and their North American Counterpart,* exh. cat. The Dixon Gallery and Garden, Memphis, Tennessee, November 21 – December 23, 1982, p. 72. See also Meixner, "Popular Criticism of Jean-François Millet in Nineteenth-Century America," *Art Bulletin* 65 (March 1983): 96–105.

53. See Chapter 1 of this book for an extended discussion of the American reception of Millet's imagery.

54. Cornelia Sage was trained as an artist before entering the museum world. She began her career as assistant secretary at the Buffalo Fine Arts Academy in 1904, and then served as the assistant to Dr. Charles M. Kurtz, director of the Buffalo Fine Arts Academy from 1905 to 1909. In 1910, she attained the position of assistant director of the Academy and upon Kurtz's death, she was appointed acting director in March

1910. In October of that same year, she was elected director of the Buffalo Fine Arts Academy, a position she held for fifteen years. In 1924, she left Buffalo to become the director of the California Palace of the Legion of Honor in San Francisco. In writing to Nicholas Murray Butler of Columbia University, she inadvertently described her position as musuem director in terms of gender difference: "Now, I believe it [a problem with the Meunier exhibition] has all been sent to me to develop some 'manly' instincts which I probably did not possess before." Cornelia B. Sage to Nicholas Murray Butler, February 10, 1914, Nicholas Murray Butler Archive, Special Collections, Columbia University.

For biographical information on Sage, see John W. Leonard, ed., *Woman's Who's Who of America, 1914–1915* (New York: American Commonwealth, 1914): 712; *Who's Who in American Art*, vol. 2, 1913–39 (Washington, DC: American Federation of Arts, 1937): 612 (listed under Cornelia Benton Sage Quinton); Chris Petteys, *Dictionary of Women Artists* (Boston: G. K. Hall, 1985): 618–19; Peter Hastings Falk, ed., *Who Was Who in American Art* (Madison, CT: Sound View Press, 1985).

55. Cornelia B. Sage to Representative Edward Jackson, October 30, 1913, Meunier Papers, Albright-Knox Art Gallery Archives.

56. Cornelia Sage, "Detroit Is Favored with Exhibition of the Works of Meunier Which Is Creating Profound Impression Among Lovers of Art," *Detroit Tribune*, February 22, 1914, sec. 1, p. 12.

57. Sage, "Constantin Meunier – An Appreciation," p. 538.

58. Butler was a distinguished educator and politician throughout his life. After an illustrious educational career, he became president of Columbia University in 1902. In 1913, his commitment to Republican Party politics was rewarded by his nomination as vice-president to William Howard Taft. In 1925, he became the president of the Carnegie Endowment for International Peace and shared the 1931 Nobel Peace Prize with Jane Addams. He retired from the presidency of Columbia University in 1945. For more information on Butler, see Albert Marrin, *Nicholas Murray Butler* (Boston: Twayne, 1976).

59. *Is American Worth Saving? Addresses On National Problems and Party Politics* (New York, 1920): 8, as quoted in Marrin, p. 121.

60. Hofstadter, *Social Darwinson*, p. 50; Marrin, *Nicholas Murray Butler*, p. 100; "Buffalo Fine Arts Academy," p. 287; William Murray Butler to the Secretary of the Treasury of Columbia University, September 25, 1912, Jacques-Meunier Files, Columbia University Archive.

61. Moreover, the Brooklyn Institute, the Rhode Island School of Design, Columbia University, the Albright Art Gallery, and the Detroit Institute of Arts purchased sculptures for their collections. Letter from Nicholas Murray Butler to Jacques-Meunier, April 2, 1914, in the Jacques-Meunier File, Columbia University Archive; the Meunier Papers, Albright-Knox Art Gallery Archives; letter from Clyde Burroughs, Director of the Detroit Institute of Arts to Glen Swanson, secretary to Cornelia B. Sage, May 25, 1914, in the Meunier Papers, Albright-Knox Art Gallery Archives.

62. William O. Partridge, "Meunier in the Eyes of a Sculptor," *Columbia Alumni News* 5 (February 27, 1914): 437.

63. George Washington Vanderbilt II, the youngest son of William Henry Vanderbilt, inherited ten million dollars, the Fifth Avenue Vanderbilt Mansion, and its art collection upon his father's death. Little is known of his life as his papers are held in the Biltmore Company and are not available to researchers. He was shy and quiet, interested in literary pursuits. He amassed a huge number of volumes for his art and architecture library and was the only child of William Henry Vanderbilt to appreciate the family art collection. After many philanthropic missions, such as aiding the construction of the Jackson Square Branch of the New York Free Circulating Library, he died of a heart attack on March 6, 1914. Vanderbilt bought the

following works for his Biltmore home: *Antwerp, Old Miner, Miner, The Hammerman, Glassblower, Woodcutter, Abbateur,* and *Old Woodcutter's Wife.* Cornelia B. Sage to the Editor of the *New York Times,* February 25, 1914, Meunier Papers, Albright-Knox Art Gallery Archives.

For more information on George W. Vanderbilt's life, see Victoria L. Volk, "The Biltmore Estate and Its Creators: Richard Morris Hunt, Frederick Law Olmsted, and George Washington Vanderbilt," Ph.D. diss., Emory University, 1984; and Wayne Andrews, *The Vanderbilt Legend: The Story of the Vanderbilt Family, 1794–1940* (New York: Harcourt, Brace, 1941).

64. Cornelia B. Sage to Christian Brinton, December 17, 1913, Meunier Papers, Albright-Knox Art Gallery Archives.

Chapter 6

1. The multiplicity of meanings generated by the exhibition of Meunier's work in this country has been explored in the previous chapter.

2. Marianne Doezema, *George Bellows and Urban America* (New Haven: Yale University Press, 1992): 1. For a thorough social history of the Ashcan artists, see Rebecca Zurier, Robert W. Snyder, and Virginia M. Mechlenburg, *Metropolitan Lives: The Ashcan Artists and Their New York* (New York: National Museum of American Art in association with W. W. Norton, 1995). Especially relevant for this study are pp. 43, 45, and 95–102.

3. "Everett Shinn's Paintings of Labor in the New City Hall at Trenton, N.J.," *Craftsman* 21 (January 1912): 379–80; 383–4.

4. Francisco Ferrer Guardia was a Spanish anarchist and libertarian educator who had been executed at Barcelona in 1909 for allegedly leading a military rebellion. For information on the Modern School of the Ferrer Center, see Francis Naumann, "Man Ray and the Ferrer Center: Art and Anarchy in the Pre-Dada Period," *Dada and Surrealism* 14 (1985): 10–31; Paul Aurich, *The Modern School Movement: Anarchism and Education in the United States* (Princeton: Princeton University Press, 1980); and Donald Drew Egbert, "Socialism and American Art," in Donald Drew Egbert and Stow Persons, eds., *Socialism in American Life,* vol. 1 (Princeton: Princeton University Press, 1952): 715–16.

Representations of the worker were widespread in the popular media at this time. Both Joseph Stella and Lewis Hine, for example, produced many images of laborers during this period. Commissioned by the reform journal *The Survey,* they documented in graphics and photography the lives of miners in the districts surrounding Pittsburgh. See, for example, "The Garment-Workers as Sketched by Joseph Stella," *The Survey* 41 (January 4, 1919): 447–50. See Chapter 7 for Hine's depictions of laboring men.

5. Elizabeth Milroy, *Painters of a New Century: The Eight and American Art,* exh. cat., Milwaukee Art Museum, 1991, p. 33. George Vanderbilt, Gertrude Vanderbilt Whitney's uncle and patron of Constantin Meunier's sculpture, gave as a gift the galleries at the American Fine Art Society building. Avis Berman, *Rebels on Eighth Street: Juliana Force and the Whitney Museum of American Art* (New York: Atheneum, 1990): 78.

6. *Monumental News* 17 (December 1905): 806.

7. Charles H. Caffin, "National Sculpture Society Exhibition," *International Studio* 18 (December 1902): ciii; *The Third Exhibition of the National Sculptural Society,* American Fine Arts Society, New York, May 1–28, 1898, in the Archives of American Art (hereafter AAA) National Sculpture Society, Roll 16, frame 572; Adeline Adams, *The Spirit of American Sculpture* (New York: National Sculpture Society, 1923): 192, 194; Lorado Taft, *The History of American Sculpture* (rpt. 1924; New York: Arno Press, 1969): 424.

8. Lewis S. Sharp, *John Quincy Adams Ward: Dean of American Sculpture* (Newark: University of Delaware Press, 1985): 79–81.

9. Adams, *The Spirit of American Sculpture*, pp. 201–2; Louise R. Noun, *Abastenia St. Leger Eberle Sculptor (1878–1942)*, exh. cat. (Des Moines, Ia.: Des Moines Art Center, 1980), p. 6.

10. Quoted in Adeline Adams, *John Quincy Adams Ward: An Appreciation* (New York: National Sculpture Society, 1912): 25.

11. No history of the National Sculpture Society exists to date. The most comprehensive discussion of the organization can be found in Michele Bogart, *Public Sculpture and the Civic Ideal in New York City, 1890–1930* (Chicago: The University of Chicago Press, 1989): 47–71. Quote by Charles McKay, cited in ibid., p. 53.

12. Leila Mechlin, "The National Sculpture Society's Exhibition at Baltimore," *The International Studio* 35 (August 1908): xlv–xlvi; Hermon A. MacNeil, "Small Bronzes," *Art and Progress* 4 (March 1913): 908; Adams, *John Quincy Adams Ward*, p. 181.

13. For an interesting discussion of the beginnings of a market for small-scale sculpture in the nineteenth century, see Michele Bogart, "The Development of a Popular Market for Sculpture in America, 1850–1880," *Journal of American Culture* 4 (Spring 1981): 3–28.

14. Charles Phelps Cushing, "A Consumer's View of Sculpture," *Collier's Weekly* 50 (December 14, 1912): 32–4.

15. Russell Sturgis, "American Bronzes," *Scribners' Magazine* 31 (June 1902): 765; Mechlin, "The National Sculpture Society's Exhibition," pp. xlvi and xlviii.

As early as 1898, Charles de Kay had written:

The Sculpture Society looks forward with hope to the time when its finances will permit of the publication of small limited editions of ideal statuary fitted for the adornment of the drawing-room and the library, the merchant's office and the music room, the school and the boudoir. Such things are better calculated to quicken the love for sculpture than equestrian monuments and the more ambitious statuary of public squares and formal gardens.

A beginning has already been made by the casting of statuettes and small groups, the work of American sculptors, for sale at prices suited to ordinary purses. The reduction machine recently introduced permits of an exact duplication of large groups and statues on any scale, so that a sculpture can now enjoy the royalty on reductions of any work which carried enough weight with the public to warrant the expense. This should be another means of making people familiar with good sculpture. (Charles de Kay. "A Word or Two Regarding the NSS," *NSS: Third Exhibition of the National Sculpture Society*, exh. cat., New York, May 1–21, 1898, p. 12)

16. Roberta K. Tarbell, "Gertrude Vanderbilt Whitney as Patron" in *The Figurative Tradition and the Whitney Museum of American Art*, ed. by Patricia Hills and Roberta K. Tarbell (New York: Whitney Museum of American Art; and Newark: The University of Delaware Press, 1980): 12. Eberle exhibited nine works, among them, *Old Woman Picking Up Coal, Girl Skating* (Fig. 54), *Girl with Hoop,* and *Girls Dancing to Hand Organ. Emergency Catalogue of the Exhibition of the N.S.S. under the Auspices of the Municipal Art Society of Baltimore*, exh. cat., April 4–25, 1908.

17. Noun, *Abastenia St. Leger Eberle Sculptor*, p. 12.

18. "The Travelling Exhibit of Small Bronzes," *The Monumental News* 22 (April 1910): 283.

19. Noun, *Abastenia St. Leger Eberle Sculptor*, p. 12; Beatrice Gilmore Proske, *Brookgreen Gardens Sculpture* (Brookgreen, SC: The Trustees of Brookgreen Garden, 1943): 211.

20. AAA Chester Beach Papers, Roll N727, frames 269 and 286; Noun, *Abastenia St. Leger Eberle Sculptor*, p. 8; Milroy, *Painters of a New Century*, 55 n 54.

21. In 1913, the Newark Museum also purchased a cast of this sculpture. Curatorial File, Worcester Art Museum, Worcester, Massachusetts; Noun, *Abastenia St. Leger Eberle Sculptor*, p. 8.

22. "At the Folsom Galleries," *The Craftsman* (March 1913): 724; *Ethel Myers*, exh. cat., Robert Schoelkopf Gallery, New York, 1963, New York Public Library Artist Files.

23. Thomas E. Toone, "Mahonri Young: His Life and Sculpture," Ph.D. diss., Pennsylvania State University, University Park, PA 1982, pp. 62–3; Wayne K. Hinton, "A Biographical History of Mahonri M. Young, A Western American Artist," Ph.D. diss., Brigham Young University, Provo, Utah, 1974, pp. 90–1.

24. Curatorial Files, the Newark Museum; Milroy, *Painters of a New Century*, pp. 62–5, quote on p. 63.

25. AAA Chester Beach Papers, roll N727, fr. 3; Noun, *Abastenia St. Leger Eberle Sculptor*, p. 10; Taft, *The History of American Sculpture*, p. 571; [Review of 1908 Macbeth Gallery Show], *The Craftsman* 15 (February 1909): 623.

26. "Exhibitions Now On: Bronzes at Macbeth," *American Art News* 7 (December 19, 1908): 6.

27. Milroy, *Painters of a New Century*, p. 27; [Review of 1908 Macbeth Gallery Show], *The Craftsman* 15 (February 1909): 624; "Women Sculptors at the New York School of Applied Design," *The Craftsman* 18 (June 1910): 404. Writing in 1911, Gardner Teall continued to expound this theme, "if there is such a thing as nationalism in art Miss Eberle seems to have caught the American spirit in her work. That is to say, her democracy finds subjects for her sculpture at every turn, in the men, women and children of the streets. . . ." Gardner Teall, "Women Sculptors of America," *Good Housekeeping Magazine* 53 (August 1911): 180.

28. "News and Notes of the Art World," *New York Times*, December 18, 1910, pt. V, p. 5; Noun, *Abastenia St. Leger Eberle Sculptor*, p. 17; *Art Notes* 45 (March 1912): 49 and 708, (November 1913): 780, both cited in Noun, *Abastenia St. Leger Eberle Sculptor*, p. 11.

29. A small catalogue/pamphlet with commentary by the contemporary critic and artist Guy Pene du Bois accompanied the show. AAA Chester Beach Papers, roll N727, fr. 295.

30. *Evening Post*, December 7, 1912, AAA Chester Beach Papers, roll N727, fr.307.

31. *Exhibition of Sculpture by Chester Beach, Abastenia St. Leger Eberle, Mahonri Young*, exh. cat., Macbeth Gallery, New York, February 17 – March 2, 1914 (AAA Metropolitan Museum of Art Miscellaneous Exhibition Catalogues, roll N540, frs. 109–11).

32. Marianne Doezema, "The 'Real' New York" in *The Paintings of George Bellows* (New York: Abrams, and the Amon Carter Museum, Fort Worth, TX, and the Los Angeles County Museum, 1992): 119; Marc Aronson, "Wharton and the House of Scribner: The Novelist as a Pain in the Neck," *New York Times Book Review*, January 2, 1994, p. 7.

33. Joseph Edgar Chamberlain, "Sculpture at Macbeth's," *Mail*, February 25, 1914, and "Macbeth's Little Academy," *New York Press*, February 22, 1914, both in AAA Chester Beach Papers, roll N727, fr. 315; "Plastic Interpretations of Labor," *Dress and Vanity Fair* 1 (October 1913): 46.

34. For an illustration of *The Rock Carrier*, see "Plastic Interpretations of Labor," *Dress and Vanity Fair* 1 (October 1913): 46. Young's image may have also brought to mind Meunier's *Stevedore* of 1890. Typically, Young adapted his own personal style of active compositions to this labor theme – a subject made famous by Meunier's heroic and dignified sculpture. For an illustration of Meunier's *Stevedore*, see Micheline Hanotelle, *Paris/Bruxelles: Rodin et Meunier* (Paris: Le Temps, 1982): 166.

35. "Works by Mahonri Young, *New York Times*, March 3, 1918, sec. VII, p. 12.

36. Toone, "Mahonri Young," pp. 1–29; Hinton, "A Biographical History of Mahonri M. Young," passim.

37. See Chapter 4 of this book for a lengthy discussion of the growing "crisis of masculinity" at the turn of the century.

38. "Art Born in the West and Epitomizing the West: Illustrated from the Work of Mahonri Young," *The Touchstone* 4 (October 1918): 10.

39. Hinton, "A Biographical History of Mahonri M. Young," pp. 80–3; Ilene Susan Fort and Michael Quick, "Mahonri Young," in *American Art: A Catalogue of the Los Angeles County Museum of Art Collection* (Los Angeles: Los Angeles County Museum of Art, 1991): 403–4. For a discussion of American genre sculpture, see Ilene Susan Fort, " 'Mere Beauty No Longer Suffices': The Response to Genre Sculpture," in *The Figure in American Sculpture: A Question of Modernity* (Los Angeles: Los Angeles County Museum of Art, and Seattle: University of Washington Press, 1995): 74–108. For illustrations of the drawing and both sculptures, see Fort, "Mere Beauty No Longer Suffices," p. 79.

40. Toone, "Mahonri Young," p. 69.

41. Brigham Young, *Journal of Discourses*, vol. 16, Liverpool, 1874, p. 66, as quoted in Toone, "Mahonri Young," p. 134 n32.

42. For the centrality of the work ethic to American experience, see Chapter 1 of this book.

43. Berman, *Rebels on Eighth Street*, p. 154; Toone, "Mahonri Young," p. 133 n26; Hinton, "A Biographical History of Mahonri M. Young," pp. 121–2. It is quite possible that Saul Baizerman, a contemporary sculptor who will be discussed in the following chapter, served as the model for Young's *Man with a Pick*.

44. "Town Builder of Today as Interpreted by Mahonri Young," *Survey* 52 (July 1, 1924): 393.

45. See Chapter 4 of this book for a further discussion of the male gaze, visual pleasure, and this process of aestheticization.

46. AAA Chester Beach Papers, roll N727, frs. 3, 147, 150, 161, 164, 251; Proske, *Brookgreen Gardens Sculpture*, 211; Chester Beach files, National Sculpture Society, New York.

47. A reproduction of *Out of Work* exists in AAA Chester Beach Papers, roll N727, fr. 315.

48. Lewisohn and his wife were well known in art circles, as evidenced by Ethel Myers' friendly lampoon of Mrs. Lewisohn in her *Miss Fifth Avenue* (Fig. 50). Lewisohn had commissioned a portrait bust from Beach, which, as a gift to the City College of New York, is currently located in Lewisohn Stadium. Curatorial File, Brooklyn Museum; AAA William Macbeth Papers, roll NM26, frs. 59, 95; Martin Green, *New York 1913: The Armory Show and the Paterson Strike Pageant* (New York: Macmillan, 1988): 19; Chester Beach Files, National Sculpture Society. For Lewisohn's philanthropic activity, see "Lewisohn Gives $50,000," *New York Times*, February 6, 1905, p. 7; "Lewisohn Gift to Yale," *New York Times*, May 10, 1910, p. 1; "Mt. Sinai Gets $130,000," *New York Times*, April 14, 1910, p. 1; "Treasures in the Adolphe Lewisohn Collection," *New York Times*, March 2, 1913, sec. V, p. 12; "Sanitary Prisons," *New York Times*, May 12, 1913, p. 12; "Start Campaign to Stop Child Labor," *New York Times*, January 9, 1914, p. 10; "Adolph Lewisohn in Suffrage Speech," *New York Times*, April 25, 1914, p. 13; "The Immigration Bill," *New York Times*, December 15, 1914, p. 12.

49. AAA Chester Beach Papers, roll N727, fr. 264; "Sculpture at the Academy," unidentified newspaper clipping, AAA Chester Beach Papers, roll N727, fr. 280; "Subtle Studies of Human Emotions Shown in the Sculpture of Chester Beach," *Craftsman* 30 (July 1916): 355.

50. Kathleen D. McCarthy, *Women's Culture: American Philanthropy and Art, 1830–1930* (Chicago: The University of Chicago Press, 1991): 224; "A Little Journey to MacDougal Alley," *Newark Evening Press*, November 20, 1909, in AAA Chester Beach Papers, roll N727, fr. 280.

51. See Chapter 5 of this book for a discussion of George Vanderbilt as artistic patron.

52. McCarthy, *Women's Culture*, pp. 216, 227–9; Roberta K. Tarbell, "Mahonri Young's Sculptures of Laboring Men, Walt Whitman, and Jean-François Millet," in *Walt Whitman and the Visual Arts*, ed. by Geoffrey M. Sill and Roberta K. Tarbell (New

Brunswick, NJ: Rutgers University Press, 1992): fn. 11; Toone, "Mahonri Young," p. 31; Berman, *Rebels on Eighth Street*, pp. 72–3, 121–2, 152–3.

53. The sculpture entered the collection of the Whitney Museum of American Art in 1931. Roberta K. Tarbell, "Sculpture, 1900–1940," in Hills and Tarbell, *The Figurative Tradition*, p. 95).

54. Proske, *Brookgreen Gardens Sculpture*, p. 157; Noun, *Abastenia St. Leger Eberle Sculpture*, pp. 2–4. As quoted in Donald Wilhelm "Babies in Bronze: The Life-Work of Miss Abastenia Eberle," *Illustrated World* 24 (November 1915): 329; Susan Casteras, "Abastenia St. Leger Eberle's *White Slave*," *Woman's Art Journal* 7 (Spring/Summer 1986): 32.

55. Noun, *Abastenia St. Leger Eberle Sculptor*, pp. 4, 12–13; R. G. MacIntryre, "Small Bronzes and Their Makers," *Arts and Decorations* 2 (January 1912): 106.

56. "Women Sculptors at the New York School of Applied Design," *The Craftsman* 18 (June 1910): 403.

57. Giles Edgarton [Mary Fanton Roberts], "Is There a Sex Distinction in Arts?," *The Craftsman* 14 (June 1908): 251.

58. "Women Sculptors at the Gorham," *American Art News* 12 (May 9, 1914): 3.

59. "Some Contemporary Young Women Sculptors," *Scribners' Magazine* 47 (May 1910): 637.

60. Noun, *Abastenia St. Leger Eberle Sculptor*, pp. 11, 16.

61. Teall, "Women Sculptors of America," p. 175.

62. Ada Rainey, "American Women in Sculpture," *Century Magazine* 93 (January 1917): 432, 438.

63. Peter Conn, *The Divided Mind: Ideology and Imagination in America, 1891–1917* (New York: Cambridge University Press, 1983): 156.

64. In addition, a group of shirtwaist makers with a banner draped in black to commemorate the recent Triangle Shirtwaist Fire marched with quiet dignity and solemnity in the 1911 parade. Noun, *Abastenia St. Leger Eberle Sculptor*, pp. 11, 13; "Suffragists March in Procession Today," *New York Times*, May 6, 1911, p. 13; as quoted in "Woman's Exhibit at Macbeth's," *Arts and Decorations* 6 (November 1915): 37.

65. Noun, *Abastenia St. Leger Eberle Sculptor*, pp. 5, 7, 16.

66. As quoted in Ibid., p. 7; John Higham, *Strangers in the Land: Patterns of American Nativism, 1860–1925* (New York: Atheneum, 1963): 119–20.

67. As quoted in Noun, *Abastenia St. Leger Eberle Sculptor*, p. 7; Paul Boyer, *Urban Masses and Moral Order in America, 1820–1920* (Cambridge: Harvard University Press, 1978): 156–7.

68. For a discussion of the "trope of the city as dark continent and the journalist and social reformer [or artist] as adventurer/ethnographer," see Barbara Kirshenblatt-Gimblett, "Objects of Ethnography," in *Exhibiting Cultures*, ed. by Ivan Karp and Steven Lavine, (Washington, DC: Smithsonian Institution Press, 1991): 410–11.

69. Quoted in Eberle's obituary, "Abastenia Eberle, Long a Sculptor," *New York Times*, February 28, 1942, Abastenia Eberle Files, National Academy of Design, New York.

70. Abestemia Eberle to William Macbeth, nd, AAA Macbeth Gallery Papers, Roll NMC 44, frames 256–257.

71. Noun, *Abastenia St. Leger Eberle Sculptor*, p. 7. For an illustration of *Old Woman Picking Up Coal*, see ibid., p. 5.

72. Bennard B. Perlman titles this painting *Microbe Alley* in *The Immortal Eight: American Painting from Eakins to the Armory Show* (Cincinnati: North Light, 1979). The painting is reproduced on p. 81.

73. Christine Merriman, "New Bottles for New Wine: The Work of Abastenia St. Leger Eberle," *The Survey* 30 (May 3, 1913): 196.

74. Marianne Doezema, *George Bellows*, p. 142; Kathy Peiss, *Cheap Amusements: Working Women and Leisure in Turn-of-the-Century New York* (Philadelphia: Temple University Press, 1986): 13.

75. Roy Lubov quoted in Boyer, *Urban Masses*, p. 245; Roy Rosenzweig, "Reforming Working-Class Play: Workers, Parks, and Playgrounds in an Industrializing City, 1870–1920," in *Life & Labor: Dimensions of American Working Class History,* ed. by Charles Stephenson and Robert Asher (Albany: State University of New York Press, 1986): 166–8; Peiss, *Cheap Amusements*, pp. 178–9.

76. Noun, *Abastenia St. Leger Eberle Sculptor,* p. 15.

77. The Metropolitan Museum purchased the sculpture in 1909 for $60. Curatorial Files, Metropolitan Museum; Noun, *Abastenia St. Leger Eberle Sculptor,* p. 5.

78. See, for example, William Merrit Chase, *Girl in White,* ca. 1898–1901; and George Bellows, *Anne with a Japanese Parasol,* 1917, reproduced in Michael Quick et al., *George Bellows* (New York: Abrams, 1992): 179, 214.

79. E. S. Martin, "East Side Considerations," *Harper's New Monthly Magazine* 96 (May 1898): 855, quoted in Kirshenblatt-Gimblett, "Objects of Ethnography," pp. 411–12.

80. Eberle continued, "Among the tenement the people do not appeal to me as poor people. They are human beings through whom I get at the living spirit of humanity more vitally than elsewhere." "Which Is True Art?" *Washington Post,* February 6, 1916, p. 4, quoted in Noun, *Abastenia St. Leger Eberle Sculptor,* p. 15.

81. For another version of this sculpture, dating from 1907, see Noun, *Abastenia St. Leger Eberle Sculptor,* fig. 11.

82. Doezema, *George Bellows,* p. 144; idem, "The 'Real'' New York," p. 118; for an illustration, see p. 117. Bellows also displayed a woman nursing her child on the front stoop – an event described in the *Harper's* article in note 79.

83. Robert W. Snyder, "City in Transition," in Zurier et al., *Metropolitan Lives,* p. 49, quote in from Harriet Burton Laidlow, review of *My Little Sister* by Elizabeth Robbins, *The Survey* 13 (May 3, 1913): 202.

84. Noun, *Abastenia St. Leger Eberle Sculptor,* p. 9; Casteras, "Abastenia St. Leger Eberle's *White Slave,*" pp. 32–3; Cynthia Blair, "The Appearance of Evil: 'Vicious' Black Women in Chicago, 1900–1930," paper delivered at American Studies Association Meeting, November 1993, Boston; Boyer, *Urban Masses,* p. 191. For two divergent studies of the "white slavery" phenomenon, see Ruth Rosen, *The Lost Sisterhood: Prostitution in America, 1900–1918* (Baltimore: The Johns Hopkins Press, 1982), and David J. Langum, *Crossing Over the Line: Legislating Morality and the Mann Act* (Chicago: The University of Chicago Press, 1994): quote on p. 30.

85. Quoted in Noun, *Abastenia St. Leger Eberle Sculptor,* p. 9.

86. Harriet Burton Laidlow, as in note 83; for viewer response to the cover image, see *The Survey* 31 (May 31, 1913): 311–13; for the editorial defense, see pp. 313–15; quote on p. 314; Noun, *Abastenia St. Leger Eberle Sculptor,* p. 10; Casteras, "Abastenia St. Leger Eberle's *White Slave*" p. 35.

87. The cartoons produced prior to 1919 were mostly confiscated in the Palmer Raids. Some of these images can be viewed in the journals *Solidarity* and the *Industrial Worker* (*"Wobbly"; 80 Years of Rebel Art,* exh. cat., Labor Archives and Research Center, San Francisco, 1987, n.p.). See also Rebecca Zurier, "The Mases and Modernism" in *1915, The Cultural Moment,* ed. by Adele Heller and Lois Rudnick (New Brunswick, NJ: Rutgers University Press, 1991): 206.

88. See Chapter 5 of this book for a fuller analysis of this image.

89. Martin Green, *New York 1913: The Armory Show and the Paterson Strike Pageant* (New York: Macmillan, 1988): 80; Mike Davis, "The Stop Watch and the Wooden Shoe: Scientific Management and the Industrial Workers of the World," *Radical America* 9 (January – February 1975): 69–96.

90. Charles Willis Thompson, "So-Called I. W. W. Raids Really Hatched by Schoolboys," *New York Times,* March 29, 1914, magazine section, p. 2.

91. As organized labor championed only the white, northern European skilled worker, the AFL formed a "strange alliance" with patricians who had consistently urged

regulations on immigration (Higham, *Strangers in the Land*, pp. 114, 138, 158, 163–4.) See Chapter 2 of this book for a full discussion of the Haymarket Affair.

92. *Herald Tribune*, June 8, 1913, quoted in Linda Nochlin, "The Paterson Strike Pageant of 1913," *Art in America* 62 (May–June 1974): 65; New York *Call*, June 8, 1913, p. 1, cited in Steve Golin, *The Fragile Bridge: The Paterson Silk Strike, 1913* (Philadelphia: Temple University Press, 1988): p. 279 n50.

93. Green, *New York 1913*, pp. 195, 198. The mural is reproduced in Nochlin, "The Paterson Strike Pageant of 1913," p. 64, and the program cover on p. 65.

94. Green, *New York 1913*, pp. 200–3; Golin, *The Fragile Bridge*, p. 166; Joyce L. Kornbluh, ed., *Rebel Voices: An I.W.W. Anthology* (Ann Arbor: University of Michigan Press, 1964): 201.

95. Nochlin, "The Paterson Strike Pageant of 1913," p. 67.

96. Ibid., pp. 67–8; Green, *New York 1913*, pp. 14, 163, 165; Boyer, *Urban Masses*, p. 256.

97. Frank Owen Payne, "The Tribute of American Sculpture to Labor," *Art and Archaeology* 6 (August 1917): 91.

98. Elvy Setterqvist O'Brien, "Charles Haag: A Sculptor of Toil and Nature," in Mary Em Kirn and Sherry Case Maurer, eds., *Harute – Out Here: Swedish Immigrant Artists in Midwest America*, exh. cat., Augustana College, Rock Island, Illinois, 1984, pp. 47–8; John Spargo, "Charles Haag – Sculptor of Toil – Kindred Spirit to Millet and Meunier," *The Craftsman* 10 (July 1906): 435; Crystal Eastman, "Charles Haag: An Immigrant Sculptor of His Kind," *The Chautauquan* 48 (October 1907): 249; "Peasant Sculptor from Sweden Seeks Field for His Art in America," *New York Times*, July 1, 1906, sec. 3, p. 6. One critic later wrote: "Broadly human in his sympathies, he feels himself as much a brother to his fellow artist as to the factory worker" (Amelia V. Ende, *Chas. Haag Sculptor*, n.d., American Swedish Museum Curatorial Files).

99. Holger Lundbergh, "Charles Haag," *The American Scandinavian Review* 34 (September 1946): 224; O'Brien, "Charles Haag," p. 49; Sofia Haag, wife of the artist, suggested that this figure represented the difficulties of an immigrant artist in this new land. Undated essay, American Swedish Historical Museum, Philadelphia.

100. "Peasant Sculptor from Sweden," p. 6.

101. *Mail*, February 25, 1914, in AAA Chester Beach Papers, roll N727, fr. 315. Beach's sculpture has not been located. "Patriotic Call to Artists," *New York Times*, September 5, 1915, sec. 2, p. 10 (for quotes); McCarthy, *Women's Culture*, pp. 230–231; and Berman, *Rebels on Eighth Street*, pp. 117–18.

102. Edna Ida Colley, "An Exhibition of Wood Carvings and Bronzes," *The Fine Arts Journal* 34 (April 1916): 186–7.

103. On the concept of "100 per cent Americanism," see Higham, *Strangers in the Land*, pp. 204–12.

104. Spargo, "Charles Haag," p. 442. See Chapter 5 for Spargo's critical commentary on Meunier's sculpture.

105. John Spargo to Caspar Purdon Clarke, September 14, 1906, Charles Oscar Haag Curatorial Files, The Metropolitan Museum of Art.

106. Eastman, "Charles Haag," pp. 261–2. John Spargo and "other gentlemen" put forward the gift of Haag's sculpture *Accord* to the museum (Charles Oscar Haag Curatorial Files, The Metropolitan Museum of Art).

107. Edward Yeomans, "City Springs," *Survey* 28 (May 4, 1912): 187.

108. "Peasant Sculptor from Sweden," p. 6.

109. In 1920, Haag drew another image that championed the equality of the sexes, *Peace: Women Suffrage Equal Rights Will Abolish Wars*, most likely in honor of the passing of the Nineteenth Amendment. For an illustration of this drawing, see Kirn and Maurer, *Harute*, p. 93.

When reproduced in a labor union journal in 1911, *Accord* evoked an extended discussion of female labor. The editor wrote; "Labor when represented in art, is almost always untrue to the subject. . . . A [strong] group is Mr. Haag's 'Female Labor' [*Accord*], which tells more eloquently a story of labor. . . . Her figure does not contain the graceful and charming outlines of a Venus, and her face has not the delicacy, refinement and rapture of St. Cecilia. The features bear the traces of toil and her frame is strong and muscular, her shoulders broad and her limbs heavy. She is a burden bearer." J[ohn] P. F[rey], "A Sculptor's Conception of Labor," *International Molders' Journal* 47 (June 1911): 424.

110. "Peasant Sculptor from Sweden," p. 6.

111. Eastman, "Charles Haag," p. 252.

112. Haag described his role as American citizen in suggestive terms – perhaps aligning himself with radical activity through his allusion to the color red, often utilized by political groups, such as the anarchists, at this time. "I started a new life in the new world, became a citizen and have succeeded in feeling very much like the true American, the Indian. If I live three hundred years more, I may be redder than the Red Man." Ende, *Chas. Haag Sculptor,* Haag Curatorial Files, American/Swedish Museum.

113. F[rey], "A Sculptor's Conception," p. 426. *Labor Union* was also illustrated in the September 1926 issue of *International Bookbinder*, the September 1928 issue of *Labor Bulletin*, and finally the February 1948 issue of *International Oil Worker*.

114. Kirn and Maurer, *Harute*, p. 106.

115. Ira J. Bach and Mary L. Gray, *A Guide to Chicago's Public Sculpture* (Chicago: The University of Chicago Press, 1983): 147–9; for an illustration of Borglum's *Altgeld Memorial,* see ibid., p. 148; Harriet Monroe, "Art," *Chicago Sunday Tribune*, May 10, 1914, sec. VII, p. 5.

116. Yeomans, "City Springs," pp. 187–8; Amelia von Ende, "Charles Haag," *The American Scandinavian Review* 6 (January–February 1918): 32; O'Brien, "Charles Haag," p. 51. For an illustration of the plaster model of the fountain, see Kirn and Maurer, *Harute*, p. 109.

117. Unless otherwise noted, all biographical information on Wolff is found in Francis M. Naumann and Paul Avrich, "Adolf Wolff: 'Poet, Sculptor and Revolutionist, but Mostly Revolutionist,'" *Art Bulletin* LXVII (September 1985): 486–501.

118. Naumann and Avrich, "Poet, Sculptor and Revolutionist," p. 486. For a discussion of anarchism in Chicago in the 1880s, see Chapter 2.

119. Egbert, "Socialism and American Art," pp. 715–6. See also, Allan Antliff, "Anarchy, Politics and Dada" in *Making Mischief: Dada Invades New York*, Francis M. Naumann with Beth Venn, eds. (New York: Whitney Museum of American Art, 1996): 209–14.

120. Mrs. Adele Lewisohn, wife of the industrialist and collector Adolph Lewisohn, owned a copy of *Songs of Rebellion, Songs of Life, Songs of Love* by Wolff (New York: A. & C. Boni, 1914). An autographed copy of the book is located in the New York Public Library.

121. Quoted in Naumann and Avrich, "Poet, Sculptor and Revolutionist," p. 394.

122. André Tridon, "Adolf Wolff: A Sculptor of To-Morrow," *The International* 8(3) (March 1914): 86.

Chapter 7

1. Stuart Hall, "The Rediscovery of 'Ideology': Return of the Repressed in Media Studies," in *Culture, Society and the Media,* ed. by Michael Gurevitch et al. (New York: Methuen, 1982): 64.

2. Hall continues, "Meaning, once it is problematized, must be the result, not of a

functional reproduction of the world in [visual] language, but of a social struggle – a struggle for mastery in discourse – over which kind of social accenting is to prevail and to win credibility" (ibid., p. 77).

3. Terry Smith, *Making the Modern: Industry, Art and Design in America* (Chicago: University of Chicago Press, 1993): 198. For a discussion of the development of socialist realism, see John Bowlt, "Russian Art in the Nineteen Twenties," *Soviet Studies* 22 (April 1971): 585–91, and C. Vaughan James, *Soviet Socialist Realism: Origins and Theory* (New York: St. Martin's Press, 1973).

4. For an illustration of this sculpture, see Jonathon Harris et al., *Modernism in Dispute: Art Since 1945* (New Haven: Yale University Press, 1993): 14.

5. The development of a nascent art market for small-scale sculpture has been outlined in full in Chapter 6.

6. One cannot help but compare Kalish's image to Jacob Epstein's *Rock Drill* of 1913 in which the artist fused man and machine into a hideous product of industrialization. In his use of machine forms, most obviously the pneumatic drill with its potent phallic content, Epstein created an ambiguous visual analogue for modern technology. Carrying his progeny in his torso, the driller symbolized industrial civilization and its future welfare. In his unusual sculpture, Epstein called into question the harmony between man and machine, a harmony that Kalish openly accepted in his visual image.

 In 1913, the American-made pneumatic drill, which functioned so prominently in the original version of the *Rock Drill,* clearly represented technological modernity to Epstein. As a new invention of the twentieth century, this connotation, no doubt, remained strong in Kalish's sculptures of the 1920s. For a complete discussion of this work, see Richard Cork, *Vorticism and Abstract Art in the First Machine Age,* vol. 1 (Berkeley: University of California Press, 1976): 467–81.

7. "He Doesn't Copy Nature, He 'Perfects' It," *Hempstead Long Island Newsday,* October 29, 1943, Max Kalish File, National Academy of Design Archives (hereafter NAD).

8. For a fascinating discussion of the issues involved in the representation of "the real," see Miles Orville, *The Real Thing: Imitation and Authenticity in American Culture, 1880–1940* (Chapel Hill: University of North Carolina Press, 1989).

9. Review of Max Kalish's work at the Milch Galleries, *Art News* 26 (December 3, 1927): 9.

10. Paul Weyland Bartlett (1865–1925) produced the pedimental sculpture for the House Wing of the United States Capitol, *The Apotheosis of Democracy,* which was installed in 1916. He chose labor as the centerpiece of his program, presenting sculptural figures associated with hunting, agriculture, manufacturing, and navigation. In a language of "limited realism," as Thomas Somma explained, Wayland depicted a contemporary style that avoided specific detail. In so doing, he made his pedimental composition intelligible to the general public without fixing it in a particular time or place. Thus, in his conflation of the modern and the universal, the pediment proclaimed the nobility of human endeavor – or, one could argue, the work ethic – as the cornerstone of American democracy. For an extensive study of this sculptural program, see Thomas P. Somma, *The Apotheosis of Democracy, 1908–1916: The Pediment for the House Wing of the United States Capital* (Newark: University of Delaware Press, 1995), quote on p. 86. See also William Walton, "Mr. Bartlett's Pediment for the House of Representatives, Washington, D.C.," *Scribners' Magazine* 48 (July 1910): 125–8, and Mitchell Carroll, "Paul Bartlett's Pediment Group for the House Wing of the National Capitol," *Art and Archaeology* 1 (January 1915): 163–73.

11. Barbara Artman-Vlasuk, "The Life and Work of Max Kalish," M.A. thesis, Kent State University, Kent, Ohio, 1982, pp. 10–11. The biographical information on Kalish has been drawn from the following sources, all located in the Kalish file, NAD

Archives: Mary Braggotti, "A War Time Who's Who Done in Bronze," *New York Post*, November 7, 1944; "The Memorial Exhibition of the Works of Max Kalish and Alexander Warshawsky," *The Bulletin of the Cleveland Museum of Art* 7 (September 1946): 135–7; "He Doesn't Copy Nature, He 'Perfects' It."

12. For the best discussion of the variety of experiences of the worker in the 1920s, see Irving Bernstein, *The Lean Years: A History of the American Worker, 1920–1933* (Boston: Houghton Mifflin, 1966), particularly the chapter "Worker in an Unbalanced Society," pp. 47–82. See also David Brody, "The Rise and Decline of Welfare Capitalism," in his *Workers in Industrial America* (New York: Oxford University Press, 1980): 48–81; Foster Rhea Dulles, *Labor in America* (New York: T. Y. Crowell, 1944); William E. Leuchtenburg, *The Perils of Prosperity 1914–1932* (Chicago: The University of Chicago Press, 1958); and most recently, Lizabeth Cohen, *Making a New Deal: Industrial Workers in Chicago, 1919–1939* (New York: Cambridge University Press, 1990). For illuminating studies of the culture of the 1920s, see Warren I. Susman, "Culture and Civilization: the Nineteen-Twenties" and "Culture Heroes: Ford, Barton, Ruth," in his *Culture as History: The Transformation of American Society in the Twentieth Century* (New York: Pantheon Books, 1984): 99–150, and Ann Douglas, *Terrible Honesty: Mongrel Manhattan in the 1920s* (New York: Farrar, Straus and Giroux, 1995).

13. For the skyscraper as cultural symbol, see Dominic Ricciotti, "Symbols and Monuments, Images of the Skyscraper in American Art," *Landscape* 25 (1981): 22–30; Karen Lucic, *Charles Sheeler and the Cult of the Machine* (Cambridge: Harvard University Press, 1991); and Merrill Schleier, *The Skyscraper in American Art, 1890–1931* (Ann Arbor: University of Michigan Press, 1986).

14. Leuchtenburg, *The Perils of Prosperity 1914–1932*, p. 245.

15. Several paintings of skilled workers by Beneker, although not this particular image, were reproduced in the popular press. See, for example, "American Workingman," *Fortune* 4 (August 1931): 54–69.

16. Images from this series were published in "Skyboys Who 'Rode the Ball' on Empire State," *Literary Digest* 109 (May 23, 1931): 30–2.

17. *Literary Digest* 91 (December 18, 1926): 26–7ff. Of the three other sculptures illustrated, the first depicted a kneeling worker holding a pneumatic drill, which "is said to suggest" according to the caption, "the sculpture of classical antiquity, in spite of the very modern machine in the foreground." The second illustration depicted a *Woodcutter*, whose wide stance, "bulging muscles and straining torso" the caption highlighted. The third illustration showed *The Discard*, a sculpture of an aged unemployed man. Even when depicting the common laborer, such as the *Woodcutter*, Kalish projected an heroic and powerful dimension to the worker. In this sculpture, Kalish presented this figure bare-chested and with bulging muscles as he wielded the axe with all his strength. There is little doubt that Kalish gained his fame as a labor sculptor from these images of workers that conveyed a superhuman strength and unyielding perseverance. For an illustrated study of his work, see *Labor Sculpture by Max Kalish A.N.A.*, intro. by Emily Genaur (New York: Comet Press, 1938).

18. Quoted in Alice Kalish, "Max Kalish As I knew Him," photocopied manuscript, Los Angeles, 1969, p. 24.

19. *A Museum in Action: Presenting the Museum's Activities*, exh. cat., The Newark Museum, 1944, p. 169.

20. See Chapter 1 of this book for an analysis of the history of the work ethic and its representation in this country. In Chapter 6, I discuss Young's images of workers under strain as a visualization of the Mormon belief in the work ethic.

21. Robert S. Lynd and Helen M. Lynd, *Middletown: A Study in American Culture* (1929 rpt.; New York: Harcourt Brace Jovanovich, 1959): 39–40.

The intellectual sources for this interest in efficiency lay in the scientific-management movement of Frederick W. Taylor. Otherwise called the "science of

industrial relations," it referred to a method of managing employees through cre-ating a professional group of managers that centralized labor administration to the goal of improving the efficiency of the enterprise. For a discussion of scientific management, see Alfred Sohn-Rethel, *Intellectual and Manual Labor* (Atlantic High-lands, NJ: Humanities Press, 1978): 148–58; Brody, "The Rise and Decline of Welfare Capitalism," pp. 52–4; for two important studies of Taylorism and its eco-nomic and social implications, see Harry Braverman, *Labor and Monopoly Capital: The Degradation of Work in the Twentieth Century* (New York: Monthly Review Press, 1974), and Robert Kanigel, *The One Best Way: Frederick Winslow Taylor and the Enigma of Efficiency* (New York: Viking, 1997).

Antonio Gramsci, in his essay "Americanism and Fordism," described Fordism as the "biggest effort" capitalists had made "to create . . . a new type of worker and man." Unlike the old worker, this new "mass worker" would display charac-teristics fully adaptable to capitalist rationality. Quoted in James R. Green, *The World of the Worker: Labor in Twentieth Century America* (New York: Hill and Wang, 1980): 110; and Smith, *Making the Modern*, p. 50. For stimulating discussions of Fordism, see Smith, *Making the Modern*, and David Harvey, *The Condition of Post-modernity: An Enquiry into the Origins of Cultural Change* (Cambridge, MA: Blackwell, 1989).

22. Peter Seixas, "Lewis Hine: From 'Social' to 'Interpretive' Photographer," *American Quarterly* 39 (Fall 1987): 399–400, quote on p. 403.

23. The common appearance of the concept of efficiency in popular journals docu-mented its broad appeal within mainstream society. In an ad from the *Literary Digest* of 1926 (the same year that Kalish's sculpture was featured), both the text and image stressed the themes of efficiency and progress. "American industry is making a steady step-by-step progress up the scale of efficiency," the ad read; the illustration showed the progress of civilization from the primitive caveman to modern industrial life. Overlording this march of progress was the benign titan of time, holding on hour glass, a symbol of the future and its promise of greater efficiency for society. *Literary Digest* 91 (October 26, 1926): frontispiece.

24. Henry Turner Bailey, quoted in "The American Worker Glorified in Bronze," p. 26.

25. Ibid., pp. 26–7.

26. These graphics were reproduced in the *American Federationist* 28 (August 1921): 645 and vol. 29 (September 1922): 658. See Chapter 1 for a discussion of Markham's "Man with a Hoe."

27. "The American Worker Glorified in Bronze," p. 26.

28. Kalish entitled this piece *End of the Day*. However, when Emily Genaur reproduced it in her 1938 monograph on Kalish, she labeled the sculpture *Unemployed* – no doubt in response to the Depression that had dragged on for so long.

29. Bernstein, *The Lean Years*, p. 57.

30. Lynd and Lynd, *Middletown*, p. 33.

31. Dulles, *Labor in America*, pp. 246, 256–7; Brody, "The Rise and Decline of Welfare Capitalism," pp. 49, 57; Bernstein, *The Lean Years*, pp. 147–50.

32. Brody, "The Rise and Decline of Welfare Capitalism," pp. 57–9.

33. Bernstein, *The Lean Years*, pp. 83, 97; Green *The world of the Worker*, p. 123; and Arthur M. Schlesinger, Jr., *The Age of Roosevelt: The Crisis of the Old Order, 1919–1933* (Boston: Houghton Mifflin, 1957): 112–13.

34. "He Photo-Interprets Big Labor: Camera Studies of Men at Work by Lewis W. Hine," *The Mentor* 14 (September 1926): 41.

35. See *The Survey* 47 (December 31, 1921): 511–18; (February 25, 1922): 851–8; (March 25, 1922): 976, 991–6; and vol. 49 (February 1, 1923): 559–65.

36. Daile Kaplan, ed., *Photo Story: Selected Letters and Photographs of Lewis W. Hine* (Wash-ington, DC: Smithsonian Institution Press, 1992): xxix.

37. "The Railroaders: Work Portraits by Lewis W. Hine," *The Survey* 47 (October 29, 1921): 159.

38. David Montgomery, *The Fall of the House of Labor* (New York: Cambridge University Press, 1987): 398; Green, *The World of the Worker*, p. 121.

39. "The Railroaders," pp. 159–66; *The Brakeman* appears on p. 161. This image was reproduced in full-page format as "The Cowboy of the Yards" in "Hine's 'Work Photographs'," *International Studio* 77 (August 1923): 379.

40. I am thinking here of Hine's images from the *Pittsburgh Survey*, a six-volume series edited by Paul Kellogg and published by the Russell Sage Foundation between 1910 and 1914, that openly criticized the excesses of industrial capitalism and exposed the horrifying conditions of workers' lives. Within this sociological study, parts of which were first published in the Progressive journal *Charities and Commons*, Kellogg reproduced a large number of visual images that he used as powerful tools in his mission of social reform. Viewed within the context of this study – written exposés on the injustices of the industrial system, drawings by Joseph Stella and photographs by Hine reinforced the need for reform practices. Hine, for example, photographed a group of immigrant steelworkers from Homestead with an alarming forthrightness. In this image, *Slavic Laborers* of 1907/08, first reproduced in John R. Common's article, "Wage Earners of Pittsburgh", in the March 1909 issue of *Charities and Commons*, Hine made visible the previously undocumented lives of contemporary industrial workers. In its powerful confrontational format that emphasized the individuals' identities as well as worker solidarity, the image bordered on the subversive. For a full discussion of the visual imagery of the *Pittsburgh Survey*, see Maurine Greenwald, "Visualizing Pittsburgh in the 1900s: Photographs and Sketches in the Service of Social Reform," unpublished manuscript. I would like to extend my thanks to Professor Greenwald for allowing me to read this chapter from her forthcoming book on the *Pittsburgh Survey*. See also *Pittsburgh Surveyed: Social Science and Social Reform in the Early Twentieth Century*, ed. by Maurine Greenwald and Margo Anderson (Pittsburgh: University of Pittsburgh Press, 1996). For an alternative perspective on this subject, see Maren Stange, *Symbols of Ideal Life* (New York: Cambridge University Press, 1989). See also Alan Trachtenberg, "Ever–the Human Document," in *America and Lewis Hine: Photographs 1904–1940* (Millerton, NY: Aperture, 1977): 133, Miles Orville, "Lewis Hine and the Art of the Commonplace," in his *After the Machine: Visual Arts and the Erasing of Cultural Boundaries* (Jackson: University of Mississippi Press, 1995): 48–51; and, most recently, Kevin G. Barnhuist, "The Alternative Vision: Lewis Hine's *Men at Work* and the Dominant Culture," in *Photo-Textualities: Reading Photographs & Literature*, ed. by Marsha Bryant (Newark: University of Delaware Press, and London: Associated University Presses, 1996): 85–108.

41. Letter to Florence Kellogg, February 17, 1933, in *Photo Story*, p. 49.

42. Seixas, "Lewis Hine," pp. 400–5; Smith, *Making the Modern*, pp. 284–92; and Alan Trachtenberg, *Reading American Photographs: Images as History, Mathey Brady to Walker Evans* (New York: Hill and Wang, 1989): 219, 224. For a differing interpretation of these photos, see Susan Meyer, "In Anxious Celebration: Lewis Hine's Men at Work," *Prospects* 17 (1992): 319–53.

43. Allan Sekula has argued that the rise of industrial documentation was an outcome of monopoly capitalism. A pressing internal demand existed for images of industry, framed within a realist (documentary) visual language that had formerly been associated with social reform. Appropriating this language and diffusing its prior associations, corporate officials, by the 1920s, used this rhetoric to enhance the logic of efficiency. Indeed, such publications as the *Western Electric News,* as well as documentary images by Lewis Hine and Gerrit Beneker, it could be argued, served these corporate ends. Allan Sekula, "Photography Between Labor and Capital," in *Mining*

Photographs and Other Pictures 1948–1968, ed. by Benjamin H. D. Buchloch and Robert Wilkie (Nova Scotia: Press of the Nova Scotia College of Art and Design and the University College of Cape Breton, 1983): 234–42.

44. Gerrit A. Beneker, "Art and the Industrial Problem," *Scribners' Magazine* 74 (September 1923): 291.

45. Ibid., p. 298.

46. Seixas, "Lewis Hine," p. 403.

47. *Gerrit A. Beneker (1882–1934): Painter of American Industry*, exh. cat., Vose Galleries of Boston, n.d. Essay by Mara Liasson.

48. William Green, "Labor at Sesqui-Centennial," *American Federationist* 33 (October 1926): 1169. The issue reproduced Beneker's *Men Are Square* on p. 1168.

49. From the "Empire State Building" series, "Plumbing a Column," in *American Federationist* 39 (December 1932): frontispiece, and "Guiding a Column as it went up on Empire State Building" in vol. 40 (June 1933). From the "Work Portrait" series – the "Railroaders," the "Aged Mechanic in Round House" in vol. 40 (September 1933). Kalish's *At Rest* also appeared in vol. 36 (November 1929). Much more work needs to be done on this set of images – asking, in essence, how did organized labor choose to represent itself during these years?

 The U.S. government used Kalish's *Spirit of American Labor* on an Office of War Information Poster with the caption: "American Labor . . . producing for attack."

50. Alice Kalish, "Max Kalish as I Knew Him," p. 25.

51. Leuchtenburg, *The Perils of Prosperity 1914–1932*, p. 260.

52. For an interesting history and analysis of *Fortune*, see Smith, *Making the Modern*, pp. 162–81. See also Sekula, "Photography between Labor and Capital."

53. "American Workingman," p. 131.

54. Reproductions of Reginald Marsh's *The Bowery* and Thomas Hart Benton's *City Building*, a portion of a mural for the New School for Social Research, also appeared in the article.

55. Quotes from "The American Workingman," pp. 131 and 56; Anne D. Rassweiler, "Soviet Labor History of the 1920s and the 1930s," *Journal of Social History* 17 (Fall 1983): 147–59.

56. As Allan Sekula has noted, "The editors of *Fortune* [were] able to celebrate technological progress and animate the ghost of artisanal work in the same article, in the same layout, occasionally . . ." (Sekula, "Photography," p. 241).

57. Eric Homberger, *American Writers and Radical Politics, 1900–1939: Equivocal Commitments* (New York: St. Martin's Press, 1986): 124. A. Mitchel Palmer ordered raids in 1919 and 1920 that affected virtually all communist organizations and temporarily destroyed any concerted radical movement in this country (Green, *The World of the Worker*, p. 97).

58. Helen A. Harrison, "John Reed Club Artists and the New Deal: Radical Responses to Roosevelt's 'Peaceful Roosevelt'," *Prospects* 5 (1980): 241.

59. The best anthology of political cartoons from this decade is *Red Cartoons for the Daily Worker, The Workers' Monthly, and the Liberator* (Chicago: The Daily Worker, 1926). For a discussion of the history and influence of these magazines, see Milton Brown, *American Painting from the Armory Show to the Depression* (Princeton: Princeton University Press, 1972): 187–91. And for a study of political cartoons from the previous decade, see Rebecca Zurier, *Art for the Masses (1911–1917): A Radical Magazine and its Graphics*, exh. cat., Yale University Art Gallery, New Haven, 1985. For quote, see p. 209.

60. Baizerman's first patron was Adolph Lewisohn, the progressive industrialist who had earlier purchased *The Stoker* by Chester Beach (Fig. 51). Baizerman sold his sculpture *The Italian Woman* of 1921 to Lewisohn the same year.

61. All the material on Baizerman's life and work, unless otherwise noted, is cited in Melissa Dabakis, "The Sculpture of Saul Baizerman (1889–1957)," Ph.D. diss.,

Boston University, Boston, 1987. See also Douglas Dreishpoon, ed., *Saul Baizerman's Lifetime Project: The City and the People*, exh. cat., Weatherspoon Art Gallery, University of North Carolina at Greensboro, 1998.

62. Saul Baizerman Papers, Archives of American Art, roll N61-4, fr. 349 (hereafter AAA).

63. Julius Held, *Saul Baizerman*, exh. cat., Walker Art Center, Minneapolis, January 16–March 1, 1953, p. 5.

64. Gold published the article under his birth name, Irwin Granich, in *The Liberator* 4 (February 1921): 20–5. Supported and founded by Aleksandr A. Bogdanov, the Proletcult, as an official program of the Soviet Union, was phased out by Lenin in 1920 but kept alive by various artists and intellectuals within the Soviet Union for several years. For a fascinating account of the roots of proletarian culture in this country, see Homberger, *American Writers*, pp. 119–24. Quote on p. 119.

65. Saul Baizerman Papers, AAA, roll N61-2, fr. 448.

66. Bernstein, *The Lean Years*, pp. 48–52.

67. In addition to the *Hod Carrier*, Baizerman depicted several manual workers on a construction crew in his "Labor Series," such as *The Digger* (Fig. 75), *Wheelbarrow Man, Cement Man* (Fig. 79), and a plaster group now lost, *The Road Builder's Group.*

68. Bernstein, *The Lean Years*, pp. 84–6; Andrew Dawson, "The Parameters of Craft Consciousness: The Social Outlook of the Skilled Worker, 1890–1920," in *American Labor and Immigration History 1877–1920s: Recent European Research*, ed. Dirk Hoerder (Chicago: University of Illinois Press, 1983): 145–6.

69. John A. Kouwenhoven, *The Columbia Historical Portrait of New York* (New York: Doubleday, 1953): 474.

70. In an undated entry, Baizerman presented a poetic response to the new modern city:

[The city] stood, a meaningless, shapeless, piled-up mountain of stone, with holes dug into the depth of the earth, and hurrying people. . . . Then, one late afternoon like in a fantasy, lights . . . filled rows of dark places, lighted storeys stood upon each other and everywhere there must be people, I thought. . . . Build and build, and tear and build, endlessly changing [and] planning. . . . Down there the great shovel dug the earth, the explosives tore the stony basin.
Building, building, building,
And there living.
. . . The iron shovel hung above . . . bringing the fear of its power to crush in the open jaws. . . . Into the crowded factories [with their] smoking chimney stacks, the man came and stayed the day in heat, in dust, forcing the helpless arms to rise again, waiting for the whistle, then a rolling train above their heads.
A wonderful fearful living thing a city is . . .
And the people.
(Saul Baizerman Papers, AAA N61-2, fr. 471.)

71. David Montgomery, "Immigrant Workers and Managerial Reform," in *Immigrants in Industrial America 1850–1920*, ed. Richard L. Ehrlich (Charlottesville: University Press of Virginia, 1977): 98. This article was subsequently published in *Workers' Control in America: Studies in the History of Work, Technology, and Labor Struggles* (New York: Cambridge University Press, 1979): 32–47.

72. Saul Baizerman Papers, AAA, N61-2, fr. 448. Entry dated August 9, 1933.

73. According to Richard Pells, "collectivism" was a key word among a number of different political groups by the mid-1930s. Its meanings were multifarious: a desire to transcend the liberal tradition; an acknowledgment that the state had grown corporate while the American state of mind remained individualistic; a belief that people were inherently social beings; and an assertion that the needs of the group took priority over those of the individual. He explained, "At worst, collectivism stood as a vague and hortatory symbol embracing every revolutionary sentiment; at

best, it gave intellectuals for the first time since the Progressive era an effective way of talking about the problems of culture and politics in the United States." *Radical Visions and American Dreams: Culture and Social Thought in the Depression Years* (New York: Harper and Row, 1973): 112.

74. *Exhibition of Sculpture by Saul Baizerman*, exh. cat., Eighth Street Gallery, New York, March 7–25, 1933.

75. Pells, *Radical Visions*, p. 61.

76. Aleksandr Bogdanov, "The Paths of Proletarian Creation," in *Russian Art of the Avant-Garde: Theory and Criticism 1902–1934*, ed. John Bowlt (New York: Viking Press, 1976): 181.

77. Nathan Altman, "Futurism and Proletarian Art," in Bowlt, *Russian Art of the Avant-Garde*, p. 163.

78. For the development of a revolutionary artistic style in Russia, see Peter Wollen, "Art in Revolution: Russian Art in the Twenties," *Studio International* (London) 181 (April 1971): 149–54. For a more detailed discussion of the conflicted relationship between modernism, individualism, and the socialist state, see John Elderfield, "Constructivism and the Objective World: An Essay on Production Art and Proletarian Culture," *Studio International* (London) 180 (September 1970): 73–80, and Andrew Higgins, "Art and Politics in the Russian Revolution," parts I and II, *Studio International* (London) 180 (November 1970): 164–7, and (December 1970): 224–7.

79. Baizerman considered submitting a design for a "Palace of Labor" in Moscow, a competition called by the Soviet government in 1923. Although never completed, he recorded his project in a few drawings that intended to commemorate the new Russia after the revolution and honor both Lenin and the Workers' Society. He utilized the sculpture *Two Men Lifting* of 1922 from *The City and the People* series in his competition design. Representing two men lowering a coffin into the ground, the sculpture initially symbolized the death of the old Russian order. Saul Baizerman Papers, AAA N61-1, fr. 283. Letter to his wife, Eugenie, dated April [1923]. Moreover, several other figures from *The City and the People* comprised a model for a "Monument to Lenin" that Baizerman submitted to the Soviet government in 1932. There seemed little doubt that Baizerman's ideological commitment to the new social order of the Soviet Union informed the production of his "Labor Series." For a thorough description of the 1923 competition, see *Art in Revolution: Soviet Art and Design Since 1917*, exh. cat., Hayward Gallery, London, 1971, p. 36.

80. *Education and Art in Soviet Russia*, foreword by Max Eastman (New York: The Socialist Publication Society, 1919): 42. See also John Bowlt, "Russian Sculpture and Lenin's Plan of Monumental Propaganda," in *Art and Architecture in the Service of Politics*, ed. by Henry Millon and Linda Nochlin (Cambridge, MA: The MIT Press, 1980): 182–93.

81. Barbara Foley, in her *Radical Representations: Politics and Form in U.S. Proletarian Fiction, 1929–1914* (Durham: Duke University Press, 1993): 398–402, discusses the "collective novel" as a product of 1930s literary radicalism. Although no unified definition of this literary form exists, it offers interesting parallels to what Baizerman was intending to express. She argues that the collective novel had three basic characteristics: the treatment of the group as greater than the sum of individuals; the use of experimental devices that intentionally ruptured the narrative illusion of seamless transparency; and the collaging of real historical events and persons within the fictive narrative to make the reader aware of ideology and its discursive formations. In visual terms, Baizerman seemed to comply with the first two characteristics of this narrative type.

82. Unless otherwise noted, all material on Wolff has its source in Francis M. Naumann and Paul Avrich, "Adolf Wolff: 'Poet, Sculptor and Revolutionist, but Mostly Revolutionist'," *Art Bulletin* LXVII (September 1985): 496–8. For an illustration that includes a model of the memorial urn, see p. 497.

For a succinct description of the Sacco and Vanzetti case, see Green, *The World of the Worker*, pp. 116–18. Wolff's sculptural monument predated the famous cycle of twenty-three paintings and prints by Ben Shahn, dating from 1931 to 1932, that commemorated the trial and execution of these two men.

83. Richard Wright, *American Hunger* (New York: Harper and Row, 1944): 61. Wright directed the Chicago John Reed Club for a number of years.

84. Aaron Goodelman Papers, AAA roll 4930, fr. 61; also quoted in part in David Shapiro, "Social Realism Reconsidered," in *Social Realism: Art as a Weapon*, ed. by David Shapiro (New York: Ungar, 1973): 18.

85. Cécile Whiting, *Antifascism in American Art* (New Haven: Yale University Press, 1989): 20.

86. For a discussion of the mythic and symbolic dimensions of Russia, see Pells, *Radical Visions*, pp. 61–9; quote on p. 304.

87. Whiting, *Antifascism*, p. 21; Foley, *Radical Representations*, p. 108.

88. John Reed Club School of Art, 1935–6 catalogue, Aaron Goodelman Papers, AAA roll 4935, fr. 1268.

89. For illustrations of *The Lynch Law* and *Negro (Arise Oppressed of the World)*, see Naumann and Avrich, "Adolph Wolff," p. 498. In contrast to Naumann and Avrich, who contend that *Negro* and *Arise Oppressed of the World* are two distinct sculptures, I argue that they are, in fact, one and the same after a careful study of the available photographs.

90. Boris Ternovetz, "John Reed Club Art in Moscow," *New Masses* 8 (April 1933): 25.

91. See, for example, Homberger, *American Writers*; Foley, *Radical Representations*; Pells, *Radical Visions*; James F. Murphy, *The Proletarian Moment: The Controversy over Leftism in Literature* (Chicago: University of Illinois Press, 1991); and Daniel Aaron, *Writers on the Left*, (New York: Oxford University Press, 1961 rpt. 1977).

92. Whiting, *Antifascism*, pp. 20–5; Patricia Hills, *Social Concern and Urban Realism: American Painting of the 1930s*, exh. cat., Boston University Art Gallery, 1983, pp. 15–16; Harrison, "John Reed Club Artists," p. 242; Donald Drew Egbert, "Socialism and American Art," in *Socialism and American Life*, vol. 1, ed. by Donald Drew Egbert and Stow Persons (Princeton: Princeton University Press, 1952): 709; Lawrence H. Schwartz, *The CPUSA and Aesthetics in the 1930s* (Port Washington, NY: Kennikat Press, 1980): 41–2. Hills argues, "During my interviews with artists close to the Party in the 1930s, conducted during 1982–1983, each denied that the CP had laid down a line as to what to paint. The CP leadership seems to have been more interested in their participation in union activities." Patricia Hills, "1936: Meyer Schapiro, *Art Front* and the Popular Front," *Oxford Art Journal* 17 (1) (1994): p. 42 n18.)

The 1932 revised statement goals of the clubs did articulate a close alignment with the Kharkov principles.

[The Club intended] to create and publish art and literature of a proletarian character; to make familiar in this country the art and literature of the world proletariat, and particularly that of the Soviet Union; to develop the critique of bourgeois and working class culture; ... to assist in developing ... worker-writers and worker artists; to engage in and give publicity to working class struggles; to render technical assistance to the organized revolutionary movement.

(Quoted in Foley, *Radical Representations*, p. 76.)

93. "American Artists Take Up Eager Roles in Social Revolution," *Art Digest* 7 (March 1, 1933): 32; Anita Brenner, "Revolution in Art," *The Nation* 8 (March 1933): 268; also reprinted in David Shapiro, *Social Realism: Art as a Weapon*, p. 74.

94. Gerald M. Monroe, "The Artist Union of New York," Ph.D diss., New York University, New York, 1971, pp. 137–9; Hills, *Social Concern*, pp. 16–18.

95. *New Masses* (February 1933): 23, as quoted in Hills, "1936: Meyer Schapiro, *Art Front* and the Popular Front," p. 31.

96. Exhibition pamphlet, December 8, 1933–January 7, 1934, Aaron Goodelman Papers, AAA roll 4935, fr. 273.

97. Hills comes to the same conclusion in "1936: Meyer Schapiro, *Art Front* and the Popular Front," p. 33. A number of sculptors exhibited works, for example, Aaron Goodelman showed *Necklace* (an antilynching sculpture); Seymour Lipton, *Proletarian*; and Adolf Wolff, *Lenin – Change Imperialist War into Civil War.*

98. "Invitation to all Artists to Participate in a 'Miner's Exhibition'," Aaron Goodelman Papers, AAA roll 4934, fr. 1141.

99. Jacob Kainen, "Revolutionary Art at the John Reed Club," *Art Front* (January 1935), Aaron Goodelman Papers, AAA roll 4935, fr. 1051. This critical view was mirrored by literary critics as well who demanded revolutionary optimism as a vital ingredient in proletarian fiction. Stories depicting the miseries of capitalism were no longer acceptable as revolutionary texts. Foley, *Radical Representations*, p. 134.

100. Gertrude Benson, "Art and Social Theories," *Creative Arts* 12 (March 1933): 218. For two reviews of the "Working Class Sculpture Show," see "Several Sculpture Shows," *New York Times*, April 14, 1935, sec. IX, p. 7, and Margaret Breuning, "Working Class Sculpture at the John Reed Club," *New York Post* April 27, 1935.

101. By 1935, Baizerman had begun producing lyrical figures through the difficult process of hammering copper. Although no longer concerned with the iconography of labor, his hammered copper works evidenced the physical labor necessary to sculptural production. For more discussion of Baizerman's later hammered copper sculpture, see Dabakis, "The Sculpture of Saul Baizerman, 1880–1957," and David Finn and Melissa Dabakis, *Vision of Harmony: The Sculpture of Saul Baizerman* (Redding Ridge, CT: Black Swan Books, 1989).

102. "Dock Walloper Turns Sculptor," *New York World-Telegram*, November 29, 1933, in New York Public Library Artist's File. See also "Aaron J. Goodelman," *Art News* 32 (November 18, 1933): 9.

103. Undated essay, Aaron Goodelman Papers, AAA roll 4930, fr. 84. All biographical information located in Goodelman Papers, AAA roll 4930, frs. 1–8.

Conclusion

1. Barbara Melosh, *Engendering Culture: Manhood and Womanhood in New Deal Public Art and Theater* (Washington, DC: Smithsonian Institution Press, 1991): 83.

2. See Chapter 1 for a fuller discussion of the labor principles that motivated both the Knights of Labor and the American Federation of Labor. See also Samuel Gompers, *Seventy Years of Life and Labor: An Autobiography*, ed. by Philip Taft and John A. Sessions (New York, 1957); Stuart B. Kaufman, *Samuel Gompers and the Origins of the American Federation of Labor, 1848–1896* (Westport, CT: Greenwood Press, 1973), and Patricia A. Cooper, *Once a Cigar Maker: Men, Women and Work Culture in American Cigar Factories 1900–1919* (Chicago: University of Illinois Press, 1987). For a short discussion and illustration of the statue of Samuel Gompers in San Antonio, see "Inventory of Labor Landmarks," *Labor's Heritage* 6 (Spring 1995): 59.

3. "Dedication of Gompers Memorial," *American Federationist* 40 (October 1933): 1044.

4. Executive Council Minutes of the American Federation of Labor (hereafter ECM), September 6–15, 1933. Samuel Gompers Memorial Committee, 1924–36, Box 1/ Folder 17, the George Meany Memorial Archives (hereafter SGMC). A front-page story for the *New York Times* – above the fold, the event was also captured in a large photograph reproduced on page 3. "Roosevelt Warns Capital and Labor," *New York Times*, October 8, 1933, pp. 1, 3.

5. "Roosevelt Warns Capital and Labor," p. 1.

6. ECM, September 6–15, 1933. SGMC, Box 1/Folder 17.

7. Dedicatory Address by Franklin Delano Roosevelt, the President of the United States, as quoted in *American Federation of Labor History, Encyclopedia Reference Book*, vol. III, p. 1 (Washington, DC: AFL & CIO, 1960): 540.

8. "Roosevelt Warns Capital and Labor," p. 1.

9. Arthur M. Schlesinger, Jr., *The Age of Roosevelt: The Crisis of the Old Order, 1919–1933* (Boston: Houghton Mifflin, 1957): 113, 184; Christopher T. Tomlins, "William Green," in *Franklin D. Roosevelt: His Life and Times*, ed. by Otis L. Graham, Jr., and Meghan Robinson Wander (Boston: G. K. Hall, 1985): 167.

10. *American Federationist* 42 (January 1935): frontispiece.

11. Schlesinger, *The Age of Roosevelt*, p. 184; James R. Green, *The World of the Worker: Labor in Twentieth-Century America* (New York: Hill and Wang, 1980): 139–40; Ellis W. Hawley, "National Industrial Recovery Act," in Graham and Wonder, *Franklin D. Roosevelt*, p. 274.

12. Schlesinger, *The Age of Roosevelt*, p. 114; William E. Leuchtenburg, *Franklin D. Roosevelt and the New Deal, 1932–1940* (New York: Harper and Row, 1963): 109.

13. Leuchtenburg, *Franklin D. Roosevelt*, pp. 106–7; Green, *The World of the Worker*, pp. 143–4. Among the most notable of work actions was the San Francisco General Strike of 1934, led by the International Longshoreman's Association. For a colorful description of this event, see Richard O. Boyer and Herbert M. Morais, *Labor's Untold Story* (New York: Cameron Associates, 1955): 282–90.

14. Leuchtenburg, *Franklin D. Roosevelt*, 107; Green, *The World of the Worker*, p. 148; "*American Federationist* 42 (April 1935): frontispiece. A brief biography of Senator Wagner accompanied the photographic portrait by Margaret Bourke-White.

15. Green, *The World of the Worker*, pp. 147–51.

16. Richard H. Pells, *Radical Visions and American Dreams: Culture and Social Thought in the Depression Years* (New York: Harper and Row, 1973): 303.

17. See *The American Federationist* editorial, as cited in note 3.

18. Charles Moore to Frank Morrison, Secretary of the AFL, December 18, 1929; SGMC Box 1/Folder 12. Charles Moore to Frank Morrison, May 1, 1926; SGMC Box 1/Folder 5. William Green to Secretaries of State Bodies, City Central Bodies and Directly Affiliated Local Unions, December 26, 1928; SGMC Box 1/Folder 8. U.S. Congress, House, *Authorizing the erection on public grounds in the District of Columbia of a stone monument as a memorial to Samuel Gompers*, H.J. Res. 163, 70th Congress, 1st Session, 1928, pp. 1571, 2049, 2253; and S.J. Res. 88, 70th Congress, 1st Session, 1928, pp. 3497, 3863, 3919, 4155.

 The members of the Samuel Gompers Memorial Committee were William Green, President of the AFL; Frank Morrison, Secretary of the AFL; Matthew Woll, Deputy to Green; Frank Duffy; T. A. Rickert; and James Wilson. The committee discussed other types of memorials, such as hospitals, libraries, and a broadcasting station. In May 1925, the committee agreed to erect a stone monument. ECM, December 1924; and Samuel Gompers Memorial Committee minutes, February 10, 1925, and May 9, 1925. SGMC Box 1/Folder 1.

19. William Green to George F. Bodwell [interested sculptor], March 7, 1929. SGMC Box 1/Folder 9. Max Kalish expressed interest in the commission but never submitted a model. "Sculptors Who Will Submit Models," SGMC Box 1/Folder 10.

20. The contract with Robert Aitken, the sculptor eventually chosen to produce the memorial, included the following clause:

 It is agreed by the sculptor that only union men, members of unions affiliated to the American Federation of Labor, shall be employed in the fabrication and erection of this Memorial. It is further agreed that all contracts awarded by the sculptor shall be awarded to only recognized union firms employing union men, members of organizations affiliated with the American

Federation of Labor. (Contract with Robert Aitken, ECM, February 2–12, 1932. SGMC Box 1/ Folder 16.)

21. ECM, August 8–20, 1929. SGMC Box 1/Folder 10.

22. (Mrs.) Lola Mavrick Lloyd to Frank Morrison, August 3, 1929. SGMC Box 1/Folder 10.

23. ECM, August 8–20, 1929; and Robert Lafferty and Alexander Zeitlin to AFL Monument Committee, August 8, 1929. SGMC Box 1/Folder 10.

24. Minutes of the Meeting of the Gompers Memorial Committee with Members of the Fine Arts Commission, March 20, 1930. SGMC Box 1/Folder 13.

25. ECM, May 5, 1930; May 7, 1930; May 12, 1930. SGMC Box 1/Folder 14.

26. Little is known about Charles Keck except that he studied for four years at the American Academy in Rome holding a Rhinhardt scholarship. Upon his return to New York, he occupied a studio at West 36th Street, once occupied by Augustus Saint-Gaudens. For more information on Keck, see Arthur G. Byne, "The Salient Characteristics of the Work of Charles Keck," *Architectural Record* 32 (August 1912): 120–8.

27. ECM, July 31–August 7, 1929. SGMC Box 1/Folder 8.

28. In addition to his designs for the Panama Pacific Exposition, Aitken produced several other important monuments before he received the Gompers commission, such as the *McKinley Monuments* of St. Helena and San Francisco, and *Zeus Armed with Thunderbolt* for the American Telephone and Telegraph Building. For more information on Aitken, see Arthur Hoeber, "Robert I. Aitken, A.N.A., An American Sculptor," *The International Studio* 50 (July 1913): iii–vii, and "Sculpture of Robert Aitken, N. A.," *The International Studio* 54 (November 1914): xv–xviii; Lorado Taft, *The History of American Sculpture* (New York: Macmillan, 1924; rpt. New York: Arno Press, 1969): 536, 558; Daniel Robbins, "Statues to Sculpture: From the Nineties to the Thirties," in *Two Hundred Years of American Sculpture*, ed. by Tom Armstrong et al. (New York: David R. Godine and Whitney Museum of American Art, 1976): 118, 153.

 Chester Beach won the Helen Foster Barnett Prize in 1909, Abastenia St. Leger Eberle in 1910, and Mahonri Young in 1911. See Chapter 6 for a detailed discussion of the National Academy of Design and its patronage of sculpture in the early part of the century.

29. ECM, October 5, 1930; SGMC Box 1/Folder 14. Charles Moore to Frank Morrison, August 8, 1931; SGMC Box 1/Folder 15. ECM, October 1931; SGMC Box 1/Folder 16.

30. Gladys Tilden, "A Sketch of Douglas Tilden's Life," pp. 16–17, Gladys Tilden Papers, Bancroft Library, University of California, Berkeley.

31. Paul Willis has discussed the role of masculinity in working-class culture. He explains that "the metaphoric figures of strength and bravery *worked through* masculinity and reputation . . . move[d] beneath the more varied, visible forms of workplace culture." He continues "The very teleology of the process of work upon nature, and the material power involved in that, becomes, through the conflation of masculine and manual work, a property of masculinity and not of production. Masculinity is power in its own right, and if its immediate expression is in the completion of work for another, then what of it?" Paul Willis, "Masculinity and Factory Labor," in *Culture and Society: Contemporary Debates*, ed. by Jeffrey C. Alexander and Steven Seidman (New York: Cambridge University Press, 1990), pp. 187, 193–4.

32. Melosh, *Engendering Culture*, p. 87.

33. Green, *The World of the Worker*, p. 168.

34. This figure may have held yet another meaning for contemporary viewers. Child labor, although discontinued during Progressive reform, was reinstalled shortly after World War I with many children forced out of school and into a dangerous work-

place. It was New Deal legislation that permanently outlawed this practice. Ibid.,
p. 168.

35. Orrie Lashin and Milo Hastings, *Class of '29* (act 1, scene 1, 32), as quoted in
Melosh, *Engendering Culture*, p. 83. Melosh's excellent chapter, "Manly Work,"
pp. 83–109, has informed much of my thinking on New Deal cultural production.

BIBLIOGRAPHY

Aaron, Daniel. *Writers on the Left.* 1961 rpt. New York: Oxford University Press, 1977.

Adams, Adeline. *John Quincy Adams Ward: An Appreciation.* New York: National Sculpture Society, 1912.

The Spirit of American Sculpture. New York: National Sculpture Society, 1923.

Adams, Graham, Jr. *Age of Industrial Violence, 1910–1915.* New York: Columbia University Press, 1966.

Adams, John Quincy. "Art and Crafts in American Education: The Relation of Art to Work." *The Chautauquan* 38 (September 1903): 49–52.

Adelman, William J. *Haymarket Revisited,* 2nd ed. Chicago: Illinois Labor History Society, 1986.

Agulhon, Maurice. *Marianne into Battle: Republican Imagery and Symbolism in France, 1789–1880.* Trans. by Janet Lloyd. New York: Cambridge University Press, 1981.

Albronda, Mildred. *Douglas Tilden: Portrait of a Deaf Sculptor.* Silver Spring, MD: T. J. Publishers, 1980.

America and Lewis Hine: Photographs 1904–1940. Millerton, NY: Aperture, 1977.

"American Artists Take Up Eager Roles in 'Social Revolution'." *Art Digest* 7 (March 1, 1933): 32.

"The American Worker Glorified in Bronze." *Literary Digest* 91 (December 18, 1926): 26–7 ff.

Anthony, P. D. *The Ideology of Work.* New York: Tavistock, 1977.

Armstrong, Tom, et al. *Two Hundred Years of American Sculpture.* Exh. Cat. New York: David R. Godine and the Whitney Museum of American Art, 1976.

Art in Revolution: Soviet Art and Design Since 1917. Exh. Cat. Hayward Gallery, London, 1971.

Artman-Vlasuk, Barbara. "The Life and Work of Max Kalish." M.A. thesis, Kent State University, Kent, Ohio, 1982.

Ashbaugh, Carolyn. *Lucy Parsons: American Revolutionary.* Chicago: Charles H. Kerr, 1976.

Avrich, Paul. *The Haymarket Tragedy.* Princeton: Princeton University Press, 1984.

The Modern School Movement: Anarchism and Education in the United States. Princeton, N.J.: Princeton University Press, 1980.

Babcock, Barbara A., and John J. Macaloon, "Everybody's Gal: Women, Boundaries and Monuments," in *The Statue of Liberty Revisited,* ed. by W. S. Dillon and N. G. Kotler. (pp. 79–99). Washington, D.C.: Smithsonian Institution Press, 1994.

Bach, Ira J., and Mary L. Gray. *A Guide to Chicago's Public Sculpture.* Chicago: University of Chicago Press, 1983.

Badger, Reid. *The Great American Fair: The World's Columbian Exposition and American Culture.* Chicago: Nelson Hall, 1979.

Barnhurst, Kevin G. "The Alternative Vision: Lewis Hine's *Men at Work* and the Dominant Culture," in *Photo-Textualities,* ed. by Marsha Bryant (Newark: University of Delaware Press and London: Associated University Presses, 1996): 85–108.

Barth, Gunther. *Instant Cities: Urbanization and the Rise of San Francisco and Denver.* New York: Oxford University Press, 1975.

Bederman, Gail. "Civilization, The Decline of Middle Class Manliness, and Ida B. Wells' Anti-Lynching Campaign (1892–1894)," in *Gender and American History Since 1890,* ed. by Barbara Melosh. New York: Routledge, 1993, pp. 207–40.

 Manliness and Civilization: A Cultural History of Gender and Race in the United States, 1880–1917. Chicago: University of Chicago Press, 1995.

Beneker, Gerrit A. "Art and the Industrial Problem." *Scribner's Magazine* 74 (September 1923): 290–300.

Benjamin, Walter. *Reflections: Essays, Aphorisms, Autobiographical Writings,* ed. by Peter Demetz and trans. by Edmund Jephcott. New York: Harcourt Brace Jovanovich, 1978.

Berkman, Alexander, ed. *Selected Works of Voltarine de Cleyre.* New York: Mother Earth, 1914.

Berman, Avis. *Rebels on Eighth Street: Juliana Force and the Whitney Museum of American Art.* New York: Atheneum, 1990.

Bernstein, Irving. *The Lean Years: A History of the American Worker, 1920–1933.* Boston: Houghton Mifflin, 1966.

Bernstein, Samuel. "American Labor and the Paris Commune." *Science and Society* 15 (Spring 1951): 144–62.

Blyn, George. "Walt Whitman and Labor." *The Mickle Street Review* 6 (1984): 18–29.

Bogart, Michele. "The Development of a Popular Market for Sculpture in America, 1850–1880." *Journal of American Culture* 4 (Spring 1981): 3–28.

 Public Sculpture and the Civic Ideal in New York City, 1890–1930. Chicago: University of Chicago Press, 1989.

Boime, Albert. *The Art of Exclusion.* Washington, DC: Smithsonian Press, 1990.

 The Unveiling of the National Icons: A Plea for Patriotic Iconoclasm in a Nationalist Era. New York: Cambridge University Press, 1998.

Bowlt, John. "Russian Sculpture and Lenin's Plan of Monumental Propaganda," in *Art and Architecture in the Service of Politics,* ed. by Henry Millon and Linda Nochlin, Cambridge, MA: The MIT Press, 1980, pp. 182–93.

 "Russian Art in the Nineteen Twenties." *Soviet Studies* 22 (April 1971): 585–91.

 Russian Art of the Avant-Garde: Theory and Criticism, 1902–1934. New York: Viking Press, 1976.

Boyer, Paul. *Urban Masses and Moral Order in America, 1820–1920.* Cambridge, MA: Harvard University Press, 1978.

Boyer, Richard O., and Herbert M. Morais. *Labor's Untold Story.* New York: Cameron Associates, 1955.

Braverman, Harry. *Labor and Monopoly Capital: The Degradation of Work in the Twentieth Century.* New York: Monthly Review Press, 1974.

Brinton, Christian. "Constantin Meunier's Message to America." *The Studio International* 5 (January 1914):149–57.

 Constantin Meunier. Exh. Cat. Columbia University, New York, 1914.

 Modern Artists. New York: Baker and Taylor, 1908.

Brody, David. *Workers in Industrial America.* New York: Oxford University Press, 1980.

Bromwell, Nicholas K. *By the Sweat of the Brow: Literature and Labor in Antebellum America.* Chicago: University of Chicago Press, 1993.

Brown, Julie K. *Contesting Images: Photography and the World's Columbian Exposition.* Tucson: University of Arizona Press, 1994.

Brown, Milton. *American Painting from the Armory Show to the Depression.* Princeton: Princeton University Press, 1972.

Bryson, Norman, Michael Ann Holly, and Keith Moxey, eds. *Visual Culture: Images and Presentations.* Hanover, NH: Wesleyan University Press and the University Press of New England, 1994.

Buder, Stanley. *Pullman: An Experiment in Industrial Order and Community Planning 1880–1930*. New York: Oxford University Press, 1967.

Burg, David F. *Chicago's White City of 1893*. Lexington: University of Kentucky Press, 1976.

Burns, Sarah. *Pastoral Inventions: Rural Life in Nineteenth-Century American Art and Culture*. Philadelphia: Temple University Press, 1989.

Butler, Judith. *Gender Trouble: Feminism and the Subversion of Identity*. New York: Routledge, 1990.

Byne, Arthur G. "The Salient Characteristics of the Work of Charles Keck." *Architectural Record* 32 (August 1912): 120–8.

Caffin, Charles H. "National Sculpture Society Exhibition." *International Studio* 18 (December 1902): ciii – cvi.

Carroll, Mitchell. "Paul Bartlett's Pediment Group for the House Wing of the National Capitol." *Art and Archaeology* 1 (January 1915): 163–73.

Casteras, Susan. "Abastenia St. Leger Eberle's *White Slave*." *Woman's Art Journal* 7 (Spring/Summer 1986): 32–7.

Clark, T. J. *The Absolute Bourgeois: Artists and Politics in France 1848–1851*. Greenwich, CT: New York Graphic Society, 1973.

"Class War in Colorado." *The Masses* 5 (June 1914): 5–8.

Cohen, Lizabeth. *Making a New Deal: Industrial Workers in Chicago, 1919–1939*. New York: Cambridge University Press, 1990.

Conlin, Joseph, ed. *The American Radical Press 1880–1960*. Westport, CT: Greenwood Press, 1974.

Conn, Peter. *The Divided Mind: Ideology and Imagination in America, 1891–1917*. New York: Cambridge University Press, 1983.

"Constantin Meunier: The Belgian Sculptor Who Has Immortalized Modern Labor Conditions in His Art." *The Craftsman* 25 (January 1914): 315–23.

Cooper, Patricia A. *Once a Cigar Maker: Men, Women and Work Culture in American Cigar Factories 1900–1919*. Chicago: University of Illinois Press, 1987.

Corber, Robert J. "Reconstructing Homosexuality: Hitchcock and the Homoerotics of Spectatorial Pleasure." *Discourse* 13 (Spring – Summer 1991): 58–83.

Couvares, Francis G. *The Remaking of Pittsburgh: Class and Culture in an Industrializing City, 1877–1919*. Albany: State University of New York Press, 1984.

Coward, Rosalind. *Female Desires*. New York: Grove Press, 1985.

Cronin, Morton. "Currier and Ives: A Content Analysis." *American Quarterly* 4 (1952): 317–30.

Cushing, Charles Phelps. "A Consumer's View of Sculpture." *Collier's Weekly* 50 (December 14, 1912): 32–4.

Dabakis, Melissa. "Gendered Labor: Norman Rockwell's *Rosie the Riveter* and the Discourses of Wartime Womanhood," in *Gender and American History Since 1890*, ed. by Barbara Melosh, pp. 182–207. New York: Routledge, 1993.

"The Sculpture of Saul Baizerman (1889–1957)." Ph.D. diss., Boston University, Boston, 1987.

Dancis, Bruce. "Social Mobility and Class Consciousness: San Francisco's International Workmen's Association in the 1880s." *Journal of Social History* 11 (Fall 1977): 75–99.

"A Danish-American Sculptor: The Work of Johannes S. Gelert." *The Architectural Record* 33 (April 1913): 334.

David, Henry. *The History of the Haymarket Affair*. New York: Farrar and Rinehart, 1936.

Davis, Katherine Bement. "Report on the Exhibit of the New York State Workingman's Model Home," in *Report of the Board of General Managers of the Exhibit of the State of New York at the World's Columbian Exposition*, pp. 396–461. Albany, NY: James B. Lyon, State Printer, 1894.

Davis, Mike. "The Stop Watch and the Wooden Shoe: Scientific Management and the Industrial Workers of the World." *Radical America* 9 (January–February 1975): 69–96.

Davis, Natalie Zemon. *Society and Culture in Early Modern France*. Stanford: Stanford University Press, 1975.

Davis, Rebecca Harding. *Life in the Iron Mills and Other Stories*, ed. by Tillie Olsen. New York: Feminist Press, 1985.

Davis, Whitney. "Erotic Revision in Thomas Eakins's Narratives of Male Nudity." *Art History* 17 (September 1994): 301–41.

Dedication Ceremonies of the Barnard Statues. Harrisburg: Legislative Commission in Charge of Dedication Ceremonies, 1912.

"Dedication of Gompers Memorial." *American Federationist* 40 (October 1933): 1044.

Denning, Michael. *Mechanic Accents: Dime Novels and Working-Class Culture in America*. New York: Verso, 1987.

Dillon, Diane. " 'The Fair as a Spectacle': American Art and Culture at the 1893 World's Fair." Ph.D. diss., Yale University, New Haven. 1994.

Dillon, Richard H. *Iron Men: Peter, James, and Michael Donahue, California's Industrial Pioneers*. Point Richmond, CA: Candela Press, 1984.

Dinnerstein, Lois. "The Iron Worker and King Solomon: Some Images of Labor in American Art." *Arts* 54 (September 1979): 112–17.

Doezema, Marianne. *George Bellows and Urban America*. New Haven: Yale University Press, 1992.

Douglas, Ann. *Terrible Honesty: Mongrel Manhattan in the 1920s*. New York: Farrar, Strauss and Giroux, 1995.

Dreishpoon, Douglas, ed. *Saul Baizerman's Lifetime Project: The City and the People*. Exh. Cat. Weatherspoon Art Gallery, University of North Carolina at Greensboro, 1998.

Dubofsky, Melvyn. "Abortive Reforms: The Wilson Administration and Organized Labor, 1913–1920," in *Work, Community and Power*, ed. by James E. Cronin and Carmen Sirianni, pp. 197–221. Philadelphia: Temple University Press, 1983.

 Industrialism and the American Worker, 1865–1920, 2nd ed. Arlington Heights, IL: Harlan Davidson, 1985.

Dulles, Foster Rhea. *Labor in America*. New York: T. Y. Crowell, 1944.

Eastman, Crystal. "Charles Haag: An Immigrant Sculptor of His Kind." *The Chautauquan* 48 (October 1907): 249–62.

Edgarton, Giles. "Is There a Sex Distinction in Art?" *The Craftsman* 14 (June 1908): 239–51.

Egbert, Donald Drew. *Social Radicalism and the Arts*. New York: Alfred A. Knopf, 1970.

Egbert, Donald Drew, and Stow Parsons. *Socialism and American Life*. Princeton, NJ: Princeton University Press, 1952.

Elderfield, John. "Constructivism and the Objective World: An Essay on Production Art and Proletarian Culture." *Studio International* 180 (September 1970): 73–80.

Erkkila, Betsy. *Whitman the Political Poet*. New York: Oxford University Press, 1989.

Ethel Myers. Exh. Cat. Robert Schoelkopf Gallery, New York, 1963.

"Everett Shinn's Paintings of Labor in the New York City Hall at Trenton, NJ." *Craftsman* 21 (January 1912): 379–80; 383–4.

Exhibition of Sculpture by Chester Beach, Abastenia St. Leger Eberle, Mahonri Young. Exh. Cat. Macbeth Gallery, New York, 1914.

Exhibition of Sculpture by Saul Baizerman. Exh. Cat. Eighth Street Gallery, New York. 1933.

Fahlman, Betsy. *John Ferguson Weir: the Labor of Art*. Cranbury, NJ: Associated University Presses and the University of Delaware Press, 1998.

 "Guest Editorial." *IA: The Journal of the Society for Industrial Archeology* 12(2) (1986): 1–4.

 "John Ferguson Weir: Painter of Romantic and Industrial Icons." *Archives of American Art Journal* 20(2) (1980): 2–9.

Filene, Peter. *Him/Her/Self: Sex Roles in Modern America*, rev. ed. Baltimore: Johns Hopkins University Press, 1986.

Fink, Leon. *Workingmen's Democracy: The Knights of Labor and American Politics.* Chicago: University of Illinois Press, 1985.

Finn, David, and Melissa Dabakis. *Vision of Harmony: The Sculpture of Saul Baizerman.* Redding Ridge, CT: Black Swan Books, 1989.

Fleming, E. McClung. "The American Image as Indian Princess, 1765–1783." *Winterthur Portfolio* 2 (1965): 65–81.

"From Indian Princess to Greek Goddess: The American Image, 1783–1815." *Winterthur Portfolio* 3 (1967): 37–67.

Flynn, John J. *Chicago, the Marvelous City of the West: A History, an Encyclopedia, and a Guide.* Chicago: Flinn and Sheppard, 1891.

Foley, Barbara. *Radical Representations: Politics and Form in U.S. Proletarian Fiction, 1929–1941.* Durham, NC: Duke University Press, 1993.

Foote, Kenneth E. *Shadowed Ground: America's Landscapes of Violence and Tragedy.* Austin, TX: University of Texas Press, 1997.

Fort, Ilene Susan. *The Figure in American Sculpture: A Question of Modernity.* Los Angeles: Los Angeles County Museum of Art, and Seattle: University of Washington Press, 1995.

Frey, John P. "A Sculptor's Conception of Labor." *International Molder's Journal* 47 (June 1911): 424–9.

Fryd, Vivien Green. *Art and Empire: The Politics of Ethnicity in the United States Capitol, 1815–1860.* New Haven: Yale University Press, 1992.

Fusco, Peter, and H. W. Janson, eds. *The Romantics to Rodin: French Nineteenth-Century Sculpture from North American Collections.* Exh. Cat. Los Angeles County Museum in association with George Braziller, 1980.

Genaur, Emily. *Labor Sculpture by Max Kalish A.N.A.* New York: Comet Press, 1938.

Gerrit A. Beneker (1882–1934): Painter of American Industry. Exh. Cat. Vose Galleries of Boston, n.d.

Gilbert, James. *Perfect Cities: Chicago's Utopias of 1893.* Chicago: University of Chicago Press, 1991.

Work Without Salvation: America's Intellectuals and Industrial Alienation, 1880–1910. Baltimore: Johns Hopkins University Press, 1977.

Ginger, Ray. *Altgeld's America: The Lincoln Ideal versus Changing Realities.* New York: Funk and Wagnalls, 1958.

Gitelman, H. M. *Legacy of the Ludlow Massacre: A Chapter in American Industrial Relations.* Philadelphia: University of Pennsylvania Press, 1988.

Glasberg, David. "History and the Public: Legacies of the Progressive Era." *Journal of American History* 73 (March 1987): 957–80.

Goldman, Emma. *Living My Life.* New York: Alfred A. Knopf, 1931.

Golin, Steve. *The Fragile Bridge: The Paterson Silk Strike, 1913.* Philadelphia: Temple University Press, 1988.

Gompers, Samuel. *Seventy Years of Life and Labor: An Autobiography.* Revised and ed. by Philip Taft and John A. Sessions. New York: Dutton, 1957.

Gorn, Elliot J. *The Manly Art: Bare-Knuckle Prize Fighting in America.* Ithaca, NY: Cornell University Press, 1986.

Graham, Jr., Otis L., and Meghan Robinson Wander, eds. *Franklin D. Roosevelt: His Life and Times.* Boston: G. K. Hall, 1985.

Gramsci, Antonio. *Selections from the Prison Notebooks,* ed. and trans. by Quentin Hoare and Geoffrey Nowell Smith. New York: International, 1971.

Green, Archie. "Labor Landmarks: Past and Present." *Labor's Heritage* 6 (Spring 1995): 26–54.

Green, James R. "Workers, Union, and the Politics of Public History." *The Public Historian* 11 (Fall 1989): 11–38.

The World of the Worker: Labor in Twentieth Century America. New York: Hill and Wang, 1980.

Green, Martin. *New York 1913: The Armory Show and the Paterson Strike Pageant.* New York: Macmillan, 1988.

Greenwald, Maurine, and Margo Anderson. *Pittsburgh Surveyed: Social Science and Social Reform in the Early Twentieth Century.* Pittsburgh: University of Pittsburgh Press, 1996.

Griffen, Randall. C."Thomas Eakins' Construction of the Male Body, or Men Get to Know Each Other Across the Space of Time." *Oxford Art Journal* 18(2) (1995): 70–80.

"Thomas Anshutz's *The Ironworker's Noontime:* Remythologizing the Industrial Worker." *Smithsonian Studies in American Art* 4 (Summer/Fall 1990): 129–45.

Gullickson, Gay L. *Unruly Women of Paris: Images of the Commune.* Ithaca, NY: Cornell University Press, 1996.

"*La Pétroleuse:* Representing Revolution." *Feminist Studies* 17 (Summer 1991): 241–65.

Gutman, Herbert. *Work, Culture and Society in Industrializing America.* New York: Vintage Books, 1977.

Halbachs, Maurice. *On Collective Memory,* ed. and trans. Lewis A. Coser. Chicago: University of Chicago Press, 1992.

Hales, Peter. *Constructing the Fair: Platinum Photographs by C. D. Arnold of the World's Columbian Exposition.* Exh. Cat. The Art Institute of Chicago, 1993.

"Photography and the World's Columbian Exposition: A Case Study." *Journal of Urban History* 15 (May 1989): 247–71.

Silver Cities: The Photography of American Urbanization, 1839–1915. Philadelphia: Temple University Press, 1884.

Hall, Stuart. "The Rediscovery of 'Ideology': Return of the Repressed in Media Studies," in *Culture, Society and Media,* ed. by Michael Gurevitch et al., pp. 56–91. New York: Methuen, 1982.

Hamerow, Theodore S. *Restoration, Revolution, Reaction: Economics and Politics in Germany, 1815–1871.* Princeton: Princeton University Press, 1963.

Hanotelle, Micheline. *Paris/Bruxelles: Rodin/Meunier.* Paris: Le Temps, 1982.

Hantover, Jeffrey. "The Boy Scouts and the Validation of Masculinity," in *American Man,* ed. by Elizabeth H. Pleck and Joseph H. Pleck, pp. 285–303. Englewood Cliffs, NJ: Prentice Hall, 1980.

Harris, Neil. "Museums, Merchandising and Popular Taste: The Struggle for Influence," in *Material Culture and the Study of American Life,* ed. by Ian M. G. Quimby, pp. 140–74. New York: W. W. Norton, 1978.

Harris, Neil, Wim de Witt, James Gilbert, and Robert Rydell. *Grand Illusions: Chicago's World's Fair of 1893.* Exh. Cat. Chicago Historical Society, 1993.

Harrison, Helen A. "John Reed Club Artists and the New Deal: Radical Responses to Roosevelt's 'Peaceful Revolution'." *Prospects* 5 (1980): 240–68.

Harvey, David. *The Condition of Postmodernity: An Enquiry into the Origins of Cultural Change.* Cambridge, MA: Basil Blackwell, 1989.

Hatt, Michael. "Muscles, Morals, Mind: The Male Body in Thomas Eakins' Salutat," in *The Body Imaged: The Human Form and Visual Culture Since the Renaissance,* ed. by Kathleen Adler and Marcia Pointon. New York: Cambridge University Press, 1993.

"Making a Man of Him: Masculinity and the Black Body in Mid-Nineteenth Century American Sculpture." *Oxford Art Journal* 15 (1) (1992): 21–35.

Haupt, George. "La Commune comme Symbole et Comme Exemple." *Le Mouvement Social* 79 (April–June 1972): 205–26.

Haywood, Robert. "George Bellows' *Stag at Sharkey's:* Boxing, Violence and Male Identity." *Smithsonian Studies in American Art* 2 (Spring 1988): 3–17.

"He Photo-Interprets Big Labor: Camera Studies of Men at Work by Lewis W. Hine." *The Mentor* 14 (September 1926): 41–7.

Heiss, Christine. "German Radicals in Industrial America: The *Lehr - und Wehr-Verein* in

Gilded Age Chicago," in *German Workers in Industrial Chicago, 1850–1910: A Comparative Perspective*, ed. by Harmut Keil and John B. Jentz, pp. 206–18. DeKalb: Northern Illinois University Press, 1983.

Held, Julius. *Saul Baizerman*. Exh. Cat. Walker Art Center, Minneapolis, 1953.

Herbert, Eugenia W. *The Artist and Social Reform: France and Belgium, 1885–1898*, 2nd ed. New York: Arno Press, 1980.

Hertz, Neil. "Medusa's Head: Male Hysteria under Political Pressure." *Representations* 4 (Fall 1983): 27–54.

Higgins, Andrew. "Art and Politics in the Russian Revolution," Parts I and II. *Studio International* (London) 180 (November 1970): 164–7, and (December 1970): 224–7.

Higham, John. *Strangers in the Land: Patterns of American Nativism, 1860–1925*. New York: Atheneum, 1963.

Hills, Patricia. "1936: Meyer Schapiro, *Art Front* and the Popular Front." *Oxford Art Journal* 17 (1) (1994): 30–41.

Social Concern and Urban Realism: American Painting of the 1930s. Exh. Cat. Boston University Art Gallery, Boston, 1983.

"The Fine Arts in America: Images of Labor from 1800–1950," in *Essays from the Lowell Conference on Industrial History, 1982 and 1983*, ed. by Robert Weible, pp. 120–64. North Andover, MA: Museum of American Textile History, 1985.

Hills, Patricia, and Abigail Booth Gerdts. *Working American*. Exh. Cat. District 1199, National Union of Hospital and Health Care Employees and the Smithsonian Institution Traveling Exhibition Service, 1979.

Hills, Patricia, and Roberta K. Tarbell. *The Figurative Tradition and the Whitney Museum of American Art*. Exh. Cat. New York: Whitney Museum of American Art, and Newark, DE: University of Delaware Press, 1980.

"Hine's 'Work Photographs.' *International Studio* 77 (August 1923): 375–9.

Hines, Thomas S. *Burnham of Chicago: Architect and Planner*. New York: Oxford University Press, 1974.

Hinton, Wayne K. "A Biographical History of Mahonri M. Young, A Western American Artist." Ph.D. diss., Brigham Young University, 1974.

Hitchcock, Ripley, ed. *The Art of the World Illustrated in Paintings, Statuary, and Architecture of the World's Columbian Exposition*. New York: Appleton, 1895.

Hobsbawm, Eric. "Man and Woman in Socialist Iconography." *History Workshop* 6 (1978): 121–38.

Hoeber, Arthur. "Sculpture of Robert Aitken, N.A." *The International Studio* 54 (November 1914): xv–xviii.

"Robert I. Aitken, A.N.A., An American Sculptor." *The International Studio* 50 (July 1913): iii – vii.

Hoeder, Dirk, *Struggle a Hard Battle: Essays on Working-Class Immigrants*. DeKalb: Northern Illinois University Press, 1986.

ed. *American Labor and Immigration History, 1877–1920s: Recent European Research*. Urbana: University of Illinois Press, 1983.

Hofstadter, Richard. *Social Darwinism in American Thought*, rev. ed. Boston: Beacon Press, 1995.

Homberger, Eric. *American Writers and Radical Politics, 1900–1939: Equivocal Commitments*. New York: St. Martin's Press, 1986.

Horowitz, Helen. *Culture and the City: Cultural Philanthropy in Chicago from the 1880s to 1917*. Chicago: University of Chicago Press, 1986.

Howe, Samuel. "Meunier: Sculptor of Labor." *Survey* 31 (February 7, 1914): 569–74.

"Constantin Meunier: A Sculptor of the People." *Craftsman* 8 (July 1905): 441–5.

"Industrial Labor in Art." *The Nation* 98 (January 15, 1914): 54.

"Inventory of Labor Landmarks." *Labor's Heritage* 6 (Spring 1995): 59.

Issel, William, and Robert W. Cherny. *San Francisco, 1865–1932: Politics, Power and Urban Development.* Berkeley: University of California Press, 1986.

James, C. Vaughan. *Soviet Socialist Realism: Origins and Theory.* New York: St. Martin's Press, 1973.

Kahn, Judd. *Imperial San Francisco: Politics and Planning in an American City, 1897–1906.* Lincoln: University of Nebraska Press, 1979.

Kanigel, Robert. *The One Best Way: Frederick Winslow Taylor and the Enigma of Efficiency.* New York: Viking Press, 1997.

Kaplan, Daile, ed. *Photo Story: Selected Letters and Photographs of Lewis W. Hine.* Washington, DC: Smithsonian Institution Press, 1992.

Kasson, Joy. *Marble Queens and Captives: Women in Nineteenth Century American Sculpture.* New Haven: Yale University Press, 1990.

Kaufman, Stuart B. *Samuel Gompers and the Origins of the American Federation of Labor.* Westport CT: Greenwood Press, 1973.

Kazin, Michael. *Barons of Labor: The San Francisco Building Trades and Union Power in the Progressive Era.* Urbana: University of Illinois Press, 1987.

Keil, Hartmut. "The Impact of Haymarket on German-American Radicalism." *International Labor and Working Class History.* 29 (Spring 1986): 14–28.

Kirn, Mary Em, and Sherry Case Maurer. *Harute – Out Here: Swedish Immigrant Artists in Midwest America.* Exh. Cat. Augustana College, Rock Island, Illinois, 1984.

Kirshenblatt-Gimblett, Barbara. "Objects of Ethnography," in *Exhibiting Cultures,* ed. by Ivan Karp and Steven Lavine, pp. 386–444. Washington, DC: Smithsonian Institution Press, 1991.

Knaufft, Ernest. "George Grey Barnard: A Virile American Sculptor." *The American Review of Reviews* 38 (December 1908): 689–92.

Kolko, Gabriel. *The Triumph of Conservatism: A Reinterpretation of American History, 1900–1916.* New York: The Free Press, 1963.

Kornbluh, Joyce L., ed. *Rebel Voices: An I.W.W. Anthology.* Ann Arbor: University of Michigan Press, 1964.

Langum, David J. *Crossing Over the Line: Legislating Morality and the Mann Act.* Chicago: University of Chicago Press, 1994.

Larsen, Lawrence C. *The Urban West and the End of the Frontier.* Lawrence: The Regents of Kansas, 1978.

Laurie, Bruce. *Artisans into Workers: Labor in Nineteenth Century America.* New York: Noonday Press, 1989.

Lavender, David. *California: A Bicentenniel History.* New York: W. W. Norton, 1976.

Lears, T. J. Jackson. "The Concept of Cultural Hegemony: Problems and Possibilities." *American Historical Review* 90 (June 1985): 567–93.

Lehman, Peter. "*In the Realm of the Senses:* Desire, Power, and the Representation of the Male Body." *Genders* 2 (Summer 1988): 91–110.

Leja, Michael. "Modernism's Subjects in the United States." *Art Journal* 55 (Summer 1996): 65–73.

Leuchtenburg, William E. *Franklin D. Roosevelt and the New Deal, 1932–1940.* New York: Harper and Row, 1963.

The Perils of Prosperity 1914–1932. Chicago: University of Chicago Press, 1958.

Lewis, Lloyd, and Henry Justin Smith. *Chicago: The History of its Reputation.* New York: Blue Ribbon Books, 1929.

Lewis, Russell. "Everything Under One Roof: World's Fairs and Department Stores in Paris and Chicago." *Chicago History* 3 (Fall 1983): 28–47.

Long, Priscilla. "The Voice of the Gun: Colorado's Great Coalfield War of 1913–1914." *Labor's Heritage* 1 (October 1989): 4–24.

"The Women of the Colorado Fuel and Iron Strike, 1913–1914," in *Women, Work and Protest: A Century of U.S. Women's Labor History,* ed. by Ruth Milkman, pp. 62–85. Boston: Routledge and Kegan Paul, 1985.

Lovell, Margaretta M. "Picturing 'A City for a Single Summer': Paintings of the World's Columbian Exposition." *Art Bulletin* 78 (March 1996): 40–55.

Low, Will H. "The Art of the White City." *Scribner's Magazine* 14 (October 1893): 504–12.

Lucic, Karen. *Charles Sheeler and the Cult of the Machine.* Cambridge, MA: Harvard University Press, 1991.

Lynd, Robert S., and Helen M. Lynd. *Middletown: A Study in American Culture,* 1929 rpt. New York: Harcourt Brace Jovanovich, 1959.

Mangan, J. A., and James Walvin. *Manliness and Morality: Middle Class Masculinity in Britain and America, 1880–1940.* New York: St. Martin's Press, 1987.

Markham, Edwin. "Labor: Hopeless and Hopeful." *The Independent* 52 (February 8, 1990): 353–4.

"How and Why I wrote the Man with the Hoe." *Saturday Evening Post* 172 (December 16, 1899): 497–8.

Marstine, Janet C. "Working History: Images of Labor and Industry in American Mural Painting, 1893–1903." Ph.D. diss., University of Pittsburgh, Pittsburgh, 1993.

Marx, Karl. *The Portable Karl Marx.* Trans. in part by Eugene Kamenka. New York: Penguin Books, 1983.

Marx, Leo. "The Railroad in the Landscape: An Iconographical Reading of a Theme in American Art." *Prospects* 10 (1985): 77–117.

The Machine in the Garden: Technology and the Pastoral Ideal in America. New York: Oxford University Press, 1967.

The Railroad in the American Landscape, 1850–1950. Exh. Cat. Wellesely, MA: Wellesely College Museum of Art, 1981.

McCarthy, Kathleen D. *Women's Culture: American Philanthropy and Art, 1830–1930.* Chicago: University of Chicago Press, 1991.

Meixner, Laura. *French Realist Painters and the Critique of American Society, 1865–1900.* New York: Cambridge University Press, 1995.

"The Best of Democracy: Walt Whitman, Jean-François Millet and Popular Culture in Post-Civil War America," in *Walt Whitman and the Visual Arts,* ed. by Geoffrey Sill and Roberta K. Tarbell, pp. 28–53. Brunswick, NJ: Rutgers University Press, 1992.

"Popular Criticism of Jean-François Millet in Nineteenth-Century America." *Art Bulletin* 65 (March 1983): 96–105.

An International Episode: Millet, Monet, and their North American Counterparts. Exh. Cat. The Dixon Gallery and Garden, Memphis, Tennessee, 1982.

Melosh, Barbara. *Engendering Culture: Manhood and Womanhood in New Deal Public Art and Theater.* Washington, DC: Smithsonian Institution Press, 1991.

"Memorial Day at Ludlow." *United Mine Workers Journal* 29 (June 6, 1918): 4.

Merriman, Christine. "New Bottles for New Wine: The Work of Abastenia St. Leger Eberle." *The Survey* 30 (May 3, 1913): 196–9.

"Meunier and Belgian 'Socialist' Art." *Review of Reviews* (American) 48 (December 1913): 743–4.

"Meunier Preaching to Americans." *Literary Digest* 48 (January 17, 1914): 106–7.

Meyer, Susan. "In Anxious Celebration: Lewis Hine's Men at Work." *Prospects* 17 (1992): 319–53.

Millet, F. D. "The Decoration of the Exposition." *Scribner's Magazine* 12 (December 1892): 692–709.

Milroy, Elizabeth. *Painters of a New Century: The Eight and American Art.* Exh. Cat. Milwaukee Art Museum, Milwaukee, 1991.

Modleski, Tania. "The Incredible Shrinking He(r)man: Male Regression, the Male Body and Film." *Differences* 2 (2) (1990): 55–76.

Monroe, Gerald M. "The Artist Union of New York." Ph.D. diss., New York University, 1971.

Montgomery, David. *The Fall of the House of Labor.* New York: Cambridge University Press, 1987.

Workers' Control in America: Studies in the History of Work, Technology, and Labor Struggles. New York: Cambridge University Press, 1979.

Moon, Michael. *Disseminating Whitman: Revision and Corporeality in Leaves of Grass.* Cambridge, MA: Harvard University Press, 1991.

Mrozek, Donald. *Sport and American Mentality 1880–1910.* Knoxville: University of Tennessee Press, 1983.

Murphy, James F. *The Proletarian Moment: The Controversy over Leftism in Literature.* Chicago: University of Illinois Press, 1991.

Nash, Roderick. "The American Cult of the Primitive." *The American Quarterly* 18 (Fall 1966): 520–38.

Naumann, Francis M. "Man Ray and the Ferrer Center: Art and Anarchy in the Pre-Dada Period." *Dada and Surrealism* 14 (1985): 10–31.

Naumann, Francis M., and Paul Avrich. "Adolf Wolff Poet, Sculptor and Revolutionist, but Mostly Revolutionist." *Art Bulletin* 67 (September 1985): 486–501.

Naumann, Francis M., with Beth Venn. *Making Mischief: Dada Invades New York.* Exh. Cat. Whitney Museum of American Art, New York, 1996.

Neale, Steve. "Masculinity as Spectacle: Reflections on Men and Mainstream Cinema." *Screen* 24 (4) (1983): 2–16.

Nelson, Bruce C. *Beyond the Martyrs: A Social History of Chicago's Anarchists, 1870–1900.* New Brunswick: Rutgers University Press, 1988.

Nemerov, Alex. "Doing the 'Old West:' The Image of the American West, 1880–1920," in *The West as America: Reinterpreting Images of the Frontier, 1820–1920,* ed. by William H. Truettner, pp. 284–343. Exh. Cat. Washington, DC: Smithsonian Institution Press, 1991.

"The Nice People of Trinidad." *The Masses* 5 (July 1914): 5–9.

Nochlin, Linda. "The Paterson Strike Pageant of 1913." *Art in America* 62 (May – June 1974): 64–9.

Noun, Louise R. *Abastenia St. Leger Eberle Sculptor (1878–1942).* Exh. Cat. Des Moines Art Center, Des Moines, Iowa, 1980.

Oestreicher, Richard. "From Artisan to Consumer: Images of Workers 1840–1920." *Journal of American Culture* 4 (Spring 1981): 47–65.

Official Catalogue of Exhibits, Part X, World's Columbian Exposition: Department K, Fine Arts. Chicago: W. B. Conkey, 1893.

O'Neill, William L. *The Progressive Years.* New York: Harper and Row, 1975.

Orville, Miles. *After the Machine: Visual Arts and the Erasing of Cultural Boundaries.* Jackson: University of Mississippi Press, 1995.

The Real Thing: Imitation and Authenticity in American Culture, 1880–1940. Chapel Hill: University of North Carolina Press, 1989.

Parry, III, Ellwood C. "Thomas Eakins's 'Naked Series' Reconsidered: Another Look at the Standing Nude Photographs Made for the Use of Eakins's Students." *The American Art Journal* 20(2) (1988): 53–78.

Patrick, Ransom R. "John Neagle, Portrait Painter, and Pat Lyon, Blacksmith." *Art Bulletin* 33 (September 1951): 187–92.

Pauly, Thomas H. "American Art and Labor: The Case of Anshutz's *The Ironworker's Noontime.*" *American Quarterly* 40 (September 1988): 333–59.

Payne, Frank Owen. "The Tribute of American Sculpture to Labor." *Art and Archaeology* 6 (August 1917): 82–93.

Peiss, Kathy. *Cheap Amusements: Working Women and Leisure in Turn-of-the-Century New York.* Philadelphia: Temple University Press, 1986.

Pells, Richard H. *Radical Visions and American Dreams: Culture and Social Thought in the Depression Years.* New York: Harper and Row, 1973.

Perchuk, Andrew, and Helaine Posner, eds. *The Masculine Masquerade: Masculinity and*

Representation. Exh. Cat. Cambridge: List Visual Arts Center and The MIT Press, 1995.

Perlman, Bennard B. *The Immortal Eight: American Painting from Eakins to the Armory Show.* Cincinnati: North Light, 1979.

Peterson, Larry. "Producing Visual Traditions among Workers: The Uses of Photography at Pullman, 1880–1980." *Views: The Journal of Photography in New England* 13 (Spring 1992): 3–10.

Pointon, Marcia. *Naked Authority: The Body in Western Paining 1830–1908.* New York: Cambridge University Press, 1990.

Popular Memory Group. "Popular Memory: Theory, Politics, Method," in *Making Histories: Studies in History-Writing and Politics,* ed. by Richard Johnson, Gregor McLennan, Bill Schwartz, and David Sutton, pp. 205–53. Minneapolis: University of Minnesota Press, 1982.

Potts, Alex. "Male Phantasy and Modern Sculpture." *Oxford Art Journal* 14(2) (1992): 24–48.

"The Protetarian Art of Constantin Meunier." *Current Literature* 39 (September 1905): 270–4.

Quick, Michael, Jane Myers, Marianne Doezeman, and Franklin Kelly. *The Paintings of George Bellows.* Exh. Cat. New York: Abrams, and Fort Worth, TX: The Amon Carter Museum and the Los Angeles County Museum of Art, 1992.

"The Railroaders: Work Portraits by Lewis W. Hine." *The Survey* 47 (October 29, 1921): 159–66.

Rainey, Ada. "American Women in Sculpture." *Century Magazine* 93 (January 1917): 432–8.

"Meunier – Sculptor of Industry." *The Independent* 77 (January 26, 1914): 126–8.

Ramirez, Bruno. *When Workers Fight: The Politics of Industrial Relations in the Progressive Era, 1898–1916.* Westport, CT: Greenwood Press, 1978.

Rassweiler, Anne D. "Soviet Labor History of the 1920s and the 1930s." *Journal of Social History* 17 (Fall 1983): 147–59.

Red Cartoons for the Daily Worker, The Workers' Monthly, and the Liberator. Chicago: The Daily Worker, 1926.

Reidy, James L. "Sculpture at the Columbian Exposition." *Chicago History* 4 (Summer 1975): 99–108.

Remember the Eleventh of November. Chicago: Pioneer Aid and Support Association, 1927.

Revisiting the White City: American Art at the 1893 World's Fair. Exh. Cat. Washington, DC: National Museum of American Art and the National Portrait Gallery, Smithsonian Institution, 1993.

Ricciotti, Dominic. "Symbols and Monuments, Images of the Skyscraper in American Art." *Landscape* 25 (1981): 22–30.

Riis, Jacob. *How the Other Half Lives: Studies Among the Tenements of New York.* Rpt., 1903 New York: Dover, 1971.

Robertson, Priscilla. *Revolutions of 1848: A Social History.* New York: Harper and Bros., 1952.

Rodgers, Daniel R. "In Search of Progressivism." *Reviews in American History* 10 (December 1982): 113–32.

The Work Ethic in Industrial America 1850–1920. Chicago: University of Chicago Press, 1978

Roediger, David. *The Wages of Whiteness: Race and the Making of the American Working Class.* New York: Verso, 1991.

Roediger, David, and Franklin Rosement, eds. *Haymarket Scrapbook.* Chicago: Charles H. Kerr, 1986.

Roosevelt, Theodore, R. *Outdoor Pastimes of an American Hunter.* New York: Charles Scribner's Sons, 1903.

The Winning of the West. New York: Current Literature, 1896.

Rosen, Ruth. *The Lost Sisterhood: Prostitution in America, 1900–1918.* Baltimore: Johns Hopkins University Press, 1982.

Rosenzweig, Roy. "Reforming Working-Class Play: Workers, Parks, and Playgrounds in an Industrializing City, 1870–1920," in *Life & Labor: Dimensions of American Working Class History*, ed. by Charles Stephenson and Robert Asher, pp. 150–76. Albany: State University of New York Press, 1986.

Rotundo, Anthony. "Body and Soul: Changing Ideals of American Middle-Class Manhood, 1770–1920." *Journal of Social History* 16 (Summer 1983): 23–39.

Rubenstein, Harry R. "Symbols and Images of American Labor: Badges of Pride." *Labor's Heritage* 1 (April 1989): 34–49.

Rydell, Robert W. *All the World's a Fair: Visions of Empire at American International Expositions, 1876–1916.* Chicago: University of Chicago Press, 1984.

Sage, Cornelia Bentley. "Constantin Meunier: An Exhibition of the Works of the Great Belgian Sculptor." *Art and Progress* 5 (February 1914): 117–22.

"Constantin Meunier – An Appreciation." *Scribner's Magazine* 55 (April 1914): 535–538.

Savage, Kirk. *Standing Soldiers, Kneeling Slaves: Race, War and Monument in Nineteenth Century America.* Princeton, N.J.: Princeton University Press, 1997.

"The Politics of Memory: Black Emancipation and the Civil War Monument," in *Commemoration: The Politics of National Identity*, ed. by John R. Gillis, pp. 127–49. Princeton, NJ: Princeton University Press, 1994.

Schaak, Michael J. *Anarchy and Anarchists: A History of the Red Terror and the Social Revolution in America and Europe.* Chicago: F. J. Schulte, 1889.

Schleier, Merrill. *The Skyscraper in American Art, 1890–1931.* Ann Arbor: University of Michigan Press, 1986.

Schlesinger, Arthur M., Jr. *The Age of Roosevelt: The Crisis of the Old Order: 1919–1933.* Boston: Houghton Mifflin, 1957.

Schmoll gen. Eisenwerth, J. A. "Denkmaler der Arbeit – Entwurfe und Planungen," in *Denkmaler im 19. Jahrhundert Deutung und Kritik*, ed. by Hans-Ernst Mittag and Volker Plagemann, pp. 253–81. Munich: Prestel-Verlag, 1972.

Schwantes, Carlos A. *Coxey's Army: An American Odyssey.* Lincoln: University of Nebraska Press, 1985.

Schwartz, Lawrence H. *The CPUSA and Aesthetics in the 1930s.* Port Washington, NY: Kennikat Press, 1980.

Sedgwick, Eve Kosofsky. *The Epistemology of the Closet.* Berkeley: University of California Press, 1990.

Between Men: English Literature and Male Homosocial Desire. New York: Columbia University Press, 1985.

Seixas, Peter. "Lewis Hine: From 'Social' to 'Interpretive' Photographer." *American Quarterly* 39 (Fall 1987): 381–409.

Sekula, Allan. "Photography Between Labor and Capital," in *Mining Photographs and Other Pictures 1948–1968*, ed. by Benjamen H. D. Buchloch and Robert Wilkie, Nova Scotia: The Press of the Nova Scotia College of Art and Design and the University College of Cape Breton, 1983.

Shapiro, David, ed. *Social Realism: Art as a Weapon.* New York: Ungar, 1973.

Sharp, Lewis S. *John Quincy Adams Ward: Dean of American Sculpture.* Newark: University of Delaware Press, 1985.

Shepp, James W., and Daniel B. Shepp. *Shepp's World's Fair Photographed.* Philadelphia: Globe Bible Publishing, 1893.

Silverman, Kaja. "Liberty, Maternity, Commodification." *New Formations* 5 (Summer 1988): 69–90.

A Sketch of the Life of Peter Donahue, of San Francisco, 1822–1885. San Francisco: Crocker, 1888.

Slotkin, Richard. *The Fatal Environment: The Myth of the Frontier in the Age of Industrialization, 1800–1890.* New York: Atheneum, 1985.

Smith, Carl. *Urban Disorder and the Shape of Belief: The Great Chicago Fire, the Haymarket Bomb, and the Model Town of Pullman.* Chicago: University of Chicago Press, 1995.

Smith, Carl S. "The Boxing Paintings of Thomas Eakins." *Prospects* 4 (1979): 403–21.

Smith, Terry. *Making the Modern: Industry, Art and Design in America.* Chicago: University of Chicago Press, 1993.

Sohn-Rethel, Alfred. *Intellectual and Manual Labor.* Atlantic Highlands, NJ: Humanities Press, 1978.

Somma, Thomas P. *The Apotheosis of Democracy, 1908–1916: The Pediment for the House Wing of the United States Capitol.* Newark: University of Delaware Press, 1995.

Spargo, John. "Charles Haag – Sculptor of Toil – Kindred Spirit to Millet and Meunier." *The Craftsman* 10 (July 1906): 432–42.

"Constantin Meunier: Painter and Sculptor of Toil." *The Comrade* 1 (10) (1902): 246–8.

Stange, Maren. *Symbols of Ideal Life: Social Documentary Photography in America 1890–1950.* New York: Cambridge University Press, 1989.

Starr, Kevin. *Inventing the Dream: California Through the Progressive Era.* New York: Oxford University Press, 1985.

Sund, Judy. "Columbus and Columbia in Chicago, 1893: Man of Genius Meets Generic Woman." *Art Bulletin* 75 (September 1993): 443–467.

Susman, Warren I. *Culture as History: The Transformation of American Society in the Twentieth Century.* New York: Pantheon Books, 1984.

Taft, Lorado. *The History of American Sculpture.* rpt. 1924. New York: Arno Press, 1969.

Tarbell, Roberta K. "Mahonri Young's Sculptures of Laboring Men, Walt Whitman, and Jean-François Millet," in *Walt Whitman and the Visual Arts*, ed. by Geoffrey M. Sill and Roberta K. Tarbell, New Brunswick, NJ: Rutgers University Press, 1992.

Teall, Gardner. "Women Sculptors of America." *Good Housekeeping Magazine* 53 (August 1911): 175–87.

Ternovetz, Boris. "John Reed Club Art in Moscow." *New Masses* 8 (April 1933): 25.

Theleweit, Klaus. *Male Bodies: Psychoanalyzing the White Terror*, vol. 2. Minneapolis: University of Minnesota Press, 1989.

Male Fantasies: Women, Floods, Bodies, History, vol. 1. Minneapolis: University of Minnesota Press, 1987.

Tilden, Douglas. "Art, and What California Should Do About Her." *Overland Monthly* 19 (May 1892): 509–15.

Todd, Ellen Wiley. *The "New Woman" Revised: Painting and Gender Politics on Fourteenth Street.* Berkeley: University of California Press, 1993.

Toon, Thomas E. "Mahonri Young: His Life and Sculpture." Ph.D. diss., Pennsylvania State University, University Park, 1982.

Trachtenberg, Alan. *Reading American Photographs: Images as History, Mathew Brady to Walker Evans.* New York: Hill and Wang, 1989.

The Incorporation of America. New York: Hill and Wang, 1982.

Tridon, André. "Adolf Wolff: A Sculptor of To-Morrow." *The International* 8 (March 1914): 86–7.

Van Hook, Bailey, *Angels of Art: Women and Art in American Society, 1876–1914.* University Park: Pennsylvania State University Press, 1996.

"From the Lyrical to the Epic: Images of Women in American Murals at the Turn of the Century." *Winterthur Portfolio* 26 (Spring 1991): 63–81.

Walton, William. "Mr. Bartlett's Pediment for the House of Representatives, Washington, DC." *Scribner's Magazine* 48 (July 1910): 125–8.

Warner, Maria. *Monuments and Maidens: The Allegory of the Female Form.* New York: Atheneum, 1985.

Weber, Max. *The Protestant Ethic and the Spirit of Capitalism*, trans. by Talcott Parsons. New York: Charles Scribner's Sons, 1952.

Weinstein, James. *The Corporate Ideal in the Liberal State, 1900–1910.* Boston: Beacon Press, 1968.

"What Is a Landmark?" *Labor's Heritage* 6 (Spring 1995): 54–64.

White, G. Edward. *The Eastern Establishment and the Western Experience: The West of Frederic Remington, Theodore Roosevelt, Owen Wister.* Austin: University of Texas Press, 1989.

Whiting, Cécile. *Antifascism in American Art.* New Haven: Yale University Press, 1989.

Whitman, Walt. *The Leaves of Grass by Walt Whitman, the 1892 edition.* New York: Bantam Books, 1983.

Wilentz, Sean. *Chants Democratic: New York City and the Rise of the American Working Class, 1788–1850.* New York: Oxford University Press, 1984.

Wilhelm, Donald. "Babies in Bronze: The Life-Work of Miss Abastenia Eberle." *Illustrated World* 24 (November 1915): 328–31.

Williams, Raymond. *Keywords: A Vocabulary of Culture and Society.* New York: Oxford University Press, 1983.

Willis, Paul. "Masculinity and Factory Labor," in *Culture and Society: Contemporary Debates,* ed. by Jeffrey C. Alexander and Steven Seidman, pp. 183–95. New York: Cambridge University Press, 1990.

Wilson, William. H. *The City Beautiful Movement.* Baltimore: Johns Hopkins University Press, 1989.

Wittke, Carl. *Refugees of Revolution: The German Forty-Eighters in America.* Philadelphia: University of Pennsylvania Press, 1952.

Wobbly: 80 Years of Rebel Art. Exh. Cat. Labor Archives and Research Center, San Francisco, 1987.

Wolf, Bryan J. "The Labor of Seeing: Pragmatism, Ideology, and Gender in Winslow Homer's *The Morning Bell.*" *Prospects* 17 (1992): 273–319.

Wollen, Peter. "Art in Revolution: Russian Art in the Twenties." *Studio International* (London) 181 (April 1971): 149–54.

Wright, Richard. *American Hunger.* New York: Harper and Row, 1944.

Wyckoff, Walter A. *The Workers: An Experiment in Reality, The West.* New York: Charles Scribner's Sons, 1900.

Young, James E. *The Texture of Memory: Holocaust Memorials and Meaning.* New Haven: Yale University Press, 1993.

Ziegler, Francis J. "An Unassuming Painter – Thomas P. Anshutz." *Brush and Pencil* 4 (September 1899): 277–84.

Zola, Emile. *Germinal.* New York: Viking Penguin, 1986.

Zurier, Rebecca. "The Masses and Modernism," in *1915: The Cultural Moment,* ed. by Adele Heller and Lois Rudnick, pp. 196–217. New Brunswick, NJ: Rutgers University Press, 1991.

 Art for the Masses (1911–1917): A Radical Magazine and Its Graphics. Exh. Cat. Yale University Art Gallery, New Haven, 1985.

Zurier, Rebecca, Robert W. Synder, and Virginia M. Mechlenburg. *Metropolitan Lives: The Ashcan Artists and Their New York.* Exh. Cat. New York: National Museum of American Art and W. W. Norton, 1995.

INDEX